The arts, literature, and society

The Arts, Literature, and Society identifies and discusses some of the major issues and problems involved in studying the relationships between society and the arts and literature. The book consists of contributions by specialist authors on a wide variety of topics relating to both Britain and Germany, from Shakespeare to German expressionism to the political thriller of today. Approaches range from those informed by the latest linguistic, cultural, and discourse theories to more traditional methods of analysis. Together, the essays address a number of key issues outlined in the editor's introduction – such as whether the terms 'the arts' and 'literature' are legitimate in the first place. The book's conclusion indicates what are the most fruitful approaches to this increasingly important field of interdisciplinary study.

Generously illustrated, *The Arts, Literature, and Society* will appeal to general readers interested in any of the topics discussed as well as to students and scholars concerned with the problems involved in interdisciplinary cultural study.

The arts, literature, and society

Edited by Arthur Marwick

ROUTLEDGE

London and New York

First published 1990
by Routledge
11 New Fetter Lane, London EC4P 4EE

Simultaneously published in the USA and Canada
by Routledge
a division of Routledge, Chapman and Hall, Inc.
29 West 35th Street, New York, NY 10001

Typeset in 10/12pt Times by
Times Graphics, Singapore
Printed in Great Britain by
TJ Press (Padstow) Ltd, Padstow Cornwall.

British Library Cataloguing in Publication Data
The Arts, Literature and Society.
 1. Western world. Society. Role in the arts
 I. Marwick, Arthur, *1936–* II. Social history. Society of the United
 Kingdom
 700'.9181'2

Library of Congress Cataloging in Publication Data
The Arts, literature, and society/ edited by Arthur Marwick.
 p. cm.
 Includes bibliographical references.
 1. Arts and society – Great Britain. 2. Arts and society – Germany.
 I. Marwick, Arthur, 1936– .
 NX180.S6A78 1990
 700'. 1' 030941—dc 20 89-70150

ISBN 0 415 01445 X

Contents

Figures

Notes on contributors

JOHN BARRELL has taught at the Universities of Essex and Cambridge, and is now Professor of English at Sussex. He is the author of *The Idea of Landscape and the Sense of Place* (1972), *The Dark Side of the Landscape* (1980), *An Equal, Wide Survey* (1983), *The Political Theory of Painting from Reynolds to Hazlitt* (1986), *Poetry, Language and Politics* (1988), and *The Birth of Pandora* and *The Infection of Thomas de Quincey* (both forthcoming, 1991).

MARK THORNTON BURNETT studied at the Universities of Exeter, California, and Oxford and taught at the University of Geneva before taking up his present post, Lecturer in English at the Queen's University of Belfast. He has published articles on Dekker, Heywood, Marlowe, Marston, Middleton, Shakespeare, and Elizabethan popular culture.

WILLI GUTTSMAN was Librarian of the University of East Anglia from 1962 until his retirement in 1985. He has published extensively in the field of political sociology and social history. His most recent publications include *The German Social Democratic Party, 1875–1933: From Ghetto to Government* (1981), *Icon and Revolution: Political and Social Themes in German Art, 1918–1933* (the catalogue of an exhibition at the Sainsbury Centre for Visual Arts at the University of East Anglia, 1986), and *Workers Culture in Weimar Germany: Between Tradition and Commitment* (1990).

CHRISTOPHER HARVIE, Lecturer at the Open University from 1969–80, is now Professor of British and Irish Studies at the University of Tübingen in West Germany. He has published and broadcast widely on modern British and Scottish history, and his latest book, *The Centre of Things*, a study of political fiction in

Britain from Disraeli to the present, will be published in 1991.

ROBIN LENMAN was educated at Merton and St Antony's Colleges, Oxford; and at the University of Marburg, and is now Lecturer in History at the University of Warwick. He has published articles on aspects of German cultural history in *Past & Present* and *Central European History*, and is at present working on a study of nineteenth-century painters and society.

ARTHUR MARWICK is Professor of History at the Open University. His books include *Class: Image and Reality*, *Beauty in History*, and *Culture in Britain since 1945*.

STANA NENADIC is a Lecturer in Economic and Social History at the University of Edinburgh and has researched and published on the middle classes and small business in the eighteenth and nineteenth centuries.

MARCIA POINTON is Professor of History of Art at the University of Sussex. She is the author of *Milton and English Art* (1970), *William Dyce, RA: A Critical Biography* (1979), *History of Art: A Students' Handbook* (1980, revised edn 1986), *The Bonington Circle: English Watercolour and Anglo-French Landscape 1790-1855* (1985), *Bonington, Francia and Wyld* (1985) and *Mulready* (1986); she is editor of *Pre-Raphaelites Re-viewed* (1989), and her latest book, *Naked Authority: the Body in Western Painting 1830-1908* will be published early in 1991.

BRIAN STONE taught in boys' schools for eleven years, and in teacher training colleges for ten, before spending his last sixteen career years at the Open University as Reader in Literature. There, most of his work, in publishing teaching material and working on broadcasts, was on drama. His other publications include many verse translations of medieval texts for Penguin Classics (1959–88), including *Sir Gawain and the Green Knight*, *Medieval English Verse*, Chaucer: *Love Visions*, and *King Arthur's Death*; *Sophocles to Fugard* (with Pat Scorer, 1978); and *Chaucer* (Penguin Critical Studies, 1987).

MARTIN WIGGINS is a Fellow of the Shakespeare Institute and Lecturer in English at the University of Birmingham.

Foreword

Social history has been one of the great success stories of the academic world in the past generation. Historians have been recreating the past with a much greater emphasis on the way societies work and on how they are structured. This explosion of knowledge has brought great gains in understanding. We not only know far more about subjects previously considered inaccessible or 'unresearchable'; the techniques and insights of social historians have increasingly informed the work of political historians, such that it is now rare to come across a serious researcher uninterested in relating his work to its appropriate social context. It can no longer be claimed, as G.M. Trevelyan once asserted in a phrase frequently quoted out of context, that social history is 'history with the politics left out'.

The founding of a new society – the Social History Society of the United Kingdom – in 1976 bore testimony to the increasing importance of the subject. The Society has always been anxious to make its work accessible to the widest possible audience. To aid this objective, it has placed particular emphasis upon its annual conferences. These always centre on a research theme, selected by its Committee, in which new and sometimes experimental work is known to be actively in progress. In this way, social historians are able to obtain insights into exciting research developments at a formative stage.

The Society has always published abstracts of papers read at the annual Conference in its *Newsletter* but it was increasingly felt that the best work deserved both a wider audience and a more substantial format. The most appropriate vehicle for this was felt to be a volume of essays which would be lively and informative but which would also indicate the importance of the chosen theme and suggest how the new approaches might be further developed. The

Society was delighted to learn that Routledge, a publishing house long known for its pioneer work in social history, was to participate in this venture.

The Arts, Literature, and Society is the second volume in this new series and follows *Death, Ritual, and Bereavement* which was published in 1989. Arthur Marwick is one of the most distinguished historians of twentieth-century social history and his recent work on visual evidence has attracted widespread attention. The Society was delighted that he accepted its proposal both to edit and to contribute to this volume.

Introduction

Arthur Marwick

The title of this book, dated as it may sound, is my own. Almost since the inception of the Social History Society in 1973, I had been urging it upon my colleagues on the committee of that learned body as a suitable theme for one of our annual conferences. At last, in 1988, the day of 'The Arts, Literature, and Society' dawned, and I found myself designated conference 'co-ordinator', charged with the task of giving our proceedings (and, of course, this book, which was scheduled to emerge from them) some coherence. A few of the speakers came at my express invitation, the majority – as is the way at Social History Society conferences – were self-selected, volunteers that is. All were sent (though perhaps rather late in the day for those who already had papers quite fully worked out) a list of six topics and asked, in the hope of setting up common issues for debate and discussion, to address themselves to one, several, or all of these.

The device was not popular: indeed, it was ignored by a substantial majority of the thirty or so speakers, since academics, very understandably, find far more enticing the prospect of communicating the results of their own most recent researches than that of participating in a systematic joint attempt to analyse such a large and treacherous problem as the relationships between the arts, literature, and society, or, more exactly (for the six topics were modest ones), to identify the problems inherent in such an attempt. John Barrell, who did most vigorously address my suggested topics, spoke for many academics (too many in my view!) when he commented: 'in my own writing I usually allow such themes to emerge obliquely, or to be guessed at by readers' (see p. 95). Two types of paper, with a rather sharp disjunction between them, predominated. On the one hand were the contributions of professional historians whose research interests (certain sorts of artistic

communities, for example) happened to touch on spheres which might be defined as those of the arts or literature. The best of these would find immediate acceptance in the pages of the historical journals: it was simply their subject matter which brought them within the ambit of *this* conference and their authors saw no need to involve themselves in questions of methodology or the place of theory, nor even to be explicit about their own approaches and assumptions. On the other hand were the contributions from the specialists in some branch of cultural studies (for example, drama) who presented accounts which would undoubtedly rate very highly within their own peer group (and indeed provided much of great interest for an audience mainly composed of historians), but which showed absolutely no awareness whatsoever that the various concepts taken as given (such as 'hegemony' or 'negotiation') actually depend upon staggering historical assumptions about social structure, class relationships, and the origins and functions of social and political values. A third and smaller group, distinguished historians with high reputations all, saw the conference as a chance to take a holiday from serious professional chores: stimulating and enjoyable to listen to, their papers proved, in written form, to do little to illuminate the methodological and conceptual problems, and less to advance the case for the possibility, let alone the desirability, of rigorous interdisciplinary study. Finally, two colleagues provided, at the opposite extreme, assiduous bibliographical surveys: invaluable hors-d'oeuvres, but scarcely the meat of exhaustive analysis.

The biggest question of all was the one directly raised by my 'dated' title. By 'the arts', I meant painting, drawing, sculpture, architecture, drama, music, the various forms of music-drama, film, and the electronic extensions of film; each of these can be fairly readily distinguished from the others (where there is a combined art-form we do not usually have great difficulty in resolving it into its separate components), and all (with the same governing parenthesis) can be distinguished from literature (which may however be taken to include dramatic *texts*). But – and this is the crux of the question as it is most usually and readily posed – is there really any such thing as 'literature'? In our world written matter (the contemporary electronic revolution notwithstanding) pullulates and proliferates: newspapers, bureaucratic memoranda, company prospectuses, advertising copy, comics, and pulp fiction. Is there any difference between any or all of this material and the poetry, novels, and plays once confidently assumed to embody 'literature'?

Contemporary cultural theorists say there is none. The concept which brings together all written (and spoken) matter is that of *discourse*. Everything written (or spoken) is in discourse, though one work may employ several discourses. The primary question does not concern differences of literary form, but differences of discourse.[1] Each discourse (it is claimed) stems from a particular position (in the social or educational hierarchy, say), expresses the values inherent in that position, and has its own rules through which ideas are connected and thoughts expressed. No piece of writing, neither play by Shakespeare nor novel by Balzac, has inherent 'literary' value of its own; all pieces of writing are valuable as representations of the society, and in particular of the power relations, the hierarchical positions, from which particular discourses come to be produced. No one piece of writing (even if by Dante) has greater value than another (even if by Agatha Christie or the chairman of ICI). All that the special term 'literature' can signify is the aggregate of written material which has been canonized by a particular society: if the word still has any value at all, John Barrell tells us, it is that it tells us 'what kinds of works, at different periods (including our own), and for different reasons, have been accorded a certain privileged value in the society that consumed them' (p. 95). The same arguments are applied to the arts: a Wagner opera is not inherently more valuable than a commercial jingle advertising Coca-Cola; St Peter's, Rome, than a multi-storey car park; Leonardo's *Last Supper* than an advertisement for a packet of gravy. Thus all 'cultural products' (that is, written and 'artistic' materials of every conceivable type) are simply 'kinds of signifying practices' which offer representations of the society out of which they came into existence (p. 95).

While traditional Marxist writers had considered it important and appropriate to explore the relationships between society, conceived essentially as a form of economic organization whose economic basis was replicated in its political system and cultural products (whether conceived in a limited, canonized, or in a universal sense), Barrell and other contemporary theorists deny that there is any separate or 'real' society whose relationship with 'signifying practices' can be discussed, for, they argue, our only knowledge of society is derived from these very 'signifying practices'. This is a contention, of course, which goes to the heart of the activities of most working historians, and a vivid demonstration that the issues in this book have nothing to do with amateurish rhetoric or idiosyncratic impressionism, but are crucial to the

nature of historical study itself. Barrell, then, rejects the assump-
tions implicit in both the wording and structure of my title: to him,
however, there is a very important purpose in scrutinizing and
comparing 'signifying practices', for, if the different discourses
which make up these practices are identified, then the competing
interests embodied in the different discourses will also be identified,
and thus much of significance learned about the structure and
power relationships of the society of which they are representations
(p. 95).

My old-fashioned title was chosen deliberately, and indeed, I
make no apologies for it. The words 'arts' and 'literature' continue
to be widely and, I believe, effectively used: I'd certainly be
unwilling to dismiss them without quite extensive further discus-
sion. And there is the point: their use provokes argument, forces an
examination of basic assumptions. Were I simply to speak of
'Culture and Society', which would certainly be in high fashion
(how many minor variations on that title have we not seen!), I
would be conceding at this stage far more than I am prepared to do.
But for the moment my immediate purpose is to integrate this book
into a venerable tradition in which historians have long discussed
what unselfconsciously they have recognized as 'literature and the
arts'. One of the most irritating features of the contemporary
academic scene is the quantity of essays and books published on
what historians ought to be doing, written by authors who not only
have clearly never known what it is to address a historical problem
or add a significant detail to historical knowledge, but are evidently
totally unfamiliar with the learned articles and monographs of those
who have.[2] Thus in a frantic, cliché-ridden tract, Tom Dunne
accuses historians of having neglected the significance of literature
in the study of the past.[3] Consider for a moment those benchmarks
of British academic orthodoxy of the 1930s, the Oxford Histories of
England. I am no supporter of the manner in which these tomes
treat literature, art, architecture, and music (Mr Dunne is himself
somewhat narrow in his interests, an obsession with the verbal
being a besetting characteristic of the British academic), but the last
thing that can be said is that they are omitted.[4] Of course, in
mainstream historical study there has been an enveloping flood of
books and articles confined to diplomatic history, constitutional
history, party political history, economic history, and the various
other limited sub-histories upon the practice of which earnest
scholars scramble their way up through the profession. But only
unforgivable ignorance or unpardonable prejudice takes no account

of such works as John Hale's *Renaissance Europe* (1960), Jacques Barzun's *Hector Berlioz and the Romantic Century* (1952), J.L. Talmon's *Romanticism and 'Revolt'*, Vann Woodward's, *The Burden of Southern History* (1961), Asa Briggs' *Victorian People* (1954), Theodore Zeldin's *France* (1976), I.F. Clarke's *Voices Prophesying War* (1966), or even my own *The Deluge: British Society and the First World War* (1965).

I do not necessarily defend the approaches or the conclusions presented in these works. Indeed, while I wish to make the point that historians have long been concerned with the arts and literature, I wish quickly to add that their treatment has often been simplistic and naive, so that there remains a positive need for proper study of the issues this book sets out to raise. But the incorporation of literature and the arts in the study of the past is not in itself a sign of surpassing grace. As always with questions of materials analysed and methods employed, everything depends upon the questions being asked. Idle (and foolish) to blame an historian who has painstakingly established the chain of actions and reactions as between the political authorities and military commands of Germany, Russia, Austria, and Serbia in June and July of 1914 (no easy task) for not discussing the novels of William Le Queux, the paintings of the Futurists, or the music of Richard Strauss, though for an understanding of the reactions in the various social classes to war when it came (not the *causes* of the war – too often the two are confused in that well-intentioned muddle that those determined to show the relevance of literature and the arts often perpetuate) an analysis of these, their production and their consumption, may well be essential.

The Oxford historians in essence were interested in the arts and literature as distinctive, high-quality products of the societies they were studying, indicators of levels of achievement, just as analysis of forms of kingship, representative institutions, systems of law, etc., contributed to the general assessment of the social organization or civilization of a particular era in English history. In my view this aspect of the historical study of literature and the arts is not one necessarily to be scoffed at. As a student of contemporary British society, I believe the great success of British theatrical presentations (as seen in ticket sales, their importance in the tourist trade, and in critical reactions) taken together with the almost total absence of any dramatist of international reputation (Pinter and the Czech-born Stoppard being the significant exceptions), the sporadic triumphs of British cinema, and the general renaissance of British

classical music to be subjects of considerable significance in themselves. However, it is proper to add that the 'Oxford approach' – often little more than a catalogue of names and titles – is profoundly inadequate. One requires exploration of at least two further questions: *Why* were certain works produced (and, if they were, *why* consumed)? *What* do they reveal about the society in which they were produced and consumed, and in which they were allocated a certain status (classic, pot-boiler, etc.)?

I make no great claims for the novelty of this collection (though loud ones for its scholarship and originality – each essay is by *the* leading authority in his or her field), still less for this homely introduction. For at least twenty years or more there have existed model examples of how to integrate literary and artistic materials into historical analysis, not for show, but as a genuine part of the analysis. It may well be that 'Eng. Lit.' and art history (or 'Fine Art') were too long studied and taught in isolation from their historical context, but it simply is not true to say that history was studied and taught without reference to artistic and literary production and practices. It was in the world of literary criticism and art history that the crisis of conscience came, resulting in cultural theory and the attempt to thrust history into the foreground (often in my view rather ill-considered and simplistic history).[5] Indisputably, cultural theorists, drawing their inspiration from Marx, Gramsci, Lukács, Barthes, Foucault, and the reaction and interaction between Marxism, Structuralism, and Discourse Theory, have made enormous contributions to the issues with which this book is concerned, but so too, it must never be forgotten, have certain mainstream historians. I wish to consider four: A.G. Dickens, formerly Director of the Institute of Historical Research in London and a scholar of distinctly conservative political outlook; R.W. Scribner, an Australian whose pioneering work in the social history of the Reformation received special encouragement from Dickens; Peter Burke, Cambridge historian, detached disciple of the French *Annales* school and avowedly non-Marxist in his sponsorship of 'open social history';[6] and Simon Schama, also a Cambridge scholar, now basking in the glory of a chair at Harvard, who brilliantly integrates detailed discussions of Dutch painting into his analysis of the emergence of the Dutch Republic, *The Embarrassment of Riches: An Interpretation of Dutch Culture in the Golden Age* (New York, 1987).[7]

The Age of Humanism and Reformation (1972) by Dickens has a basic framework of strong political narrative, informed throughout

by its carefully placed reproductions of visual sources and its quotations from contemporary poems and writings. When the author comes to confront two traditional (though conflicting) assertions about cultural developments in the period, on the one hand that the Counter-Reformation laid a dead hand on cultural activity, on the other that it gave birth to the Baroque, he judiciously introduces the materials central to the debate:

> Thus within two decades of his death, history falsified the prediction of Martin Luther that a moribund Papacy would swiftly vanish from the scene. Its victory had perhaps been won at a heavy price, yet although the Inquisition and the Index hampered some thinkers, this price did not include the atrophy of intellectual life, much less that of great art and music, within the Catholic countries. Despite such episodes as the persecution of Galileo, southern Europe continued its contribution to most branches of scientific enquiry, while the worlds of Palestrina, of Rubens, and Bernini, were far from being cast into the shade by those of Rembrandt, Newton, and Bach. Yet concerning one related theme beloved by many histories of civilization, the present writer must admit to scepticism: the notion that the Baroque art and architecture of the seventeenth century was the child of the Catholic Reformation, a 'Jesuit-style,' 'a hymn of joy raised by the triumphant Church.' The style of the middle and later decades of the sixteenth century was not of course Baroque: it was what we now call Mannerism, that somewhat cold and stilted derivative from the era of Michelangelo. The full-blooded Baroque had its origins around 1600 but did not reach its climax until a full century after the formation of the Society of Jesus. On this reckoning it seems to have taken the Church a long time to decide whether it was enjoying the Counter-Reformation! In actual fact, when it did at last arrive, Baroque soon became a multi-purpose style contributing as much to the glorification of monarchs and aristocrats as to the triumph of the Church. Even in Rome, the building and decoration of the great Baroque churches came far less from the religious Orders than from the aristocracy and cardinalate, rich patrons allowed once more to rival the splendors of the High Renaissance – but in return for an adherence to dogmatic and moral purity. The great spirits of the Catholic Reformation had strangely little in common with the Baroque age: they were surely among the least pompous and flamboyant characters in the history of the Church.[8]

R.W. Scribner's 'attempt to combine print and picture' in 'a study of visual propaganda, and of its role in the dissemination of the evangelical movement during the first half-century of the Reformation in Germany', entitled *For the Sake of Simple Folk* (Cambridge, 1981), triumphantly vindicates his argument 'that through a study of visual propaganda we may gain a wider understanding of how the Reformation appealed to common folk than by concentrating attention more narrowly on printed propaganda alone'.[9] On the lower quarters of each of the two facing pages 60-1 Scribner prints reproductions of two woodcuts (illustrations 43 and 44 respectively in the book); across the same two pages Scribner provides the following verbal analysis, concerned with the point that within the popular culture of the day the 'uses of play for propagandists are numerous'. (I have omitted Scribner's footnote references.)

A good example can be found in the title page to the pamphlet *The Lutheran Strebkatz* (ill. 43). The Strebkatz was a popular game in which two opponents engaged in a tug-of-war by gripping between their teeth two rods, which were connected by cords. This contraption was itself called the *Strebkatz* and the players contended for its sole possession. In this version, the cords pass around the contestants' necks. The original form of the game is depicted in the title page of a 1522 pamphlet (ill. 44), where two monks contend for the prize, a wreath held by a watching damsel. In the first instance, the contestants are Luther and the pope, who is helped by a crowd of supporters representing some of Luther's main opponents – Eck, Emser, Cockleus, Murner, Hochstraten, Lemp and Alfeld. Although the contest seems unequal, Luther has dragged the pope to his knees so violently that his tiara has fallen off and his money purse has burst. Luther's victory is aided only by the crucified Christ, signified by the small crucifix he holds aloft in the faces of his opponents....The scene at the top of illustration 44 uses a similar technique, based on another typical contest of the time, the tournament. Christ is shown jousting with the pope, who wears armour and is seated on a war-steed attended by a footsoldier-devil.... The pope carries in his left hand a letter hung with seals, signifying a papal bull, the weapon of the pope. It is from this hand that the lance has fallen, connoting that Christ is more powerful than papal condemnations.

Peter Burke's *Culture and Society in Renaissance Italy 1420–1540* was originally published in 1972. Its resilience and longevity were

well earned and the book reappeared in revised form in 1986 as *The Italian Renaissance: Culture and Society in Italy*. What I want to stress is Burke's absolutely precise use of 'quotation', from literary sources in the traditional way, or in the form of reproductions of visual sources perfectly placed in the text, and his use of statistical analysis. Statistics are the servants of historical study, never its master. For many tasks this particular servant may not be required; but Burke showed how a high degree of exactitude could be introduced into his analysis of the changing content of Renaissance paintings.[10] He has a splendid chapter, chapter 6, on 'Taste' (which along with 'style', he obviously sees as a useful and helpful concept). Here is part of his lucid and persuasive account of the interrelationship between taste and social groups (I have omitted Scribner's footnote references):

According to contemporary theorists, different styles of building or music were appropriate for different social groups. Filarete, for example, declared that he could design houses for 'each class of persons [*ciaschuno facultà di persone*]' which differed not only in size but in style. Nicolò Vicentino distinguished two kinds of ancient music, one public, for 'ordinary ears [*vulgari orecchie*]', the other private for ears which were 'cultivated [*purgate*]'. In literature, the hierarchy of styles – high, middle and low – was associated with different social groups. Aristotle had said in his *Poetics* that tragedy dealt with good men, comedy with ordinary ones, but in the Renaissance he was believed to be referring to noblemen and commoners. Literature in the high style was literature for and about the elite.

It is difficult to assess the effect of social background on artistic and literary taste even in our own day. It would be unwise to make any general or unqualified assertions. We certainly have to take account of the fact that humanists and nobles participated in what we call 'popular' culture. Poliziano declared his enjoyment of folksongs, Lorenzo de'Medici wrote songs for Carnival, while the Neapolitan humanist Giovanni Pontano stood in the piazza to listen to a singer of tales [*cantastorie*]. Ariosto also took pleasure in the romances of chivalry sung by the *cantastorie*, and his *Orlando Furioso* draws on this popular tradition. Conversely, the *Orlando Furioso* made its way into Italian popular culture via chapbook versions of particular cantos. All this has to be borne in mind but it does not imply that literary tastes did not vary according to the social group of readers or listeners.

Both Burke and Schama use the word 'culture' in their titles, entirely properly since each is dealing with one particular society (or, more accurately, with societies in the process of formation). The use of the word 'culture' to include all aesthetic, intellectual, leisure, and recreational activities is a fruitful one, which can often be made still more fruitful by suggesting a distinction between 'elite' or (perhaps less desirably) 'high' culture and 'popular' culture. But the Social History Society conference was not concerned with one society and *its* culture: the older phrase 'the arts and literature' again seemed more appropriate to the endeavour of discussing issues relating to several periods and several societies. I was hoping too, I must confess, that the conference would be deliberately steered away from an exclusive concern with popular culture, a fascinating topic in which I myself have a deep personal interest, but one that, perhaps, has had rather a good run for its money recently and one that, too, does not offer quite the same problems of analysis as the discussion of the social relations of canonised elite culture. I now sadly regret I did not make more deliberate efforts to commission papers on, for example, high art and on opera. (Verdi's struggles with the various Italian censorships, the way he sometimes seemed to turn these to positive advantage, his involvement with the Italian nationalist movement, are topics which would repay thorough exploration: the manner in which *Un Ballo in Maschera,* apparently 'about' the assassination of a seventeenth-century Swedish king, came to be set in colonial New England, with all the resonances that entailed of democratic aspirations and racial attitudes, is a fascinating subject in itself.)

A few more words on the legitimacy of the terms 'literature' and 'the arts' or, to be frank, on what deep down I feel to be the illegitimacy of the criticism of these terms. From my colleagues at the Open University I have learned just how much effort one must put into the reading and understanding of poetry.[12] Poems are sometimes, as it were, deliberately difficult in order to draw in the reader and force him or her to tease out very carefully all the meanings and implications. With canonized poetry at any rate, it is essential to make several readings, to be sure that one is clear what it is the poet is saying, before one proceeds to further steps in analysis and interpretation. Certain novels, too, have to be read several times, and perhaps certain passages many times, before the full richness of the work can be appreciated (my colleague Dennis Walder urges most persuasively to this effect with regard to Cesare Pavese's *La Luna e i Farò.*)[13] For our students studying music or art

history, the directive is the same. Very attentive scrutiny of a painting is called for – even content, let alone formal elements, will not immediately jump out at one. Systematic and repeated listening is required for canonized music. But I have heard no one recommend similar intensity of effort for Coca-Cola jingles, gravy advertisements, novels by Agatha Christie, or ICI chairmen's addresses. (Each of these may call for a great deal of analysis and investigation of context, conditions of production, implied value systems, etc., but that is *not* the same as the direct effort called for in comprehending the poem, string quartet, novel, or painting.) The fact that certain forms of literary or artistic production demand thorough and painstaking 'reading', while others manifestly do not, seems to me to offer a very serious challenge to the theory that there are not distinctions between those products which can be recognized as 'art' or 'literature' and those which are simply the ephemera of the daily world, and that our prime concern should be with different discourses rather than with differences in the forms of cultural production. I also have a very profound suspicion that most of those cultural theorists who proclaim it impossible to make distinctions of inherent value between, say, a Beethoven symphony and a Doris Day ballad, in fact show themselves to be very discriminating when it comes to a question of laying out money and effort on one cultural practice rather than another. Would our cultural theorist really pay the same money, and make the same effort, to see *The Mouse Trap* as to see, say, a new RSC Shakespearian production? If our cultural theorist replies that he too has simply fallen victim to the prevailing values, or dominant ideology, of the age, then one has to ask what special value can be attached to his or her analysis, if he or she is just as weak a vessel as the rest of us.

It may perhaps seem unfair, and unseemly, for an editor to come forward so boldly with his own views or prejudices. But it would be dishonest for me not to do so. John Barrell and Marcia Pointon, and other colleagues, will speak for themselves shortly. My point of general relevance is that the terms 'literature' and 'the arts' are not inherently absurd: if they are to be dismissed, that dismissal must be argued for. At the same time, of course, they are not rigid and exclusive terms. Where literature ends and, say, bureaucratic minutes begin, or where art ends and, say, the commercial advertisement begins, can be matters for fertile discussion and debate. It does, as I have already hinted, seem to me to be particularly useful always to bear a rough distinction in mind

between elite literature and art, and popular literature and art. The production of labels, of course, solves no problems; though it can help in guiding and structuring discussion.

For most of this Introduction so far I have been worrying over the overriding question, do art and literature actually exist? Now, at last, I come to the six separate (but manifestly overlapping) questions which I posed in advance to contributors to the conference, and then repeated in my introductory presentation to the conference (I have not tampered with the headings, but in some cases have expanded the glosses). They are:

1 *Methodology* In what ways do the methodological approaches followed in the various arts, or in literature, differ from those employed in history? Are there, for instance, different ways of approaching 'texts', or is there perhaps some common ground? Or is there simply one methodology applicable in 'cultural studies'?

2 *Theory* What is the place of theory when studying the relationship between the arts, literature and the historical and social context? Is it necessary in each individual case to establish the precise nature of social structure and social relationships, or can one accept some prior theory about the nature of class structure, class conflict, dominant and oppositional ideologies, etc?

3 *Style, period, taste* How valid are any, or all, of these concepts, and how useful are they in bringing together cultural artefacts and the social context?

4 *National culture and foreign influences* Is the notion of a national culture a useful one? Is it possible to detect influences from one culture affecting another? (The British are often said to be parochial, Dickens to be 'very English'. The influences of Italian Renaissance architecture have, on the other hand, been widely detected in other societies; it is sometimes said that in his later years Verdi absorbed influences from French opera; the notion that America has influenced twentieth-century popular culture is widespread.)

5 *Autonomy versus social construction* In discussing cultural products, what weight is to be placed on such concepts as autonomy (or relative autonomy), individual genius, the particular traditions, preoccupations or 'logic' of a particular art-form? Can it be successfully argued that all art is socially constructed?

6 *Cultural production, consumption, and status* Is it helpful, and if so in what ways, to analyse the conditions of cultural production

and consumption, and to evaluate the status awarded to partic-
ular cultural artefacts, at the time of their production and
subsequently?

The sixth question derives directly from Marxist analysis[14]
though non-Marxist historians, concerned with the social context of
art and culture, have long been involved in the same kind of
discussion. It is over the importance of this question that we might
expect to find the greatest amount of agreement among contributors
with varying intellectual or ideological commitments. The other
questions, particularly questions 1 *Methodology,* 2 *Theory,* and 5
Autonomy versus social construction, could be expected to reveal
sharp disagreements. Cultural theorists will incline towards the
notion of there being one theory (derived ultimately from Marxism
in that it will concern the nature of power relations and dominance
in society, the manner in which cultural practices are used to
maintain dominance in society, and the conflicts which occur as one
group strives to replace another) and one methodology, perhaps that
related to the concepts of 'hegemony' and 'negotiation', or that
dependent upon discourse theory. They will generally tend to see art
as socially constructed, and to discount artistic autonomy and the
achievements of individual genius. Traditional historians, art
historians, or literary critics will be more likely to stress the
specialized methodologies of their own disciplines, and also pay
attention to questions 3 *Style, period, taste,* and 4 *National culture
and foreign influences.*

Much traditional work on the arts and society *was* profoundly
unsatisfactory. Raymond Williams, distinguished Marxist and pro-
genitor of cultural theory and cultural studies in Britain, sought to
indicate a better way in the series he launched at the beginning of
the 1980s on *English Literature in History.* In his editorial
introduction he acutely identified the weaknesses of the older
notion of 'the relatively unproblematic body of study "literature",
with its own inherent and autonomous qualities, and on the other
hand, a body of general and summary knowledge which is,
correspondingly, "history"'. Historians, Williams continued, illus-
trated aspects of their topic from the most 'relevant' literature,
while literary scholars looked to history as 'background'. While both
approaches appear to be complete they were in fact 'fundamentally
selective and partial'. In two of the chapters which follow, both
Stana Nenadic and Martin Wiggins develop further this kind of
criticism of the traditional 'separatist' approach. Williams wanted

his authors to discuss literature *in* history, which he thought could be done by the authors selecting two or three themes and then following these through in *all* kinds of writings.[15] Here certainly was one potentially fruitful way of examining some of the interrelationships between society and literature.

But the mistake all critics tend to make is to assume that there is only *one* proper approach: it just cannot be too often stated that in any aspect of historical studies the particular approach to be followed depends upon the questions being addressed. Frequently historians are concerned with presenting a rounded interpretation and analysis of a past society. In doing this they will make use of the widest available range of different types of primary source material; however, it may well not prove practical (or even necessary) to study every single written item created in that society, in particular, with reference to the present argument, every single piece of imaginative literature, nor to study every painting and every physical artefact. As 'general historian' the scholar will present as complete and persuasive a reconstruction of the past society as possible, indicating for readers the evidence and assumptions upon which the account is based. Another historian, or indeed the same historian on another occasion, may wish to make a specialist analysis of a particular literary artefact or cultural product, with reference to its relationship to the past society which has already been the subject of the general account. Now it is true that this literary artefact or cultural product may have been used as a primary source in the creation of the original general account (thus, at first sight, particularly if one is not an historian, there may seem to be force in Barrell's point about society itself not having an existence separate from the sources), though it may well have been ignored as being too limited in interest, too untypical, or on the contrary too similar to dozens of other sources. In any case, this account oversimplifies: with regard to most past societies a quite extensive body of knowledge already exists, represented in large numbers of secondary accounts, each of which will have built upon, refined, or corrected accounts of predecessors. To all of this it must be added that accounts of the past, the body of knowledge produced by historians, do not depend solely on verbal discourse (again there is this besetting fixation with words and language): historians also use archaeology in all its forms, 'history on the ground', buildings, street plans, physical relics of all types, land patterns, old roads (what powerful testimony to the impact of Napoleon are the straight, narrow, tree-lined *routes nationales*; what a joyous legacy of

the Revolution that the old bishop's palace at Limoges is now a free municipal museum). My main point here is that the way in which historians study the relationships between the arts and society will depend upon the general focus of their study – there is no one ideal method; but I am also expressing disagreement with Barrell's point that one cannot envisage an actual distinction between society (clearly known, in my view, through the complex activities of generations of historians) on the one hand, and cultural products (particularly literature) on the other.

Barrell himself had first drawn the attention of those interested in interdisciplinary historical study (myself included) with his *The Idea of Landscape and the Sense of Place 1730–1840: An Approach to the Poetry of John Clare* (Cambridge University Press, 1972). The central emphasis is on language; the sense of historical process is derived from Marx. The book consists of three substantial chapters: Chapter 1 describes the set of attitudes towards landscape found among the sophisticated reading public in the second half of the eighteenth century, Chapter 2 that of the rural professional class, including, as the poet John Clare perceived it, support for enclosure. Clare, indeed, saw both sets of attitudes as threatening his idea of the identity of the village of Helpston: Chapter 3 discusses 'The Sense of Place in the Poetry of John Clare'. Barrell defines the historical process 'responsible for the enclosure of Helpston' as 'a long process of delocalization inseparable from the progressive capitalization of agriculture, and which operated indifferently by opening up a village to the world outside, or by opening up the world outside to the villagers' (p. 188). In 1980, Barrell published another impressive example of interdisciplinary cultural study, entitled *The Dark Side of the Landscape: The Rural Poor in English Painting 1730–1840*. Not surprisingly he was one of the first to be invited to participate in the Raymond Williams series; perhaps even less surprisingly (for those who know him) he departed from Williams' slightly simplistic programme: 'I have tried', Barrell explained in introducing his *English Literature in History 1738–80* (1983), 'to ask how some writers of the period themselves attempted to construct an understanding of contemporary social changes' (p. 13). This was followed in 1986 by *The Political Theory of Painting from Reynolds to Hazlitt*. Here, 'discourse' was used in a way which, I would think, every historian would find completely acceptable: 'In the early decades of the 18th Century in England, the most influential attempts to provide the practice of painting with a theory were those which adopted the

terms of value of the discourse we now describe as civic humanism' (p.1). Barrell's 'story' was of how the discourse of civic humanism was abandoned in the face of the growth of commerce and capitalism. The originality, and importance, of this work lay in showing how changes in the theory of painting related to the growth of commercial, entrepreneurial society. Barrell's approach, in summary, was highly illuminating for the problems it addressed; but it does not, it seems to me, mean that his approach, the identifying of discourses and the conflicts between them, has the universal validity he seems to claim.

Again, I may appear to be interpreting my editorial role in a peculiar and partial way, but then I have never been able to stand those introductions which are simply a series of blurbs for the contributions to follow. Indeed, I am now going to presume to identify three areas of study to which, I feel, cultural theorists ought to give rather more attention than they presently do (in their belief, apparently, that no history has been written since the death of Gramsci, or at any rate the heyday of Foucault). These are:

1 *Class structure and class conflict* However much cultural theo- rists may claim to have gone on beyond Marx in, for instance, stressing ideas and language, not economic imperatives, they seem to *assume* a class structure identical to the simple one postulated by Marx. The 'bourgeoisie' continues to be presented in a simplistic, all-pervasive manner even though historians of seventeenth-century England can no longer identify a bourgeoisie which was agent in and beneficiary of 'The English Revolution', nor historians of the French Revolution a distinctive bourgeoisie in clear conflict with an aristocracy,[16] and in spite of the researches of F.M.L. Thompson or James Sheehan, or the *arrière-penseé* of Arno J. Mayer, showing that landed elements continued to exercise power long after they are supposed to have been superseded by this bourgeoisie.[17] Cultural theorists need to look very closely to see whether what they so easily read off as class-consciousness may not simply be class-awareness.[18] In writing of the rural poor, Barrell certainly demonstrates their class-awareness, but whether this is really class-consciousness is much more open to question.[19]

2 *Ideology* In common with other historians and writers I use the word 'ideology' as a descriptive term meaning 'system of thought', 'system of belief', or 'symbolic practices'. Cultural theorists hold what can politely be termed a *critical conception* of ideology, or, less

politely, a politically loaded one, where, according to J.B. Thompson, the best recent guide to the concept, 'ideology is essentially linked to the process of sustaining asymmetrical relations of power – that is to the process of maintaining domination.'[20] To study ideology (in this sense), Thompson proposes, 'is to study the ways in which meaning (or signification) serves to sustain relations of domination'. Then, without actually discussing the sort of evidence of which he asserts little exists or citing any evidence in favour of what he declares to be 'more likely', Thompson unloads a set of assumptions which in my view require far closer scrutiny than cultural theorists ever give them:

> There is little evidence to suggest that certain values or beliefs are shared by all (or even most) members of industrial societies. On the contrary it seems more likely that our societies, in so far as they are 'stable' social orders, are stabilised by virtue of the diversity of values and beliefs and the proliferation of divisions between individuals and groups. The stability of our societies may depend, not so much upon a consensus concerning particular values or norms, but upon a lack of consensus at the very point where oppositional attitudes could be translated into political action.[21]

The study of ideology, in the view of Thompson and the cultural theorists, should be directed 'away from the search for collectively shared values and towards the study of the complex ways in which meaning is mobilised for the maintenance of relations of domination'.[22] This points to the significance of language and of discourse. The analysis of ideology 'is fundamentally concerned with *language*, for language is the principal medium of the meaning (signification) which serves to sustain the relations of domination';[23] the concept of discourse is 'an avenue for the investigation of the relation between language and ideology'.[24]

Discourse theorists like to claim that they stand upon the solid ground of linguistic theory. In fact, what they pursue is a branch of linguistic theory heavily dependent upon certain historical assumptions. These assumptions cannot, in my view, be taken as read. What, in any given society at any given time, are the 'asymmetrical relations of power'? While, *by careful research*, it can be established that certain systems of thought pertain to particular social classes or groups, it can surely also be shown that other values, of national pride, religious belief, the nature and role of sporting activities, are shared throughout certain societies: matters, certainly, for thorough

investigation. Have these points 'where oppositional attitudes could be translated into political action' ever actually existed? (I am sure they have, but the nature of the situation and of the potential political action again needs thorough scrutiny.)

Fundamental to the whole concept of ideology (in the 'critical' sense) is the argument that without ideology, the reality of dominance in society would be utterly apparent; no longer fooled, the dominated groups or classes would perceive their true interests and seek to overthrow the dominating group or class. Yet is this really so? Can one identify a real historical situation where without ideology something drastically different would have happened from what actually happened? Those who assume the existence of ideology must surely be prepared to hold to the position that without ideology revolution would be an immediate prospect. If this is not actually believed to be the case, then ideology becomes a rather trivial technical counter in a self-contained game, without sufficient significance to justify all the attention that is lavished on it. The associated concepts of *hegemony, strategies*, and *negotiation* depend in turn both on the fundamentally Marxist notion of ideology, and also on the Marxist assumptions about class structure, class consciousness, and class conflict. It is not for me to insist that these assumptions are wrong. My point is that they are too readily taken as read by cultural theorists who seem to have paid little attention to the results of recent historical research (dismissing inconvenient discoveries as the products of 'liberal humanism' is a gambit which quickly wears thin).

3 *History as narrative.* Marxists once believed in the possibilities of writing 'objective' history. As history, as it manifested itself through events, persistently failed to conform to this 'objective' account, the view (associated particularly with the work of Barthes and the discourse theorists) began to be put forward that history was simply another narrative, another representation, another discourse on a level with, in particular, those of the writers of novels or epics. Stories are told which justify the exercise of power by those who possess it;[25] what a pathetic summary of the great wealth of social, economic, and cultural, as well as political history ready to be consulted by anyone embarking on a specialized topic (such as those contained in this book)! For my part, I believe the writing of history, that is the making of serious, properly validated contributions to a secure and developing body of knowledge, to be entirely different from the writing of fiction.[26]

Which takes me to what I believe *is the* fundamental issue behind all issues, that of *purpose* in academic study. On the one side, ignorant and philistine politicians, on the other, all too often, academics who do what they do because that is what they do, unquestioningly following old traditions, or just as unquestioningly following the latest intellectual fashion, playing with little private languages just as gentlemen in the early nineteenth century played with the language of the picturesque. The function of the arts and the humanities, it seems to me, is to help us better to understand ourselves, our society, and our world, in all their aspects, the better in turn to provide us with the freedom and knowledge to grapple with the many problems of all types which beset us. The qualities of revelation, inspiration, and life-enhancement possessed by those cultural artefacts which have (rightly) been canonized, seem to me beyond question. The systematic academic study of such artefacts should be aimed at making them more accessible and more comprehensible in all their aspects. As for history, I have argued elsewhere that its study is a social necessity: the past determines so much of our life today that an exact understanding of it is vital.[27] The past is perverted and mistaught in many countries for political purposes, but thanks to the determined labours of generations of professional historians, trying within their frail limits to be as objective as possible, we do in fact know a remarkable amount about vast sectors of the past. There is the achievement, and the task, of history. Frankly, I cannot see how a study reduced to the identification of discourses and the conflicts between them could illuminate very much in the way of what actually happened in the many different societies which historians study. Thompson indeed admits that the results of discourse analysis have been disappointing.[28] That knowledge we have, and which we are constantly adding to, was not given: it was hard won. Since the human past involves cultural activities as well as political and economic ones, the study of literature and the arts is an important part of historical study. And historical study, for its part, can add to the illumination of the study of cultural text. These purposes are simple to set down and perhaps sound banal; but they are not simple to carry out and their results are only banal if the sorts of issue this book raises are ignored.

Now I must turn to my contributors and the book *they* have written. First, I should reveal that the two participants I made greatest efforts to involve in the conference and in this collection were John Barrell, to whom I have already referred, and Marcia

Pointon, distinguished art historian and also a leading practitioner of discourse theory. Whatever my own tastes or prejudices, I wanted this book to contain the best possible examples of that branch of thought and scholarship. As this Introduction has made clear, I believe that where academic differences exist it is best that they be stated, but that does not mean that fruitful co-operation is thereby rendered impossible. As it happens, Marcia Pointon was external assessor for the Open University Arts Foundation Course which I chair, while John Barrell currently is one of the external examiners. All who contributed to the conference were invited to submit drafts for publication in this book. One who failed to do so was Martin Wiggins: having heard his oral presentation I also made considerable efforts to secure his paper. My final selection was based entirely on whether or not I thought a particular paper had a genuine relationship to any or all of the seven questions posed (that is including the overriding one about whether 'the arts' exist). Of those published here, I fancy that only that by Stana Nenadic leans towards the cultural theory so splendidly exemplified by Barrell and Pointon. Chronology matters deeply to historians, and these papers are presented in simple chronological order. Major areas are completely neglected, I fear. Each paper, however, is genuinely authoritative in its field, and together, as I shall hope to bring out in my short Conclusion, they do offer thoughtful and interesting responses to the major issues raised by this book.

Notes

1 For accessible introductions to discourse theory, see Michael Lane, *Structuralism: A Reader*, London: Cape, 1970; and John B. Thompson, *Studies in the Theory of Ideology*, Cambridge: Polity Press, 1989. Not least of the virtues of the chapters by Pointon and Barrell are that they gave very clear expositions of discourse theory in practice.
2 See, e.g., Christopher Floyd, *Explanation in Social History*, Oxford: Basil Blackwell, 1986; Paul Veyne, *Writing History*, Manchester: Manchester University Press, 1984.
3 Tom Dunne, 'A polemical introduction: literature, literary theory and the historian', in Tom Dunne (ed.), *The Writer as Witness: Literature as Historical Evidence*, Cork: Irish Historical Studies, Cork University Press,1987.
4 See, e.g. J.B. Black, *The Reign of Elizabeth*, 1936; J. Steven Watson, *The Reign of George III*, chs XIII 'A civilized security' and XX 'The transformation of economic and cultural life'; R.C.K. Ensor, *England 1870–1914*, chs V, X, and XV: all Oxford: Clarendon Press.
5 For 'historical' surveys which would rate Y + in any decent undergraduate history syllabus, see Terry Eagleton, *Literary Theory: An Introduction*, Oxford: Basil Blackwell, 1983, pp. 19, 54.
6 Peter Burke, *The Italian Renaissance: Culture and Society*, Cambridge: Polity Press, 1986, p. 4.
7 For a brief discussion, see Arthur Marwick, *The Nature of History*, London: Macmillan, 1989, p. 325.
8 A.G. Dickens, *The Age of Humanism and Reformation*, Englewood Cliffs, N.J.: Prentice Hall, 1972, pp. 190-2.
9 R.W. Scribner, *For the Sake of Simple Folk*, Cambridge: Cambridge University Press 1981, p. iv.
10 Burke, *The Italian Renaissance*, p. 12.
11 ibid, pp. 159-60.
12 See Graham Martin, *Introduction to Literature: Arts Foundation Course*, Units 4–6, Milton Keynes: The Open University, 1986.
13 Dennis Walder, *Cesare Pavese's La Luna e i Farò: Liberation and Reconstruction*, Unit 15, Milton Keynes: The Open University, 1989.

As I was revising this Introduction, David Lodge's new novel, *Nice Work* was published. I draw the reader's attention to this brief exchange between Robyn Penrose, a lecturer in English Literature, and Vic Wilcox, managing director of an engineering firm, who has been reading *Wuthering Heights,* and 'getting in a muddle about who was who'.

'It's incredibly confusing especially with all the time-shifts as well,' said Robyn. 'It's what makes *Wuthering Heights* such a remarkable novel for its period.'

'I don't see the point. More people would enjoy it if it was more straightforward.'

'Difficulty generates meaning. It makes the reader work harder.' (David Lodge, *Nice Work*, London: Secker & Warburg, 1988, p. 240.)

14 See in particular Raymond Williams, *Marxism and Literature,* Oxford: OUP, 1977 and Janet Wolff, *The Social Production of Art,* London: Macmillan, 1981.

15 General editor's Introduction to John Barrell, *English Literature in History 1738-80,* London: Hutchinson, 1983, p. 10.

16 The best summary is that of the American Marxist William Reddy, *Money and Liberty in Modern Europe,* Cambridge: Cambridge University Press, 1986.

17 F.M.L. Thompson, *English Landed Society in the Nineteenth Century,* London: Routledge, 1962; James Sheehan, *German Liberalism in the Nineteenth Century,* Chicago: Chicago University Press, 1978; Arno J. Mayer, *The Persistence of the Old Regime*, Beckenham: Croom Helm, 1982.

18 Class-awareness is discussed in Arthur Marwick, *Class: Image and Reality,* London: Collins, 1980; and *Class in the Twentieth Century,* Brighton: Harvester Press, 1986.

19 John Barrell, *The Dark Side of the Landscape: The Rural Poor in English Painting 1730-1840,* Cambridge: Cambridge University Press, 1980, pp. 2-3.

20 Thompson, *Studies in the Theory of Ideology,* p. 4.

21 ibid.

22 ibid., p. 5.

23 ibid., p. 13.

24 ibid., p. 8.

25 See, e.g. Roland Barthes, 'Historical discourse', in Lane (1970), pp. 145-55; Hayden White, *Topics of Discourse*, Baltimore: Dunne (1987).

26 Arthur Marwick, *The Nature of History,* London: Macmillan, 1989.

27 ibid.

28 Thompson p. 8.

1 *Macbeth* and premeditation

Martin Wiggins

Among the aims of the discipline of History is the reconstruction of
the conceptual landscapes of the past, the spectrum of ways of
thinking available to human beings in any given period. This is
assembled from the variety of positions apparent in a range of
(usually) written evidence from the period: documents. Among the
aims of literary criticism, in contrast, is to render more intelligible
a number of individual items of written material, usually plays,
poems, or works of prose fiction: texts. In one discipline, then,
writings are the single objects of study, in the other, the plural raw
materials for study. There is a more fundamental difference,
however. The historian's documents are valuable as evidence in so
far as they make statements about the topic under consideration.
Texts, however, are not statements but artefacts about which
statements may be made. This is particularly so with plays: to see
a performance of *Serjeant Musgrave's Dance* is not to be told that
war is a bad thing or that violence breeds violence, but it may be
an experience that will lead one to those conclusions. To reduce the
play to mere statement (platitudinous or otherwise) is to lose the
things that make it a play and not a tract. Plays deal with characters,
not concepts, and use sound, movement, and colour, not argument.
They are, in a word, experiential, whereas the historian's docu-
ments are discursive.

 That, at least, is a traditional view of the distinction between the
outlook and aims of the two disciplines. There remains scope for
cross-fertilization between them, however, and as this work pro-
ceeds, the hard-and-fast boundaries have become blurred: for
instance, David Norbrook has thrown valuable light on the poetry
of the English Renaissance through a consideration of its political
context.[1] Of course, the university system still works in subject
categories, but let us not be misled by this institutional bifurcation.

If there is to be genuine interdisciplinary co-operation between the historian and the literary critic, each must understand the methodology of the other and have a use for its results: historians must feel they need to know about literature, and literary critics must feel they need to know about history.

It goes without saying that knowledge of a period, such as History can provide, can be valuable in understanding the literary texts of that period. What I want to consider here, however, is the converse issue of what literary criticism can do for History – whether there are ways of reading literary texts that can be useful to historians. To address this question, I shall present two bodies of research in the two disciplines: a study of some aspects of the sixteenth-century conception of the crime of murder, and an analysis of *Macbeth*, a text usually dated 1606, which portrays (among other things) one man's experience of becoming a murderer. In considering the conclusions of these two arguments, I shall present a view of the relationship between literature and history which places some literary texts as documents of a singularly important kind, precisely because they are not purely discursive.

PREMEDITATION

The early Tudor period saw a revolution in homicide law, relating to the definition and the perceived seriousness of murder. In the Middle Ages, all culpable homicide was felonious and all therefore carried the death penalty. There was a recognized form of homicide called murder, but its perpetrators were treated no differently from criminal killers of any other kind. Moreover, the term was not used, as it is today, of premeditated killing: rather it meant homicide committed in secret, or stealthily, and it was heinous in that it gave the criminal a chance to get away with it, evading hue and cry, and in that it gave the victim no chance to defend himself.[2] After 1380, the word came to be used more loosely of homicide in general, but traces of the older definition survive in legal textbooks as late as 1580; the underlying taboos remained potent even longer.[3]

With capital crimes, there was a loophole in benefit of clergy, the system whereby criminals who could pass a literacy test were handed over to the church courts, which did not pass sentence of death. The notion was that clerics, identifiable by their ability to read, did not fall under civil jurisdiction. Obviously it was a system open to abuse, the more so as literacy spread: accordingly, controls were established under Henry VII. By a statute of 1489, persons not

in holy orders were to be allowed benefit of clergy only once in cases of 'murder' (i.e. homicide), rape, robbery, and theft; this was enforced by branding offenders on the thumb with a letter M for murderers, T for others.[4] Seven years later, the benefit was withdrawn altogether from cases of petty treason involving servants murdering their masters. The preamble to this statute explained that 'abhominable and wilfull purpensed murders be, by the lawes of God and of naturall reason, forbeden and ar to be eschewed'.[5] This was the first appearance in law of the notion of criminal premeditation. Finally, in 1512, benefit of clergy was withdrawn from all murder committed 'apon malice prepensed' or, as we should now say, with malice aforethought.[6] This effectually established the modern legal distinction between murder and manslaughter by differentiating the courts' treatment of one type of culpable homicide. The especial heinousness defining murder now lay in premeditation.

This was not a legal fiction but a taboo – the preamble to the 1496 statute makes that clear enough. Nor was it strictly a taboo against premeditation as such: rather premeditation was taken as a significant of settled criminal intent, hence the formula 'malice prepensed'. Thus, for example, Hamlet thinks 'disclaiming from a purposed evil' will exonerate him of the killing of Polonius.[7] A legal commentator under Henry VIII remarks, 'the intent in felony nor murdre is not punysshable by the comon lawe of the realme though it be dedly synne afore god'; but far from being content to render unto God the things that are God's, the state was taking the sin as well as the action under its jurisdiction.[8] It was in the sixteenth century that attempted murder became a misdemeanour punishable at law in Star Chamber. The most telling attitudes are those towards the murderous witch: even sceptical thinkers argued for the punishment of these malicious individuals; the criminal's state of mind was just as much a consideration as the harm done.[9]

To understand the prominence of this taboo, we must survey the various explanations of murderous action that were current in the sixteenth century. A fundamental question is whether the immediate stimulus comes from inside or outside the individual. While the former alternative commanded a strong consensus of learned opinion, there was a frequent and not entirely plebeian tendency to ascribe crime to Satanic prompting: 'And surely howsoever openly the Divell sheweth not himselfe, yet he is the mover and perswader of all murders, and commonly the doctor. For hee delighteth in

mens blouds and their destruction, as in nothing more.'[10] He may work through intermediaries like the witch whom the Scottish king Nathalocus consulted: his messenger was told that he himself would soon murder the king, which he did as an alternative to being continually under suspicion – an incident, we are told, 'wherin we may see the craft, and malice of the deuil, who thirsting after mans blood and perdition, framed such an answere to this messenger, as he thought most likely to moue him to the murder of *Nathalocus*.'[11] Alternatively, Satan is sometimes said to 'possess' the murderer – that is, enter and control his body. For example, the domestic murder play *A Yorkshire Tragedy* (1605–7) includes a striking image of his leaving the possessed body:

> now glides the devil from me,
> Departs at every joint, heaves up my nails.[12]

Some murderers even alleged a physical diabolic manifestation such as can be seen in the woodcuts that appear on the covers of contemporary pamphlet accounts. In 1584, for instance, one Mrs Arnold, an infanticide, admitted 'that the diuell was with her and helped her to dispatch it in that manner.'[13] Presumably these unfortunates were suffering from the same kind of hysteria that afflicted self-confessed witches; we know from *The Comedy of Errors* and *King Lear* that seeing the devil was a perceived characteristic of insanity in other circumstances.

One effect of this admission of a causal element outside the individual is the diminishing of that individual, and by implication of human action in general: Man becomes merely a focus for conflict between supra-human powers, his own impulses irrelevant because ineffectual. One man, for instance, was able to murder only with unholy assistance: 'though before this time he had attempted many wayes to murther [his victim], yet performance thereof was thus long by Gods prouidence preuented: but at this time the diuel had possessed him, that now was the time to finish his reuenge.'[14] In one case it even took 'the subtletie of sathan' to make the murderess think of using a knife as a weapon![15] Not surprisingly, then, Satan was sometimes used as an excuse, a means of evading personal responsibility: 'I was seduced by the Diuell,' Buckingham's assassin assured the crowds at his execution in 1628, 'such a foule thing could not haue proceeded from mee else.'[16] Equally unsurprisingly, theologians did not accept the excuse: 'the devil alone is not the author of sin, so that, when we sin, the blame thereof should redound to him,

and we that sinned escape without fault . . .; because it is in his power to egg and persuade, but not to enforce a man to do evil.'[17]

The doctrine of human responsibility for human sin led to another interpretation of criminality, which sought to explain the murderer's receptivity to Satan's influence. Discussions of this factor do not in general consider temptation as such: the concern is with behaviour, not ethics and metaphysics. Moreover, 'Certain it is that customable sinners have but small temptations: for the devil letteth them alone, because they be his already.'[18] Murder tends to be regarded as the act of a 'customable sinner': it is placed at the top of a hierarchical arrangement of sins or crimes, and the murderer graduates to that role from lesser offences. 'There is no man suddenly either excellently good or extremely evil', writes Sidney in the *Arcadia* (1580), 'but grows either as he holds himself up in virtue or lets himself slide to viciousness.'[19] The conventional sequence of this slide, though not the only one, led from Idleness, 'the nourse of sin', to Theft, then to Lust, and finally Murder.[20] In effect, lechery induces murderousness:

It follows needfully as child and parent;
The chain-shot of thy lust is yet aloft,
And it must murder.[21]

As an explanation, this is invalid because the association is not genuinely causal: it is grounded in moral preconceptions, not observed human behaviour. The deficiency is in the excessively linear nature of the arrangement (clearly arrived at by inverting the Decalogue), which effectively allows a classification of transgression only by degree. This is a result of the limitations of the theological discourse from which the sequence is derived: thought is dominated by the irreducible absolutes of Good and Evil, and Sin commands more attention than sins, so that the cause of an act is less important than its moral nature. The latter therefore dictates the former in the simplistic sequence which entered popular currency in lieu of any more sophisticated version which might have been provided by the divines, and the act of murder is placed in a broad biographical context and assigned a specific but unlikely immediate cause.

Of course, the ideas so far discussed are primarily by-products rather than serious attempts to explain homicide. There was, however, a criminological tendency emerging in sixteenth-century thought, taking as its starting-point not the act of murder itself but the psychological state of the killer at the time. This state was

understood in two ways: a pleasure in violence that we would now term sadism and a fixation on it expressed as bloodthirstiness, a new word in the period. For those who bothered to think beyond catch-all terms like *cruelty,* the underlying causal theories reflected the distinction between passions and habits. On the one hand, murderousness is understood to be a passion inherent in mankind which is activated in particular circumstances, so that, theoretically at least, all men are potential killers. On the other, murderers kill through habit and may therefore be philosophically segregated from the rest of humanity as if they were a different species.

Those who kill sadistically will do so habitually. The fundamental claim is that the individual is somehow 'desensitized' (to use a modern term) by some feature of his environment such as 'cruel laws and customs', violent forms of entertainment, or, most commonly, war.[22] Soldiers as a peer-group were notoriously violent and quarrelsome: 'By a great oth they wil sweare, he is a braue delicate sweet man, for he kild such & such a one; as if they should say, *Caine* was a braue delicate sweet man, for killing his brother *Abel.*'[23] The argument was that prolonged exposure to warfare changes a man's nature, so that even when discharged he brings home with him the aggression and killing of the front.[24]

Bloodthirstiness is less immediately related to a particular causal hypothesis, but as a short-lived state of mind it reflects the view of murder as a product of passion. The distinctive humanity of mankind was held to be located in the reason, by which the passions are normally controlled; they may, however, take over in certain circumstances, resulting in a kind of insane frenzy. This could be understood physiologically in terms of humoural imbalance: for instance, excessive choler was thought to make a man irascible; melancholy too was a murderous humour according to some thinkers.[25] The assumption is that the individual can no longer act autonomously, although the control originates within himself rather than, as in the diabolic view, outside: writing in 1580, Montaigne says of anger, 'we moove other weapons, but this mooveth us: our hand doth not guide it, but it directeth our hand; it holdeth us, and we hold not it.'[26] Indeed, the passion of wrath was the archetypal antecedent of murder, classically defined as the desire to revenge an injury.[27] Spenser personified Wrath as a murderer, with blood-stained clothes and hand on dagger, and presented him riding alongside Envy, the other principal murderous passion.[28] Envy too was personified as a murderer, this time by Thomas Middleton in his pageant *The Triumphs of Truth* (1613): she is 'attired in red silk,

suitable to the bloodiness of her manners' and carries 'in her right hand a dart tincted in blood'.[29] The envious person, it was thought, would seek the death of the object of his envy, as Iago does Cassio's: 'He hath a daily beauty in his life/ That makes me ugly' (V.i.19–20); what he cannot have, or attain to, must not be allowed to exist.

These, then, are the ways in which murderous action was explained in the sixteenth century: the influence of Satan, a criminal career, the influence of a violent environment, the dominance of the passions or of the humours. It is notable that in every case, the act is referred back to something prior to the will of the murderer. This means that there is an absolute distinction between the causes of a murder and the motives for it, and that motives were not considered to be of substantive importance: they are construed as excuses or pretexts for something the criminal would have done anyway, authenticating details on a par with the clothes he was wearing at the time; even in cases of passion, where it is accepted that the killer acts for a reason, he none the less has no choice.

Obviously the period's ideas about criminality are related to its concepts of human behaviour more generally. One position understood psychology in terms of a 'rational soul' which had a divinely implanted instinct to virtuous action – the original meaning of 'common sense'. A quite opposite view was that fallen Man was depraved and could act virtuously only with the help of God's grace. Neither of these concepts of humanity allows for the rational choice of evil essential for motive to be of substantive importance: it is simply a matter of the dominant human instincts being either followed or overruled by some more powerful force, depending on what is perceived to be the nature of those instincts. Between these extremes was the Aristotelian view of the mind as a *tabula rasa*, but even this did not allow the primacy of an evil will. There is no sin but there is first ignorance, argues Thomas Starkey, writing in the 1530s: negligence produces ignorance, so Man must actively will his knowledge of Good into being, but it is impossible to will an evil act knowing its moral nature.[30] Erasmus took much the same position in his Christian humanist argument for free will: his discussion presents two possibilities: actively to will Good and passively not to will Good. The option of actively willing Evil is never considered.[31] The simpler and more pragmatic presentations of human behaviour to be found in more popular material tended to undervalue motive, too. For example, it is Thomas Kyd's unstated assumption in his pamphlet *The Murder of John Brewen* (1592) that Man acts purely in accordance with the dictates of survival. His argument is that,

since it is universally acknowledged that murder will inevitably be
revealed and punished, the crime should never occur: 'the feare of
God, or extreame punishment in this world' should intervene, and
it is 'onely through Sathans suggestions' that the murderer forgets
these considerations.[32] Murder, then, is a product of causes prior to
human choice: these causes may precipitate motives and choices,
but it is the causes which have primacy and are therefore the subject
of commentary.

A further system of thought, emergent in the fifteenth and
sixteenth centuries, was what was to become liberal humanism.
This places Man as (in the terminology of some recent cultural
historians) an 'autonomous subject': human action is significant and
human potential for action unrestrained. As an example of the
thought involved, an important early text, influential in England,
was Pico della Mirandola's *Oration on the Dignity of Man* (1486),
which posits a protean humanity:

> you may form yourself in what pattern you choose. You will be
> able to degenerate into the lowest ranks, which are those of the
> brutes. Through the judgement of your soul, you will be able to
> be reborn into the highest ranks, those of the divine.[33]

It is ascent which captures Pico's imagination and much of his
attention: his theme is after all the *dignity* of Man. But he cannot
deny the possibility of degradation. It is frequently an apologist who
constructs a being's subjectivity, so the option for autonomous evil
is the hardest thing to accept; much as many people today feel an
instinctive reaction against the notion that a woman or a black man
could be 'evil' or criminal. The result in the sixteenth century was
a view of criminality inherent in the logical structure of liberal
humanism, but as yet not fully conceptualized.

Clearly this difficulty is related to the increasing predominance in
the Tudor period of the taboo against intent and its significant,
premeditation. A taboo is an evasion, a society's rejection of
something it must recognize, but either cannot or does not wish to
conceptualize or understand. A parallel might be drawn with our
modern response to psychopathic killings like the Hungerford
massacre: we recoil from them because we are perplexed at their
motivelessness, motive being so necessary to our conception of
human action. In the sixteenth century, to consider the psychology
of evil in terms of will and motive rather than of cause was to give
tacit assent to the subjectivity of Man, and to do this was to
endanger the more established philosophical systems, and so to

destabilize the world. In other words, the notion of a settled evil intent was too horrifying to contemplate on its own terms because it threatened Man's very understanding of himself; so taboo, in this case, functioned as a mechanism of social and intellectual inertia. The problem was with evil rather than good acts because there was already a degree of acceptance for human autonomy in the latter – in God's service there was perfect freedom. Consequently, the desire to punish overcame the drive to understand: intent defined the crime without being admitted as a substantive explanation of the criminal's behaviour, and there was no need to conceive of wilful premeditated murder as anything other than a hanging offence.

MACBETH

Turning to the drama, it can be both useful and flatly unpromising to approach plays via contemporary criminological ideas. Take, for example, *Julius Caesar* (1599), which explicitly interprets Brutus and his fellow assassins in the closing minutes:

> All the conspirators save only he
> Did that they did in envy of great Caesar.
> He only in a general honest thought
> And common good to all made one of them.
> <div align="right">(V. v. 68–71)</div>

This is not simply, as we would interpret it today, a question of good and bad motives. Most of the assassins were activated by envy: they were slaves of passion. Brutus, however, was problematic. Today, we respect his motives, but a sixteenth-century audience would, in the old sense, have respect of his motives: no cause is cited, only 'a general honest thought'. But that thought must be a tortured one:

> Between the acting of a dreadful thing
> And the first motion, all the interim is
> Like a phantasma or a hideous dream.
> <div align="right">(II. i. 63–5)</div>

Here we enter territory that Shakespeare was to explore more fully in *Macbeth*.

The problem of Brutus is as much ethical as existential. The act of killing Caesar is culpable homicide, but Brutus expects good to come of it. We are not yet in the deep waters of criminal intent, where a rational man commits a wholly evil act, knowing its moral

nature. In showing Macbeth to be such a man, and the murder of Duncan to be such an act, we must begin by considering the role of the Weird Sisters in the play.

When the witches greet Macbeth as Glamis, Cawdor, and, hereafter, King, we see two contrasting reactions: Macbeth is stunned into silence, but the level-headed Banquo proceeds to question the three apparitions further, pausing only to ask his companion,

> Good sir, why do you start and seem to fear
> Things that do sound so fair?
> (I. iii. 49–50)

The contrast is underlined by the *fear/fair* assonance: at face value the prophecy is fair, and the innocent Banquo can take it as such; it is a cause for fear only in a man whose ambitions already aim at the crown. Macbeth's silence, that is, is the silence of a man found out. Although this conclusion will turn out to be a correct one, however, it is based on a false premise. The witches' words do not apply equally to Macbeth and Banquo, so it is only natural that they should respond to them in different ways. By using the language of the dialogue to prompt us to draw a contrast, Shakespeare pulls off a theatrical confidence trick; but Macbeth will incriminate himself far more effectively the moment he speaks.

This moment comes as the witches wind up their spiel:

> – So all hail, Macbeth and Banquo!
> – Banquo and Macbeth, all hail!
> (66–7)

The first word, 'So', and the chiastic structure of the two lines both signal a rounding-off to which Macbeth responds, over-eagerly:

> Stay, you imperfect speakers, tell me more.
> (68)

Then begins a fascinated picking-over of the threefold series, *Glamis–Cawdor–King,* which the witches have fed into the rhetorical fabric of the play:

> By Sinel's death I know I am Thane of Glamis,
> But how of Cawdor? The Thane of Cawdor lives,
> A prosperous gentleman, and to be king
> Stands not within the prospect of belief,
> No more than to be Cawdor.
> (69–73)[34]

As in the original sequence, there is a progression here: Glamis he is, but Cawdor is an unlikely honour and King an incredible one. The word 'king' is strongly placed at the end of a line, enforcing a momentary lingering which can only arouse suspicion; but it is the last line that gives the game away: 'to be king/Stands not within the project of belief, *No more than to be Cawdor.*' The progression is subverted, and *King* and *Cawdor* level off, the one as unlikely or incredible as the other. Macbeth has had to puncture his own rhetoric like this because with *King* both the prophecy and his rejoinder come too close to his own ambitions for comfort. To *utter* is to *outer* (the words are cognate), and thoughts of the crown he must keep inside, without even a denial to disrupt his innocent facade. Bringing back *Cawdor* returns him to safe ground – he has no ambitions in that direction. But that moment of unease has raised a pragmatic concern, and he continues,

> Say from whence
> You owe this strange intelligence, or why
> Upon this blasted heath you stop our way
> With such prophetic greeting. Speak, I charge you.
>
> (73–6)

The word *intelligence* here palters in a double sense: for Banquo's ears it means *news* or *information*, but another connotation was the communications of spies (or intelligencers), among whose concerns was the exposure of intended treason. Macbeth's thoughts may somehow have been discovered, or the witches' greeting may have been genuinely prophetic: either way he needs to know. It is the lack of an answer (the witches vanish at this point) that makes the experience all the more disturbing for him: 'Would they had stayed' (80), he says, while Banquo puzzles over their disappearance. Again we contrast their behaviour: which is the more likely response from a man who has just seen a ghost? Macbeth's behaviour throughout has revealed a preconception of ambition and foul play, dangerous thoughts which the Weird Sisters have threatened to bring to light.

But why *should* we interpret the sequence in this way? So far, 'noble Macbeth' has been presented to us as a 'worthy gentleman' (I. ii. 67, 24), and there has been no mention of murder, at least in the text as we have it. An audience does not need a pointer such as this if it already knows the plot, of course: it will be watching for indications of Macbeth's murderous intent (and, in 1606, for the cause of it) from the start of the play. There is every likelihood that the original audience would have had this foreknowledge, for

Shakespeare's was not the only treatment of the Macbeth story in the period. The early Jacobeans were a people interested in their new king and his background, and the fact that James regarded Banquo as his ancestor made this part of Scottish history especially relevant. This fact posed a problem, however, for an audience expecting Macbeth to murder Duncan could equally expect Banquo to be his accomplice, as told in Shakespeare's source, Raphael Holinshed's *Chronicles of Scotland* (1587). Not surprisingly, this is a part of the story that is silently altered by Jacobean authors, and Shakespeare is more cautious still than this. A non-dramatic version such as William Warner's in *A Continuance of Albion's England* (1606) can skimp on details and bring in Banquo purely as Macbeth's major victim. In a play, so drastic a diminution would be almost as insulting as absolute fidelity to the Chronicle source, and the prophecies were anyway too important and well-known a part of the narrative to omit. Rather, Shakespeare had to dissociate Banquo from Macbeth at an early stage, and this is precisely the effect of the contrast he encourages us to draw between the two men in their reaction to the Weird Sisters and their greeting: audience presuppositions about Macbeth are swiftly confirmed, and about Banquo denied; events proceed from there.

Macbeth's public discomfort with the witches' third 'all hail' is stressed several times by re-enactment. For a man who rejected the prophecy, he is very loath to lay his fingers off it. 'Your children shall be kings,' he tells Banquo, who replies, disconcertingly, 'You shall be king'; Macbeth dodges the issue by insisting, 'And Thane of Cawdor too' (I.iii.84–5). The evasion recurs yet again when, created Thane of Cawdor, he says, 'Glamis, and Thane of Cawdor./ The greatest is behind' (114–15). Nicholas Rowe made this line an aside in his edition of 1709, an emendation that has passed into editorial tradition: even Stanley Wells, the most reputably radical of the play's editors, has retained it in the Oxford Shakespeare. The line makes little sense as an aside, nor was it printed as such in the 1623 Folio. The greatest is not behind: the greatest office, of King; still lies ahead, and, since Cawdor fell to Macbeth unasked, the greatest effort too.[35] Why then should Macbeth say to himself that it is? Rather this is a modesty topos spoken to Ross and Angus, like his earlier refusal of Cawdor's title, 'Why do you dress me/ In borrowed robes?' (106–7). It is another denial of the terms of the prophecy, an assertion that he has reached his apogee. But he cannot leave it at that. Having suppressed the third greeting under 'the greatest is behind', he comes obsessively back to the witches' promises,

reminding Banquo of his children's future. It is left to Banquo once again to fill in the blank; but this time the evasion has already taken place and he has inferred Macbeth's innocence from it, so he drops into the conditional to warn him that the prophecy

> Might yet enkindle you unto the crown,
> Besides the thane of Cawdor.
> (119–20)

It is this as much as the reiteration of *Cawdor* that makes a riposte from Macbeth unnecessary.

At this point Banquo interprets the Weird Sisters as diabolic tempters:

> And oftentimes to win us to our harm
> The instruments of darkness tell us truths,
> Win us with honest trifles to betray's
> In deepest consequence.
> (121–4)

The implications of *win* are particularly unsettling: Macbeth is the object of seduction, but he is also the prize. Banquo sees his companion's fascinated return to the witches' words as the first stage of a temptation which, unchecked, may lead him on to regicide. The audience, however, knows that it is not an innocent obsession, and can see that Macbeth is deceiving himself when he takes up Banquo's view in the aside that follows:

> Two truths are told
> As happy prologues to the swelling act
> Of the imperial theme....
> This supernatural soliciting
> Cannot be ill, cannot be good.
> (126–30)

The Weird Sisters have solicited nothing.[36] They cannot be advanced as a cause of the murder of Duncan, instruments of Satan like the witch in the Nathalocus story, because the murder pre-exists as an idea in Macbeth's mind. This is not a play about temptation; rather our attention is drawn to the long process of premeditation, the hideous phantasma between conception and action.

None the less, the obsessional quality of this premeditation is referrable back to the witches' prediction: they are a factor, though no cause. Nor is this simply a fascination at having been told he will be king hereafter. He can reason to himself,

If chance will have me king, why, chance may crown me
Without my stir

<div align="right">(142–3)</div>

but when chance promptly throws Malcolm in his way as Prince of
Cumberland, Duncan's successor, his thoughts turn straight back to
murder. That Malcolm will now be the beneficiary he does not even
consider, much as he forgets the matter of Banquo's posterity until
it is too late. He has conceived, irrationally, a necessary relation
between killing Duncan and taking his place; it is pure chance that,
in the event, Malcolm flees and leaves the field to him. The
misconception originates in the values with which he invests the
Glamis–Cawdor–King triad when he first hears it:

By Sinel's death I know I am Thane of Glamis,
But how of Cawdor? The Thane of Cawdor lives...

The lines contrast his title of Glamis, held by virture of his father
Sinel's death, with the title of Cawdor, whose current holder still
lives. To hold a title requires the death of one's predecessor: the
application to the third title in the series must remain unspoken –
the treason laws in Shakespeare's England made the death of the
monarch a taboo subject. As yet, however, no form of death is
inherent in the sequence: that emerges when Glamis becomes
Cawdor. There is no evidence, from either Shakespeare or Holin-
shed, that Sinel's was other than a natural death; Cawdor's, however,
was premature, through execution as a traitor. *Glamis–Cawdor–
King*: the sequence has a progression to it, both numerically and in
terms of rank. And now: natural death – execution – what more
obvious than murder to close the series? Macbeth asks,

why do I yield to that suggestion
Whose horrid image doth unfix my hair
And make my seated heart knock at my ribs
Against the use of nature?

<div align="right">(133–6)</div>

He yields because he has just inscribed it in the witches predictions,
and so invested it with a future reality: what was an option is now
a necessity, what was an idea is now an image.[37] Articulation is
complete and Macbeth now faces the struggle to act.

There is, of course, a second possible cause for the murder of
Duncan, in line with a different interpretation of criminality.

Macbeth is a soldier, and we first hear of him from the bleeding captain performing the particularly gruesome killing of Macdonwald:

> For brave Macbeth – well he deserves that name! –
> Disdaining fortune, with his brandished steel
> Which smoked with bloody execution,
> Like valour's minion
> Carved out his passage till he faced the slave,
> Which ne'er shook hands nor bade farewell to him
> Till he unseamed him from the nave to th' chops,
> And fixed his head upon our battlements.
>
> (I.ii.16–23)

There is incidental violence in the passage, too: the sword covered with fresh, steaming blood, the butcherly resonance of 'carved'. 'Can someone be even minutely sensitive about killing one person when mass murder is his profession?' asked Erasmus.[38] Not that killing enemies in battle can fairly be called mass murder: Iago may be lying when he assures Othello,

> Though in the trade of war I have slain men,
> Yet do I hold it very stuff o'th' conscience
> To do no contrived murder
>
> (I.ii.1–3)

but it is a lie that plays on contemporary ethics. And Macdonwald's killing is doubly legitimate, for disembowelling followed by decapitation and the display of the head is more than a little reminiscent of the prescribed form of execution for traitors such as he.

As for sensitivity, the contrast between the killings of Macdonwald and of Duncan could not be clearer. Macbeth is purposive, unmeditative, as he makes for the traitor and despatches him in an instant.[39] But killing like this has not perverted him. When he sees the murder of his King in image, he both knows and feels it to be evil: knows in that he can reason from it that the Weird Sisters' prophecy 'cannot be good'; feels in that it prompts an involuntary physical reaction – increased heart rate and falling hair. 'A soldier and afeard?' taunts his wife at one point, underlining the contrast.[40] From this knowledge and feeling springs the struggle with himself that is the second stage of his premeditation:

> The genius and the mortal instruments
> Are then in counsel, and the state of man,

> Like to a little kingdom, suffers then
> The nature of an insurrection.
> (*Julius Caesar* II.i.66-9)

As a debate, however, it is all very one-sided: Macbeth is trying to talk himself out of it. He presents himself with conditions which he knows do not obtain: 'If it were done when 'tis done.../... If th'assassination/ Could trammel up the consequence' (I.vii.1-3). The answer comes swiftly back that it is not done with once committed: even if you jump the life to come, there is still judgement and infamy in this world –

> And pity, like a naked new-born babe,
> Striding the blast, or heaven's cherubin, horsed
> Upon the sightless couriers of the air,
> Shall blow the horrid deed in every eye.
> (21-4)

Flickering beneath the surface, too, is the realization that the afterlife is not to be jumped. Babies do not usually stride the blast: this is the Christ-child, God made flesh out of pity for mankind, the Son who will eventually sit in judgment on the last day. When looked at coldly, moreover, why is he even considering murder?

> I have no spur
> To prick the sides of my intent, but only
> Vaulting ambition which o'erleaps itself
> And falls on th'other.
> (25-8)

If ambition is a man leaping into the saddle, it can so easily turn into the standard icon of pride, a man falling off a horse. But if, morally, Macbeth equates the two, the image allows of another interpretation, for it is quite possible to vault successfully into the saddle. The stability he reaches in determining to 'proceed no further in this business' (31) is illusory, belied by the too-earnest enumeration of his reasons that follows. As the exchange with his wife continues, minor pragmatic worries take over – 'If we should fail?' (59) – and, these once resolved, other objections are forgotten.

The exercise has been futile for Macbeth because the question is not simply whether or not to kill the King: the matter is weighted. The phantasm of the murder already haunts and horrifies him, but it also impels him onwards: 'Thou marshall'st me the way that I was going' (II.i.42), he tells the dagger that he later sees. To exorcise the

image, he must enact it, outer it: "twere well/It were done quickly'
(I.vii.1–2), rapidly as well as soon. This is the spur pricking the
sides of his intent, a spur he cannot identify. His struggle is between
'if it were done' and 'when 'tis done', the future conditional and the
future perfect; it is a struggle to keep open the option not to kill. He
loses the option because he assumes he still has it, assumes that
willing a murder into psychological being, unlike willing one into
actuality, will have no consequences. He fails to recognize the
deepest level of his own premeditation and, having persuaded
himself to drop the matter, concludes:

> I am settled, and bend up
> Each corporal agent to this terrible feat.
>
> (79–80)

From this point there is no turning back.

Macbeth recognized at an early stage what the consequence of
actualizing the image would be:

> The eye wink at the hand; yet let that be
> Which the eye fears, when it is done, to see.
>
> (I.iv.54–5)

It is one thing to be tempted, another thing to fall. Killing Duncan
has objectified the phantasm, given the murderer the option not to
see it:

> I am afraid to think what I have done,
> Look on't again I dare not.
>
> (II.ii.49–50)

But this is at the expense of making permanent the guilt and the
horror. 'To know my deed 'twere best not know myself' (71), he
insists at the end of the scene, but the *Glamis–Cawdor–King* triad,
making its penultimate appearance here, affirms otherwise:

> Glamis hath murdered sleep, and therefore Cawdor
> Shall sleep no more, Macbeth shall sleep no more.
>
> (40–1)

The evasion of *King* no longer works because, the deed done,
Macbeth *is* King, and insomnia goes with the office. But there is
more than this. Macduff and Lennox will not wake Duncan with
their knocking: the murder cannot be undone. In the production
that Simon Forman saw at the Globe in 1611, Macbeth and his wife
had permanently red hands for the rest of the play.[41] It has been a

kind of spiritual deflowering, as Macbeth later recognizes, using a common image of virginity – 'mine eternal jewel/ Given to the common enemy of man' (III.i.69–70). But as yet he is still trying not to come to terms with it.

We can deal with the rest of the play in fairly short order. When Macbeth, intending Banquo's death, tells his wife,

> Be innocent of the knowledge, dearest chuck,
> Till thou applaud the deed
>
> (III.ii.46–7)

he is not just excluding her from criminal guilt as an accessory before the fact – after all, none can call their power to accompt. There is a tenderness in the line, for he is protecting her, however misguidedly, from that state of premeditation which was so painful and disturbing to him before the murder of Duncan, and is so again now: 'O, full of scorpions is my mind, dear wife!' (37). He also seeks to protect himself. He explains to his assassins that in hiring them to kill Banquo he is 'Masking the business from the common eye' (III.i.126). His own eye is just as important. His fixation on the image has been so powerful that, the second time around, he must ensure that he never comes into contact with it – not, as it turns out, with any great success. He is seeking to evade premeditation, to make the very firstlings of his heart the firstlings of his hand. This he achieves with his third murder, that of Lady Macduff. He conceives it – 'This deed I'll do before this purpose cool' (IV.i.170) – and then is heard no more. We see no hiring, no preparation: he treats the murder with the terrible casualness of Antony in *Julius Caesar* – 'Look, with a spot I damn him' (IV.i.6).

The effect on our sympathies is carefully contrived. Macbeth is never absent from the stage for longer than after he has determined the death of Lady Macduff. With the man distanced from what we know remains his crime, our sense of that crime is objectified. We see a touching domestic exchange between mother and son interrupted by violence. We see the widower's grief, his stunned incomprehension of the extent of the slaughter: 'My children too?'; and then, 'My wife killed too?'; and then, 'All my pretty ones?/ Did you say all?' (IV.iii.212, 214, 217–18). Of Macbeth we see nothing; and must assume he feels nothing. On his return to the stage, our dislike is confirmed: he is over-confident, abusive to his cream-faced loon of a servant, and he has a new, oily attendant whose name is not without significance: it is Seyton (i.e. Satan).[42] He has lost the capacity to think and plan: there is no more need to make

the future, for the Weird Sisters have given him assurance of it. So tomorrow and tomorrow and tomorrow is indeed a petty pace, when tomorrow cannot be invested with meaning, cannot be premeditated upon.

CONCLUSION

It should be clear by now that what we find in *Macbeth* is exactly what we should expect not to find in the light of contemporary criminological thought. Premeditated intent, which is usually excluded from articulated ideas about murderousness, is central to the play. Even the condition of its exclusion, its placement as a taboo or transgression, is violated: we feel Macbeth to be most heinous when he premeditates the least. This does not necessarily mean that the play is simply a document which was overlooked in compiling the survey in the first half of this paper. Its portrayal of the antecedents of murder is of a different order, particular, specific, with nothing pat or prepackaged about it. Nor do intent and premeditation exist independently as a means of explaining the crime: a condition of their presence in the play is the rejection of other accredited explanations like diabolic influence and soldierly perversion. This is clearest, expressible as an *either–or* statement, in the incident of the murder of Duncan's grooms. Macbeth presents this done in righteous passion:

O, yet I do repent me of my fury
That I did kill them.
(II.iii.106–7)

The lie only stresses how calculated a killing it really was. Shakespeare is first exposing a conceptual lacuna and then setting out to fill it. He does not simply import the idea of criminal intent for use in the play; rather the play itself contributes to the articulation of that idea.

Macbeth is not unique in this respect: English Renaissance drama frequently addresses the question of the autonomous evil will through its villains; Shakespeare's play is simply the most developed and sophisticated example. In this respect the drama is out of step with the ideas of the time in so far as they can be determined from other sources; but it is a precursor of concepts that begin to appear soon after. Subsequent generations found it far easier to conceive of substantive motives as possibilities alongside substantive causes. An important case is that of Enoch ap Evan, a

Shropshire matricide and fratricide hanged in 1633. One pamphlet account of the case runs through the possible reasons for the crime, both causal and motivational:

> Neither was this man madd or franticke, as his owne hand doth witness? Neither was it to inherite after his brother, (if the murder could haue bin concealed) being the eldest? whether for any iniury offered? or debate that grew from words, and after came to blowes? And for his Mother's part, not that she had crost him in any choice? or curbed him of his liberty? or railed, or reuiled him? or that she bare any strict eye, or seuere hand ouer him? whether can it be imputed to his want of yeeres, or discretion, or to any destraction of braine, or deepe apprehended melancholly? what then might bee the motiue to induce him vnto a deede so execrable?[43]

The revelation of this fact is the focal point of the pamphlet. Apparently, Evan was a nonconformist who objected to his family's receiving the sacrament in the prescribed Anglican fashion, kneeling, and who ensured that they would never do so again by decapitating them. That, at least, was the official version. Understandably concerned, the Puritan community claimed that 'Sathan (working upon his predominant humour of melancholy) tempted him to commit these murders.'[44] Again, anti-Puritan accounts stress Evan's premeditation: he committed the murders the day after arguing with the victims (a dispute which ended, allegedly, 'without much heat'), using an axe 'which he had provided it seems on purpose'.[45] According to the nonconformists, however,

> he never thought of such a fact, towards man, woman, or child, till within one houre or lesse before the murder was done, and...his thoughts did so rise upon him that he could not have any rest or quiet till he had done the deed.[46]

Ironically, then, the authorities upheld Evan's autonomous criminal intent, while the Puritan claims, based on accepted prior causes, were refused a licence for publication and only went to press after the breakdown of censorship under the Long Parliament.[47] The political reasons for this are obvious enough, but what concerns us here is that it was possible to present a motive as an adequate explanation in the first place: clearly the early seventeenth century saw the emergence of a new way of understanding criminality.

In the vanguard of this conceptual development was the drama, and this is highly significant. Partly, of course, this is because a play

is an imitation of an action rather than the action itself, and so can bypass the intellectual block of a taboo the more easily. There is a kind of false security in fiction which makes audience response more tractable than if it were considering a real man: we have seen how the murder of Lady Macduff is made to appear more heinous than that of Duncan, even though, in contemporary terms, it was far more explicable, being the act of a man already inured to violence. Moreover, the taboo against premeditation is retrospective: the law applies it to define the criminality of a killing that has already taken place. In contrast, in *Macbeth* we see events in their chronological sequence, so we cannot condemn Macbeth until his premeditation has given way to action; and the suspense thus created forces us to attend to the psychological process involved.

Of more general importance, however, is the fact that drama is as much re-enactment as it is action: as such it constitutes in itself a stage in the development of concepts. To take a model from educational psychology, this is the stage of the pre-concept, a schema which remains 'midway between the generality of the concept and the individuality of the elements composing it, without arriving either at the one or at the other'.[48] A play, that is, has as its object of representation the acts and characters of particular individuals such as Macbeth; but whereas individuals in life have no necessary importance beyond themselves, the characters and actions in a play, merely by virtue of their *being* in a play, are accorded some more general significance. It is not just that they have been selected; they have also been internalized and re-created. This is the first stage of that abstraction from the particular that is the genesis of the concept, because the re-creation will not be faithful to the original: some features will be privileged, as premeditation is in *Macbeth*. Yet being an enacted event, a play is less dependent on already existing concepts than any other form of fiction, and so better able to reflect the reality of its original: an audience sees Macbeth as a man, even if that man is really Richard Burbage; it does not have to construct him out of words as the reader of a novel would have to; the conjunction of general and particular is at its sharpest. Drama, that is to say, is the symbolic play of civilization.

Obviously I am not implying that audiences in 1606 walked away from *Macbeth* suddenly understanding the psychology of evil and realizing that Man could autonomously choose to be a villain after all. Nor do I suggest that Shakespeare had any didactic intent in writing and staging the play: drama is not so much a matter of *learning,* with its implied obverse of *teaching,* as a mutual process

of *finding out.* Concepts are never articulated in a flash. Rather dramatist and audience shared a problem, often felt with villains but now at its most acute. The problem was a conflict between perception and preconception, between the behaviour enacted on the stage and the theories that denied its possibility. In 1606, in the character of Macbeth, nothing was but what was not.

Notes

1 D. Norbrook, *Poetry and Politics in the English Renaissance,* London: Routledge & Kegan Paul, 1984, *passim.*
2 See H. de Bracton, *Bracton on the Laws and Customs of England, ed.* G.E. Woodbine, rev. and tr. S.E. Thorne, 4 vols, Cambridge, Mass.: Harvard University Press, 1968-77, II, p. 379; J. Bellamy *Crime and Public Order in England in the Later Middle Ages,* London: Routledge & Kegan Paul, 1975, pp. 53–4.
3 See J.M. Kaye, 'The early history of murder and manslaughter', *Law Quarterly Review,* 83, 1967, p. 387.
4 *The Statutes of the Realm,* 10 vols, London: Eyre and Strahan, 1810–28, II, p. 538.
5 ibid., II, p. 639.
6 ibid., III, p. 49.
7 *Hamlet,* V.ii.187. In fact, in both English and Roman law, he would be guilty of murder on transferred malice. All further references to W. Shakespeare, *The Complete Works,* ed. S. Wells and G. Taylor, Oxford: Oxford University Press, 1986, appear in the text.
8 C. St German, *The secunde dyalogue in englysshe wyth new addycyons,* London, P. Treueris, 1531, sig. O2ᵛ. This might be seen as an earlier stage in that development which precipitated the change in penal practice observed by Foucault in the late eighteenth century, when the soul rather than the body became the object of punishment. See M. Foucault, *Discipline and Punish,* tr. A. Sheridan, Harmondsworth: Penguin Books, 1979, pp. 16–22.
9 K. Thomas, *Religion and the Decline of Magic,* Harmondsworth: Penguin Books, 1973, p. 625.
10 T. Beard and T. Taylor, *The Theatre of Gods Judgements,* 4th edn, London, S.I. and M.H., 1648, sigs. Q3ʳ⁻ᵛ.
11 T. Fitzherbert, *The First Part of a Treatise concerning Policy, and Religion,* Douai, L. Kellam, 1606, sigs. 3K4ʳ⁻ᵛ.
12 *A Yorkshire Tragedy,* ed. A.C. Cawley and B. Gaines, Manchester: Manchester University Press, 1986, scene X, 18–19.
13 T.I., *A VVorld of vvonders,* London [V. Simmes?], 1595, sig. F2ᵛ.

14 *Two most vnnaturall and bloodie Murthers,* London, V. S[immes], 1606, sig. D1ᵛ.

15 T.I., *A VVorld of vvonders,* sig. F3ʳ.

16 *The Prayer and Confession of Mr Felton,* London, no bookseller/printer, 1628, sig. A3ᵛ.

17 H. Bullinger, *The Decades,* ed. T. Harding, tr. H.I., 4 vols, Cambridge: Parker Society, 1849–52, II, p. 362.

18 H. Latimer, *Sermons,* ed. G.E. Corrie, Cambridge: Parker Society, 1844, p. 441.

19 Sir P. Sidney, *The Old Arcadia,* ed. K. Duncan-Jones, Oxford: Oxford University Press, 1985, p. 18.

20 E. Spenser, *The Faerie Queene,* ed. A.C. Hamilton, London: Longman, 1977, I.iv.18.6.

21 G. Chapman, *Bussy d'Ambois,* ed. N. Brooke, London: Methuen, 1964, V.i.90–2.

22 J.R. Hale, 'Sixteenth-century explanations of war and violence', *Past and Present,* 1971, vol. 51, pp. 18–19.

23 T. Nashe, 'Christs Teares over Iervsalem', in *Works,* ed. R.B. McKerrow, 2nd edn, 5 vols, Oxford: Basil Blackwell, 1957, II, p. 109.

24 Hale, 'Sixteenth-century explanations', p. 10.

25 L. Babb, *The Elizabethan Malady,* East Lansing: Michigan State College Press, 1951, p. 84.

26 M.E. de Montaigne, 'Of anger and choler', in *Essays,* tr. J. Florio, 3 vols, London: Everyman, 1910, II, p. 448.

27 Seneca, 'De Ira', in *Moral Essays,* ed. J.W. Basore, 3 vols, London: William Heinemann, 1928–35, I, p. 112.

28 Spenser, *The Faerie Queene,* I.iv.33–5.

29 T. Middleton, 'The triumphs of truth', in *Works,* ed. A.H. Bullen, 8 vols, London: John C. Nimmo, 1885–6, VII, p. 241.

30 T. Starkey, *A Dialogue between Reginald Pole and Thomas Lupset,* ed. K.M. Burton, London: Chatto & Windus, 1948, pp. 42–5.

31 S. Davies, *Renaissance Views of Man,* Manchester: Manchester University Press, 1978, pp. 97–100.

32 T. Kyd, 'The Mvrder of Iohn Brewen', in *Works,* ed. F.S. Boas, Oxford: Oxford University Press, 1901, p. 287.

33 Davies, *Renaissance Views of Man,* p. 67.

34 Cf. E. Jones, *Scenic Form in Shakespeare,* Oxford: Oxford University Press, 1971, pp. 206–7.

35 I am grateful to Dr J.S. Bratton for explaining to me the rationale of Rowe's emendation. Shakespeare often imagines futurity as a sequence of events passing by, rather like the show of kings in Act IV; so that each successive event is behind its predecessor (e.g. *The Winter's Tale* I.ii.64). However, he also uses *behind* in the sense I suggest here, to signify the past: 'My grief lies onward and my joy behind' (Sonnet 50, 14).

36 Cf. A.C. Bradley, *Shakespearean Tragedy,* London: Macmillan, 1957, p. 288.

37 G.W. Knight, *The Wheel of Fire*, London: Methuen, 1949, p. 153.

38 Hale, 'Sixteenth-century explanations', p. 10.

39 This is the more noticeable if, as Steevens suggested, Shakespeare was thinking of the death of Priam here: in his treatment of that incident in the Player's speech in *Hamlet*, Pyrrhus, unlike Macbeth, undergoes a frozen hesitation before he can kill his victim.

40 The line in fact comes from the sleepwalking scene (V.i.35), but at a point when she is re-enacting the first murder in her dreams. If the text as we have it is an abridged version of the play (cf. W.W. Greg, *The Shakespeare First Folio*, Oxford: Oxford University Press, 1955, pp. 389–90), she may have had a similar line earlier; but even as it is the implication is clear.

41 So I interpret, in the light of Alan Dessen's ideas about stage 'realism' (A. C. Dessen, *Elizabethan Stage Conventions and Modern Interpreters*, Cambridge: Cambridge University Press, 1984, pp. 105–29), Forman's statement that 'when Mack Beth had murdred the kinge, the blod on his handes could not be washed of by Any meanes, nor from his wiues handes, which handled the bloddi daggers in hiding them' (S. Wells and G. Taylor, *William Shakespeare: A Textual Companion*, Oxford: Oxford University Press, 1987, p. 543).

42 Cf. Dessen, *Elizabethan Stage Conventions*, p. 6.

43 A *True Relation of a barbarous and most cruell Murther, committed by one Enoch ap Euan*, London, N. Okes, 1633, sig. A3[v].

44 R. More, *A True relation of the Murders committed in the Parish of Clunne*, London, T.B., 1641, sig. E10[r].

45 J. Howell, *Epistolae Ho-Elianae*, ed. J. Jacobs, London: David Nutt, 1892, p. 633.

46 More, *A True relation of the Murders*, sig. E2[v].

47 ibid., sig. A3[v].

48 J. Piaget, *The Psychology of Intelligence*, tr. M. Piercy and D.E. Berlyne, London: Routledge & Kegan Paul, 1950, p. 127. I use Piaget with the caveat that there are obvious differences between the learning processes of children and of cultures, which qualify the applicability of his theory. The ways in which cultures change and develop would be a fruitful object of interdisciplinary collaboration between historians and psychologists.

2 Masters and servants in moral and religious treatises, c. 1580–c. 1642

Mark Thornton Burnett

From the presses of the late sixteenth and early seventeenth centuries in England poured a torrent of popular works instructing the godly householder how to manage his finances, domestic affairs, and family. Puritan divines and other writers arguing from a religious standpoint drew on biblical texts, classical scholarship, and pre- and post-Reformation writing to describe the duties and responsibilities of every member of the household.[1] This paper examines a large body of the prescriptive literature, concentrating in particular on the master and servant relationship and on the way in which it was represented in the literary genre known as the conduct book.

Moral and religious treatises, of course, more often than not found their origins in sermons delivered by preachers before their local parish congregations. This was a markedly different process of literary production from that of the drama, for instance, where a busy team of professional playwrights wrote (sometimes in collaboration) for the demanding audiences of the London theatres. Servants, however, are figures common to both fields of literary activity and one has only to turn to Shakespeare to find pertinent and well-known examples. Adam in *As You Like It* (1599) might be seen as an instance of an ideal of loyal and faithful service, while Malvolio, the ambitious and ridiculous steward in *Twelfth Night* (1601), is at the opposite end of the spectrum: he bustles about the play bent only on his own self-aggrandizement. In texts addressed to a range of social classes and dictated by different cultural assumptions, then, servants occupied a prominent place.

Historians have, of course, been drawing on many types of literary source material for generations. Literary scholars, in contrast, have only recently been turning away from drama and poetry to consider texts traditionally looked down upon as cultural

marginalia. 'Literature' is now coming to be reinterpreted in its broadest sense – as 'writing' or as one element in a set of discursive cultural practices. Thus Stephen Greenblatt, in his latest book on Shakespeare, looks less at 'the literary domain than at its borders, to try to track down what can only be glimpsed, as it were, at the margins of the text'. He is motivated by the will to gain 'insight into the half-hidden cultural transactions through which great works of art are empowered'.[2] This 'cultural poetics', as Greenblatt calls it, leads him to examine not only Shakespeare, but court depositions, contemporary accounts of Elizabethan voyages, travel journals, and anti-Catholic propaganda. Likewise, Stephen Mullaney, in his study of licence, play, and power in Elizabethan and Jacobean drama, asserts:

> Literature itself is conceived neither as a separate and separable aesthetic realm nor as a mere product of culture, but as one realm among many for the negotiation and production of social meaning, of historical subjects, and of the systems of power that at once enable and constrain those subjects.[3]

The methodological project of what has been called the 'New Historicism' by literary scholars of the English Renaissance underlines much of the thinking in this article as I find its objectives both welcome and provocative. Contemporary conduct books as well as Shakespearean drama cannot be considered in isolation as they are part of a more wide-ranging cultural discourse. In an attempt to map this terrain, I take on evidence from other disciplinary fields, employing historical materials to try to explain why these works were so plentifully produced and popularly consumed. If we confine ourselves to the treatises themselves, I argue, we fail adequately to assess their historical significance.

To understand and to situate our texts in an early modern context, it would be useful to give some details of the writers who produced them, of their authors. They were for the most part vicars or lecturers who held it their divinely appointed duty to reform a situation they saw as degenerate and corrupt. Robert Cleaver, author of *A godly form of householde gouernement* (1598), wrote sermons on how the Sabbath should properly be kept, while William Gouge, who produced the magisterial *Of domesticall duties* (1622), was a puritan preacher and a vicar of Blackfriars, and fell foul of Laud when he tried to buy up, with eleven others, impropriations to found a puritan ministry. William Whatley, who published a number of later works, was nicknamed the 'Roaring

Boy of Banbury' and appeared before the authorities for his controversial views on divorce.[4] The writers of conduct books were sometimes a fiery, boisterous lot, ever ready spiritedly to defend their principles and support their cause.

The ideas these pamphleteers disseminated, however, were not entirely original. The genre of the sixteenth- and seventeenth-century conduct book had its roots in much earlier traditions. One can find puritans, for instance, echoing in their writings on servants the advice of Scholastic philosophers such as Aquinas or Reformers such as Calvin.[5] It was mainly, though, the Christian humanists to whom treatise authors turned in search of guidance, justification, and authority. The theories of Aristotle and Erasmus were particularly influential and can help account for the puritan stress laid on marriage as companionship and the proper bringing up of children. From Sir Thomas Elyot and Juan Luis Vives, conduct writers derived recommendations for household religious teaching and for reason and sense to be used in the meting out of punishment.[6] This is not necessarily to argue that the texts we shall be discussing were no more than reiterations of long-established moral precepts; rather, they revitalized and reinterpreted those prescriptions in response to contemporary problems. Zealous protestants, to use Margo Todd's term, reinvented classical and biblical learning in an attempt to solve master–servant difficulties that were a particular product of their own historical moment.

First, I examine the master's duties, then those of the servant, and to determine the extent to which authors were responding in their injunctions to social questions, historical evidence which helps to set the 'ideal' against the 'reality', in so far as that can be ascertained, is cited.[7] Three final sections stress the generally unsympathetic view of the servant, show how writers tried to resolve the problems they addressed, and offer reasons why these moral and religious treatises were such bestsellers – Gouge's *Of domesticall duties* (1622), for example, was reprinted three times in ten years.[8] The period *c.*1580–*c.*1642 seems a particularly fruitful one to investigate as it was during these years that manuals of devotion, self-help, and domestic management were most widely read and were printed in their greatest numbers.

I

A commonplace of puritan writing was the equation of the master with God: the master was a priest in his own household and

invested with divine authority.[9] As such, he was expected to give religious instruction to his family, and some conduct books provided details of how the Sabbath was to be observed, recommending church attendance, daily prayers, catechizing, and private religious instruction.[10] Other writers went further, Josias Nichols in 1596 going so far as to suggest that the godly household would prevent dearth and plague, and Lewis Bayly stating in about 1612 that it would keep drunkards off the streets and reduce the number of murders committed![11] Puritans argued with conviction for the beneficial social influence of religious masters and servants, though their claims seem to have been prey to exaggeration and a certain amount of wish-fulfilment.

How far these injunctions were ever realized in practice is difficult to determine. Diaries written by the 'middling sort' contain only frustratingly brief references; thus the Essex minister, Ralph Josselin, seems to have tried to press religion on his servants but failed as he wrote plaintively in 1645: 'my maide went away. send mee one Lord that feareth thy name.'[12] For the gentry and aristocracy, the evidence is fuller. Samuel Fairclough's *The saints worthinesse* (1653), for instance, asserts that the enthusiasm of the servants of Sir Nathaniel Barnardiston, a Suffolk puritan, was such that they congregated to discuss the Sunday sermon in the buttery.[13] The reliability of these paeans to godliness, however, is questionable. Celebrations of puritan worthies written by puritans, often for a funeral or a public occasion, would have of necessity devoted space to the servants' involvement in the family's religious affairs. We should hesitate before accepting the accuracy of statements designed to comfort and flatter. There is little doubt that puritans attempted to instruct their servants, but it is less certain with what success their endeavours were rewarded.

At the same time conduct literature seemed implicitly to recognize that it was difficult for the master to instruct his servants in religion, especially given the fact that the young and lower orders appeared ignorant, irresponsible, and degenerate. A 1577 pamphlet contains a speech by Puer, a would-be apprentice; asked if the local minister adheres to the old faith, the baffled Puer can only say wearily: 'I cannot tell, hee sayeth one thing without his booke, and he sayeth another on his booke, but what it is, I doe not vnderstand.'[14] Later comments bear out the fear that servants knew little of the purpose of divine service, indeed, that they lived in a state of spiritual oblivion. In 1581, a writer protested against servants abusing the 'Saboth dayes' by 'gulling, gurmandizing and

bowsing, tippling and quaffing, dauncing and frisking, that . . . they prooue as giddie as Geese, and as wise as Woodcocks', while Gervase Babington attacked in 1583 servants who 'burst out in vngodly and disobedient speeches' when asked to accompany the master and mistress to church.[15] Contradictory impulses run beneath the surface of these works, for while puritans stressed the desirability of a godly household, they also acknowledged they were fighting a losing battle.

Religious observance, in short, was thought to be in a state of decline. Yet little or no attempt was made by writers to examine how this had come about; the decay provoked complaint, but it was not anatomized. Edward Topsell, author of *Times lamentation* (1599), enjoined church-goers not to thrust servants behind the doors as this, not surprisingly, had a detrimental effect on their understanding of the sermon, but he did not offer any other form of analysis.[16] Richard Bernard in a later work called on masters not to continue prayers for too long as the easily distracted servants would fall asleep.[17] Comments that tried to uncover causes, though, were rare; the authors of conduct books were either unable or unwilling to find a solution to a state of affairs they bewailed, even while it seemed to threaten the very foundations of society.

Abundant evidence exists to suggest that the protests voiced by divines were not unjustified. The indifference of servants to religion and their rare church attendance can be convincingly demonstrated. The York authorities were troubled in 1599 by servants who spent their time lying about or idling on the Sabbath, and also on the Sabbath in Coventry in 1605 a group of servants made themselves unpopular by playing football.[18] James Bankes, a Lancashire gentleman, gave up as a lost cause any attempt to instil a religious awareness in his servants, noting bitterly in 1610: 'the[y] car[e] not . . . so that the[y] have mett, drink and wagues. Small feare of God is in sarvantes'.[19] Even if lured to church by some means, servants could still be a nuisance, such as in Stratford-upon-Avon in 1622 when, during service, a fight involving some local serving-lads broke out.[20] If masters and mistresses neglected the Sabbath, their servants would probably have followed suit. Servants were the least likely members of a parish to attend church, despite the strenuous efforts of some local authorities to remedy the situation by punishing the offenders. The authors of conduct books, as a result, felt powerless to prevent what they saw as the inevitable collapse of household religious discipline.

Religious writers were more forthcoming on the subject of the master's treatment of his servant, and he was exhorted to show kindness, respect, and consideration. Almost all would have agreed with Babington who required masters not to work their servants on the Sabbath.[21] Servants should not be 'punished both in belly and backe' to maintain the pride of their employers, advised Thomas Carter in 1627, and Bernard in 1629 willed masters not to 'dogge [their servants] . . . day and night to their labour'.[22] Behind these warnings lurked social and economic considerations. An anxiety about the fragility of master and servant relations and the ease with which they might be damaged emerges. Conscious, it seems, of the possibility of the master tyrannizing over his servants, compelling them to leave his service and turn to vagrancy, writers approved a caring attitude that would promote mutual affection.

Scattered through diaries and wills are expressions of regard and displays of concern, though mostly from the employers, that suggest some masters and servants did come to share intimacy and attachment. When Lady Isabella Twysden's servant, Hugh ap Richards, died in 1651, she was sufficiently moved to note in her diary, 'an honest man he was and a true, and died a true servant of christs'.[23] Giles Moore, a Sussex rector, nabbed Thomas Dumberill, his servant, in bed with one of the maidservants in 1659; they were promptly dismissed from his service but by the following year he had forgiven them and generously bestowed 'Rabbets Pigs & Woodcocks' on their marriage.[24] These and similar instances testify to the fact that the wishes of moral and religious pamphleteers were often taken up and implemented. There appears to have been a certain amount of toleration on the masters' part of their servants' youthful indiscretions. If servants had been loyal and trustworthy, masters made arrangements for their future welfare. On occasions, they even extended their responsibilities beyond the term for which the servant had been hired.

Thus far we have seen that authors' recommendations were observed, that treatise writers had legitimate reasons for their grievances and that their suggestions were characterized by a combination of perspicacity and a liberal sprinkling of good sense. In other ways, however, conduct manuals were misleading in the claims they made, unrepresentative, and, in some areas, positively blinkered and obstructionist, treating matters of import with a notable lack of insight or intelligence. Wage disputes, for instance, were given attention by pamphleteers, but divines were most troubled by the theological objections to the master not paying his

servant a regular salary. A pre-Reformation work, therefore, stated that the master who defrauded his servant of wages was guilty of manslaughter which, during this period, was still equivalent to murder.[25] Thomas Becon thought that withholding payment was an act of theft, and later writers such as Robert Cleaver, William Gouge, and Carter condemned it as covetousness.[26] On this issue, puritans only saw as far as the sinfulness of the master's action; economic factors were less important than individual conscience.

Cases of servants being cheated or denied their wages are a recurrent feature of quarter sessions records, masters being summoned before magistrates for not reimbursing regularly or for trying to defraud their employees of salaries altogether. Unpaid servants, in rags and in debt, were reduced to desperate straits; Christopher Gould, a Somerset servant, having served his master, William Atwell, for five years, demanded his wages in 1631 and was immediately turned out of service.[27] Payment was not necessarily prompt even if a servant's petition was accepted by the authorities, and masters sometimes refused to appear when they received a summons, presumably in the hope that they would not be asked again.[28] None of these complications entered into discussions of finance in household guides. We find, instead, the parading of biblical commonplaces and moral indignation that had little bearing on real conditions; the advice given by conduct literature writers was unhelpful as it failed to take into account the destitution the servant faced when salary disputes arose.

If a servant fell ill, religious authors argued, the master was bound to take on the responsibility of arranging medical care that would lead to his dependant's recovery. Manuals of domestic instruction are rife with examples of the master's cruelty and indifference towards his sick servant and suggestions as to how he should be properly treated. Philip Stubbes, that most ferocious of puritan pamphleteers, lamented in *The anatomie of abuses* (1583) the instability of the servant's position: 'And if anye be sicke of the plague . . . or any other disease, their Maisters and Maistres are so impudent . . . as straight way, thei throw them out of their dores.'[29] Carter inveighed in 1627 against the master who placed his sick servant in a 'garden house' and held that it was a crime for the master not to attend on him personally.[30] In 1653, Thomas Hilder commiserated with the servant who was 'sent home' in illness or 'mued up in a hole'[31]. As he was morally obliged to treat his servant as a member of his family, the master was upbraided for begrudging him the privileges to which he was entitled.

A sense of outrage was not entirely misplaced. In times of plague, it may well have been the servant who would suffer, being thrown out onto the streets to fend for himself, and one can also come across instances of masters displaying a callous if not barbaric attitude to their employees when they experienced physical hurt.[32] But the bleakness of the picture should not be overemphasized. Diaries, for instance, show that, in many cases, servants were cared for, though possibly not in their masters' households.[33] (Good servants were, after all, valuable commodities and their labouring and domestic skills often highly prized.) A sampling of wills suggests that servants were nursed by a neighbour or local amateur physician whom the master had temporarily engaged. John King of Bedfordshire, servant to Lady Cheyne, gave six shillings in his will of 1598 to 'brinkloes wife w[hi]ch keapeth me in this my sicknesse . . . '[34] It is difficult to accept unreservedly the depiction of the servant's tenuous position and of his being dismissed on the flimsiest pretext. If taken ill, servants were not personally taken care of, as puritans would have liked, and there are some grounds for the statements about the master's indifference to his dependant's state of health. We should not lose sight, however, of the fact that other, more kindly disposed masters displayed solicitude and concern when their employees' lives were at stake.

A master was permitted to correct his servant if he thought that punishment was required and justified. The extent of his authority in this area was painstakingly examined. Masters were directed not to overstep the bounds of lawful correction, and to realize that gentle words were often preferable to physical castigation. Becon counselled masters in 1559–60: 'by no means like a mad man fall out with them, curse and lame them, cast dishes and pots at their heads, beate them, [or] put them in daunger of their life.'[35] Paul Baynes in the early 1640s was more categorical: 'this fixon-like [*sic*] rating, and huckster-like menacing of them on every occasion, is here forbidden'.[36] Punishment was severe by modern standards and 'stripes' accepted, even recommended. But conduct literature generally adopted a moderate approach; if feeling rather than reason dominated a master when he corrected his servant, writers feared, the relationship was certain to collapse.

Puritans invoked biblical precedent in order to encourage the master to recognize that his authority over the servant was not absolute. Ephesians was constantly cited in reminding masters that they, too, had a master in heaven.[37] Correction was an integral part of the master's power over his servant, but this power was

temporary and circumscribed. In exceptional circumstances, when servants proved incorrigible and beyond redemption, masters were allowed to expel them.[38] The admission that it was necessary to dismiss a servant who, when corrected, refused to be reformed, constituted an awareness of the master's limitations and weaknesses, of his potential for failure. It could not be assumed that the moral rectitude of masters would always be reflected in their servants' conduct.

Physical abuse of the servant by his master was frequent: this, at least, is the *impression* given by assize and quarter sessions records. Sarah Fenner, the maidservant of Mary Holbroke of Kent, lost the use of her left hand in 1572 when her mistress assaulted her with a firebrand, and in 1633 it was reported in Devon that

> Iohn Clapp of Otterie S[ai]nt Marie hath excessivelie beaten Henrye Bastyn his apprentice and broken his head in five seu[er]all places and tyed him to a tree by the thumbs and whipt him starke naked and suffereth him to be full of lice.[39]

The dividing line between correction and savagery was thin; servants could be maimed and made unfit for employment. If this occurred, the abused servant was usually cared for by the parish, and in their writing on the subject, divines may have had the economic repercussions of a master's brutality in mind. Retaliation was one of the means by which a servant resisted punishment, though the paucity of cases of this kind is curious. Where details are provided, quarter sessions suggest that servants only attacked their masters when provoked. Thus Robert Simons, a Kentish yeoman, was assaulted by his servant with part of a plough in 1654 when he ordered him to start work before breakfast.[40] Outside of the companies which had developed their own punitive methods, the common fate of servants found guilty of physical abuse was the house of correction. With the fate of the local bridewell hanging over them, it seems more than likely that servants decided to submit to correction rather than offer resistance.

Appalled by the severe treatment inflicted on servants, religious writers attempted to search out reasons for the incidence of physical violence. They offered a variety of explanations which unwittingly reveal the preconceived attitudes of the 'middling sort' towards their social inferiors. A number of writers thought that the master was to blame if a disagreement arose. The author of *A glasse for housholders* (1542), for example, instructed masters not to provoke their servants.[41] But most authors accused the servant of being the

guilty party. In 1615 Edward Elton was horrified by the servant who took 'the staffe by the end' to 'resist' punishment, while William Whately's explanation in 1640, reflecting a hardening of attitude, was particularly unsympathetic: 'All you that be servants, if you finde your Governours sharp and rigorous, consider with your selves, whether your irreverent and disobedient behaviour have not provoked them against you, and exposed you to this affliction.'[42] Authors may also have attempted to pinpoint the reasons for master and servant altercations and to resolve the antagonism themselves because of the leniency (or laziness) of contemporary justices who did not, it seems, pause to ask why breakdown had occurred or to consider the possibility of its being repeated: the insubordinate and wayward servant was not infrequently sent back to his employer after having done no more than apologize for his conduct.[43]

The writers of conduct manuals, in their treatment of the master's responsibilities, revealed their hopes and ideals but also their narrow-mindedness and prejudices. They referred only in passing to the difficulties the servant experienced if oppressed and victimized, while the part played by the master in cases of domestic violence was barely mentioned. Armed with a set of expectations about the lower orders, divines were alive to the possibility of conflict but could offer no viable alternative to the problems they highlighted.

II

As for the servants' duties, Ephesians was quoted with a tedious regularity by puritan divines. The key passage (VI, 5–8) exhorted servants to be faithful and obedient, and to recognize that serving well was a commendable virtue. Jacob and Joseph were repeatedly extolled as examples for other servants to imitate. Some writers thought these examples too inaccessible and chose to make their points without reference to biblical precedent. Cleaver stated in 1598 that the servant should be dutiful so as to avoid dismissal, and Carter advised in 1627 that servants should work hard so as not to be beaten.[44] Idleness in a servant was expressly forbidden and was associated with poverty and vagrancy.[45] It was antithetical to quickness and diligence in the performance of duty, signs of a servant's love for his master, of their closeness and affection.

Whether or not the servant was dutiful and did grow fond of his master is a subject on which we might wish only to speculate. Written accounts by servants of their relationships with their

employers are rare. There are, however, ballads or references to ballads in which servants lament their masters' deaths or regretfully bid farewell.[46] Testimonies from servants, too, suggest that some lasting ties developed and that conduct writers were not unrealistic in their recommendations: John Webb, who died in 1642, a servant with the Hawtyns of Calthorpe, Oxfordshire, was recorded as saying that he loved Anne, the youngest daughter of the family, more than any person alive.[47]

But it was widely held by conduct literature writers that servants would not prove dutiful as they were, by nature, dissatisfied and restless. Implicit in Becon's prescription in 1559–60 that the servant should be happy in his vocation was the assumption that he was discontented with his lot.[48] In 1592 Babington thought that if the servant was 'flitting euery day and changing', he would end up as a vagabond, and Carter echoed the disapproval in 1627, finding fault with servants who 'seeke to free themselues from the estate of seruitude when they are therein, to the end they may be Masters and gouenors themselues', and who run away when punished for the first time.[49] Divines were conscious of the masterless hordes so feared by contemporaries when they issued their threatening injunctions. Although they argued that if he stayed put he would prosper, they also harboured doubts about the servant's stability and the extent of his commitment.

The findings of recent social historians have demonstrated that servants did belong to a group that was primarily young and mobile; servants and apprentices departed before their terms were over or ran away and the relationships they entered must have been casual and uncertain as they did not put down roots and moved on at short, regular intervals.[50] Explanations for this mobility are what concern us here, though, particularly as far as regards domestic instruction manuals. One obvious reason was travelling in search of a better position and for reasons of social advancement, yet this should not blind us to cases of servants leaving because of harassment and criminal neglect – escaping from ill-treatment looms large in their examinations and depositions.[51] Prunell Cowley, a Southampton maidservant, took off in 1590 to avoid the lascivious attentions of her master.[52] When William Woodward, a Staffordshire gentleman, discovered one of his maidservants was pregnant by him in 1593, he asked his servant, John Hall, to admit to being the father. Hall refused and was at once dismissed.[53] A Kent apprentice in 1603 preferred the open road to his master's attempts to starve him to death.[54] Through no wish of their own,

many servants were forced to move on and to look for another place. Conduct literature writers, however, did not take such factors into account. Their theorizing was rudimentary and inadequate in that the servant was held responsible if he became a vagrant, and the master's role in this coming about barely acknowledged.

The servant in moral and religious treatises, then, was allowed few opportunities to make personal decisions or to exercise freedom of choice, and was also required to submit to correction, even when unjustly punished.[55] Only in one area was the servant permitted to trust and act upon his own judgement. God was to be obeyed in the event of a master proving ungodly, authors such as Robert Allen and Gouge maintained.[56] Conveniently, they did not consider when and on what grounds the ungodly master was to be resisted; this, and the complicated theological issues, were left to the individual servant's discretion.

Well may puritans have comforted the harshly treated servant that he would ultimately be rewarded and his wrongs redressed! It cannot have been very reassuring for a distressed servant to be told that his grievances could only be heard at judgment.[57] At the same time as some writers were praising the virtues of absolute subjection, others were admitting that servants should be allowed to resist unfair correction and seek legal remedies in the event of their wages not being promptly paid. Thomas Fosset, a preacher with puritan tendencies, stated in 1613 that the servant defrauded of wages could enlist the assistance of a justice. He immediately qualified his advice, however, by saying that even if the master were called before the authorities, the servant would probably never recover what was owing to him.[58] In 1659 Samuel Cradock contended that 'If ... *Masters* should *command* any thing ... *imprudent*', servants should '*humbly* offer their reasons to the contrary.'[59] A reaction took place to the severe and unaccommodating view of the labouring classes. Later divines granted the servant a greater measure of freedom and autonomy, and this was reflected in a growing awareness of his status as an individual.

Religious writers may have discouraged servants from appealing to justices because of the fact that in rural areas, at least, the 'lower sort' were legally powerless. When apprentices were mistreated, mothers, fathers, and relatives petitioned, rarely the apprentices themselves.[60] A Somerset woman was rightly indignant in 1615 when George Sibley, her son and an apprentice, was 'used' by his master 'more like a dogge or a Galli slave, then a Christian or one that beareth the image of a man.'[61] Between 1656 and 1659,

William Thomson, a puritan justice in Cumberland, kept a detailed record of his official activities. It shows that out of ten warrants for arrest issued to masters and servants during this period, eight were granted to masters and only two to servants; the balance of power was in favour of the employer and the servant had few chances to prosecute.[62] Puritans possibly recommended the acceptance of injustice as they could not conceive of an alternative. For the small number of extant petitions testifies to servants' unfamiliarity and disillusionment with legal procedure; they were deterred from defending themselves by contemporary judicial bias and inequality. In household guides, therefore, when resistance was proposed, it was only to be as a final, desperate resort.

A further requirement of servants was that they should not filch and steal, that they should respect their masters' goods and property. If pamphleteers stressed the need for morality and responsibility, though, they were also convinced that servants were by nature 'pickers.' A nobleman's servant entrusted with money would spend the lot in 'pompe, pride, and superfluitie' and neglect his master's affairs, thundered Leonard Wright in 1589.[63] Patrick Hannay urged the housewife to supervise her maidservants at all times, lest their extravagance with money plunge the household into economic difficulties.[64] Great importance was attached to honesty and reliability in servants, therefore, and if they possessed these qualities they were highly esteemed.

The most likely members of a household to thieve may well have been servants, and the items that attracted them fall into a number of broad categories. They took small articles such as silver spoons that could easily be hidden and afterwards sold for profit.[65] Cloth was also pilfered, either to make new clothes or, again, to sell.[66] Apprentices and journeymen embezzled money from their masters; Nehemiah Wallington, a puritan artisan in early seventeenth-century London, was defrauded of £100 by his journeyman.[67] There may, after all, have been grounds for unease and a fear of financial ruin.

Little wonder, therefore, that puritan divines doubted servants would keep the secrets with which they were entrusted. Francis Dillingham described servants in 1609 as 'running vessels that can keepe nothing', and in their choice of servants, masters were thus directed to be circumspect.[68] To reduce the possibility of servants pilfering, writers advised masters to give them generous going-away presents.[69] Only in part was this a reward for faithful service. Writers believed it was necessary for a master to be able to place

trust in his servant, though they held out little hope he would prove dependable; they were innately suspicious of the light-fingered servant who, once installed in his master's household, could bring the family to the brink of economic disaster.

The emphasis on trust in conduct books is understandable. Living in close proximity with their masters and mistresses and in considerable domestic intimacy, servants knew or discovered where the valuables of the house were kept. Agnes Fiven, a Dorchester servant, was courted in 1615 by Thomas Norman, a local labourer, when her master and mistress were away from home. In one of the bedrooms Norman tried to persuade her to tell him where her master's money was concealed:

> And asked her what money her M[aste]r had, shee answering shee knew not hee said hee would warrant hee had a 100^li, shee said noe sure, hee had not soe much ... And then hee said vnto her this other coffer at the beddes feete, is that wherein yo[ur] M[aste]r puttes his money and shee said Yes, then hee ... bad her not to tell her M[aste]r that hee had ben there for then hee would bee angry ...

The following day a broken coffer was found in the garden, its contents rifled. Norman was apprehended soon afterwards.[70] When they left their masters' employ, it was also common for servants to steal. Christopher Scott, a servant with adventurous and romantic leanings, made away with a sword and three books when he quit the service of a Wakefield merchant in 1657.[71] The chances of arrest and detection were fewer when servants moved on, and they took advantage of the situation by helping themselves to goods they had previously coveted.

Underlying discussions of the servant's duties – the need for constant care and a sceptical attitude towards an employee's steadfastness and integrity – was the assumption that servants had to be governed. The widely-held belief that they would imitate the behaviour of those around them prompted divines to exhort masters to be sober and godly.[72] Above all, servants were to be regarded as children.[73] Religious authors often associated the servant with the child, at least in the later sixteenth century; he was to be seen as impressionable, easily led, and, most importantly, as a member of his master's household and family.

The view of the servant as child gradually changed and eventually dropped out of the repertoire of stock opinions voiced in conduct books. To Richard Brathwait in 1630, the servant was a 'precious

jewell', but not a child, and William Ames wrote in 1639 that 'Servitude is much different from the state of a child.'[74] A loosening of the bonds was taking place and a greater distance between the master and the servant being argued for: the servant was coming to be recognized as a person in his own right.

The precise age at which one may have become a servant during this period has not been firmly established. Servants as young as ten and eleven years appear in assize and quarter sessions records, though there is always the possibility they were pauper apprentices.[75] We have been warned by historical sociologists to reject the notion of the early modern family as a large and extended unit with domestic tasks undertaken by relatives. Examples of kin being employed as servants, however, are not uncommon. William Tyndall, a Bristol merchant, asked in his will of 1558 for his daughters to be put 'to s[er]vice in the howse, and to vse their nedilles'.[76] Thomas White, an Oxfordshire servant, gave in his will of 1615 the majority of his goods to his cousin and master.[77] An intricate network of kinship and neighbourliness facilitated the employment and mobility of servants; the puritan ideal of the family, in which younger members were treated and loved as children or relatives, may have had a historical basis other than second-hand commonplaces and undiscriminating readings of biblical texts.

One can, therefore, in recommendations for servant behaviour, locate a number of parallels between the instructions given in conduct books and historical evidence. Anxieties about theft and an implied criticism of the legal system (one of the changes that overtook moral and religious treatises) may be situated quite precisely in surviving documentary evidence. Yet, at the same time, some of the assumptions, untested by experience, that are articulated, go against the sympathy and reason expressed elsewhere. Little sensitivity can be found in the account of servants' social mobility, and the descriptions of the supposed lazy and indifferent character of servants do not stand up to rigorous historical scrutiny. When it came to talking about the sexuality of servants, moreover, divines were at their most stubborn and short-sighted. The servant, it was thought, would almost certainly commit sexual misdemeanours and, governed by a licentious temperament, would lead the other members of the household into corruption and depravity. The Catholic Robert Southwell said of servants in a work published in about 1597 but written some years previously:

I must take special heed of any secret meetings, messages, or more than ordinary liking between the men and the women of my family. I must see that the men have no haunt of women to their chambers, lest lewdness be cloaked under some other pretense.[78]

This view anticipated that of Cleaver who urged the mistress to watch out for servants' 'tickings and toylings . . . least . . . there follow wantonnesse' in 1598.[79] In 1622 Gouge accused servants of defiling each other and claimed they would 'draw' their masters' children to similar kinds of 'folly' for personal gain.[80] Only very occasionally did the master come in for criticism, such as in Daniel Rogers' *Matrimoniall honovr* (1642) which condemned, in highly ambiguous terms, those employers who 'seek to other younger ones, and defile them . . . polluting themselves with their servants'.[81] Divines wrote easily about the importance of the wife's fidelity, and did not hesitate to describe the underworld of professional whores waiting to pounce on the neglectful, backsliding husband. They were less sure about how to approach the subject of sex between master and servant; they shied away from the delicate social questions, and most authors avoided considering the possibility of an illicit union altogether. Sustained attacks, however, were directed at servants; they revelled in immediate sexual gratification, the argument ran, and tempted others to lewd conduct for purposes of future self-advancement.

An examination of bastardy cases regularly reveals the culpability of servants living in the same household. In 1583, Richard Wright, an Oxfordshire vicar, expelled John Gibbs and Margaret Mecock, his servants, because they had 'plaide the naughtie packes together in [his] . . . howse'.[82] But masters and their sons were also named as fathers; indeed, some recent research has suggested that maidservants were more likely to be impregnated by their employers than by fellow servants.[83] Agnes Bungie, a Hampshire maidservant, was deflowered by her mistress' son in 1614; when she told him she was carrying his child, he callously refused to have anything further to do with her, 'sayinge he had done her no hurt'.[84] A worse fate was in store for Lydia Prynne, a Sussex maidservant, in 1655; she succumbed to the advances of Francis Haddon, her master, but refused to name a fellow servant as the father on becoming pregnant. She finally confessed the truth after Haddon had threatened 'hee would teare her in peices' if she did not do as he commanded, and violently inserted his hands up her vagina,

'hauing oyled them for that purpose', in an attempt to abort the child.[85] Desperate pregnant maidservants, the playthings of their masters and on the receiving end of magisterial oppression, committed infanticide or, dismissed and impoverished, turned to vagrancy.[86] One searches without very much success for evidence that convincingly demonstrates that servants were sexually corrupt and manipulative. Conduct guides invariably assumed that servants were prey to sexual irregularity, but not masters. Unilluminating and impercipient, religious writers ignored the fact that some masters exploited their servants and turned a blind eye to the misery and want the victims consequently experienced.

III

A wide range of criticisms was levelled at servants in moral and religious treatises, therefore, and the opinions they expressed were generally wrong-headed and hostile. Some puritans may have agreed with Joseph Hall, who argued in 1609 that it was necessary to correct servants physically because they refused to understand verbal chastisement.[87] Whately suggested in 1619 that inherent laziness prevented the servant from being quick and efficient in the performance of duty. His imaginary dialogue ran: 'Sirra, bring mee hither, or beare forth such a thing (saith the Master). Sir, I cannot (answeres the seruant). Why so (saith he againe)? It will make my shoulders ake, & put me to paines and sweate (replies the other).'[88] Baynes summed up the climate of opinion when he commented in the early 1640s: 'service is . . . a miserable condition, which entreth through sinne.'[89] Servants, then, were relegated to a sort of sub-species. Writers thought they had difficulty in understanding human discourse, and that they had little hope of salvation because unregenerate by nature. Their brutish character made them unfit for decent employment. It is remarkable that the authors of conduct literature expended so much effort in attempting to bring about the servant's reformation.

The preconceived attitudes that are revealed in domestic instruction manuals also characterize discussions of servants in memoirs, diaries, and correspondence of the 'middling sort' and gentry. There are similar suspicions and fears, contradictions, and inconsistencies. Ralph Taylor, the chief servant of Anne Fitzwilliam, a Northamptonshire gentlewoman, wrote to his mistress in 1598 saying that he had found a virtuous young woman who was willing to wait on her. Anne replied incredulously (as did many puritan

authors who constantly lamented that the golden age of good servants had long passed), saying that if the 'mayde' did live up to the glowing description of her, she would be most grateful to Taylor, 'for such servauntes are now a dayes hard to fynde'.[90] Other masters and mistresses were afraid of their servants; Henry Ferrers, a peevish Warwickshire gentleman, developed a persecution complex, and was convinced his servants deliberately annoyed him by lacing his food with strong-tasting herbs. He wrote in his diary in 1622 that he told Thomas Lawrence not to 'put in dill into the cowcumbers'; tasting his food, he was still suspicious, went into the cellar, found dill in one of the barrels of preserves and concluded his servant 'was a knave to abuse me with a thing that I so abhor'.[91] Margaret Cavendish, the Duchess of Newcastle, wrote in 1656 that during her childhood she had been told not to spend too much time with the servants; her mother, she remembered, never permitted 'the vulgar serving-men to be in the nursery among the nurse-maids, lest their rude love-making might do unseemly actions . . . knowing that youth is apt to take infection by ill examples'.[92] Contemporaries saw servants simultaneously as innocent and worldly-wise, child-like and depraved. Servants were to be treated as members of the family, but fraternizing with them was disallowed. Dutiful and godly servants were constantly written about, despite a general conviction there was none to be found. These views created contradictions which conduct guides inherited and did little to resolve.

IV

Did religious writers try to find answers to master and servant problems? What solutions did they offer? How did they think the regeneration of the servant would occur? A number of authors maintained that undutiful servants could be accounted for by the decay of religious observance.[93] Most other divines contributed different and sometimes more realistic explanations. *A glasse for housholders* (1542) suggested that servants became 'lumpyshe, luskyshe, drowsye and slouthfull' if not adequately fed.[94] Pamphlets written in the 1620s argued that numerous children and a quarrelling master and mistress contributed to servants' disobedience and negligence.[95] The list, and the variety of explanations, could easily be extended. Few specifically religious measures were proposed, however, and this is of interest as most of these guides were the work of divines. It is an index of the gravity of the problem

and the desperation of contemporary writers that they turned to secular reasons to explain why servants provoked such widespread complaint.

V

I turn now to a discussion of the popularity of moral and religious treatises: how, for instance, can we relate the cultural production of these works to their being so voraciously consumed? A perhaps obvious point needs underlining at the outset: this was a period in which, since the introduction of the printing press in the late fifteenth century, there was 'a growing demand for the printed word'.[96] One historian has calculated that between 1576 and 1640, about 200 titles were printed each year, making a grand total of some 300,000 volumes.[97] Many of these publications concerned themselves with education and religion, a sign of the spread of grammar school education and rising levels of literacy. Literacy standards were certainly improving: in the mid-sixteenth century, perhaps 20 per cent of men and 5 per cent of women could sign their names, but by the mid-seventeenth century, this had increased to 30 per cent of men and 10 per cent of women.[98] A typical scenario may well have been that the newly literate artisan or tradesman, proud of his learning, would rush to his local bookseller, snap up the latest copy of Gouge and hurry home to read the relevant portions to his assembled servants.

In addition, as Kathleen M. Davies observes, because of the changes brought about by the Reformation, according to an Act of 1549, priests were allowed to marry.[99] There were escalating numbers of recently espoused clergymen in our period, unfamiliar with the management of a household and in desperate need of instruction which would ease the process of adjustment to a new family lifestyle.

Any interpretation of this period is dogged by the theory of the 'rise of the middle class'. This is a question which must vex historians of other periods, too, for it sometimes appears that there was no time when the 'middle classes' were not rising. However, it seems clear for the early modern period that there did exist more prosperous middling groups enjoying an increased prominence: this was a society which, because of developments in mercantilism, domestic manufacture, industry, and foreign trade, was becoming more commercially based and oriented towards consumerism. In other words, the householders who made up the members of these

expanding professional classes had not previously been able to take on servants: they turned in their imitation of aristocratic habits to conduct guides to acquaint themselves with their new status as employers.

Economic factors were also important as conduct literature promised prosperity to the hard-working artisan, tradesman, or shopkeeper. As Babington wrote in 1592, the 'mayster prospereth by his faithfull' servant.[100] Historians in recent years have been less willing to argue that the puritan work ethic was a formative influence on the development of a more capitalistic ideology. No conduct book guaranteed riches, but the accumulation of wealth for the benefit of the commonwealth was allowed if not encouraged. This could only be accomplished if the master and servant relationship was stable and harmonious – a good servant was a wise investment.

Moral and religious treatises also appealed to contemporaries because they presented the family as a stable organization, with husbands and wives enjoying conjugal bliss for many years, children remaining with their parents, and servants working diligently for long periods of time. The early modern family in England, however, was essentially fragile: older members died, children were orphaned, the structure of households changed, servants moved on, and widows and widowers remarried. Plague threatened to wipe out many households altogether.[101] The fictions that conduct books disseminated – myths of domestic harmony and ideals of service – struck a common chord of feeling and earned them a wide audience.

A final consideration: domestic service was probably the largest single occupation for unmarried men and women in the early modern period and beyond. The institution mainly attracted young people who made up a particularly high proportion of the population. In the late sixteenth century over half of the population was aged less then twenty years; by the end of the seventeenth century this figure had dropped to 40 per cent.[102] Up to 1640, however, service was in expansion rather than decline, contrary to the claims of the preachers. Conduct literature, in short, addressed a question that must have been on every adult householder's mind – how was adolescence to be disciplined in a primarily youthful society?

VI

To return to one of our opening propositions, how helpful is it to attempt to implement in a reading of household instruction guides the theory that literature and history are closely related and can be

profitably combined? This paper has tried to show that our
understanding of these works is predicated upon an awareness of
their historical context; despite the fact that divines upheld ideals,
for example, they were still alive to social and economic concerns.
They discouraged social mobility as they believed it would end in
poverty and vagrancy. It may also have been that they called on
apprentices to complete their terms to prevent them setting up for
themselves, away from guild control and ignoring company restric-
tions. This would have found favour with merchants and craftsmen
worried about the possibility of economic rivals — obedient ser-
vants reflected well on their masters, flattered their self-esteem and
sense of authority.

The master and servant relationship may not have been so
unstable as has been argued here, although the literature suggests
that breakdown was ever imminent and for confirmation one has
only to refer to the anguished cries of masters calling for solutions
recorded in conduct books.[103] Recent research on this period has
pointed to the high proportion of servants who committed suicide,
and one is tempted to argue that there were deep-seated tensions
and grave difficulties.[104] Domestic instruction manuals, although
aware of the existence of abuses, could not rectify them. Writers
considered only the extremes, ignored complexities, and generally
did not attempt to look for causes. In blaming the servant and
privileging the master's rights, divines may have done more to
encourage conflict than to prevent it. As their essential loyalties lay
with the employing class, they were constantly contradicting
themselves and becoming entangled in unsupportable arguments.
Servants were independent individuals and anonymous, sinful
creatures at the same time, children who combined corrupt
experience with the simplicity of innocence. They had legal
privileges but were expected to live in total subjection. These
incompatibilities (which ran across religious disciplines and were
articulated with a remarkable degree of consistency) should not
strike us as surprising. Clerics and preachers who accepted the bible
as divine truth wrote conduct books, not philosophers or econo-
mists. The extent to which moral and religious treatises were a
response to master and servant problems can only be accurately
measured when we know much more about how and why young
people entered service in early modern England. But that is another
territory and is still waiting to be fully explored.[105]

Notes

1 I have used the (incomplete) lists in D.M. Doriani, 'The godly household in puritan theology, 1560–1640', unpublished PhD thesis, Westminster Theological Seminary, 1986, pp. 479–92; R.L. Greaves, *Society and Religion in Elizabethan England*, Minneapolis: University of Minnesota Press, 1981, pp. 314–25; C. Hill, *Society and Puritanism in Pre-Revolutionary England*, London: Secker & Warburg, 1964, pp. 443–81; C.L. Powell, *English Domestic Relations 1487–1653*, New York: Columbia University Press, 1917, pp. 243–56; L.L. Schücking, *The Puritan Family*, tr. B. Battershaw, London: Routledge & Kegan Paul, 1969, pp. 185–91.

2 S. Greenblatt, *Shakespearean Negotiations: The Circulation of Social Energy in Renaissance England*, Oxford: Clarendon Press, 1988, p. 4.

3 S. Mullaney, *The Place of the Stage: License, Play, and Power in Renaissance England*, Chicago and London: University of Chicago Press, 1988, p. x.

4 K. Davies, 'Continuity and change in literary advice on marriage', in R.B. Outhwaite (ed.) *Marriage and Society: Studies in the Social History of Marriage*, London: Europa Publications, 1981, p. 80.

5 Doriani, 'The godly household', pp. 440, 471.

6 M. Todd, *Christian Humanism and the Puritan Social Order*, Cambridge: Cambridge University Press, 1987, pp. 96–117.

7 I realize I am here entering the terrain of recent literary theory and, in particular, the 'deconstructionist' notion that 'reality' is ultimately irrecoverable, that 'reality' itself and the materials we use in our attempts to recover it (court records, diaries, wills, etc.) are themselves 'fictions', as is literature. This essay contends that the historical moment can be reconstructed, if never completely. The position of the servant in early modern England can be quite fully documented, despite the occasional unreliability and fragmentary nature of the sources.

8 Davies, 'Continuity and change', p. 80.

9 W. Gouge, *Of Domesticall Duties*, London: J. Haviland, 1622, p. 591.

10 T. Becon, *A New Catechisme* (1559–60), in T. Becon, *The Worckes*, 3 vols, London: J. Day, 1560–4, I, fo. cccccxxviv; R. Cleaver, *A*

Godly Form of Householde Gouernement, London: T. Creede, 1598, pp. 30–8.

11 L. Bayly, *The Practise of Piety*, 3rd edn., London [T. Snodham], 1613, p. 434; J. Nichols, *An Order of Household Instruction*, London: Orwin, 1596, sig. B2ʳ.

12 A. Macfarlane (ed.) *The Diary of Ralph Josselin 1616–1683*, London: Oxford University Press, 1976, p. 47.

13 S. Fairclough, *The Saints Worthinesse*, London, R.D., 1653, p. 17. For illuminating details of the servants' part in 1600–1 in the family services of Lady Margaret Hoby, see P[ublic] R[ecords] O[ffice], STAC 5/H16/12, STAC 5/H22/21, STAC 5/H50/4.

14 J. Fit John, *A Diamonde most Precious*, London: H. Jackson, 1577, sig. Ciiʳ.

15 B. Battus, *The Christian Mans Closet*, tr. W. Lowth, London: T. Dawson, 1581, fo. 36ʳ; G. Babington, *A Very Fruitfull Exposition of the Commaundements by Way of Questions and Answeres*, London: H. Midleton, 1583, p. 200.

16 E. Topsell, *Times Lamentation*, London: E. Bollifant, 1599, p. 302.

17 R. Bernard, *Josuahs Resolution for the Well Ordering of his Household*, London: J. Leggat, 1629, pp. 24–5.

18 D.M. Palliser, *Tudor York*, Oxford: Oxford University Press, 1979, p. 259; C. Phythian-Adams, *Desolation of a City: Coventry and the Urban Crisis of the Late Middle Ages*, Cambridge: Cambridge University Press, 1979, p. 230.

19 J. Bankes and E. Kerridge (eds), *The Early Records of the Bankes Family at Winstanley*, Chetham Society, 3rd ser., 21, 1973, p. 37.

20 Kent A[rchives] O[ffice], U269 Q24, p. 7.

21 Babington, *A Very Fruitfull Exposition*, pp. 177–8.

22 T. Carter, *Carters Christian Common Wealth; or, Domesticall Dutyes Deciphered*, London: T. Purfoot, 1627, p. 212; Bernard, *Josuahs Resolution*, p. 25.

23 B[ritish] L[ibrary], Additional MS. 34172, fo. 14ʳ.

24 R. Bird (ed.) *The Journal of Giles Moore*, Sussex Record Society, 68, 1971, pp. 70, 172, 349.

25 H. Parker, *Diues and Pauper*, 3rd edn, London: T. Bertheleti, 1536, fo. 172ᵛ.

26 Becon, *A New Catechisme*, fo. ccclixᵛ; Cleaver, *A Godly Form*, p. 371; Gouge, *Of Domesticall Duties*, pp. 685–6; Carter, *Christian Common Wealth*, p. 227.

27 Somerset R[ecords] O[ffice], Q/SR 65/77ᵛ. Cf. also PRO, Req. 2/6/174.

28 D.E.H. James (ed.) *Norfolk Quarter Sessions Order Book 1650–1657*, Norfolk Record Society, 26, 1955, p. 77; D.L. Powell and H. Jenkinson (eds) *Surrey Quarter Sessions Records Order Book and Sessions Rolls 1661–63*, Surrey Record Society, 14 March 1935, p. 161.

29 P. Stubbes, *The Anatomie of Abuses*, London [J. Kingston], 1583, sig. Evᵛ.

30 Carter, *Christian Common Wealth*, pp. 215–16.
31 T. H[ilder], *Conjugall counsell*, London: J. Stafford, 1653, p. 156.
32 F.R. Brooks, 'Supplementary Stiffkey Papers (1578–1620)', in *Camden Miscellany*, Camden Society, 3rd ser., 52, 1936, p. 19; P. Slack, *The Impact of Plague in Tudor and Stuart England*, London: Routledge & Kegan Paul, 1985, p. 288. See also the interesting case of the broken-legged, abandoned servant in Hertfordshire R[ecords] O[ffice], HAT/SR 28/232.
33 Macfarlane (ed.) *The Diary of Ralph Josselin*, p. 39; E.M. Symonds, 'The Diary of John Greene (1635–57)', *English Historical Review*, 1929, vol. 44, no. 173, p. 108.
34 Bedfordshire Records Office, APB/W/1598/134. See also Suffolk Records Office, Bury St Edmunds Branch, IC 500/1/86 (172).
35 Becon, *A New Catechisme*, fo. cccccxxviiv.
36 P. Baynes, *An Entire Commentary vpon the vvhole Epistle of the Apostle Pavl to the Ephesians*, 2nd edn, London: M. Flesher, 1647, p. 708.
37 Cleaver, *A Godly Form*, p. 371; Gouge, *Of Domesticall Duties,* p. 690.
38 N. Breton, *The Mother's Blessing* (1602), in N. Breton, *The Works*, (ed.) A.B. Grosart, 2 vols, Edinburgh: Chertsey Worthies' Library, 1879, I, p. 9; J. Jackson, *A Taste of the Truth*, London, A.M., 1648, p. 71. Quotations from Jackson come from the added *Directions*.
39 J.S. Cockburn (ed.) *Calendar of Assize Records: Kent Indictments Elizabeth I*, London: HMSO, 1979; Devon Records Office, QS 1/7/3.
40 Kent AO, Q/SB 5/21.
41 *A Glasse for Housholders*, London: R. Graftoni, 1542, sig. eiiir.
42 E. Elton, *An Exposition of the Epistle to the Colossians*, London: E. Griffin, 1615, p. 1148; W. Whately, *Prototypes*, London: G. M[iller, R. Hearne, at Eliot's Court Press], 1640, p. 152.
43 L. Fox (ed.) 'Diary of Robert Beake, Mayor of Coventry, 1655–56', in R. Bearman (ed.) *Miscellany I*, Dugdale Society, 31, 1977, p. 123. See also East Sussex R[ecords] O[ffice], QO/EW 1, fos. 14v, 19r; Essex R[ecords] O[ffice], Q/SR 8/1; Suffolk R[ecords] O[ffice], Ipswich Branch, B105/2/1, fos 46r, 49v.
44 Cleaver, *A Godly Forme*, p. 87; Carter, *Christian Common Wealth*, p. 242.
45 A. Dent, *The Plaine Mans Path-way to Heaven*, London [T. Creede], 1601, p. 192.
46 W. Chappell (ed.) *The Crown Garland of Golden Roses, Part II*, Percy Society, 15, 1845, pp. 1–6; H.E. Rollins (ed.) *An Analytical Index to the Ballad-Entries (1557–1709) in the Registers of the Company of Stationers of London*, Chapel Hill, N.C.: University of North Carolina Press, 1924, pp. 193, 216.
47 J.S.W. Gibson, 'A disputed inheritance', *Cake and Cockhorse*, 1976, vol. 6. no. 5, p. 83.
48 Becon, *A New Catechisme*, fo. cccccxxixr.
49 G. Babington, *Certaine Plaine, Briefe, and Comfortable Notes vpon*

euerie Chapter of Genesis, London [A. Jeffes and P. Short], 1592, fos. 86ᵛ, 126ᵛ; Carter, *Christian Common Wealth*, pp. 205, 252.

50 C.W. Chalklin, *Seventeenth-Century Kent: A Social and Economic History*, London: Longmans, 1965, p. 248; P. Laslett and J. Harrison, 'Clayworth and Cogenhoe', in H.E. Bell and R.L. Ollard (eds) *Historical Essays 1660–1750: Presented to David Ogg*, London: Adam & Charles Black, 1963, pp. 157–84. See also Essex RO, Q/SR 24/11; Somerset RO, Q/SR 56/22.

51 Greater London Records Office, MJ/SR 508a/106; PRO Req. 2/95/54.

52 Southampton R[ecords] O[ffice], SC 9/3/8, fo. 2ᵛ.

53 Staffordshire Records Office, Q/SR 42/9ʳ.

54 Kent AO, Q/SR 4, m. 5, 2.

55 Becon, *A New Catechisme*, fo. ccccccxxviiiᵛ; Gouge, *Of Domesticall Duties*, p. 607.

56 R. Allen, *A Treasurie of Catechisme, or Christian Instruction,* London: R. Field, 1600, p. 130; Gouge, *Of Domesticall Duties*, p. 638.

57 G. Babington, *Comfortable Notes upon the Bookes of Exodus and Leviticus*, London [H. Lownes and T. Purfoot], 1604, p. 171; Gouge, *Of Domesticall Duties*, p. 626.

58 T. Fosset, *The Servants Dutie*, London, G. Eld, 1613, pp. 49–50.

59 S. Cradock, *Knowledge & Practice*, London: J. Hayes, 1659, p. 422. See also Elton, *An Exposition*, p. 1193; M. Griffith, *Bethel: or a Forme for Families*, London: R. Badger, 1633, p. 384.

60 B.H. Cunnington (ed.) *Records of the County of Wilts*, Devizes: George Simpson, 1932, p. 193. See also PRO, Req. 2/46/12; Somerset RO, Q/SR 91/46.

61 Somerset RO, Q/SR 22/104.

62 P.H. Fox (ed.) 'The Note Book of William Thomson of Thornflatt, Justice of the Peace for Cumberland during the Commonweath', *Transactions of the Cumberland and Westmorland Antiquarian and Archaeological Society*, 14, 1914, pp. 158–95.

63 L. Wright, *A Summons for Sleepers,* London: J. Wolfe, 1589, p. 7.

64 P. Hannay, *A Happy Husband or, Directions for a Maide to Choose her Mate,* London (J. Beale), 1619, sig. C4ʳ.

65 B.H. Cunnington (ed.) *Some Annals of the Borough of Devizes,* 2 vols, Devizes: George Simpson, 1925–6, I, p. 83. See also Somerset RO, Q/SR 98/135.

66 Southampton RO, SC 9/3/9, fo. 18ʳ; Chester Records Office, QSE/7/10.

67 P.S. Seaver, *Wallington's World: A Puritan Artisan in Seventeenth-Century London*, Stanford: Stanford University Press 1985, pp. 118–19.

68 F. Dillingham, *Christian Oeconomy*, London [J. Windet], 1609, fo. 49ᵛ; Cleaver, *A Godly Form*, p. 378; Gouge, *Of Domesticall Duties* p. 649; H. P[eachum], *The Worth of a Penny*, London: R. Hearne, 1641, p. 13.

69 Cleaver, *A Godly Form,* p. 371; Gouge, *Of Domesticall Duties,* p. 688.
70 BL, Harley MS. 6715, fo. 8r.
71 G.D. Lumb (ed.) 'Justice's Note-Book of Captain John Pickering, 1656–60', in *Miscellanea,* Thoresby Society, 11, 1900, p. 88. Cf. G. Mayhew, *Tudor Rye,* Falmer: Centre for Continuing Education, University of Sussex Press, 1987, pp. 209, 229.
72 Babingon, *A Very Fruitfull Exposition,* p. 212; T. Floyd, *The Picture of a Perfit Common Wealth,* London: S. Stafford, 1600, p. 104.
73 Allen, *A Treasurie of Catechisme,* p. 109; Babington, *A Very Fruitfull Exposition,* p. 235.
74 R. Brathwait, *The English Gentleman,* London: J. Haviland, 1630, p. 160; W. Ames, *Conscience with the Power and Cases Thereof,* Leyden and London: W. Christiaens, E. Griffin and J. Dawson, 1639, V, p. 159.
75 Cockburn, *Calender of Assize Records: Kent,* p. 100; Hertfordshire RO, HAT/SR 1/47.
76 Bristol Records Office, Great Orphan Book, 04421(1)a, fos. 284^{r-v}.
77 Oxfordshire Records Office, MS. Oxon. wills 196, fo. 131r.
78 R. Southwell, *Two Letters and Short Rules of a Good Life,* (ed.) Nancy Pollard Brown, Charlottesville: University of Virginia Press, 1973, p. 49.
79 Cleaver, *A Godly Form,* p. 86.
80 Gouge, *Of Domesticall Duties,* p. 632.
81 D. Rogers, *Matrimoniall Honovr,* London: T. Harper, 1642, p. 67.
82 E.R. Brinkworth (ed.) *The Archdeacon's Court: Liber Actorum 1584,* Oxfordshire Record Society, 23, 1942, p. 98.
83 M.J. Ingram, 'Ecclesiastical justice in Wiltshire 1600–1640, with special reference to cases concerning sex and marriage', unpublished D.Phil. thesis, Oxford University, 1976, p. 225; J.A. Sharpe, *Crime in Seventeenth-Century England: A County Study,* Cambridge: Cambridge University Press, 1983, p. 60.
84 Hampshire Records Office, 4M53/140, fo. 66r.
85 West Sussex Records Office, Sessions Roll, October 1655, fo. 72r.
86 Cockburn, *Calendar of Assize Records: Kent,* pp. 11, 27, 160, 175, 185, 238; J.S. Cockburn (ed.) *Calendar of Assize Records: Surrey Indictments Elizabeth I,* London: HMSO, 1980, p. 261; J. Raine (ed.) *Depositions and Other Proceedings from the Courts of Durham,* Surtees Society, 21, 1845, pp. 302–4. See also East Sussex RO, QO/EW 1, fo. 48r; Hertfordshire RO, HAT/SR 1/176; Kent AO, QM/SB 525–26; Portsmouth City Records Office, S3B/4/4, sheets 1, 2; Suffolk RO, Ipswich Branch, B105/2/1, fo. 24r; West Yorkshire Archive Service, Wakefield, QS 10/1, p. 369.
87 J. Hall, *Salomons Divine Arts,* London: H. L[ownes], 1609, p. 173.
88 W. Whately, *A Bride-bush: or, a Direction for Married Persons,* London: F. Kyngston, 1619, p. 56.
89 Baynes, *An Entire Commentary,* pp. 694–5. See also N. Byfield, *A Commentary: or, Sermons upon the Second Chapter of the First Epistle of Peter,* London: H. Lownes, 1623, pp. 719–38.

74 *Mark Thornton Burnett*

90 Northampton Records Office, F. (M). C. 109. Cf. also Babington, *Certaine Plaine, Briefe, and Comfortable Notes*, fo. 100r; Fosset, *The Servants Dutie*, p. 42.
91 Bodleian Library, MS. Rawl. D. 676, fo. 22r.
92 M. Cavendish, *A True Relation of the Birth, Breeding and Life, of Margaret Cavendish, Duchess of Newcastle,* (ed.) Sir Egerton Brydges, Lee Priory: Johnson and Warwick, 1814, p. 5.
93 J. Bridges, *A Sermon, preached on Paules Crosse on the Monday in Whitson weeke,* London: H. Binneman, 1571, p. 111; J. Knewstub, *Lectures vpon the Twentieth Chapter of Exodus,* London: L, Harrison, 1577, p. 88; R. Stock, *A Learned and very Usefull Commentary upon the Whole Prophesie of Malachy,* London: T. H. and R. H., 1641, I, p. 88.
94 *A Glasse,* sig. giiir.
95 *A Discourse of the Married and Single Life,* London [F. Kingston], 1621, p. 27; T. Gataker, *Marriage Duties Briefly Couched Togither,* London: W. Jones, 1620, p. 4.
96 J.A. Sharpe, *Early Modern England: A Social History 1550–1760,* London: Edward Arnold, 1987, p. 254.
97 ibid., p. 254.
98 ibid., p. 270.
99 Davies, 'Continuity and change', p. 58.
100 Babington, *Certaine Plaine, Briefe, and Comfortable Notes,* fo. 126v.
101 V. Brodsky, 'Widows in late Elizabethan London: remarriage, economic opportunity and family orientations', in L. Bonfield, R.M. Smith, and K. Wrightson (eds) *The World We Have Gained: Histories of Population and Social Structure,* Oxford: Basil Blackwell, 1986, p. 140.
102 Sharpe, *Early Modern England,* p. 41.
103 Baynes, *An Entire Commentary upon . . . the Epistle to the Ephesians,* p. 696; W. Whately, *A Care-cloth: or a Treatise on the Troubles of Marriage,* London: F. Kyngston, 1624, p. 54.
104 T.R. Murphy, '"Woful Childe of Parents Rage": suicide of children and adolescents in early modern England, 1507–1710', *Sixteenth-Century Journal,* 1986, vol. 17, no. 3, pp. 259–70; M. Zell, 'Suicide in pre-industrial England', *Social History,* 1986, vol. 11, no. 3, p. 314.
105 I would like to thank the following libraries, record offices, and trustees for permission to refer to or quote from manuscript materials in their possession: the Bedfordshire Records Office, the Bodleian Library, the Bristol Records Office, the British Library, the Chester Records Office, the Devon Records Office, the East Sussex Records Office, the Essex Records Office, the Greater London Records Office, the Hampshire Records Office, the Hertfordshire Records Office, the Kent Archives Office, the Northampton Records Office (the trustees of the Estate of the late Earl Fitzwilliam), the Oxfordshire Records Office, the Portsmouth

City Records Office, the Public Records Office, the Somerset Records Office, the Southampton Records Office, the Staffordshire Records Office, the Suffolk Records Office (the Bury St Edmunds and Ipswich Branches), the West Sussex Records Office, and the West Yorkshire Archive Service, Wakefield. I am also greatly indebted to Professor Emrys Jones and Sir Keith Thomas for their suggestions and very helpful comments on earlier drafts of this paper. Other versions of the present essay were delivered at All Souls College, Oxford, and at the University of Geneva. I am grateful to Dr Richard Smith for the invitation to speak at his seminar and for his constructive criticism, and to the members of the seminar for their illuminating questions. Former colleagues at the University of Geneva were generous with advice and support. Giving a penultimate form of the paper at the Social History Society of the United Kingdom Conference and talking with Dr J.A. Sharpe were similarly invaluable.

3 Aesthetic and commodity: an examination of the function of the verbal in J. M. W. Turner's artistic practice

Marcia Pointon

> Representations are not rooted in a world that gives them
> meaning; they open of themselves on to a space that is their own,
> whose internal network gives rise to meaning. And language
> exists in the gap that representation creates for itself.
>
> (M. Foucault, *The Order of Things*, 1970, p. 78).

This essay is concerned with language: its relation with, and effect on, imagery.[1] It may seem contrary to talk about Turner, a strikingly colouristic artist, and analyse verbal texts instead of visual. My purpose is, however, to demonstrate the centrality of the verbal in Turner's practice and in our accession to that practice. Fundamental to my argument is the notion that the commercial and the aesthetic (the world of buying and selling art and the world of visual pleasure) cannot be separated out by varying procedures such as style analysis, iconography, reception, and patronage studies but are imbricated in the verbal. I want to show that the apparent contradiction between the assumed specialness of the work of art and the work as product of a set of economic circumstances is a contradiction that Turner himself was obliged daily to negotiate as well as one through which he is constructed as artist and producer in history. I shall be suggesting that his grasp and deployment of language was the precise and only means at his disposal for forging a way of working within these contradictions.

Three propositions underpin this essay. The first is the notion that we construct the past from our own perspective in the present, as a (potentially limitless) series of narratives. As art historians we may believe our concerns to be primarily with material culture, but access to a visually constructed history is always regulated by the verbal. It is always mediated by acts of writing that are themselves subject to the same historical determinants.

The second proposition is that any act of writing is the sum of conscious intent and the working of the unconscious. It is never a simple act but necessitates a deal of some kind between the writer and the reader, even if the latter is never specified.

The third is that literacy in general and the book in particular occupy a specially powerful place in nineteenth-century culture. Olivia Smith has pointed out that 'between 1790 and 1819, the hegemony of language was severely challenged. Because ideas about language justified class division and even contributed to its formation by accentuating differences in language practice, they were sensitive to any political movement which threatened to disturb class boundaries.'[2] The overall cultural dominance of word over image needs, therefore, to be examined to discover how the word interpellates the image, how image creation and the making of an artist's reputation respond to the imperatives of the word.

What ways do we have of evaluating these differences of language in cases where Turner is the speaking subject (i.e. in his letters) and in cases in which he is the spoken subject (i.e. in writing about him)? I shall be seeking a framework within which to register these differences that is historically located and which does not depend on impressionistic readings ('He sounds cross, doesn't he') or expressionistic readings ('That letter tells me how sensitive Turner was'; 'That statement shows how unsympathetic that biographer was'). I do not regard these verbal constructions as revelatory of a hidden truth about Turner the man, but as a domain of communication which functions according to certain rules, which formulates and gives prominence to particular problems and effectively excludes others, which develops characteristic vocabularies and orders of priorities.

Turner's letters are my starting point. John Gage, their editor, declared, 'there are many reasons for gathering and publishing [Turner's] letters'. In fact, he articulates only one: 'that such a collection will help to dispel the impression still left by his earliest biographers, that Turner was an unsocial being, that he wrote infrequently and reluctantly, & that he showed a habitual distrust of, and incapacity with words'. Reviewing the Letters, Luke Herrmann expressed the view that: 'Compared to the correspondence of Constable, that of Turner ... will play only a minor role in the study of British art history.'[3]

The issue of language is present in historiography (as Gage and others have recognized); we do not choose to put it there. It is there from the start as a series of ways of defining Turner, ways of

constructing the man and his work, Turner speaker, writer, and maker. Linguistic theory may highlight the issue but it does not create it. The historical framework for an inquiry into language and Turner is that defined by questions of literacy, class, rhetoric, convention, biography, and communication in all its forms. To put it very simply, Turner, the man in history, is caught between (and must function within) the terms of a written language of craft, technology, and the market on the one hand and, on the other hand, a rhetoric of the aesthetic, a language of learning and cultivation, which, like the language of business, has its own rules and conventions.

Language has always been a vital means by which the artist established his or her status; the distinction between *ingegno* or practical skill-oriented talent and the kind of academic and theoretical knowledge postulated by Reynolds in the *Discourses* needed to be constantly reaffirmed. It was this second, ekphrastic language, learned language, which marked out the artist from the artisan. There are other languages too that are relevant here: the rhetoric of *belles lettres*, the language of poetry, the language of technology.

The language of poetry and that of technology can be seen as the terms within which the titles of Turner's Royal Academy contributions function. They alternate between the informative/technological and the poetic/imaginative. A look at examples from one year will serve to make the point: in 1832 Turner exhibited at the Royal Academy six paintings, three of which have factually informative titles and three of which offer poetic verbalizations. The first three are: *The Prince of Orange, William III, embarked from Holland and landed at Torbay, November 4 1688, after a stormy passage. The yacht in which his majesty sailed was, after many changes and services, finally wrecked on Hamburgh sands while employed in the Hull trade* (no. 153), *Van Tromp's Shallop at the entrance of the Scheldt* (no. 206), and *Helvoetsluys – the city of Utrecht, 64, going to sea* (no. 284). The three poetically worded titles are: *Childe Harold's pilgrimage – Italy. 'And now, fair Italy! Thou art the garden of the world, etc.' – Byron* (no. 70), *Then Nebuchadnezzar came near the mouth of the burning fiery furnace, and said, 'Shadrach, Meshac, and Abednego, come forth and come hither, etc.' – Daniel iii, 6* (no. 355), and *Staffa, Fingal's Cave. 'Nor of a theme less solemn tells, etc.' Lord of the Isles* (no. 453). There is no doubt that for a contemporary

audience the linguistic differences between the informative and the poetic signalled different categories of response.

Turner's age is the age of the biography and of the lecture; two genres that define status and power within a community of learning and achievement, one eye constantly on posterity, as it were. Turner, in terms of class and professional identity, is *contemporaneously* defined by his words just as he is by his painting; the fact that they were few only serves to indicate how powerfully they signified and still do signify. So once we acknowledge our subject, Turner, suspended in what Geertz calls 'webs of significance' which he in common with the collective cultural practice of his age has helped to spin,[4] what tools can we devise to examine and interpret this phenomenon?

It is here that linguistic theory can help us. Let us look at a passage from one of Turner's letters:

> The picture was Exhibited at the British Institution about 8 years ago – 30 years between the two makes Lord Egerton Pict the first about 1806 – Lord Gower bought it and thereby launched my Boat at one with the Vandervelde – I should wish much the Duke of Sutherland to see it – but in regard to the price that is the greatest difficulty. With me the price was not sent with it to the Institution – so I escape condemnation on that head – and any who likes may offer what they please.[5]

Traditional art historical practice, quite correctly, would extrapolate from this letter a variety of factual information about Turner and his work:

1 Turner has a good memory for his own work.
2 He is able to produce a chronological account of his own career in which certain key works can be seen as markers.
3 He is sensitive about money and his reputation as a businessman but he is also prepared to be defiant.

But if we look at this passage as discourse we might make some further observations that will be historically illuminating. By discourse I mean those sequences of linked and cohesive speech-acts the understanding of which requires more than simply knowing what any particular linguistic act refers to. Discourse alerts us to ideology in language and to questions of who controls language (and, therefore, forms of knowledge); it defines its object and there are, therefore, no criteria of truth external to it.

1 The structure and syntax in Turner's letter is fragmentary and abrupt, it thus offers a discourse of *discontinuity* that undermines or at least challenges the notion of chronological continuity that the listing of works establishes. So one might say that the text is continuity – the continuous existence of Turner's paintings as well as the continual production of paintings by Turner – and the sub-text is discontinuity.

2 The one figure of speech, 'launched my Boat, is embedded in a sequence of factual statements, summary and even legalistic in their brevity.

3 The discourse of commerce (which this whole passage may be taken to exemplify) has no place for the 'I'; the market is the imperative and Turner does not, therefore, appear as 'I' until half-way down the passage. However, once this discourse of commerce is recognized, the 'ship launched' then can be seen as part of the commercial discourse, a metaphor for financial investment as well as career progress. In the terms of ship-building and ship-launching Turner must be designer, builder, financier, and master mariner.

4 The dominant discourse, that of commerce, once recognized, can then be seen to be suddenly undermined by the introduction of another, conflicting, discourse, that of the confessional subject with its neatly framed disavowal of its own involvement: 'So I escape condemnation on that head.'

5 The discourse of commerce is finally reasserted as the object being bartered over (the painting) is thrust by its producer onto an open market: 'And any who likes may offer what they please.'

Now an analysis such as the one I have just undertaken can tell us much about the constraints within which Turner as an artist must operate. I am not suggesting that we can know what Turner was *thinking* or how he was *responding* as an individual. (We can never actually know such things as this though we might wish to try to deduce them.) What we can know, by recognizing discourse in this way, is something of that complex cultural web in the formation of which language works as a systematic practice. Beliefs, aspirations, and regulations are not such as often get openly declared or written down but they operate none the less as the medium within which artists, like everyone else, live and work at any particular time.

I now want to go somewhat further and suggest that language is inextricably linked to image production. I want to look at the discontinuities and spaces (linguistically defined) within which art is

shaped. I am not implying that these are the only considerations deserving of attention in relation to Turner's images, but they are the ones that interest me for this project. I am going to take as my example three of a series of letters written by Turner in connection with the production of his *View of the High Street, Oxford* (commissioned in 1809 and finished in 1810: see Figure 3.1). The circumstances of the commission as known are as follows: the 'View of the High Street' was commissioned by the Oxford dealer and frame-maker James Wyatt in November 1809 as the basis for an engraving. Late in December Turner went to Oxford to make a drawing. The picture was finished in March 1810, sent to Oxford before 6 April but returned for the opening of Turner's gallery on 7 May. Some alterations were made to the figures, and the spire of St Mary's was raised at Wyatt's request. It was subsequently engraved by John Pye and S. Middiman, with figures by C. Heath, and published by Wyatt on 14 March 1812. A smaller print by W.E. Albutt was published in Paris in 1828.[6]

LETTER 1, TURNER TO WYATT, 4 FEBRUARY 1810

> Sir / You may prepare a frame 2 feet 3 inches high by 3 feet 3 long, but I think that it must be cut less, having at present too much sky, so do not put the frame together until you hear again from me. By way of consolation let me tell you the picture is *very forward*, but I could wish you to send me back the annexed sketch with information how the several windows are glazed, and those *blank* in front of the All Souls entrance, particularly those in the *large Gable part*, if they project in a bow, like the two by the gateway, as I find two marked in my second sketch more than in my first, and therefore suppose some alteration has taken place since the first was made. Pray tell me likewise if a gentleman of the name of Trimmer has written to you to be a subscriber for the print.[7]

In what ways is the visual being negotiated here via the verbal? What is immediately striking with these texts is precisely how shifting, how unstable, and changeable is this declared subject of Turner's painting, that is OXFORD. To begin with, the fenestration of the very buildings he is recording appears to change: 'I could wish you to send me back the annexed sketch with information how the several windows are glazed, and those *blank* in the front of the All Souls entrance . . .'

3.1 J.M.W. Turner, *View of the High Street, Oxford*, 1809–10, oil on canvas, private collection.

LETTER 2, TURNER TO WYATT, 28 FEBRUARY 1810

Sir/ I did not receive yours yesterday early enough to answer by Post, but with respect to the picture, I have continued it on the same size, viz 2F 3¼ i by 3F 3i utmost measure. Yet the sky I do think had better be an inch at least under the top Rabbit [rebate i.e. the margin round the print], therefore I should advise you to make the Rabbit deep, so that it can be hid. Therefore the sight measures may be as follows – 3Feet 2½ by 2Feet 2½./ The Picture you may inform Mr. Middiman can be seen if he will favour me by calling, and with a line when it will suit him, that I may be sure to be at home. I am afraid it will not be finished as early as you mention'd, but I shall not long exceed that time March 7, for it certainly would be desirable to you to have it while *Oxford* is full./ The figures introduced are as follows . . . two Clericals, one in black with a master of arts gown, the other with lawn sleeves for the Bishop (being in want of a little white and purple scarf) preceded by and follow'd by a Beadle – Hence arise some questions – first? is it right or wrong to introduce the Bishop crossing the street in conversation with his robes, whether he should wear a cap? what kind of staff the Beadles use, and if they wear caps – in short, these are the principal figures, and if you will favour me with answers to the foregoing questions and likewise describe to me the particularities of each dress, I should be much obliged to you, for I could wish to be *right*.[8]

Oxford may be full of people or empty; houses are demolished and a gateway removed: 'The figures taking down the old Houses are not only admissable but I think explains their loss and the removal of the gateway.'[9] The discourse is one of flux, change, and transformation, a language which (at one and the same time) both describes an actual changefulness (houses being demolished, etc.) *and* provides an analogue to that slow, cumulative process of brushstroke, amendment, correction, affirmation by which the surface of the painting slowly comes into being. The image comes to represent the permanent element in a world that shifts and changes before one's very eyes; the task of the painter is manifestly to maintain the illusion of permanence and agelessness in forms which his eye has already registered and verbally recorded as changeful and decaying. The verbal provides the key to the transition between those two contradictory states.

'You may prepare a frame 2 feet 3 inches high by 3 Feet 3 long, but I think it must be cut less, having at present too much sky, so do not put the frame together until you hear from me,' Turner tells Wyatt in the first letter of the series. The frame must be prepared but not put together, made but left unmade. The picture is *very forward*, Turner tells Wyatt in the next sentence but immediately asks Wyatt to send *back* the sketch with the information about the windows. In other words the picture is forward but instantly things are to move backward, that is in the wrong direction if we take the trajectory from artist to patron, from painting to production as engraving, from Turner to Wyatt. In the next letter continuity is affirmed ('I have continued it on the same size') and then instantly undermined with the change of mind about the sky ('Yet the sky I do think had better be an Inch at least under the top Rabbit'). The figures are in procession: 'two Clericals, one in black with a master of arts gown, the other with lawn sleeves for the Bishop . . . preceded by and follow'd by a Beadle'. They are in temporal sequence just as the painting is, but the latter is (unlike the beadles) a little late ('it will not be finished as early as you mentioned').[10]

LETTER 3, TURNER TO WYATT, 14 MARCH 1810

Sir/ I have not heard or seen Mr. Middiman, and not being so fortunate as to meet with him at home yesterday evng., I now write to ask – how to proceed, *the Picture being finished*, and in a day or two can be varnished for the last time. The packing case is likewise ready. Therefore be so good as to say what conveyance you wish me to use to send it by, and whether you positively wish Mr. M. to see it first? In which case you had better write to him again, or perhaps my delivering the Picture to him, you may consider the same (sending you a receipt for it)./ As to the figures introduced, I have made use of those you sent, and therefore hope you will find them right. Yet I took the hint, for the sake of color, to introduce some Ladies. The figures taking down the old Houses are not only admissable but I think explains their loss and the removal of the gateway. In short, I hope that the Picture will *please* and that you will find your endeavours seconded and prove ultimately very advantageous.[11]

In the third letter the question is how to *proceed*; here the discourse of 'completion' takes over from that of transformation. The painting caught up in time is *finished* but its narrative is not

complete just as the frame is to be made but left incomplete: varnish, packing case, etc. await it. Looking back to the first letter where Mr Trimmer, a potential subscriber, is mentioned we find this discourse of the *completed work* (launched like one of Turner's ships) already present. The painting itself becomes a narrative, a story to engage an audience, and that is Turner's point of exit: 'I hope that the Picture will *please*,' he says, and that the market will justify the investment.

Clearly on one level all this toing and froing was inevitable if two people at a distance were to collaborate over a work in which some topographical accuracy was required and there was no chance of a telephone conversation. But the act of writing is always more than the mere imparting of information. What is, I think, intriguing is how the art of naming and defining plays such an important part in this process: windows are to be glazed or blank, gables projecting or in a bow, lawn sleeves, caps, master of arts gowns, and so on. Turner could not have produced the painting without the words to define the categories of objects he is painting. The almost desperate enumeration in this writing should alert us to the problem of the relationship of words to the production of visual imagery.

In support of my hypothesis about the function of the verbal in the configuration of the visual in this particular instance, I want to draw attention to a second discourse that is present within these letters. This is the discourse of Authority which encompasses the invocation of a whole series of authorities. Turner, the young artist here without authority in the public sense, issues what amounts to an instruction: 'You may prepare a frame.' Wyatt's (and Middiman's) authority underlies the anxiety to complete. The authority of artist is in interplay with the authority of patron. But the real authority is Oxford, town and institution, the embodiment of learning and knowledge which is linguistically constructed and verbally experienced. Oxford, to put it bluntly, is full of words and it is with a cascade of words about bishops, beadles, clerics, and their *proper* attributes that Turner seeks approval of this ultimate authority 'for', as he says, 'I could wish to be *right*'.[12] Within the public domain of learning, a domain which we have already remarked upon in relation to Turner's careful imparting of information in the titling of paintings, knowledge is constituted by the ability to name correctly and in proper order. Only that ability lends authority.

I want to conclude by addressing the same kinds of questions to writing not by Turner but about Turner. And as the thematic

underpinning of this essay has been the intersection of art as aesthetic with art as commodity, I propose to turn to the *Liber Studiorum*. The first text I want to examine is a curious hybrid affair about which much could be said in terms of historiography. It consists of a clutch of notes about Turner writter by the engraver and author, John Pye (who probably never intended to publish them), which have been collated, edited, and augmented by a third person with a claim to artistic knowledge and special access to Turner's works, John Lewis Roget, proto-historian of the English watercolourists and their institutions.[13] While our starting point, Gage's edition of Turner's collected correspondence, presents itself as a series of fragments which turns out to have the authority of a whole, the *Liber Studiorum* presents itself as a named whole which, on inspection, turns out to comprise only fragments. The *Liber Studiorum*, a collection of plates and texts which aspires to be a book (though it never quite became one), is thus framed first by Pye and then, in an outer-casing as it were, by Roget. One is reminded of the framing devices of the *Liber*'s own frontispiece (see Figure 3.2). An account of Turner is constructed in Pye and Roget via a series of fragmentary and conflicting statements. The empirical explanation for this fragmented discourse must lie in the note-taking, memoranda, and accretions of the various authors and editors. But I would suggest that the narrative is contradictory and ruptured also because it addresses the conflicting concepts of the aesthetic and the commercial, those terms that in Turner's writing acts are already seen to be reconcilable only by a wrenching and determined use of language.

Pye's account of the origin of the *Liber Studiorum* tries to bridge this gap. He gives two reasons for Turner having commenced his series of engraved works: 'deficiency of employment' as a result of a slack market and desire on the part of Turner to show that he could depict everything in the visible world:

> Instead, therefore, of painting more pictures 'to increase the dead stock in hand', he in 1807 entered upon the *Liber Studiorum*. He commenced that work 'in consequence of having deficiency of employment' and 'to demonstrate that in a work of elementary composition and chiaroscuro' he 'could demonstrate everything that is visible beneath the sun'.[14]

The pragmatic and speculative (dead stock, deficiency of employment) here confronts the symbolic search for a demonstration of omniscience (everything that is under the sun). Art can do everything and there is nothing that it cannot encompass.

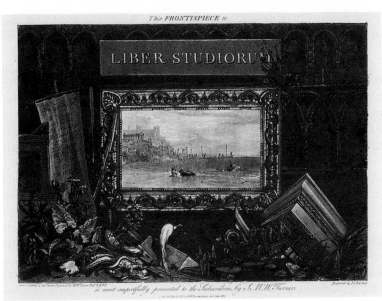

3.2 J.M.W. Turner, frontispiece to the *Liber Studiorum*, inscribed: 'This frontispiece to *Liber Studiorum* is most respectfully presented to the Subscribers by J.M.W. Turner. Drawn, Etched and the Centre Engraved by J.M.W. Turner Esqr. RAPP. Engraved by J.C. Easling. Published May 23 1812 by J.M.W. Turner, Queen Ann Street West.' Trustees of the Victoria & Albert Museum.

The same contradiction reappears a few pages later when we are told that 'the neglect of the public caused [Turner] to abandon the work when fourteen parts . . . had been published.'[15] Market forces had intervened. Yet the artist allegedly insisted on the wholeness of the fragmented work and the oft-quoted 'What is the use of them but together', Turner's plaintive refrain upon finding his plates scattered in print shops and collectors' portfolios, is the voice of the artist mediated and repeated, framed in the observations of others. The discourse of wholeness is most clearly enshrined in the declared taxonomy of the *Liber*'s preface: 'It is intended in this publication to attempt a classification of the various styles of landscape, viz, the historic, the mountainous, pastoral, marine, and architectural.' This classifying system challenges the overall Genre system within which all academic art functioned to a greater or lesser degree. The system thus by

implication subsumes *all* artistic practice. What else could be left to do once that was completed, one may ask?

There is a perpetual promise of wholeness, of completeness, in the formation of the *Liber Studiorum* (which is, let us remember, a collection of pages which never quite attains the status of 'Liber', a Book, Turner having had to content himself with issuing a fragmentary collection of prints and a frontispiece). This promise of wholeness derives both from the sense that it is formed of parts and from the sense that it purports to display the whole of nature. The promise, an unfulfilled promise, is repeated in the Pye–Roget search for a whole account, a whole 'portrait' of Turner.

The crucial moment in the biographical account of the artist (whether declared or implicit) is the moment of the origin of the work of art. While neglect and the market are invoked to account for the failure of Turner to complete the series, that very failure simultaneously generates the account of artistic originality: 'During that time [i.e. the eleven years 1807–1818 when the *Liber* was in course of publication] it was that Turner threw off all deference to the works of Claude, Gainsborough, Wilson and others, to repose solely on his own learning and genious.'[16] The *Liber* thus becomes a place of innovation and the point at which the artist frees himself from his ancestral lineage becomes *original*. Free of Wilson, Gainsborough et al., it is now imperative for the narrative to proceed to establish the *Liber* itself as the foundation of a new lineage, a new artistic genealogy. Thus the language is that of legacy, ownership, and association. 'Permit me to say that it [the *Liber*] was first thought of at the house of his friend, Mr. Wells.' Mr Wells is defined as the person 'at whose house the *Liber* was projected'. Turner's first twentieth-century biographer appropriates this discourse (a testimony to its power) and heroicizes Wells accordingly: 'The conception of the undertaking was so bold and unprecedented . . . only a disinterested friend, like Wells, sublimely confident in Turner's genius . . . only a friend like Wells whom Turner loved and esteemed . . .'[17]

The authenticity of the account of the *Liber*'s origins is evinced by reference to Turner having left a legacy to Mr Wells' three daughters. Nothing establishes the idea of continuity and wholeness like genealogy and family trees. So the *Liber* is grafted firmly to a lineage and sealed with a cash bequest.

Pye and Roget may thus be seen as collaborators in the production of a discourse which proposes the *Liber* as an abstract principle rather than as a commercial or artistic undertaking.

'Originality' and 'wholeness' are the key concepts that underpin their joint account. Both concepts are, however, major currency in the art market; there the authenticity of the work, its value as an 'original', and the wholeness or material completeness of an object affect its monetary value.

The question can be further explored by turning to what is, if not precisely a collaborative publication, certainly an account of Turner that fully declares its affiliation to an authority external to the text. This is Walter Thornbury's *The Life of J.M.W Turner, RA* first published in 1862 and the first full-length biography of the artist. It is significant for a discussion centred on the *Liber Studiorum* that this was the year the copyright bill was passed, one culmination of over a century of debate about 'originality'. Thornbury's book opens with a letter from Ruskin of four years earlier, written in response to an enquiry from Thornbury, intended to ascertain whether or not Ruskin himself intended to write on Turner. Ruskin, giving Thornbury the go-ahead, instructs him to fix the main characteristics of Turner in his mind as the key to the secret of all the artist *said* and *did*:[18]

Uprightness
Generosity
Tenderness of Heart (extreme)
Sensuality
Obstinacy (extreme)
Irritability
Infidelity

Here, then, we have Turner constructed by Ruskin, a master of the discursive translation of image into word, as seven contradictory categories. Thornbury writes with the authority of Ruskin whose own reputation was founded upon his writing about Turner, about what Turner *said* and *did*, equally weighted thus. In a sense, therefore, the whole of Thornbury's account becomes an attempt to resolve the contradiction between 'uprightness' and 'infidelity', between 'generosity' and 'irritability'

The *Liber* plates, by 1862, eleven years after Turner's death, had become one of the registers for the artist's reputation in the market. The *Liber* could, in Thornbury's account, be seen as an ideal model for a commercial age, that is an investment which would accrue in monetary value:

The 'Liber' was not successful in the business sense of the term. But the price that a fine and perfect copy will fetch at the present time would seem almost fabulous. Engraved by Charles Turner, and others, at a cost varying from five to seven guineas only per plate, proof impressions of single plates have recently sold for upwards of 10 l and proofs touched on by the artist himself for more than double.[19]

The *Liber* was engraved on copper plates which wore very quickly; the metal being soft, the surface rapidly deteriorated. Thus the 'proofs' or the first set of impressions would be much clearer than later ones. It is, however, not the empirical, technical, history of Turner's engravings that concerns me but the discourse of the commercial and the aesthetic upon which these contemporary accounts are predicated.

Great difficulty is experienced in both the Pye–Roget and the Thornbury accounts around the issue of Turner's own relationship to the *Liber* prints. Not only is the artist seen as having thwarted the imperatives of completion and wholeness, he is also perceived as subverting the concept of the 'original' within the already difficult framework of the original engraved reproduction. As far as it is possible to ascertain, the situation was that eleven of the plates were engraved by Turner himself, others were put out to engravers, but even in these cases Turner is also alleged to have worked on them himself; all the outlines were done by Turner. Most notoriously, Turner repaired the plates when they became worn, thus creating confusion in the terms of the market between 'proofs' and the less valuable 'prints'. Furthermore, he removed from the margins the marks that distinguished one class of impression from another.[20] The very disjuncture between 'uprightness' and 'infidelity' is thus most fully manifest in the account of the production of the *Liber*. Moreover, the allegedly subversive practices that undermine the principle of wholeness and originality (that is, the imperative of the aesthetic) are attributed by Thornbury to 'tradesmanlike' practice.[21] The discourse is one in which genius is under attack from commercial pressure: 'Turner superintended the printing and publication in a most minute and yet in a most capricious manner.'[22] Yet, Turner being the man he was, we are told, 'sometimes the result would be, but very seldom, a patchwork of incongruous intentions. Sometimes the design was so perfect and grand, it could not be changed or injured.'[23] The 'art' of Turner is here construed as being deployed to deceive: 'Generally speaking,

the alterations were made with consummate art merely to hide the wear and tear of the copper; the faintness, the blur, or the pallor of the plate's old age. It would have bordered slightly on sharp practice, had it not been for Turner's inventive genius.'[24]

These actions allegedly made it extremely difficult to form a complete set of first impressions of the *Liber*. In fact, as we now know, Turner kept for himself all first impressions as a form of private investment. They were released onto the market only after his death. The demands of collecting, the need to assemble a coherent whole from many parts, are thus seen by his early biographers to be countered by Turner's practice. Turner himself is presented as undermining those very concepts of wholeness and originality upon which the market depended. While Turner is by one definition 'tradesmanlike', the manner of producing and printing the *Liber* was 'unbusiness-like, fitful and peculiar'. Thornbury, referring to an account that is repeated in the Pye–Roget text[25] about the woman employed by Turner to sew the prints together in numbers and whom the artist allegedly refused to pay except in kind, says: 'We can scarcely wonder that, as is generally reported, some female servant of Turner employed to stitch the numbers, stole many of the plates and sold them privately.'[26] It is as though the contradictions can only be explained by the introduction, into the narrative, of a dishonest female servant.

It is historically significant that this debate should take place around questions of engraving. *Oxford High Street* was produced for an engraver; it was designed with mass reproduction and dissemination in mind. The *Liber Studiorum* paradoxically was tied to the notion of originality; it was, after all, conceptually related to the so-called *Liber Veritatis* of Claude, a drawn record of his own work made popular through the engravings of Earlom, published by Boydell in the 1770s. Claude's series was intended as a means of verifying his own work as original and distinct from forgeries or imitations. Yet Turner's *Liber* was also, by its very medium, reproductive. Engravings, and especially engraved series, formed the backbone of the vast commercial empire of buying and selling art in nineteenth-century Britain, a market that catered for an unprecedentedly wide audience. Thus while Earlom is described by Finberg as 'an enterprising publisher who skilfully exploited Claude's reputation',[27] Turner is construed as one who seizes the exploitative medium and turns it to his advantage, uniting the commercial and the aesthetic in an unprecedented act of visionary boldness.

Susan Lambert points out that 'formal definitions of the print were not promulgated until the 1960s and then ostensibly to help tax inspectors and customs and trading standards officials to distinguish original work from reproductions so that the former could receive privileged treatment and to protect the public from reproductive work which masqueraded as "original".'[28] The complex history of printmaking and the shifting definitions of originality which are part of that history are outside the scope of this essay. None the less it is instructive to note that the aftermath of the nineteenth-century debate that has been the subject of this essay is a form of classification in the fiscal domain rather than in what is more recognizably a cultural arena. Turner's tradesmanlike action in repairing and regenerating his plates is construed as one that confounds the market's own system of classification. Thus a response to the market on the part of the artist – for this, according to the accounts of Pye, Roget, and Thornbury, is *one* of the points of origin of the *Liber* prints – results in the destruction of that very system that allowed for the commoditization of the work, a system analogous to, and as significant as, the Genre system that safeguarded the aesthetic hierarchy in the Academy. In its place, Turner introduced a private system of marking plates to distinguish different states, a system that challenged the language of recognition and classification through which the market operated. The market was thus exploited – Turner's engravings could only be recognized by the science of connoisseurship then evolving.

Assumptions about the artwork as commodity in a market underpin Turner's discourse. Here, moreover, language is a working practice accommodating the visual construction within a system – the market economy – defined by and dependent upon the verbal. In contemporary writing about Turner, the interdependency of the commercial and the aesthetic is disavowed and a polarization produced through a discourse of 'originality' and 'wholeness' which the biography, as a genre, itself reinforces. This discourse of 'originality' and 'wholeness' contains within it an opposing and contradictory discourse of fragmentation within which the artist is construed as breaking up the system of signification, blurring the necessary distinctions and threatening the equilibrium. Turner's commoditization of his own work was contingent with, and exploitative of, language and system. The politics of current art-historical practice, whether in academic discourse or within the institution of the museum, further work to expel from the definition of art the principle of commodity with which it is imbricated.

Notes

1 Parts of this essay appeared in *Art History*, December 1987.
2 O. Smith, *The Politics of Language, 1791–1819*, Oxford; 1984, p. 3.
3 *Collected Correspondence of J.M.W. Turner*, ed. J. Gage, Oxford, 1980; L. Herrmann, review, *Turner Studies*, 11/2, 1981.
4 C. Geertz, *The Interpretation of Cultures: Selected Essays*, New York, 1973, p. 5, drawing on Max Weber.
5 *Collected Correspondence*, no. 264, 1 February 1844.
6 *Turner, 1775–1851*, Tate Gallery, 1974, no. 160; the painting is in a private collection.
7 Gage, no. 29.
8 Gage, no. 30.
9 Turner to Wyatt, 14 March 1810, Gage, no. 31.
10 Turner to Wyatt, 28 February 1810.
11 Gage, no. 31.
12 Turner to Wyatt, 28 February 1810, Gage, no. 30.
13 J. Pye, *Notes and Memoranda respecting the Liber Studiorum of J.M.W. Turner, R.A., written and collected by the late John Pye, Landscape engraver. Edited, with additional observations, and an illustrative etching by John Lewis Roget*, 1879.
14 ibid., pp. 19–21.
15 ibid., p. 22.
16 ibid.
17 A.J. Finberg, *The Life of J.M.W. Turner, R.A.*, Oxford (1939), 1961, p. 128.
18 My italics. W. Thornbury, *The Life of J.M.W. Turner, R.A.*, 1862, preface.
19 ibid., p. 286.
20 Pye and Roget, *Notes and Memoranda*, pp. 68–9.
21 p. 275, 'These crafty tradesmanlike alternations which, when studied, are the strongest proofs I know of his genius and of his thriftiness, were made under his own eye, if not by his own hand.'
22 Thornbury, *The Life* p. 274.
23 ibid.
24 ibid., p. 275.

25 p. 61.
26 Thornbury, *The Life*, p. 274.
27 Finberg, *The Life*, p. 129.
28 S. Lambert, *The Image Multiplied*, Victoria and Albert Museum, 1987, p. 32.

4 Visualizing the division of labour: William Pyne's *Microcosm*

John Barrell

I

The object of this conference, as it is defined in the brief circulated to contributors, is 'to explore the *connections* between the Arts, Literature, and Society in history'; and in the same brief contributors are asked to bear in mind, when composing their papers, one or more of a number of general themes, methodology, theory, and so on. In my own writing I usually allow such general themes to emerge obliquely, or to be guessed at by my readers, but as I have now been put on the spot, I shall begin with a general statement about the theory that I attempt to bear in mind in my writing, and I shall frame it as a comment on the terms of that definition of the object of this conference, for it has become virtually impossible nowadays for historians of literature and the arts – if they have been at all moved by the theoretical inquiries of the last fifteen or twenty years – to operate with terms such as those, unless they first operate *upon* them.

I shall begin with the terms 'the Arts' and 'Literature'. If these terms still have a value, it is that they tell us what kinds of works, at different periods (including our own), and for different reasons, are accorded a certain privileged status in the society that consumes them. But except among those whom people like me accuse of being liberal humanists, the terms have lost the kind of authority they had twenty years ago. To cut a long argument short – and it is an argument familiar enough not to need lengthy rehearsal – the notion that writing can be divided between the 'literary' and the 'non-literary' has conventionally depended on the claim that works of literature have a particular character and quality because they characteristically exhibit a relation of inherence between form and content. This claim has been made difficult to sustain by the

invention of the notion of discourse, which argues that all written works exhibit such a relation, and exhibit it by the mere fact of their being written. Sequences of ideas, according to this notion, are always linked together within specific rhetorical structures or discourses, each of which has its own rules of procedure, embodies its own account of reality, and embodies also the position from which that account is assembled and the discourse is articulated. The discourse within which we make an utterance determines to a large extent the nature of the connections we can make between ideas: it determines, for example, what can stand as the cause of an effect, and what can be claimed as the effect of a given cause. Thus it determines what can be said within it about, for example, what it is to be human, or the nature of social experience. Though it is possible to move from using one discourse to another, even within the same sentence, it is never possible to speak or write except in discourse. Considered in these terms, the relations of form and content may tell us a great deal about the practice of writing, but nothing about the quality of any particular piece of writing. And by and large, similar arguments have been used to question the notion of the 'arts', when that notion is used to distinguish between artefacts and events that partake of some distinctively 'artistic' character, and others that do not.

For the purposes of this conference, quite a lot can be made to follow from this. For it seems that verbal and visual traces of the past are best characterized not in terms of their relative value, one to another, but as different kinds of signifying practices, producing different kinds of representation. And whatever it is that these traces can be taken to represent, it is difficult to imagine that it could not be reduced to one or another aspect of the society that produced them. That society, however, is known to us only in the form of these very representations, and so once we have expanded the terms 'literature' and 'the arts' to include the totality of signifying practices within society, we seem to have come close to exhausting the category 'society' before it is available to be brought into 'connection' with anything. Of course we can still use these terms, if we take 'the arts' and 'literature' to mean the totality of signifying practices by which a society represents itself, and if we take 'society' to mean the totality of what they signify. But the nature of this signified is so thoroughly inseparable from the nature of the signifying practices that produce it that we cannot conceive of it as the real, and cannot compare verbal or visual representations of a society with that society itself, with what it was really like.

All we can bring into connection are different representations of that society, none of which can be taken to be more real, in the sense of being less of a representation, than any other.

There is, of course, a purpose and a point in comparing how the different traces of a society differently represent that society; and if I say something about what that point might be, I may be able to put myself in a position to recover some of the material history which this stress on representation seems in danger of obliterating. For different signifying practices, different systems of representation, can be classified in at least two ways: in terms of the material means they employ – writing, speech, gesture, paint, stone, and so on – and, within each practice, in terms of the discourses which organize the nature of the representations they produce. These materials and discourses are not simply 'different': they are in relations of confirmation and competition with each other; they are involved in a competition to establish a hierarchy among themselves. It is in terms of a notion of hierarchy that the categories 'the arts' and 'literature' require to be understood – not simply in terms of the privileging of art over craft, or literature over other forms of writing, but in terms of a hierarchy among the material means of signification themselves – as, for example, writing over speech, oil-paint over watercolour, stone over brick, porcelain over earthenware – with the effect that the medium itself comes to be represented as a constituent of the authority of the message. To claim that one medium is more authoritative than another, the discourse which defines that claim must establish itself as more authoritative than any other; and within any field of human activity, there is a competition among discourses, to be won by whichever can claim to exhibit the greatest explanatory power, the most adequate and so the most authoritative account of reality; one more resistant to invasion and appropriation by other discourses, and itself more able to appropriate others.

We can understand this competition among different discourses as a representation of the competition among different material and psychic interests, so long as we do not thereby imagine that, in understanding them like that, we are seeing through the veil of representation and laying hold of the real something which discourses represent. Neither interest nor discourse can be approached as if it were prior to the other: discourses represent interests, and interests can be known only as they are articulated in discourse. From one point of view, it may be less helpful to imagine that competing discourses are invented to represent competing

interests, as if those interests were prior to discourse, than to imagine them as inventing, by strategies of normalization and exclusion, subjects whose different interests they constitute by that invention; and then to imagine that we identify with those subjects as provisional representations of ourselves, according to the shifting discursive contexts in which we find ourselves, or look for them. From another point of view, it may be more helpful to emphasize the point that individual discourses, because they work by exclusion, constantly evoke what they exclude, and in doing so reveal themselves as partial, and in need of other discourses to supplement and qualify them. The study of the discourses of a text, therefore, is both the study of how different discourses differently represent the real, and of how, in doing that, they also constitute the different interests which then compete to produce the material history of a society. I can sum up the presupposition behind what follows by saying that interests compete to produce the text of material history, but not in discourses altogether of their own choosing.

II

Since the late eighteenth century the idea of the division of labour has been a crucial tool in the attempt to isolate and define a notion of cultural modernity; but it has always been a double-edged tool.[1] We are most familiar nowadays with the idea as it was used by Marx, and so with the notion that the narrative it recounts is a bad narrative – a story of alienation, from the unity of the productive process, from the social totality, from the self. But in the late eighteenth century, the idea of the division of labour already functioned as a fully articulated discourse, offering a comprehensive account of human history, which could be appealed to by aestheticians, linguists, literary critics, and speculative historians. It was predominantly associated, however, with the institution of political economy: with the celebration of economic expansion and industrial improvement, and with the attempt to vindicate the structure of modern commercial societies as, precisely, a structure, as something that, despite its arguably chaotic appearance, was available to be known, to be comprehended. And for political economists, of course, it was a discourse that had, for the most part, a good story to tell. It posited a primal, pre-social moment of undifferentiated occupational unity, when each person performed all the tasks necessary to his or her survival. The coming together of men and women in communities, however, enabled and produced a differ-

entiation of occupations. As population increases and communities become larger, an ever-greater degree of occupational specialization is required and encouraged, and the products, whether of manual or of intellectual labour, become increasingly refined by being the products of progressively more specialized labour.

As elaborated in writings on economics, the discourse of the division of labour acknowledges that specialization can be understood as a threat to social cohesion, for diverse occupations can also be seen as competing interests – to put it briefly, it is in the interests of each occupational group to sell its own product as dear as possible, and to acquire the products of other groups as cheaply as possible. The field of intellectual production is also acknowledged to be an arena of specialization and conflict, in which the various discourses of a culture can be understood as so many 'faculty languages', or occupational idiolects, which severally attempt to interpret the world in terms of the different occupational interests they represent and articulate. But whereas, in other fields of enquiry, the discourse of the division of labour could be used to suggest that this atomization of occupations, interests, and discourses might lead in time to the corruption of the body politic, in political economy it enabled a new conception of social cohesion, as something that is itself predicated upon occupational division. When each of us produces only one thing, or has only one service to offer, we are obliged to depend on each other for every other service and product that we need. Those apparently in competition with each other are in fact dependent on each other; apparent economic conflict is the basis of actual social coherence. This mutual interdependence, by which 'the structure of the body politic', as the statistician Patrick Colquhoun described it,[2] comes to be defined in economic terms, in terms of the structure of employment, and of the market, thus becomes a guarantee of the unity, and so of the health of society, and not a symptom of its corruption.

The problem in this account, however, was that of defining the place from which that social coherence could be perceived, for the discourse of the division of labour seemed to deny the very possibility of the social knowledge it sought to invent. It represented every individual within a modern, commercial society, as performing a specialized task, and so it represented every subject-position as partial, as defined and constrained by the specialization necessary to compete successfully in the market. What people could know was no more than a function of what they did: in Adam Smith's

famous example,[3] the philosopher and the street-porter were both creatures defined by the propensity to truck and barter, and the relations between them were governed by an unspoken agreement – the porter would carry the philosopher's burdens on his back, if the philosopher spared the porter the burden of philosophizing. The porter's knowledge of the world was no more than the knowledge of what was good for porters; and all the philosopher knew was what it was in the interests of philosophy to call knowledge. Everyone, therefore, has an occupational interest which makes it difficult, or even impossible, to perceive occupational difference in the recuperated form of social coherence: that, after all, is why the mechanism that ensures that everyone, in acting for themselves, acts also for the common good, was described by Smith as an 'invisible hand'.[4]

In short, the very invention of this account of social organization and social knowledge required also the invention of a knowing subject who, within the terms of the discourse, could not conceivably exist within any developed, commercial society. This problem is sometimes managed by delegating the task of comprehension to an abstract viewing-position, borrowed from the discourses of natural science, 'the philosophic eye'. It would probably take, we might reflect, such a disembodied observer to see an invisible hand at work; and the phrase has the additional advantage of maintaining the pretence that the discourse is articulated by no one in particular, that it represents no interest, that it is not, finally, a discourse at all.

But the problem is more usually managed by making a simple division, which is never clearly articulated, between manual labour and intellectual labour, and thus between those whose labour is visible, who can be seen to do things, and those whose function Smith describes as 'not to do any thing, but to observe every thing'.[5] By this distinction, the diversity of manual labour is used as a synecdoche to represent all forms of doing, all occupational diversity. Society becomes divided between the observers and the observed, and the occupational identities of the observers are ignored. In his early draft of *The Wealth of Nations*, Smith had written:

> Philosophy or speculation . . . naturally becomes, like every other employment, the sole occupation of a particular class of citizens. Like every trade it is subdivided into many different branches, and we have mechanical, chymical, astronomical, physical, metaphysical, moral, political, commercial, and critical philosophers.[6]

In the published version, this passage is considerably revised: the varieties of philosophy are no longer listed, and 'trade' is replaced by 'employment', with the effect that philosophy becomes less plural and less directly comparable with manual trades.[7] More generally in the *Wealth of Nations*, though the philosopher is formally acknowledged, in the opening chapters, as a specialist participating in the market economy, he is quickly accredited with an impartiality, an integral subjectivity (manifested in the pronoun 'we'), and a disinterestedness which enable him to perceive the real history of society as the real and unchanging coherence of continuously subdivided activities and interests; and he is imagined as articulating that perception in terms which, because they cannot be identified as the terms of any specific occupation, elude the constraints of specific discourses as entirely as they elude determination by an economy of exchange. Knowledge becomes a disinterested knowledge of what the public is, and of what is good for the public, and it becomes the property of a particular *social*, and not simply of a particular occupational, class. Ignorance too becomes the property of a particular class, the class which is the object of knowledge, and so the object of the discourse.

III

I want to look further at the problem of authority in the discourse of the division of labour by offering a reading of an early nineteenth-century text, the *Microcosm*, a text that consists mainly of hundreds of vignettes of figures engaged in agriculture and in manufacturing and distributive trades. These vignettes were drawn and etched by the watercolourist W.H. Pyne and aquatinted by John Hill; an introduction, and what the title-page calls 'explanations of the plates' in the form of brief prose essays, were provided by someone called C. Gray. The first complete edition of the *Microcosm* was published in two volumes in 1806 and 1808; the plates had earlier begun to be issued in monthly parts, in 1803.

The text has an alternative title which gives a fuller account of what its authors supposed to be their intentions: *A Picturesque Delineation of the Arts, Agriculture, Manufactures, &c. of Great Britain, in a Series of above a Thousand Groups of Small Figures for the Embellishment of Landscape*, and so on. These alternative titles disclose that the book has two separate objects, which the introduction to the first volume tries to represent as easily compatible. The *Microcosm*, it claims,

presents the student and the amateur with picturesque represen-
tations of the scenery of active life in Great Britain. And, by
means of this, it, at the same time, places before them actual
delineations of the various sorts of instruments and machines
used by her in agriculture, in manufacture, trade, and
amusement.[8]

Now evidently what is imagined to be at stake in this 'double
object' is an opposition between 'picturesque representations' and
'actual delineations', where the actual is conceived of as extra-
textual, a real which can be directly reproduced by one kind of
drawing but not by another. But as we shall see, the competition
between the two is played out as a competition between discourses
inside the text itself, discourses which must, I want to suggest, be
incompatible.

One of these discourses is that of the division of labour; and its
presence within the introduction is signalled by the claim that the
Microcosm will represent the *variety* of occupations which together
compose the economic structure of Britain. Thus the *Microcosm*,
the introduction argues,

is devoted to the domestic, rural, and commercial scenery of
Great Britain, and may be considered as a monument, in the
rustic style, raised to her glory. While it assists the students of
both sexes in drawing, and teaches them to look at nature with
their own eyes, it sets before them, in pleasing points of view, the
various modes in which her capital is invested, and by which her
industry is employed: in short, the various ways by which she has
risen to her present high situation, as one of the first among
nations.

This acknowledgement of the variety, of occupations, of labour, of
employment, in a modern commercial society, is a defining feature
of the discourse of the division of labour. But the acknowledgement
is always predicated on the ability of the discourse to produce some
general truth about that variety, such as will describe its *unity*, when
it is examined by the eye of the economic philosopher. Thus Smith,
for example, after examining 'all the variety of labour' that goes into
the production of a labourer's tools and woollen coat, continues:

Were we to examine, in the same manner, all the different parts
of his dress and household furniture, the coarse linen shirt which
he wears next his skin, the shoes which cover his feet, the bed he
lies on, and all the different parts which compose it, the

kitchen-grate at which he prepares his victuals, the coals which he makes use of for that purpose, dug from the bowels of the earth, and brought to him perhaps by a long sea and a long land carriage, all the other utensils of his kitchen, all the furniture of his table, the knives and forks, the earthen or pewter plates upon which he serves up and divides his victuals, the different hands employed in preparing his bread and his beer, the glass window, which lets in the heat and the light, and keeps out the wind and the rain, with all the knowledge and art requisite for preparing that beautiful and happy invention, without which these northern parts of the world would scarce have afforded a very comfortable habitation, together with the tools of all the different workmen employed in producing these different conveniences; if we examine, I say, all these things, and consider what a variety of labour is employed about each of them, we shall be sensible that without the assistance and co-operation of many thousands, the very meanest person in a civilized country could not be provided, even according to, what we very falsely imagine, the easy and simple manner in which he is commonly accommodated.[9]

The strategy and structure of this extraordinary sentence (which are closely matched in some sentences by Mandeville on the same topic of the 'variety' of employment)[10] have the effect of instantiating precisely the transcendent form of knowledge which is taken to characterize the subject of the discourse of the division of labour. It begins with a proliferation of examples of the 'variety of labour', and the sheer number of these examples, the random order in which they are mentioned, the listing of general categories and particular objects confusedly together ('the furniture of his table', the knives, forks, and plates), the multiplication of binary terms (sea and land, heat and light, and so on), and the tendency of some items to prompt reflections which delay the conclusion of the list (the glass windows, for example), have the effect of producing a consciousness which seems to be constituted by, and dispersed among, the numberless consumable articles that demand attention in a modern commercial society. The next sentence will contrast the vast number of such articles available to the European labourer with the frugal accommodation of 'the African king'.

But the conditional form of the sentence is available to rescue this dispersed consciousness, and acts (so long as we do not lose sight of it) as a promise, whose fulfilment becomes the more urgent the

more it is deferred, that order will finally emerge, and that some general truth will be produced from all these confusing particulars. The conditional form is eventually reactivated at 'if we examine, I say', announcing the imminent fulfilment of the syntactical contract; more to the point, the parenthetic 'I say' (Mandeville uses precisely the same expression, at precisely the same rhetorical moment in a similar sentence),[11] can be read as a guarantee – a claim at least – that one consciousness, the philosopher's, has never been bewildered: throughout this long recital he has had his eye on the enunciation of a general truth, though the reader may have been blind to it, and a transcendent truth, because it will be produced by a transcendent subject.

The acknowledgement of *variety*, in occupations and employments, is therefore always predicated, in the optimistic version of the discourse of the division of labour, on the possession of a position of knowledge beyond discourse, beyond occupation and interest; and so on the possession of a knowledge of the effective *unity* of apparently divided labours (the 'co-operation of many thousands'). It is this which enables the concern for variety in the first place, and it is this which accounts for and justifies the concern of the *Microcosm* to represent the various modes in which capital is invested and labour is employed, and 'the various sorts of instruments and machines' used in British agriculture, manufacture, and trade.

In offering to present an image of the unity of apparently divided labour, the *Microcosm* does not offer its reader an ascent to the elevated viewing-position from which the knowledge of that unity is originated. Its pedagogic address to 'young people' offers that vision of unity in the more restricted, the more marketable, and the more easily consumable form of 'useful knowledge' – as a 'useful knowledge', for example, 'of the practical part of various arts and manufactures'. The educational movement of which this phrase was the watchword sought to represent as true knowledge only what it was 'useful' to know, and its notion of usefulness was tailored to fit a subject more easily identifiable as an intelligent artisan or mechanic than as a member of the polite, more liberally educated classes.[12] This subject was imagined to be impatient with all knowledge which was not empirically derived and which had no practical application; and it is to young people destined to become just such subjects, to whom the useful and the practical were one and the same, that the introduction addresses itself.

It was as a branch of 'useful knowledge' that the teaching of political economy was legitimated in the early nineteenth century, for example, in Bentham's plans for chrestomathic education, and in the Mechanics' Institutes[13]; and it was their occupational identity as mechanics, of course, which meant that those who attended such institutes could be thought of as acquiring only the conclusions which political economy arrived at, and not the principles by which those conclusions had been reached. I take it that the *Microcosm* is offering a knowledge of the 'variety of labour' on the same terms. It is predicated on the assumption that the knowledge necessary to produce the book, and the knowledge it seeks to impart, are very different: the authors are able to *initiate* a knowledge of how the body politic is organized; the young people who read it will be able to do more than *recognize* that organization when it is presented to them, and to understand, perhaps, where they belong within it. Thus 'useful knowledge', when it takes in political economy and the division of labour, becomes a hybrid or transitional form of knowledge: it is neither one of the variety of functions to be observed, nor at the point where observation originates.

IV

But the *Microcosm*, as we have seen, has a 'double object': it seeks also to offer 'picturesque representations' – it wishes to please as well as to instruct, and it is looking for a market among those whose interest is in art as a polite accomplishment, as well as among those concerned to acquire 'useful knowledge', or concerned that their children should acquire it. And in order to describe this second aim, the introduction engages a discourse which, like that of the division of labour, had come to be fully articulated only in the final decades of the eighteenth century. The discourse of the Picturesque, as originally developed by William Gilpin, and subsequently by Richard Payne Knight and Uvedale Price, can be understood as giving definition to the aesthetic concerns of the connoisseur and the amateur, the gentleman-artist. In doing so, it represents itself as thoroughly hostile to the values inscribed within political economy; but, except in the later writings of Knight,[14] it seeks also to privilege the concerns of the gentleman-amateur over those of the professional artist, especially the professional artist in landscape and *genre* – and I use the word 'professional' to mean simply the opposite of amateur, rather than to describe artists (we shall come to them

presently) who thought of themselves as engaged in a profession, rather than a manual trade. For the discourse of the Picturesque reinscribed the traditional distinction between the intellectual and the mechanical aspects of painting, in terms that suggested that modern painters, if left to themselves, and unguided by the gentleman connoisseur, would become preoccupied with matters of execution at the expense of a concern for correctness of taste.

A sign of these distinctions, between gentleman and economist and between amateur and professional, is the concern everywhere evinced within the discourse of the Picturesque with the visible appearances of objects, to the entire exclusion of a consideration of their use or function. This concern is often expressed in connection with a disdain for manual labour: the discourse represents itself as capable of being articulated only by a subject who is sufficiently remote from the need to regard the material base of economic life to be able still to consider an interest in the useful as a mean interest, as an interest in the mechanic at the expense of the liberal arts. Here, for example, is Gilpin, on the objects worthy to be represented in a picturesque landscape. 'We hardly admit the cottage, and as to the appendages of husbandry, and every idea of cultivation, we wish them totally to disappear.'[15] Or here he is again, on the 'vulgarity of ... employment' which, he says, 'the picturesque eye, in quest of scenes of grandeur, and beauty, looks at with disgust'.[16] And here he announces a primitive version of the Group Areas Act: 'in grand scenes, even the peasant cannot be admitted, if he be employed in the low occupations of his profession: the spade, the scythe, and the rake are all excluded'.[17] And here, finally, he is more generous, acknowledging what was implicit in the previous quotation, and allowing the peasant entrance into picturesque scenery, if he leaves his tools behind:

> In a moral view, the industrious mechanic is a more pleasing object, than the loitering peasant. But in a picturesque light, it is otherwise. The arts of industry are rejected; and even idleness, if I may so speak, adds dignity to a character. Thus the lazy cowherd resting on his pole; or the peasant lolling on a rock, may be allowed in the grandest scenes; while the laborious mechanic, with his implements of labour, would be repulsed.[18]

The object of the Picturesque, in that last quotation, is seen 'in a picturesque light' rather than in a 'moral' light; and in the same way the subject of the discourse is sometimes identified as the 'eye of taste' or the 'picturesque' eye. The phrase has the effect of

acknowledging that this subject is a partial subject only, one among the various discursive identities available to the inhabitants of the polite world – an acknowledgement essential to the legitimation of the discourse, precisely because, especially in its lofty disdain for manual labour, for industriousness, it defines itself in contradistinction from the moral as well as from the economic.

The fact, however, that this disdain for labour can also be read as the gentlemanly disdain of the amateur enables the Picturesque to lay claim to that transcendent viewing-position which had through the eighteenth century been regarded as the perquisite of the gentleman; a transcendence (as I have argued elsewhere)[19] similar to that claimed by the political economist in that it represents itself as disinterested, but distinct from it also, in that it is characterized by a tendency to overlook, rather than to comprehend, the details of trades and occupational identities. In an essay on his own sketches, for example, Gilpin had described a picture of the Colosseum, 'adorned with a woman hanging linen to dry under its walls. Contrasts of this kind', he commented, 'may suit the moralist, the historian, or the poet, who may take occasion to descant on the instability of human affairs. But the *eye*, which has nothing to do with *moral sentiments*, and is conversant only with *picturesque forms*, is disgusted by such unnatural union'.[20] Gilpin represents the Picturesque here as if it were a *faculty* of pure unmediated vision: it is the 'eye', unqualified by any adjective, disjoined from any specific occupational and discursive identity, entirely disinterested. He considers three occupational identities, moralist, historian, and poet, and the vision of each of them is shown to be mediated by their specific interests, with the result that each is imagined to approve of a picture which, for Gilpin, depicts an 'unnatural' union of forms and sentiments. As opposed to these, the 'eye' – not even, now, the 'picturesque' eye or the 'eye of taste' – is pleased only by what is *natural*: the natural is located in picturesque forms devoid of ethical, political, or sentimental meanings. If they are not devoid of such meanings, he argues, they are 'disgusting' – they appeal only to a partial, or to a perverted, taste.

That this claim to a transcendent vision could serve to distinguish the amateur student of picturesque forms from the professional artist in landscape and *genre* will be clear enough, if we consider the rural subject-pictures produced in the 1790s by such artists as George Morland, James Ward, and Francis Wheatley, which are everywhere concerned with just such meanings as Gilpin rejects. But if we consider the art of painting in terms of its institutional

history in the late eighteenth and early nineteenth centuries, it will
be apparent that artists who painted for a living found no great
difficulty in accommodating, within their own self-image, the
opinions of the gentleman-connoisseur on matters of taste, however
much they resented the claim of the connoisseurs to dictate to them
on such matters.[21] For the master-narrative of that institutional
history is the continual concern to represent painting as, precisely,
a profession, a liberal profession, and not a mechanical or a manual
trade, and thus to claim for the painter at least as much gentlemanly
status as the practitioners of other professions laid claim to. The
disdain for mere execution, for the manual aspects of painting,
expressed by the picturesque connoisseur, could certainly be
understood as a negation of this claim; but it could be used, also,
to validate it. For to establish painting as a liberal profession, it was
not sufficient simply to establish visible institutions, such as the
Royal Academy, and to substitute professional training in the place
of apprenticeships. It was also necessary to appropriate such
discourses as presupposed a liberal, a gentlemanly subject to
articulate them.

 Painters of history were justified, by the long tradition of amateur
criticism, to mobilize a version of the discourse of civic humanism
to represent their aims and status.[22] There was also a tradition of
heroic landscape-painting in oils, continued in the nineteenth
century especially by Turner, which could arguably be defined and
defended in civic terms. Essential to the civic theory of painting was
the claim that the painter of heroic subjects, at least, was an
inventor and not a mere maker of objects, and thus the practitioner
of a liberal art. But this discourse was not easily available to
painters in the lower genres of landscape and genre, unable to depict
heroic actions or the ideal forms of humanity; and it was especially
unavailable to artists in watercolour. (Pyne himself was primarily
an artist in watercolour, and was to become an active propagandist
of the medium.) The restricted size of landscapes in watercolour,
and the traditional use of the medium to produce images for the
purpose of conveying factual information rather than moral instruc-
tion, required that the professional aspirations of landscape artists
in watercolour should be defined in other terms. What was taken to
characterize the art of watercolour, especially in the newly popular
technique of painting in watercolour, as opposed to colouring in or
washing over a previously drawn image, was the spontaneous
facility necessary to a medium in which mistakes could not easily be
corrected. For artists in watercolour, therefore, the disdain for

labour and the concern for pure aesthetic values of the Picturesque were a valuable resource, in the early decades of the nineteenth century,in the representation of their professional and gentlemanly aspirations.

It was doubly necessary to represent painting in watercolour as a liberal, a polite activity, for what was at stake was not simply the status of the artist as practitioner, but the economic viability of watercolour-painting as an occupation. Professional artists in watercolour made their livings not simply by selling their works; equally if not more important to most of them were the fees they received for teaching their art, and this required them to represent it as an accomplishment suitable to the sons and daughters of the politer part of the bourgeoisie, or of those aspiring to politeness;[23] and for this purpose too the discourse of the Picturesque, with its connotations of amateur status and gentility, could be a valuable resource. It became the primary discourse employed in the numerous instructional manuals produced by watercolour artists in the early decades of the nineteenth century,[24] and the *Microcosm*, as its full title indicates, offers itself as just such a manual. The offer is repeated in the claim that the book presents the student and the amateur with 'picturesque representations'. The 'amateur' is the polite connoisseur of the Picturesque; and the 'student', I take it, is not here conceived of as one studying to enter the profession: the students of art referred to later in the introduction may be 'of both sexes' (this at a time when women were excluded from an institutional education in the fine arts), and are apparently studying art as an accomplishment and a pastime.

It is this pedagogic concern which announces that the discourse of the Picturesque is articulated, in the *Microcosm*, not by an amateur such as Gilpin, but by a polite professional, such as Pyne wishes to be considered. And in the terms of the discourse of the division of labour, the appropriation of the Picturesque by such men as Pyne must identify the Picturesque as a discourse which has forfeited its claim to be a disinterested, transcendent form of knowledge. It has come to be used to market a specific service, to define a specific interest, and to claim a specific status for the practitioners of a particular occupation.

On the one hand, then, the *Microcosm* intends to represent the 'variety of employment', packaged as useful knowledge, and this intention is announced within the terms of the discourse of the division of labour. On the other, the *Microcosm* offers the pleasures of the Picturesque, and that intention is inscribed within the

discourse of what, within a commercial publication such as this, must be understood as a specific occupational interest, a defining characteristic of which is a disdain for the 'vulgarity of employment', the very occupations the book is committed to representing. Thus, at a time when the importance of drawing was being increasingly emphasized as a useful part of mechanical education, the *Microcosm* is anxious to stress the accuracy of its illustration; and at a time when drawing was also becoming pre-eminent among the polite accomplishments, it is equally concerned to stress how well it combines the 'agreeable' with the 'useful'.

There is no necessary incompatibility between these two intentions and concerns at the level of social practice: we need not even think of the *Microcosm* as addressing itself to two different markets, for it is not hard to imagine the existence of large numbers of parents among the upwardly mobile or upwardly aspiring middle classes who would have been anxious to encourage their children in both practical and liberal pursuits. Nor, in the first decade of the nineteenth century, was the distinction between technical and what we may call 'aesthetic' drawing as rigid as it soon became. The problem faced by the introduction is a discursive problem: it is a problem of how to describe two social practices which may not have been experienced as incompatible, in the terms of two discourses which are quite evidently so. The problem is to make these two discourses act in concert, and not in conflict and contradiction; and the introduction seeks to manage the problem by treating this discursive opposition as if it can be seen as a matter of due balance between equal concerns, and as if the pleasure offered by the Picturesque could be additional to, a supplement to, an 'actual' account of the variety and coherence of economic activities.

It attempts at one point to describe this balance by conceiving of the illustrations themselves as divided into two discursive units, whereby the machines carry the responsibility for the usefulness of the book, and the figures are left free to give pleasure. This solution is probably borrowed from the convention established in the late eighteenth century for the illustrative plates of encyclopaedias of arts and sciences, whereby one half of a plate would be devoted to a bustling *atelier*-scene in which a number of artisans pursued their divided labours with the tools and machine-parts delineated in the other half. But the basic strategy of the introduction remains to announce, simply, that the book does *this* and that it does *this* too; it does so much of the one and the same amount of the other. It is as if each discourse has a similar kind of status and authority, when

what is at stake is precisely the negation, by the division of labour, of any claim that a merely occupational discourse might have to articulate an objective form of social knowledge, and when one defining characteristic of the Picturesque is such as to throw into doubt the very knowledge that it is the object of the division of labour to impart.

But if the introduction can handle this discursive opposition only by offering to re-cast that opposition as balance, the book itself constructs a set of relations between the discourses of the Picturesque and of the division of labour in which their opposition is apparent if it is not acknowledged, and in which each can be read as attempting to appropriate the other. In the next two sections of this paper, I want to examine how this discursive conflict is played out in the *Microcosm*.

V

I want to begin by concentrating on one half of the 'double object' of the *Microcosm*, the attempt to represent the various divided labours of commercial Britain, and to grasp that occupational variety in the form of economic and social unity. From the point of view of the discourse of the division of labour, the Picturesque as it has so far been characterized seems to be entirely disabled from assisting in that attempt, by virtue of its reluctance to represent manual labour, and by virtue also of the fact that, in the view of the economic philosopher, it must be identified, by that very reluctance, as an occupational, and so as an interested discourse. The profession of the artist, or more specifically of the landscape and *genre* artist in watercolour, is evidently in these terms one of the divided labours that the philosophic eye must attempt to comprehend in its vision of the social totality, rather than a situation from which a view of that totality can be advanced.

But equally evidently, if the illustrations to the *Microcosm* instantiate a visual discourse of the Picturesque, they must embody a version of that discourse very different from the Picturesque of Gilpin, or of the artist whose claim to be a member of a liberal profession depends upon his lofty disdain for the mechanical. To depict, as this book does, picturesque groups of workers, is one thing; but to depict picturesque groups of workers actually *working* as well as sitting idly round (Figure 4.1), is immediately to compromise that gentlemanly disdain for manual labour, and to that degree also to compromise the occupational specificity of the

4.1 *Microcosm*, plate 98. *Woodmen*. Lopping branches off timber.

Picturesque. To the philosophic eye, we could say, picturesque drawing, once it has overcome that disdain, ceases to instantiate a discourse at all, in that it no longer instantiates a claim to define its own proper objects of attention, and its own hierarchy of values, and to generate its own specific kind of social knowledge. In the *Microcosm*, picturesque drawing seems to have become a victim of the process by which, as social knowledge was increasingly defined in the late eighteenth and early nineteenth centuries as economic knowledge, the arts were increasingly denied a cognitive function. And so it has become, rather, a rhetoric, a style, and one which, I shall suggest, can usefully be appropriated by the discourse of the division of labour to give a visible form to its account of social organization.

Considered as a style, rather than as the instantiation of a mode of knowledge, there were characteristics of picturesque drawing which made it particularly appropriate to the representation of the unity of commercial and manufacturing economy. The Picturesque, as I argued earlier, is concerned only with visible appearances, to the exclusion of the moral and the sentimental. The picturesque eye is a polaroid lens, which eliminates all sentimental and moral reflection. It is thus also absolutely hostile to narrative; and when it depicts figures it attempts to do so in such a way as raises no question about their thoughts or feelings or their interactions with other figures. Picturesque drawing – Figure 4.2 is an example by Gilpin himself – seeks to represent figures as, precisely, figures, no more than that. It employs, for example, none of the conventional signs, physiognomic or pathognomic, by which, in other contemporary visual discourses, the stereotypes of individuality are encoded. Accordingly, the working figures in the *Microcosm* – Figure 4.3 is a case in point – are distinguished by the attitudes they adopt and the movements they perform; by their physical relations to the various objects they work with and work on, by their occupations, rather than by their thoughts or feelings about those occupations. They are what they do: identity becomes largely a matter of what movements they make, and of which implements they apply to which raw materials.

The non-narrative neutrality which characterizes picturesque delineations of the human figure is reinforced by a characteristic method of drawing. The picturesque line is often hardly a *line* at all: it is discontinuous, spiky, concerned to represent texture at the expense of outline. Texture is communicated in the *Microcosm* both by Hill's aquatinting, and by Pyne's etched lines, which are broken

4.2 William Gilpin, 'A few landscape groups', illustration to his 'Essay on the Principles on which the Author's Sketches are Composed', in Gilpin, *Three Essays on Picturesque Beauty*, 3rd edn (1808).

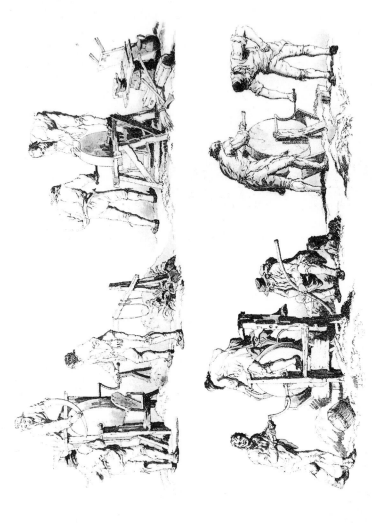

4.3 *Microcosm*, plate 14. *Grinders*. Left, above and below: Grinding a scythe. Right, above and below: Carpenters grinding the blade of a hatchet.

as if to represent the building-up of an image out of rapid, successive scratches of the pen as it stumbles over the textured surface of hand-made paper. The line seems to call attention to its own discontinuity, and so to the spontaneous movement of the masterly hand which produced it; but the notion of the 'natural' in this sketching from nature represents 'mastery' not in terms of the individuality of the artist's manner, but of the 'accuracy' with which it registers the visual appearances of objects supposed to be humble and informal. It is expressive of a neutrality, not an idiosyncrasy of vision; it instantiates a conception of 'accuracy' which governs indifferently the representation of both people and things, in such a way as assimilates each to the other by suggesting that both are capable of being observed with the same kind of neutral aesthetic attention. The neutrality of picturesque vision can thus be read as the sign of a disinterested, not a partial observation. In short, the Picturesque as style, applied to the representation of manual labour, becomes an ideal visual vehicle for the representation of an account of the various occupations by which the British economy is constituted, one which can reinforce the claim that the knowledge and understanding of that variety proceeds from no occupational interest or identity at all.

Each plate in the *Microcosm* consists of two or three, but more usually four or more small vignettes of individual figures, groups of figures or, occasionally, implements of trade. For the most part each plate is devoted to a particular mechanical trade or occupation. And in each plate, there is evidence of Pyne's concern to pattern the various individual vignettes into a well-designed page. When two groups are illustrated on the same horizontal axis, they will be carefully balanced or contrasted, as in Figures 4.4 and 4.5, of market-groups and dairy-work. Where the page is arranged vertically, as in Figure 4.5, it is usually organized into three tiers, with the largest vignettes at the bottom and the smallest at the top; sometimes a vignette may artfully invade the space of the tier above it, as in Figure 4.6 of sheep-shearing.

More or less the same principles of organization inform the plates which are arranged horizontally, except that a good number of these are divided into four vignettes of about equal size, the composition of one answering that of the other on the same tier, as in Figure 4.7 and 4.3, 'Mills', and 'Grinders'. This careful patterning of separate vignettes on the same page clearly announces the genre Pyne thought of himself as working within. In the 1790s George Morland in particular, but other artists as well, had taken to publishing

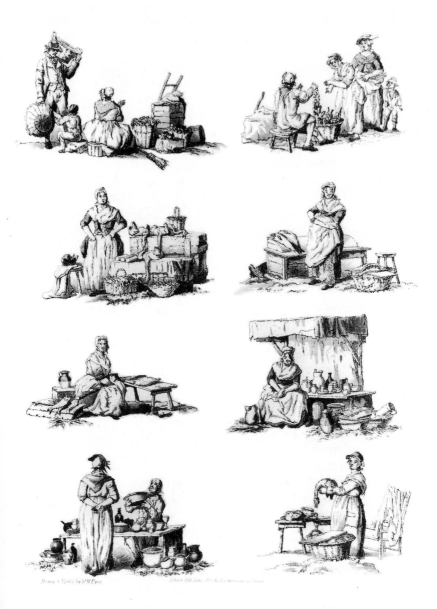

4.4 Microcosm, plate 71. *Market Groups*. Left to right, top to bottom: Group selling fruit. Selling onions. Selling poultry. Selling fish (1). Selling fish (2). Selling earthenware (1). Selling earthenware (2). Selling geese.

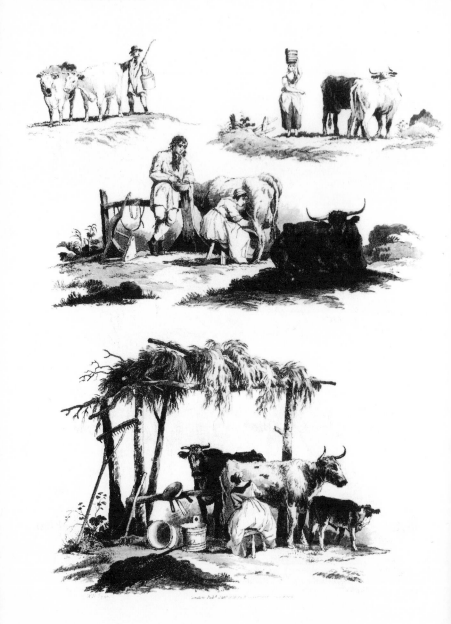

4.5 Microcosm, plate 51. *Dairy*. Left to right, top to bottom: Milkman driving his cows. Dairy-maid. Woman milking. Milking, with cows underneath a shed.

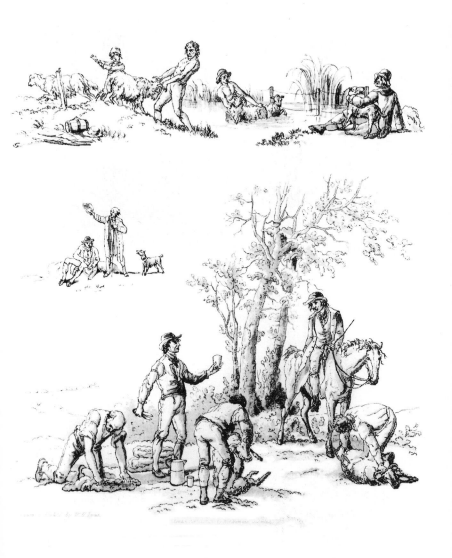

4.6 Microcosm, plate 45. *Sheep-Shearing & c.* Left to right, top to bottom: Washing the sheep preparatory to the shearing. Shepherds. Sheep-shearing, rolling the fleece, &c.

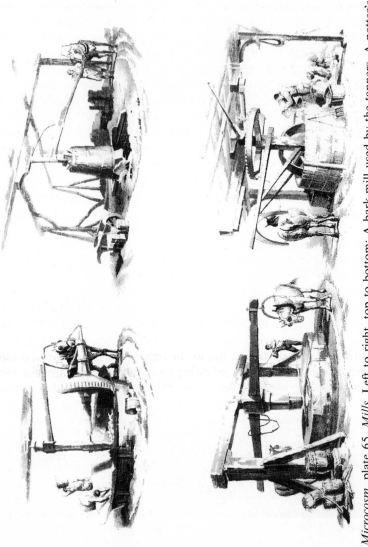

4.7 *Microcosm*, plate 65. *Mills*. Left to right, top to bottom: A bark-mill used by the tanners. A potter's mill for grinding clay. Machine for raising water. A mill for grinding chalk.

volumes of etchings which purported to be reproductions of their private notebooks or sketchbooks. These volumes sometimes devote a single sheet to the reproduction of a single finished drawing, but as often a number of separate studies are grouped together on the same plate, with a careful attention to the balance of each composite sheet – though never, so far as I have observed, with quite as meticulous an attention as Pyne's. This style of presentation, which became very common in nineteenth-century drawing manuals, seems to have been governed by a specific aesthetic. Ten of Morland's published sketchbooks have the title *Sketches from Nature*, just as Pyne's vignettes are said on his title-page to be 'accurately drawn from nature'. The notion involved here is that sketches and drawings from nature are, precisely, accurate, because, unlike finished oil-paintings, they instantiate, once again, a vision unmediated by fancy or sentiment.[25]

But this specifically picturesque concern with the patterning of vignettes is useful to the aim of the *Microcosm* for more reasons than the fact that the vignette-sketch can be taken to represent a vision of objects disjoined from narrative, or from a concern with anything other than supposedly neutral visual appearances. For the patterned page, when it no longer depicts, as in Morland's sketch-books, a random collocation of figures and objects, but a deliberate sequence of actions, could of course also be used to propose a new form of narrative structure, different from the sentimental narratives that inform contemporary rustic *genre*-painting, and of particular use to the representation of the *division* of labour, when the point of doing so is to make a claim for the *coherence* of divided labour, or for the ability to understand it *as* coherent. Each vignette can be used to represent the various stages of a divided productive process. In the depiction of this process, the separate figures and groups may appear preoccupied with their own particular tasks, and so unaware of themselves as participating in this new form of narrative; and in this light, the *Microcosm* can be seen as a depiction of a fiction of alienated labour, labour in which the other various stages of production are conceived of as incomprehensible to those whose task is confined to just one of those stages.

The contrast with the bustling *atelier*-scenes of collective work in the plates of late eighteenth-century encyclopaedias could hardly be more marked. That contrast is to be understood in discursive rather than in material terms. It is not that the work of artisans is being

differently performed in 1800; it is being conceived differently, by those who do not perform it, as a collection of individual and separate operations.[26] By conceiving of manual and artisanal labour in this way, those who do not perform it – the readers of the *Microcosm* – can establish their superiority over, and distance from, those who do, by the claim that they (and only they; that is the fiction) can construct the narrative that links each operation to the others.

That task is made easier in the *Microcosm* by the prose essays that accompany the plates (for the sequence of actions the plates illustrate cannot always be read from left to right and top to bottom – Figure 4.8, of potters and leather-dressers, is a case in point). The meticulous patterning of the plates positively invites us to understand these different stages of production as together composing not just a coherent story, with a beginning, a middle and an end, but a unity. To understand *how* the different stages of a productive process cohere into unity, it seems, what is necessary is to take up a position outside that process – it is from there that its unity can be observed, from the place, so to speak, of the philosophic eye; and of the picturesque eye too, now that the Picturesque has been reduced to a style, and employed in the attempt to give a visible shape to the otherwise invisible structure of the division of labour.

VI

So much, then, by way of justifying my contention that in the *Microcosm* the discursive conflict I identified results in an appropriation of the Picturesque by the discourse of the division of labour: an appropriation, I have argued, which has the effect of divesting the Picturesque of its character as an occupational idiolect, the discursive articulation of an occupational interest. I want now to represent another result of that conflict, in which the Picturesque, instead, can be understood as resisting the totalizing and appropriating efforts of the discourse of the division of labour, and as advancing its own competing version of social knowledge.

The point can be made by examining what occupations the *Microcosm* does and does not illustrate. In 1815, Patrick Colquhoun produced a table which attempted to 'ESTIMATE THE NEW PROPERTY ARISING ANNUALLY IN GREAT BRITAIN AND IRELAND, Arising from the Use of Capital combined with Human Labour and Machinery . . . as derived from *Agriculture, Mines and Minerals, Manufactures, Inland Trade, Foreign Commerce and*

4.8 Microcosm, plate 10. *Pottery* and *Leather-dressing*. Left to right, top to bottom: Removing the pots from the kiln (1); Removing the pots from the kiln (2). Packing the ware in crates. [Undescribed]. Making heavy vessels in clay, such as pans, dishes, &c.

Staking the leather (1). Two men withing leather (a process in the production of white leather). Staking the leather (2). Grounding the leather (a softening process). Soaking white leather to get rid of the salt.

Shipping, Coasting Trade Fisheries, and Foreign Income A Treatise on the Wealth, Power, and Resources of the British Empire.[27] Colquhoun's estimates are for the year 1812, a few years after the publication of the collected edition of the *Microcosm*. His text is probably the most comprehensive attempt, contemporary with the *Microcosm*, to understand the economic structure of Britain in terms of the discourse of the division of labour. When I tried to divide the occupations illustrated by Pyne into Colquhoun's categories, I was struck by two things in particular. To begin with, I had somehow gained the impression that a far greater proportion of plates than was in fact the case were devoted to representations of agricultural employments. I had assumed, that is, and wrongly, that the claim made by the Picturesque, to a special privileged perception of 'the natural', and the stated object on the title-page, that the vignettes would be used for the embellishment of landscape, would have tended to privilege agricultural over manufacturing employments as suitable subjects for representation. The hostility of the Picturesque to images of manufacturing industry is far greater than its hostility to images of industrious agricultural workers,[28] as Gilpin's distinction between the 'laborious mechanic' and the 'loitering peasant' has already suggested to us, for his implication is that we associate the mechanic with industry, but that we can more easily associate the peasant with a sauntering disinclination to labour. But in fact, only about nineteen of Pyne's plates represent agricultural employments, while some twenty-nine depict what Colquhoun classified as manufactures, and some twenty-two depict subjects of inland distributive trades. Another three illustrate trades associated with mines and minerals, and about four each represent coastal trade and fisheries – the figures are approximate because not all the plates can be easily classified.

Second, however, I was struck by the fact that of what were, according to Colquhoun, easily the four most productive manufacturing industries, Pyne chooses to illustrate only the leather industry, which appears in two plates. Thus apart from one plate of sheep-shearing, the *Microcosm* makes no acknowledgement at all of the textile trades in Britain and Ireland, cotton, woollen and linen manufactures, to the increasing mechanization of which Colquhoun among others attributed Britain's economic miracle.[29] Of exportable manufactures, 'by far the most extensive', according to Colquhoun, were '*cotton, woollen, leather, linen, fabricated metals, glass,* and *porcelain*', in which he includes all ceramic manufactures.[30] Of these seven, Pyne illustrates only three; and of

the sixteen most productive manufacturing industries, according to Colquhoun's estimates, only eight are depicted by Pyne.

These two things are, of course, related. At the point at which woollen and linen production become manufacturing industries, they move, for the most part, indoors, and are lost to the landscape and the rustic *genre* artist. My impression that there was a bias towards images of agricultural employments was the result not only of the bias of my own interest in landscape, but of the fact that, of Pyne's 121 plates, only about ten or eleven illustrate occupations that are carried on wholly or partly indoors.[31] Three of these are plates of cottage interiors and domestic work, a favourite theme of rural subject-painters, and in the case of none of the others is the interior location suggested except by the absence of the usual landscape motifs. What purports, then, to be a 'microcosm', a comprehensive and a disinterested delineation of the 'various modes' in which Britain's 'capital is invested', and 'her industry is employed', turns out to be a thoroughly partial view from the vantage-point of a particular occupation, that of the artist in landscape and *genre*.

Thus employments are divided and distinguished by Pyne according to the different possibilities they offer for the embellish-ment of landscape, and the potential of figures to embellish is so much more important a qualification for their inclusion in the *Microcosm* than their ability to contribute to Britain's wealth, that in disregard of his own stated purposes, and in deference to an imperative enunciated by Gilpin, Pyne devotes a number of plates to labour conceived of as so unproductive that it is not recognized as labour at all. In his poem 'On Landscape Painting', Gilpin had advised the artist not only to exclude, as usual, the 'low arts of husbandry' from 'rocky', 'wild', and 'awful' scenes, but to invite in their place 'gypsey-tribes' and 'banditti fierce', who would be as appropriately 'wild as those scenes themselves'.[32] And accordingly, Pyne introduces two plates of gipsies, who, for all their 'sloth and idleness' as Gray describes it, 'certainly afford us some very picturesque groups'.[33] There is a further plate devoted to smugglers, partly on the grounds that 'the scenery . . . in which they are generally found, has much of the grand and the wild', and partly because they can stand as home-grown substitutes for the 'banditti' who provide the conventional *staffage* of landscape-painting in the style of Salvator Rosa.[34]

But in case there are some for whom only the real thing will do, Pyne also provides (Figure 4.9) four vignettes of banditti in the

4.9 Microcosm, plate 60. *Banditti.*

genuine Calabrian style, wearing armour, lounging on rocks and under trees, and contributing only in the most unimaginably indirect way to the economic progress of Britain. By plates like these, but also by the nearly exclusive concentration on outdoor employments, social knowledge is defined as knowledge useful to the landscape artist. And in this connection, it is worth noticing that when the book was republished in 1845, by which time a clearer division had been produced between technical and decorative drawing, its title was changed. 'Microcosm' was dropped, the main title became *Picturesque Groups for the Embellishment of Landscape*, and reference to whatever useful application the book still aspired to was relegated to the small print of the title-page.

In this process of resistance to the totalizing aspirations of the discourse of the division of labour, that discourse is itself revealed as an occupational, an interested discourse, with its own specialized account of what knowledge is. For the whole point is that gipsies, smugglers, banditti (or armed robbers, for that is how they are treated in the accompanying prose-essay) were indeed *participants* in the economic structure of early nineteenth-century Britain. They performed a variety of labour, which was, however, ignored in accounts of the division of labour, not because it was illegal, but because it was invisible to the philosophic eye. And it was so because economic philosophy conceived of society as structured like a market, in which each person exchanged the goods and services they had to offer for the goods and services they needed or desired. Gipsies, who were almost universally regarded as thieves, robbers, and smugglers, were all excluded from the visible market; the goods they had to exchange had not been acquired by anything that a political economist could understand as labour or could recognize as an act of exchange.

The absence of such occupations from the economic and social totality envisaged by the discourse of the division of labour reveals, as I say, that this discourse offers a restricted and an interested account of what social knowledge is. It could be argued that the presence of such occupations in the *Microcosm*, and the absence of images of large-scale manufacturing industry, reveal the occupational bias of the Picturesque. But it could equally be argued that the Picturesque, by virtue of its ability to notice and to represent the activities of criminals and of others who are invisible within the commercial market, and by virtue too of its ability to represent leisure as well as industry – the *Microcosm* includes plates of archery, cricket, hunting, skittles, and so on – produces an account

of the variety of social activities no less expansive, though certainly less methodized, than that revealed to the economic philosopher.

I have not been able to compress my account of the plates sufficiently to allow me to discuss the accompanying essays at any length, so I can only give the most general idea of what interests me about them. It is that they seem unable to produce an account of the various occupations they describe which can represent them as other than divided, and as divided beyond the point of being comprehensible in terms of their participation in what might be, however invisibly, a coherent form of social organization.

We have seen how the possibility of envisaging a coherent society depended, for the discourse of the division of labour, upon the production of a unified and a disinterested subject to articulate that discourse. The visual discourse of the Picturesque, deployed through the plates, could produce the illusion of such a subject, by bestowing the same kind of alienated attention on all the objects illustrated. There is no equivalent coherence in the essays, because there seems to be no similarly coherent discourse available to govern the representation of all the various occupations they describe. Their incoherence arises partly from the fact that many of those occupations present themselves to the writer far more thoroughly inscribed within their own individual discursive histories: the shepherd within the Pastoral, the ploughman within the Georgic, the haymaker within the Comic, the soldier within a discourse of popular patriotism, and so on. It arises also from that hospitality to discursive variety which characterizes the essay-genre in the eighteenth and early nineteenth centuries. Thus some employments are discussed in terms of their history and some in terms of the supposed moral condition of their practitioners; of others, Gray simply observes that there is nothing much to say about them. Interwoven with all these discourses is the discourse of the division of labour, which attempts to establish a unified subject, with a stable viewing-position and with a coherent grasp of each occupation in particular, and of the structure of the body politic in general. But it is unable ever to silence those other discourses for any length of time and becomes just one of a hubbub of voices, which together produce the representation of a society irretrievably atomized and dispersed.

Notes

1 What is, as far as we know, the first extended discussion of the division of labour occurs in Book 2 of Plato's Republic (Plato, *Republic*, tr. P. Shorey, London: Heinemann, and Cambridge, Mass.: Harvard University Press, 1970, pp. 149–71). Plato's account was imitated in the eighteenth century by Hume (D. Hume, *A Treatise of Human Nature* (1739–40), (eds) L.A. Selby-Bigge and P.H. Niddich, Oxford: Oxford University Press, 1978, pp. 485ff.); and by James Harris (J. Harris, 'Concerning Happiness, A Dialogue' (1744), in *The Works of James Harris*, London: Thomas Tegg, 1841, pp. 59ff.). The fullest eighteenth-century elaboration of the discourse of the division of labour is Adam Ferguson (A. Ferguson, *An Essay on the History of Civil Society*, London: A. Millar and T. Cadell, and Edinburgh: A. Kincaid and J. Bell, 1767).

2 P. Colquhoun, *A Treatise on the Wealth, Power and Resources of the British Empire, in Every Quarter of the World, Including the East Indies, &c.* (1815), facsimile reprint, New York: Johnson Reprint Corporation, and London: Johnson Reprint Company Limited, 1965, p. ix.

3 A. Smith, *An Enquiry into the Nature and Causes of the Wealth of Nations* (1776) (eds) R.H. Campbell, A.S. Skinner and W.B. Todd, Oxford: Clarendon Press, 1976, I. pp. 28–9.

4 ibid., I, p. 456.

5 ibid., I, p. 21.

6 A. Smith, *Lectures on Jurisprudence*, (eds) R.L. Meek, D.D. Raphael and P.G. Stein, Oxford: Clarendon Press, 1978, p. 570.

7 Smith, *An Enquiry*, I, pp. 21–2.

8 The text of the *Microcosm* used in the writing of this essay is the facsimile of the second (1845) edition, with A.E. Santaniello's valuable introduction and brief bibliography of studies of Pyne's work (W.H. Pyne, with C. Gray and J. Hill, *Microcosm, or A Picturesque Delineation of the Arts, Agriculture and Manufactures of Great Britain in a Series of above a Thousand Groups of Small Figures for the Embellishment of Landscape* (1806, 1808, reprinted 1845 as *Picturesque Groups for the Embellishment of Landscape*),

130 *John Barrell*

facsimile reprint of 1845 edition, with 1806 title, New York:
Benjamin Blom, 1971). Unless otherwise stated, all quotations from
the *Microcosm* are from the introduction by C. Gray, pp. 24–5.

9 Smith, *An Enquiry*, I, p. 23.

10 See B. Mandeville, *The Fable of the Bees* (1714–24), (ed.) P. Harth,
Harmondsworth: Penguin, 1970, pp. 359–60.

11 'But if we turn the prospect, and look on all those Labours as so
many voluntary Actions, belonging to different Callings and
Occupations, that Men are brought up to for a Livelihood, and in
which every one Works for himself, how much soever he may seem
to Labour for others: if we consider, that even the Saylors who
undergo the greatest Hardships, as soon as one Voyage is ended,
even after the Ship-wreck, are looking out and solliciting for
employment in another: If we consider, I say, and look on these
things in another View, we shall find that the Labour of the Poor, is
so far from being a Burthen and an Imposition upon them; that to
have Employment is a Blessing, which in their Addresses to Heaven
they Pray for, and to procure it for the generality of them is the
greatest Care of every Legislature' (ibid., p. 360).

12 See N. Hans, *New Trends in Education in the Eighteenth Century*,
London: Routledge & Kegan Paul, 1951, pp. 152–60; J.W. Hudson,
The History of Adult Education, 1851, facsimile reprint, London:
Woburn Books Ltd., 1969, pp. 29–35; T. Kelly, *A History of Adult
Education in Great Britain*, Liverpool, Liverpool University Press,
1970, pp. 78–9.

13 See e.g. Bentham's the definition of *technology*: 'From two Greek
words: the first of which signifies an *art* ... a *connected* view is
proposed to be given, of the operations by which *arts* and
manufactures are carried on ... On this occasion will be to be shown
and exemplified, the advantages, of which, in respect of *despatch* and
perfection, the principles *of the division of labour* is productive.
Here will be shown how, by the help of this most efficient
principle, as *art* and *science* are continually making advances at the
expense of *ordinary practice* and *ordinary knowledge*, so *manufacture*
(if by this term be distinctively designed *art*, carried on with the
help of *the division of labour*, and thence *upon a large scale*) is
continually extending its conquests, in the field of *simple handicraft*–
art carried on *without* the benefit of that newly found assistance' (J.
Bentham, *Chrestomathia* (1817) (eds) M.J. Smith and W.H. Burston,
Oxford: Clarendon Press, 1983, p. 85).
For Mechanics' Institutes, see J.F.C. Harrison, *Learning and Living
1790–1960: A Study in the History of the English Adult Education
Movement*, London: Routledge & Kegan Paul, 1961, pp. 79–84.

14 See P. Funnell, 'Visible Appearances', in M. Clarke and N. Penny,
(eds) *The Arrogant Connoisseur: Richard Payne Knight, 1751–1824*,
Manchester: Manchester University Press, 1982, pp. 82–92.

15 Quoted in C.P. Barbier, *William Gilpin*, Oxford: Oxford University

Press, 1963, p. 112. Barbier's book is the best account of Gilpin, and an excellent guide to the early phases of picturesque theory.

16 W. Gilpin, *Observations Relative Chiefly to Picturesque Beauty, Made in the Year 1772, On Several Parts of England; Particularly the Mountains and Lakes of Cumberland, and Westmoreland,* 3rd edn, London: R. Blamire, 1792, II, pp. 44–5.

17 Gilpin, *Observations,* II, pp. 43–4. Compare Archibald Alison (A. Alison, *Essay on the Nature and Principles of Taste,* 3rd edn, Edinburgh: George Ramsay, 1812, I, p. 121) on the same topic: 'The sublimest situations are often disfigured, by objects we feel unworthy of them – by traces of cultivation, or attempts towards improvement ... The loveliest scenes, in the same manner, are frequently disturbed ... by the signs of cultivation ... [and] the traces of manufactures.' Alison is not truly a theorist of the Picturesque, and bases his aesthetic on the association of ideas. The point of this passage is to prohibit the intrusion into aesthetic experience of mean associations, rather than to invite us to consider 'sublime situations' independently of the associations they may evoke.

18 Gilpin, *Observations,* II, p. 44.

19 See J. Barrell, *English Literature in History 1730–1780: An Equal, Wide Survey,* London: Hutchinson, 1983, introduction.

20 W. Gilpin, *Three Essays on Picturesque Beauty; on Picturesque Travel; and on Sketching Landscape: with a Poem on Landscape Painting. To these are now added Two Essays Giving an Account of the Principles and Mode in which the Author executed his own Drawings,* 3rd edn., London: Strahan and Preston, 1808, p. 165.

21 See F. Owen and D.B. Brown, *Collector of Genius: A Life of Sir George Beaumont,* New Haven and London: Yale University Press, 1988, chapters 10 and 11.

22 See J. Barrell, *The Political Theory of Painting from Reynolds to Hazlitt: The Body of the Public,* New Haven and London: Yale University Press, 1986. For civic humanism, see J.G.A. Pocock, *The Machiavellian Moment: Florentine Political Thought and the Atlantic Republican Tradition,* Princeton N.J. and London: Princeton University Press, 1975.

23 See M. Clarke, *The Tempting Prospect: A Social History of English Watercolours,* London: British Museum Publications, 1981, chapter 5.

24 ibid., chapter 5.

25 For drawing books, see P. Bicknell and J. Munroe, *Gilpin to Ruskin: Drawing Masters and their Manuals, 1800–1860* (catalogue of an exhibition at the Fitzwilliam Museum, Cambridge, and at Dove Cottage, Grasmere), London: Christie's, 1987, and K. Spelman, *The Artist's Companion: Three Centuries of Drawing Books and Manuals of Instruction,* York: Spelman, no date. For a list and discussion of Morland's sketch books, see F. Buckley, 'George Morland's Sketch

Books and their Publishers', *The Print Collector's Quarterly*, 1933, vol. 20, no. 3, pp. 211–20.

26 The history of Encyclopaedia illustration in eighteenth-century Britain is complicated by the fact that new encyclopaedias might buy or copy the plates of their predecessors, as well as from the Diderot/D'Alembert *Encyclopédie*. By and large, however, it seems fair to generalize that the *atelier*-scene more or less disappears around 1790. Such scenes appear, for example, in the first edition of *Encyclopaedia Britannica* (1771); in Hinde's *New Royal and Universal Dictionary of Arts and Sciences* of 1771–2; and in Middleton's *New Complete Dictionary of Arts and Sciences* of 1778; there are none in Howard's *New Royal Cyclopaedia* of 1788, or in Chambers' *Cyclopaedia* of 1791; and they are most uncommon thereafter.

27 Colquhoun, *A Treatise*, pp. 89–96.

28 For example, in a review in the *Somerset House Gazette*, 5 June 1824, vol. 2, no. 35, p. 130, Pyne praised the peasants depicted by Joshua Cristall, which, he said, 'though truly English, are not the slouching boors or slatternly ale-house maids of George Morland. They are selected from the sequestered village, yet uncontaminated by the vicinity of manufactories.'

29 Colquhoun, *A Treatise*, p. 68.

30 ibid.

31 Basket Makers and Coopers, Brewing (1/2 sheet), Copper Smiths, Cottage Groups, Cottagers, Domestic Employments, Iron Foundry, Pottery and Leather Dressing, Slaughter-Houses, Statuary, Wheelwrights.

32 Gilpin, *Three Essays*, 1808, p. 165.

33 Pyne, *Microcosm*, 1806, p. 17. For some useful remarks on attitudes to gipsies in the last decade of the eighteenth century and the first decade of the nineteenth, see D. Simpson, *Wordsworth's Historical Imagination: The Poetry of Displacement*, New York and London, Methuen, 1987, pp. 43ff.

34 Pyne, *Microcosm*, 1808, p. 25.

5 Illegitimacy, insanity, and insolvency: Wilkie Collins and the Victorian nightmares

Stana Nenadic

INTRODUCTION

This chapter has three intentions. The first is to offer certain speculations on the relationship between literature, society, and history. It then considers the problems and opportunities provided by the nineteenth-century novel as a source of social and economic history, and in considering these issues suggests a model by which the novel as history can be exploited. Finally, it applies this model to a particular type of nineteenth-century fiction, usually called 'sensation' fiction,[1] and the work of one notable writer within that genre, Wilkie Collins. The purpose is experimental and the conclusions are tentative. The essay has developed from a concern with a number of aspects of the common use of novels as history. It would seem, for instance, that the apparent 'realism' of much nineteenth-century fiction has often led to the assumption that these are true reflections of past reality. Moreover, the fiction which is today defined as having literary value, and consequently continues to command an audience, tends to be more exploited than that which has little value as literature and is no longer popular. It is also apparent that in using novels as history there is limited reference to why they were written, whom they were written for, and the changes that occurred over time in these producers and consumers. The approach suggested here is illustrated through a form of popular fiction that is highly unrealistic, has limited literary merit, and is little read today. None the less, it has important things to say about the society that created and consumed it.

LITERATURE, SOCIETY, AND HISTORY

It is a truism that works of literature or art are products of the relationship between artists as individuals, the cultural environ-

ments in which artists work and the societies and economies that give rise to those cultures.[2] Dilthey, the late nineteenth-century German philosopher and historian, explored these relationships in depth. Building from the ideas of Goethe, he regarded literature as an important source of representation of the essence of a society:

> Artistic creation produces types which raise and intensify the manifold of experiences to an image and thus represent it. Thus, the opaque and mixed experiences of life are made comprehensible in their meaning through the powerful and clear structure of the typical.[3]

As an historian Dilthey stressed the value of the study of artistic creations as the 'symbolic expressions' of their society.[4] He also emphasized the role of dominant artistic forms or genre as the manifestation of qualities typical to an age. In the development of an appropriate type of literature to represent and communicate the ideas of nineteenth-century society he identified the rise of the modern novel as the significant 'type':

> Society needs such a form and searches for it. This task reflects the nineteenth century, which was steeped in social reality. The same epoch which brought forth sociology . . . also brought forth the social novel. Without the needs, questions and scientific tendencies of this time, the novel would not be conceivable.[5]

Similar views were expressed by a number of British writers, including Carlyle and Tennyson. The latter regarded the novel as 'the vital offspring of modern wants and tendencies', fulfilling the symbolic functions once occupied by Drama or the Epic in earlier ages.[6] But for Dilthey the dominant forms of 'artistic creation' were far more than just simple, functional symbols by which to interpret a society or an age. Works of literature are important because they have what he defined as pre-scientific immediacy. They are forms of knowledge which though neither rigorous nor precise often precede scientific, statistical, and objective knowledge. Literary art, therefore, is considered to be a 'privileged repository of the understanding of life'.[7] Through images of experience, it conveys knowledge of society in ways that are capable of anticipating other types of knowledge or would not be possible in other forms. But since such art is not tied to abstract or systematic schema, as in the human or natural sciences, it also incorporates 'fantastic situations and inventions'.[8] The only qualification of Dilthey's view that I wish to offer, a qualification that is historically specific since it is relevant

mainly to the modern era, is that the forms of literature that best represent the 'types' of a society are the popular forms for mass consumption. Additionally, in interpreting the historical value of this 'art' (if this is still an appropriate term) close attention should be paid to the character and motives of the consuming audience. Though this can be further qualified by stating that in the age of art for mass consumption the forms that best act as pre-scientific knowledge are probably fine or intellectual art where the audience is inevitably limited.

Now, none of these prefatory remarks can be regarded as particularly startling, since the ideas of Dilthey as a philosopher of literature and history are familiar. They are introduced here because despite the existence of this body of analysis, which should be capable of providing the foundation for a rigorous methodology of source use, literature is not generally subject to systematic attention by historians. Novels, plays, or poetry are regarded as at best peripheral and often completely irrelevant, particularly in the pursuit of scientific history which tends to reject the narrative in discourse and evidence.[9] This perspective, born out of statistics-based social science history, is strong, yet it seems clear (to this historian at least) that an understanding of the actions of people in the past is best approached through an analysis of *mentalité* and a good point of access to group *mentalité* is creative and especially literary art.[10] Following from the argument of Dilthey, with reference to the nineteenth century, this would imply the novel, which is, I would suggest, a major unexploited resource. What it awaits is a theory of source use and a systematic methodology. This essay is an initial attempt to address the related problems of source theory and method based on the briefly drawn philosophical foundations outlined above.

THE PROBLEMS AND OPPORTUNITIES OF THE NINETEENTH-CENTURY NOVEL

The novel was a product of the eighteenth century, where it served a distinct function, both didactic and entertaining, but gained maturity as the dominant literary type in the nineteenth century. From the 1840s, mainly through the development of serial publication, it also became the most notable form of popular art for mass consumption. Indeed, certain novels and novelists of the period 1840 to about 1870 occupied unique positions within their society, since great art was both popular and highly oriented to the

consumer.[11] In the study of British society and economy it is novels of these middle decades of the nineteenth century that have been most exploited by historians. Usually this is in one of three ways. First there is the use of description as illustration or example, employed to give a sense of landscape or place, or sometimes a sense of character or types of individual. The squalor and grime of the metropolis in Dickens' *Bleak House*; the train journey into an industrial town described in Gaskell's *North and South*; or the manners and style of the Anglican clergy in Trollope's *The Warden* are examples. Allied to this is another use, that of voiced opinions as example or illustration. These might be the opinions of particular characters within a novel, or the views of the author as narrator. Frequently there is an inference that the opinions of certain characters are those of the author. A good illustration is provided by the debates in Charlotte Brontë's *Shirley* on gender and the limited opportunities available to women. A final approach is seen in the use of incidents, often of a dramatic kind, that provide a dynamic illustration of social relationships or attitudes – incidents such as the factory riot in *North and South*, the dismissal of Stephen in Dickens' *Hard Times*, or the seduction of Ruth in Gaskell's novel of that name.

These related approaches – description, opinion, and incident employed as example or illustration – represent the commonest uses of the novel as history.[12] But they present problems. By removing descriptions, opinions, or incidents from the original fictional work there is a loss of both context and narrative sequence which undermines value and leads to the inevitable status of 'second-class' or corroborative evidence. When used comparatively to illustrate change over time this problem is compounded since not only is the context lost and value undermined, there is frequently also an unspoken assumption that the novel as a cultural product, in its supply, demand, and impact, is unchanging. A familiar illustration of these problems, in a thesis that relies heavily on literary evidence, is provided by the strikingly influential set of ideas, advanced most cogently by Martin Weiner in *English Culture and the Decline of the Industrial Spirit*, that middle- and upper-class attitudes to business and commerce changed in the mid-nineteenth century and this change signified the rise of an anti-industrial culture which undermined the quality of British entrepreneurship. Although it is not possible to consider these ideas or their development in depth, it is worth saying that even a superficial knowledge of nineteenth-century literature casts doubt on the

'anti-industrial' culture hypothesis. Weiner relies on selective readings, taken out of their historical and cultural context, of the fictional works of Dickens, Trollope and Hardy and also of writings of Mill, Carlyle, Ruskin, and Arnold.[13] These authors are used to support an argument that is not based in any systematic exploration of bodies of texts relative to their writers and audience, but is located in an apparent decline of British industrial performance and competitiveness that is hard to account for in economic terms. There is a confusion of anti-commercial and anti-industrial sentiments,[14] certain writers and texts are ignored,[15] and literary opinions and characters are used as though they were facts and these facts as though they portrayed a universal reality.[16]

Now this criticism should not be held to imply that descriptions, opinions, and incidents abstracted from novels have no value. The corroborative example or illustration can have worth where it 'vivifies, personalises and renders concrete what the historian already holds'[17] and it can, additionally, bring variety to the historical text as work of literature. But this kind of source use does not conform to Dilthean notions of the relationship between the arts, society, and history nor can it be regarded as rigorous in method. I would suggest, however, that rigour can be achieved if the source is approached not as corroboration, a form of second-class evidence, but as the point of departure, the text read for itself and in its entirety; fictional genre, to take the point further, read as a whole within the cultural context of their production. In reading the individual work or the genre as an entity two clear routes to the novel as history are presented. The first involves the linguistic exploration of texts and the interpretation of specific words, phrases, or even syntax structures that reflect changes in language and the perceptions that underpin language. Few have approached novels in this way, though Briggs and Williams have surely indicated the potential, now greatly enhanced by the evolution of computer-based text analysis.[18] The second approach to the novel also allows for a rigorous method and is based on the systematic exploration of the situations, circumstances, or relationships that typify novels within a particular genre. By taking account of the evolution of the novel as a cultural artefact (its production, consumption, and impact) this approach also seeks to understand the significance of changes in the typical situations, circumstances, and relationships that occur in fictional genre. The latter, what might be termed the macro-analysis of a body of texts as situations, complements the first method, that is the micro-analysis of texts as

language. Both give access to the cultural ideas that inform group *mentalité* and give rise to social action, and since the analysis is in-context and text-centred, both sustain the integrity of the art-form.

The second approach, the exploration of texts as situations, is the one that will be developed here. In order to do this it is necessary to consider further one of the major reasons why novels have been exploited as history, and use the discussion as a basis for advancing a specific analytic model. As previously indicated, nineteenth-century novels command attention because in subject-matter they are often concerned with the dynamics of society or social relationships and in narrative framework they tend to be constructed out of commonplace, realistic details and everyday experiences. Fictional characters (or the author) voice opinions on society and relationships and in so doing frequently also make overt reference to some of the real political or economic events and environments that shaped contemporary experience. Those novelists who do this most consistently and loudly, and in particular those who do it with reference to industrial and urban relationships, or relationships between the rich and the poor, are most valued, reflecting, of course, the preoccupations of historians of the period.[19] But although the 'realism' of detail and the presence of contemporary social opinion is what makes these novels attractive, and consequently exploited as description, opinion, or incident, it is the same characteristics that can render them dangerously misleading. This is important because I want to argue that although the nineteenth century gave rise to novels that seem realistic because they present elements of the familiar and typical, they are not what they seem. The fictional types that dominated the nineteenth century, the middle decades in particular – the social problems novel, incorporating works of Dickens, Gaskell, Disraeli, and Kingsley, the domestic novel exemplified by Trollope and Oliphant, and the sensation novel of Collins or Reade – do have elements of social realism about them. But this realism only exists in certain limited dimensions, associated with, for instance, location, and this is quite clear if you analyse the situations, circumstances, and relationships they typically confront. Though usually enacted in commonplace environments, they are what Dilthey called 'fantastic situations and inventions'. And this caution, commonly made and with a provenance that can be traced to Tawney,[20] should be considered in any reading of the novel as history.

If the nineteenth-century novel is not realistic, if it is composed of 'fantastic situations and inventions', then where lies the value as a historical source? One possible approach to this question is through an exploration of the reasons why authors write novels (the supply and production side of the equation) and why readers read them (the demand and consumption side). In considering these two sides of cultural production we need to ignore modern judgements of literary value, which consign most of the fiction of the nineteenth century to oblivion regardless of popularity or perceptions of worth at the time of production.

We should also ignore the simple fact that some of the cultural products of earlier ages, in either original or pastiche forms, continue to generate a demand. By keeping in mind the supply and demand aspects at the time of production, and by looking at the typical situations, circumstances, and relationships within genre, it can be argued that novels, as with other forms of art, are to do with creating, affirming, testing, or undermining the dominant cultural ideas and perceptions that characterize a society. And these cultural ideas or perceptions are generally explored through an evocation of the *desires* and *anxieties* of the consuming groups.[21] This notion of desires and anxieties can be demonstrated in a brief survey of certain types of nineteenth-century fiction and the situations, circumstances, and relationships they present.

The desires and ideals of the middle class,[22] the principal novel-consuming group, are well illustrated by the popularity of the 'silver fork'[23] novels of 1830s and 1840s, exemplified by Bulwer-Lytton and Disraeli, and later parodied by Thackeray. These stories of rich and aristocratic London society found favour among the aspirant and upwardly mobile provincial middle class who were hungry for details about the lifestyle, the etiquette, and the material trappings of the wealthy. When in 1838 Harriet Martineau published her novel *Deerbrook* it caused disgust among critics and audience alike, because, as she later said, 'the heroine came from Birmingham and...the hero was a surgeon. Youths and maidens in those days looked for lords and ladies in every page of a new novel'.[24] 'Silver fork' novels presented the middle class with their own notions of desired lifestyle and manners and affirmed the preoccupation with objective and material symbols of success. They dealt with aspirations of the future, yet in such a way as to confirm an existing pattern of status since these aspirations were, for most readers, simply fantasies. From the 1840s novels also explored the middle-class desire for a sense of community, something that was

once held but now perceived to be lost. It is a common observation that many nineteenth-century novels construct complex and many-peopled communities – 'knowable communities' to use the term coined by Raymond Williams[25] – and that these communities exist to be enjoyed vicariously by the reader. The most striking examples are furnished by Gaskell's *Wives and Daughters* and Eliot's *Middlemarch*, published in 1866 and 1871 respectively. Often, as in these cases, such novels are set in the recent past of personal memory, before the railways, before the perceived anonymity of the big-city life had settled upon Britain, and before the development of restrictive, suburban domestic environments. They are usually located in the provinces, often in small towns and villages, and concern the everyday and minor activities of the middle classes. Striking in another way are the communities of Dickens, located mainly in cities and constructed out of tenuous connections and chance occurrences so carefully crafted that their improbability is overlooked.

The individual desire for romantic love, companionable marriage, and the domestic ideals of family and home are also affirmed through nineteenth-century fiction. This was particularly important to women since the identity and status of the middle-class woman came through reference to husband and family. But it is also seen from the male point of view through the systematic development of 'the angel in the home' model of wifely, motherly, and daughterly virtues.[26] The most powerful statement of individual love, narrated in the first person, widely emulated, and still popular is Charlotte Brontë's *Jane Eyre*. Again this is a work of fiction that is usually regarded as 'Victorian' in situation, and it is obliquely concerned with a significant Victorian issue, the plight of the governess, the middle-class woman with no husband, family, or wealth and ambiguous status.[27] Yet careful reading shows that it is set in the past, somewhere in the late eighteenth or early nineteenth centuries, as is most of the Brontë fiction.[28] *Jane Eyre* is a romantic fantasy providing a vicarious ideal of love for the unlovely, status gained by the status-less, linked to an evocation of a gothic past with a quintessentially Byronic hero.

Mid-nineteenth-century novels can, therefore, be viewed as 'fantastic situations and inventions' concerned with the exploration of class, community, or individual desires and these desires are often fixed on perceived losses of the past or hopes for the future. But in contrast to desire there is also anxiety, and the two are frequently juxtaposed in fiction. In cultural terms the nineteenth

century gave rise to the modern experience of anxiety and social instability, conditions that can be conceptualized as having resulted from an increasingly rootless, technological, and bureaucratic understanding of existence. Such anxieties and instabilities are perceived to be of man's making and can only be resolved by man's intervention. There are three striking aspects of manmade anxiety that exist as counterpoints to the desires just outlined.

The status aspirations and lifestyle desires of the middle class were clearly affirmed and explored through the popular 'silver fork' genre. But such aspirations were frequently coupled to status anxieties. The maintenance of status in an unstable and changing world was widely perceived to be a problem and had been a significant theme of fiction since the eighteenth century. Such anxieties are seen in Austen, Thackeray or Trollope and also in the sensation novels of the 1850s and 1860s. Alongside the desire for knowable communities, and the evocation of communities of the recent past, there was the parallel anxiety arising out of the disintegration of community in the present. The increasing gap between rich and poor, between north and south, between rural and urban, are anxieties explored in a range of fiction from 1840s to 1870s. Such works as Disraeli's *Sybil*, Kingsley's *Alton Locke*, or Gaskell's *North and South* – often called the social problem novels – conform in a striking sense to the Dilthean notion of pre-scientific immediacy. They explore and test certain issues and controversies, such as the idea of 'two nations' or the nature of poverty, that were pertinent to their society and influential in generating debate and policy.[29] Lastly, the desire for love and the pursuit of the domestic ideal should be set alongside a profound anxiety, particularly among women, arising from the inability to fulfil the ideal. Often reflecting the personal experience of the author several novels, the most notable being *Shirley*, examine the 'spinster problem' and the limited choices available to women who fail to find a husband and are forced to independence. The loveless marriage as a denial of the domestic ideal are themes of Dickens and Thackeray. Anxieties about love, marriage, and the family were also explored by Wilkie Collins and other 'sensation' novelists.

In summary, what I have attempted here is to construct a model by which to approach nineteenth-century novels as historical records. The model gives emphasis to fictional types or genre and is located in the exploration of common situations, circumstances, and relationships. It does not distinguish between great art and works of limited literary merit, but rather uses the audience (as

viewed by the author) and the popularity with that audience as the index of significance. The notion of the perceived audience is important, particularly for literary or artistic works intended by their creators for wide public consumption. So we have to ask ourselves why people wrote and read these cultural artefacts which are inventions. And I have proposed that one reason is because they are concerned with the desires and anxieties of those groups that furnished both the writers and the audience, namely the middle class. These novels presented fantastic situations which allowed the vicarious enjoyment of those things that were commonly desired, the vicarious suffering of the common sources of anxiety and by their juxtaposition the resolution of anxiety through the attainment of desires.

Now, the simple fact that individuals or groups have desires and anxieties which inform *mentalité* and are the basis of action should not be held to imply that the objects of desire were commonly attained or that the sources of anxiety were a part of everyday experience. Nevertheless, to heighten the potential that they could be part of the everyday, desires and anxieties were often conveyed to the audience through the medium of commonplace and realistic detail, particularly of location, lifestyle, and manners. The placing together of realistic details and fantastic situations is a striking aspect of that body of popular literature of the 1850s and 1860s known as sensation fiction. The second part of this essay considers the historical context and significance of this fiction, mainly through an analysis of the novels of Wilkie Collins.

WILKIE COLLINS AND SENSATION FICTION

Works of art can represent the 'types' or essence of an age and culture, but they are produced by individuals and informed by the individual's life and experiences. So it is worthwhile at the outset saying a little about the life of Wilkie Collins.

He was born in 1824, the eldest son of William Collins a successful artist, and named after David Wilkie, the great Scottish genre painter and his father's close friend.[30] He spent most of his life in London and his family enjoyed a comfortable middle-class lifestyle, though this was only maintained through his father's prodigious work-rate since the family had no inherited wealth. At the age of eighteen Collins was apprenticed as a clerk to a city-based tea trading house, but this was not a success and soon after he entered Lincolns Inn to train for the Bar. Although he never

practised as a lawyer, his legal knowledge was exploited in many of the novels.[31] Indeed, they often have a legal style or 'attitude of mind' which a later admirer, Dorothy Sayers, saw as the basis of what she called their 'curiously satisfying intellectual quality'.[32] Collins started to write in his early twenties and from about 1850 until his death in 1889 he published a novel, usually first in serial form, every two or three years. Many of the novels were successfully adapted for the stage, an important medium for Collins and for other sensation writers.[33] He had many friendships in the literary, theatrical, and artistic world of mid-nineteenth-century London. Dickens was close, a patron of his early work and related by marriage. Both as a child and adult he lived in that metropolitan subculture of professional artists who provided popular and commercialized art and entertainment mainly for the middle classes, but frequently disregarded middle-class norms of behaviour. Collins, for instance, never married but had two long-term and sometimes simultaneous mistresses, one bearing him several children.[34]

The most popular of Collins' novels during his own lifetime were those of the 1850s and 1860s at the height of the vogue for 'sensation' fiction. Indeed, the genre is commonly held to be exemplified by *The Woman in White* which first appeared in 1860. The sensation genre has many links with earlier gothic and romantic fiction and with 'novels of low life', or Newgate fiction. There are parallels with the so-called 'penny dreadfuls', the staple reading of the working class, and with certain forms of popular journalism. The essence of the genre is that it overturns and subverts domestic reality and domesticity. It takes everyday and commonplace family situations or relationships, with which the mainly middle-class and female readership would readily identify, and presents their threatening, sinister, and nightmarish possibilities. People are not what they seem. Mysteries and secrets abound. Physical, moral, and legal violations are the norm. The domestic world is a vile and violent place. According to one contemporary reviewer, 'a book without a murder, a divorce, a seduction, or a bigamy, is not apparently considered worth either writing or reading.'[35] Such a catalogue of horrors, in the opinion of *Punch* in 1863, was intended for 'harrowing the mind, making the flesh creep, causing the hair to stand on end, giving shocks to the nervous system, destroying the conventional moralities and generally unfitting the public for the prosaic avocations of life'.[36]

'Sensation' novels appealed to the sense of anxiety concerning what Henry James called 'those most mysterious of mysteries, the

mysteries which are at our doors ... the terrors of the cheerful country-house and the busy London lodgings'.[37] This appeal was made more powerful by the tendency for authors to insist that their work was based on real facts and incidents, and for presenting evidence in support of such contentions in either footnotes, preface or appendix. Charles Reade stated in his introduction to *Hard Cash* (a tale of courtship gone wrong, an inheritance that corrupts, a scheming father, and wrongful imprisonment in a madhouse where bureaucratic terrors, and violence, prevail) that this is

> A matter-of-fact Romance – that is, a fiction built on truths: and these truths have been gathered by long, severe, systematic labour, from a multitude of volumes, pamphlets, journals, reports, blue-books, manuscript narratives, letters, and living people, whom I have sought out, examined and cross-examined, to get at the truth on each main topic I have striven to handle.[38]

Collins engaged in a similar emphasis of the facts on which he built his fiction. In the preface to *Basil* (another tale of courtship gone wrong, with plotting servants and employees, a seduction, and disinheritance) he gives an outline of the guiding principles behind the sensation genre as a whole.

> Directing my characters and my story ... towards the light of Reality wherever I could find it ... in certain parts of this book where I have attempted to excite the suspense or pity of the reader, I have admitted as perfectly fit accessories to the scene the most ordinary street-sounds that could occur at the time and in the place represented – believing that by adding to the truth they were adding to the tragedy Those extraordinary accidents and events which happen to few men seemed to me as legitimate materials for fiction to work with, when there was a good object in using them, as the ordinary accidents and events which may, and do happen to us all.[39]

In a 'sternly prosaic age'[40] these explanatory prefaces were intended to heighten the appeal to the readers' senses, but were also a defence against the many professional critics who saw his type of fiction as at best ridiculous and at worst a source of moral corruption. The moral environment of many sensation novels is far distant from the usual middle-class ideal, and the typical characters, especially the women, behave in ways that were unlike anything previously explored through fiction. But most sensation novels do point to moral conclusions. Wrongs are righted, villains are punished, and

headstrong, mannish, and active heroines ultimately fulfil an 'angel in the home' destiny. Reference to a factual base and the resolution of plot in moral terms made these novels acceptable and popular with the public. The status of Collins was reinforced by his use of fiction to highlight certain social causes and iniquities and campaign for their reform. There is a clear parallel here with the social problem novels of the 1840s and early 1850s, though the causes and iniquities that Collins addressed – such as the legal dimensions of marriage and illegitimacy or women's property rights – were those that imposed on the family and the individual rather than on society as a whole.

Mrs Oliphant, a noted reviewer of the 1860s, declared of one of the sensation novelists, 'she never invented any circumstance so extraordinary as this public faith and loyal adherence which she seems to have won'.[41] Though frequently condemned by literary and moral critics, there is no doubt that these writers commanded a wide audience and were a commercial success. This was important to Collins. His aim was to be popular, to take his ideas, style, and causes to a broad readership, and to make a good living in consequence.[42] The most successful novel, *The Woman in White*, went into seven editions in six months, and while in serial form sold more copies of *All the Year Round* than the *Tale of Two Cities*, which preceded it in that journal. The success was so great that manufacturers made 'Woman in White' perfumes and 'Woman in White' cloaks and bonnets.[43] The first edition of *No Name*, his next novel, was almost sold out on the day of publication in 1863[44] and he received advances of five thousand pounds for *Armadale* in 1866.[45] Like other novelists who published in serial form, Collins had a close relationship with his readers. They were mainly middle-class in a period when most middle-class incomes were derived from business.[46] They were family-oriented and socially aspirant. In particular, they were women.[47] Reflecting this audience, his situations, circumstances, and relationships explore the desires and more especially the anxieties of middle-class families and middle-class women. Three central sources of anxiety are affirmed and explored in the novels of Collins: illegitimacy, insanity, and insolvency, the major threats to the middle-class family as a moral edifice and financial enterprise. The plot of *The Woman in White* turns on a complex relationship between these three factors. I have called these anxieties the 'Victorian nightmares', an appropriate term in two regards. First, as previously indicated, because the narrative structure of the sensation novel

takes the form of a sort of nightmare, where what is usual and expected is gradually undermined. Typical situations or relationships are distorted and overturned. But also because sensation novels often employ the dream or nightmare as a narrative device. As in earlier gothic fiction, nightmares point to future threatening situations or are used to explore subconscious motivations. But there is a difference in that Collins' nightmares are not usually founded in the supernatural. Though fantastic, they are located in possible situations and in real, manmade, and often legally constructed iniquities which real people feared. Fears about the real, if improbable, possibilities of gender relationships, marriage, family life, and property transfer are at the heart of the sensation novels. As indicated in the following analysis of the three 'nightmares', this is where the historical value of this type of fiction lies.

THE VICTORIAN NIGHTMARES

Illegitimacy is a common theme in nineteenth-century fiction. It is often employed as a vehicle for mystery and discovery as in Dickens' *Bleak House* or in Collins' *Hide and Seek.* In Gaskell's *Ruth* the illegitimate child is explored as a moral issue, a consequence of the possible circumstances that could afflict vulnerable young women.[48] A third aspect, and the one that particularly concerned Collins, is that of illegitimacy as a legal situation with implications for the family as an enterprise and for the transfer of property within families. This aspect is explored in depth in *The Woman in White* and *No Name*, and is also present in *Man and Wife* and *The Dead Secret.* In the first, Sir Percival Glyde, the villain, has falsified a parish register to hide the fact that his now dead parents were unmarried and that he has no legitimate claim to the title and fortune he holds. The mad Anne Catherick (the 'Woman in White') half-knows this secret and is, as it eventually transpires, the illegitimate half-sister of the heroine, Sir Percival's much abused wife, Laura Fairlie. *No Name* deals with the experiences of two sisters, Norah and Magdalene Vanstone, whose lives are plunged into ruin on the discovery (following the death of their parents) that their mother and father had not been married at the time of their births (though they had married subsequently) and had not made wills to transfer their considerable property to the children. In consequence the girls have no claim in law to their parents' estates, which pass to an unsympathetic relative, and lose

their wealth as well as their respectable status. The story revolves on their efforts to make their way in the world, and the means whereby one of them, Magdalene (one of the strong, active, and morally suspect Collins heroines) succeeds in regaining the property through marriage. In *Man and Wife* the first case of illegitimacy occurs following the annulment of a legally ambiguous, irregular Irish marriage, which the mother had entered into in good faith, but which her husband had declared void in order to marry for fortune elsewhere. The second case (which in fact does not occur since the child is still-born) follows the seduction of a young woman (the illegitimate child of the first instance) and is confused with issues concerning another irregular marriage, this time in Scotland. In both *No Name* and *Man and Wife* Collins was contributing to the then current debates on the reform of certain legal iniquities related to marriage, illegitimacy, and property transfer. In the latter novel much of the evidence on which he based the situations was derived from the 1868 Royal Commission on the Laws of Marriage, which examined abuses such as the elopement of minors to Gretna Green and other irregularities that were partially resolved by the 1870 Irregular Marriages Act. When it came to the claims of illegitimate children on the estates of their parents, however, there was no resolution in law until 1926.[49]

Now, from a reading of mid-nineteenth-century novels one would be forgiven for thinking that illegitimacy and irregular marriages were common problems. But this, of course, was not the case. In the early and mid-nineteenth century only six per cent of total births were illegitimate;[50] among the middle classes it was exceptional and irregular marriages were rare. Why then should these be subjects of interest, and as I have proposed, sources of considerable anxiety? There are two related reasons. The first arises from the middle-class perception of women as the moral focus of the family. The second is linked to the middle-class family as a unit of business and finance. The moral purity of women, which was derived from sexual purity, was viewed as the bedrock of family respectability, and respectable status was the essential key that allowed entry to all areas of middle-class social and economic life.[51] Yet it was also believed that women were weak of character and often so exposed by their circumstances as to make them vulnerable to lapses in moral and sexual standards. If sexual propriety was seen to be infringed – the illegitimate child was the most extreme evidence of this – then even where the woman was not at fault, it would be almost impossible to regain respectable status unless a

marriage could be proven. Hence, much of the plot of *Man and Wife* revolves around the attempt to demonstrate that in law a marriage had taken place and thereby save the good name of the woman concerned, despite the fact that this meant proof of marriage to a villain (though as an act of convenience he subsequently dies). The social blight that this situation could represent is demonstrated very strikingly by Mrs Catherick, the odious mother of the 'Woman in White', who lives under the suspicion that her child was born illegitimate. A tenacious hypocrite, she is determined to be accepted as respectable in her small town society. But even after many years of appropriate behaviour that status is fragile. As she states:

> 'I came here a wronged woman – I came here robbed of my character and determined to claim it back. I've been years and years about it – and I have claimed it back. I have matched the respectable people fairly and openly on their own ground. If they say anything against me now they must say it in secret – they can't say it, they daren't say it openly. I stand high enough in this town to be out of . . . reach. The clergyman bows to me.'[52]

Illegitimacy, then, provoked anxiety because it compromised family morality and respectability. In a society where 'family, hearth and home were both rationale and setting for the business enterprise',[53] this sense of anxiety was heightened by the consideration that illegitimacy and irregular marriages could also pose a threat to the basis of wealth transfer and business finance. Much of the legislation of the eighteenth and nineteenth centuries concerning the matter of regulation and registration of births, marriages, and deaths was prompted by the need for reliable documentation of these vital events in order to provide evidence in legal cases concerning property. This was underlined in 1838 by the General Register Office when it was stated, in reference to the 1837 Births and Deaths Registration Act, that

> It is of importance to all classes of persons to be able to prove when and where they were born . . . to the wealthier classes such a Register is especially useful for proof of pedigree, and for various legal purposes connected with the disposition of property, and for the settlement of claims thereto.[54]

Individuals with no legitimate claims on family property, such as the fictional Sir Percival Glyde, or Rosamond in *The Dead Secret*, found themselves in a difficult position. So too Laura Fairlie, who was wrongfully registered as dead and therefore lost both identity

and property. The nightmarish situations that could afflict the individual and family if a marriage were not properly constituted and wills not properly made are indicated in *No Name* and *Man and Wife*. Indeed, for society as a whole, the issue of family wealth and legitimate entitlement could be a nightmare, as explored by Dickens in *Bleak House*, dominated as it is by 'Jarndyce versus Jarndyce', a protracted legal suit over claims to property.[55]

In exploring these related legal, financial, and moral aspects of illegitimacy and marriage, Collins outlines one of the major areas of anxiety for the middle class in a society of growing wealth and increasing bureaucracy. He indicates a source of threat to the family as the basic unit of morality and property. He points to the significance of the law and state and stresses the importance yet vulnerability of women. The second Victorian nightmare, insanity, is also one with legal implications, is strongly associated with bureaucracy and the state, is linked to the perceived weaknesses of women, and again poses threats to the family. As with the illegitimate, sensation novels give prominent roles to characters who are insane, half-witted, eccentric, or manic-depressives. The use of such characters is a common and well-established literary device. The 'fool' often has a clearer vision than the sane and the unpredictability of the mad allows for 'a source of mystification and incomprehensibility' which is a central feature of this type of novel.[56] But insanity, and the institutional frameworks for dealing with the insane, are used far more systematically in sensation fiction than in other areas of literature. Usually it is women who are portrayed as insane,[57] their insanity is often generated through their relationships with men, and there is a common theme of illegal incarceration of the sane in an asylum for the insane. The latter theme is explored in horrifying detail in Charles Reade's *Hard Cash*.

In *The Woman in White* both Anne Catherick and Laura Fairlie are wrongfully imprisoned in an asylum, and driven to madness in consequence, in order that the villains might seize Laura's fortune. In *Armadale* an asylum plays a role in Lydia Gwilt's scheme to murder Allan Armadale and seize his inheritance, and her husband Allan Midwinter is a manic-depressive. There is the comic imbecile Mrs Wragge in *No Name*, her mind unhinged by a life of serving men, and the maniacally suicidal servant Rosanna Spearman in *The Moonstone*. Indeed, most women in sensation fiction are presented as psychological extremes. They are the weak and vulnerable who totter at the edge of madness, like Laura

Fairlie, or the strong and active, with powers and attractions defined in physical and sexual terms, but also often tottering near madness, as with the manly and heroic Marion Halcolme, the villainous seductress Lydia Gwilt, or the illegitimate and revenging Magdalene Vanstone. Perhaps the most complex exploration of insanity is that of Hester Detheridge in *Man and Wife*. She is a respectable lower-middle-class woman who must work to support herself and has been driven to madness by a drunken husband she cannot divorce and who is legally entitled to seize her earnings and property whenever he wants it. Her last desperate act is his murder.

Why are the insane, in particular the female insane, and the situations that create insanity so prominent in this type of fiction, and what does this say about middle-class anxieties? It is quite clear that mid-nineteenth-century society was preoccupied with the nature and control of insanity. The institutional framework for dealing with the mad was consolidated in 1845 with the passing of the Lunatic Act. This required all counties and boroughs to provide public facilities and led to a significant phase of asylum building. Within two years thirty-six of the fifty-two counties and boroughs in England and Wales had opened insane institutions.[58] The official concern to understand the extent of insanity was such that the Population Census of 1871 included a question on the number of lunatics within households. State interest and the development of public facilities was accompanied by a rise in the numbers of registered insane and a growing tendency towards the institutionalization of the mad. There was also an increasing presence of women in the statistics. In the eighteenth and early nineteenth centuries most registered institutional lunatics were men. By the mid-nineteenth century women were about half the number and by 1872 they were in the majority.[59] This expansion was paralleled by a rise in the number of doctors involved in the research and treatment of what were seen to be distinctly female forms of insanity.

As indicated by Foucault and other analysts of madness in history, insanity is a socially constructed phenomenon based in situations and perceptions specific to a given time and culture.[60] For many nineteenth-century women, particularly of the middle classes, activity and thought were constrained by the persuasive doctrine of 'separate spheres'. This determined that the public 'sphere' of politics and work should be exclusive to men and the care of husband and family within the private 'sphere' of home should be the proper business of women. A pattern of existence that

was often limited and frustrating was defined as 'natural' for women, and the consequent problems were frequently compounded by anxieties of failure arising from widely-held notions of what the ideal home, marriage, and family life should be.[61] Diaries and memoirs suggest that this could lead to depression and hysteria, both commonly defined as insanity and evidence of women's innate mental weakness.[62] Any attempt to break away from the restrictive domestic environment, to reject the ideal roles, and to seek other outlets were viewed with suspicion as either eccentric or mad. Moreover, wilful infringement of the sacred ideal of sexual purity was also usually attributed to mental instability. Insanity, sexuality, and the distortion of 'the angel in the home' ideal were linked in contemporary perceptions. Together they represented significant threats to the middle-class family since the sane and moral woman who fulfilled her 'separate spheres' role was the focus of the respectable family. Popular awareness of middle-class female sexuality and of its potential threat to the family was heightened in the mid-nineteenth century following the passing of the 1857 Matrimonial Causes Act. Divorce was only allowed where proof of adultery was furnished to the courts, and this was reported in all its scandalous detail in the popular press.[63] Occasional murder trials like that of Madeline Smith, a young, unmarried doctor's daughter accused in 1857 of murdering her French lover, also commanded public interest.[64] Such real, dramatic, if uncommon experiences were exploited by the sensation novelists, as were the real and more usual experiences of anxiety and frustration arising out of the domestic ideals. The most notable and controversial literary evocations of insanely unnatural female sexuality as a threat to the family were penned by women in the early 1860s. Mrs Wood's *East Lynne* is a tale of adultery by a woman and M.E. Braddon's *Lady Audley's Secret* is concerned with female bigamy.

Female insanity was, therefore, equated with sexuality and perceptions of female sexuality were linked to anxieties concerning the collapse of marital and family relationships. Female insanity was profoundly deviant and difficult to accommodate within the middle-class home when family respectability depended so heavily on the capacity of women to engage in desirable female behaviour. The insane asylum offered institutional protection and treatment, but also concealment, loss of liberty, and the potential for abuse. In representing such situations in the form of entertainment, the sensation novelists gave chilling expression to real fears. Collins furnishes a fine evocation of some of these connected themes in

Armadale when he describes a public visit to a newly opened asylum by a group of bored, excitement-seeking, middle-class women:

> In the miserable monotony of lives led by a large section of the middle classes of England, anything is welcome to the women which offers them any sort of harmless refuge from the established tyranny of the principle that all human happiness begins and ends at home. While the imperious needs of a commercial country limited the representatives of the male sex, among the doctor's visitors, to one feeble old man and one sleepy little boy the women, poor souls . . . old and young, married and single – had seized the golden opportunity of a plunge into public life. Harmoniously united by the two common objects which they all had in view – in the first place to look at each other, and in the second place to look at the Sanatorium – they streamed in neatly dressed procession through the doctor's dreary iron gates, with a thin varnish over them of assumed superiority to all unlady-like excitement, most significant and most pitiable to see![65]

In addressing the related anxieties of illegitimacy and female insanity, sensation novels explored the problems that sometimes occurred when men and women entered into the domestic ideal of marriage and family only to find the ideal had turned into a nightmare. People were not what they seemed and relationships not what they should have been. The family as moral edifice is undermined from within and the family as a financial enterprise is violated and collapses. Behind this last nightmare and threat to the family was the very real, middle-class concern with insolvency and debt. Financial and commercial issues were major themes of nineteenth-century fiction.[66] Dickens in particular explores the shady worlds of commercial chicanery and fraud and the human despairs arising out of improvidence. Debts and financial complications underlie many of the crimes committed in Collins' fiction, and schemes to gain access to property and wealth, or stop others securing it, are at heart of the sensation genre. Sir Percival Glyde, for instance, marries Laura in order to gain her fortune because he is in debt, having spent his own (fraudulently gained) inheritance. Lydia Gwilt conspires to seize the Armadale inheritance. In *Man and Wife* a marriage is declared void so that a husband can take a richer wife and Hester Detheridge is driven to madness because she cannot prevent her estranged husband's claim to her property and income. The aristocratic Basil, in the novel of that name, is

disinherited by his father following his marriage to a draper's daughter. In *The Dead Secret* there is the fear that an inheritance will be lost. Debts and financial worries are the background to much of the plot of *The Moonstone*. And, of course, the illegitimate Vanstone girls face poverty when their parents die without a valid will and the estate passes to a resentful uncle who believes that their father had cheated him out of an earlier inheritance.

A significant feature of many of these situations is an actual or feared sudden reversal of fortunes; a rapid plunge from relative affluence to poverty. Collins was not interested in the plight of the working-class poor, it was the plight of the wealthy who faced poverty in consequence of manmade circumstances such as improvidence, family quarrels, chicanery, or the workings of the law that concerned him. Though defined in sensational and melodramatic terms, these circumstances which gave rise to debt and loss of fortune nevertheless reflected realities. They represent anxieties that faced the middle-class family, some of which were the subject of intense discussion in this period. Many members of the middle class were, after all, recent creations and had experience and knowledge of relatively poverty. The rise from rags to riches by the 'Bounderby styled' self-made man may not have been a usual occurrence[67] but contemporaries believed that it was and this informed perceptions of upward mobility. However, alongside the faith in upward mobility through personal endeavour there were also the fears of reversed fortunes and downward mobility, a common experience that could be brought about in a number of ways.

There was, for instance, intense and growing pressure on individuals and families of the mid-nineteenth century to spend beyond their means. The display of expensive material possessions, especially those associated with housing and dress, was an aspect of status and the observing of certain expensive domestic conventions, notably servant-keeping, was linked to respectability.[68] Conspicuous consumption was common at all levels of society and given the instability of most family incomes usually accomplished on credit. Inevitably this sometimes resulted in intractable debts. Most middle-class incomes were derived from business profits, and these could fluctuate widely within a year and over a lifetime.[69] Business failures were common, as were individual bankruptcies. Records of bankrupts and insolvent debtors for the mid-nineteenth century indicate up to 3,000 cases each year of individuals or businesses brought before the bankruptcy courts in England.[70] Given the

absence of limited liability and the tendency to rely on relatives for business capital, each case could represent a family reduced to penury, a situation rendered more traumatic prior to 1868 by the imprisonment of insolvent debtors. An aspect of business life that these records indicated, which was also explored in the work of contemporary novelists,[71] was the 'low state of commercial morality . . . and the widespread existence of fraudulent practices'.[72] The implications of this were rendered more profound by the absence of legal remedies for those who suffered the effects of sharp practice and fraud. To gain greater stability and safety of income families sought to diversify their financial interests. Investments in banks or public utilities were relatively stable and therefore favoured. But as charted in a number of novels, even these comparatively low-risk areas could experience catastrophic failures.[73]

Women were especially vulnerable in financial matters. The law and the doctrine of separate spheres conspired against them. Single women or widows found their investment outlets circumscribed and the management of their affairs was usually undertaken by men. Women's wealth was often invested in the family business. This had advantages for the business concerned since, in the event of failure, it would not be burdened with creditors seeking recompense through the courts. But from the woman's perspective it did not always imply security of income. The situation of married women was also difficult. Prior to 1870 and the passing of the much debated Married Women's Property Act they had no rights to own or control their own property or earnings unless they had entered into a pre-nuptial contract or marriage settlement.[74] Only the rich could afford this; but even where a marriage settlement existed a woman was still vulnerable since the settlement was usually instigated by male members of the family on whose good intentions she must rely. *The Woman in White* underlines this vulnerability. Due to the indifference of her guardian, and the machinations of her future husband, Laura Fairlie's marriage settlement is against her best interests and her fortune is lost. The potential effect of discriminatory property laws and the opportunities they afforded the ruthless husband are also shown in the tragedy of Hester Detheridge.

Behind this array of anxieties and potential problems arising out of marriage, family, and wealth was the simple reality that most business enterprises were family-based and for large elements of the middle class a good relationship with the family was necessary to secure employment, income, or property. Hence the very real fear

of disinheritance. Following from this, marriages were frequently made to reinforce financial contacts within or between families. Cousins marrried to keep property in the family, commercial partnerships were reinforced through marriage, and investment for the family estate or business was often part of the expectation of marriage. But long-standing notions of marriage and family stood at variance to the more recent middle-class desire for marriage as a spiritual partnership based on love and companionship.[75] Similarly, commitment to the ideal of the family as a focus of domestic felicity did not sit happily with the realities of the family as a unit of business and finance. These striking contradictions were a cause of anxiety to the nineteenth-century middle class, and a central subject of contemporary literature.

CONCLUSION

The exploration of a type of nineteenth-century fiction as an aspect of group *mentalité* has been the purpose of this essay. The sensation genre is often dismissed by analysts of literature as of little intrinsic value and judgements of literary value also tend to be implicit in historical studies that rely on literature as evidence. I hope I have shown that sensation novels do have value to the historian, not because they have great style or erudition, but because they were popular and important in their time. Sensation novels provide a perspective on the situations, circumstances, and relationships that caused anxiety among their readership, primarily the middle classes. As indicated here, most of these anxieties were based on perceptions of threat to the family and the domestic ideals. Stressful, contradictory, and unrealistic notions of what marriage, the family and women within the family should be were at the heart of such perceptions of threat. It is useful to remember that the novel as a literary form was central to the construction of ideals of middle-class domesticity in the late eighteenth century.[76] As the sensation novelists show by 1860, when *The Woman in White* was published, these ideals had become a source of anxiety and were starting to lose credibility. By turning the familiar world on its head, by presenting the sinister or threatening sides of marriage and family, such novelists, Collins in particular, deconstructed the domestic ideals of the middle class.

Notes

1 The term 'sensation' novel was in common use by the early 1860s as shown in Mrs Oliphant's unsigned review 'Sensation novels', *Blackwood's Magazine* 91 (5), 1862, 565–74. For a theoretical discussion of the genre, see P. Brantlinger, 'What is "sensational" about the sensation novel?', *Nineteenth Century Fiction*, 37(1), 1982:1–28.

2 A. Marwick *The Nature of History*, London: Macmillan Education, 1981, p. 190.

3 Quoted in M. Ermarth *Wilhelm Dilthey: the Critique of Historical Reason*, Chicago: University of Chicago Press, 1978, p.263.

4 W. Kluback, *Wilhlem Dilthey's Philosophy of History*, New York: Columbia University Press, 1956, p.60.

5 Ermarth, *Wilhelm Dilthey*, p.297.

6 K. Tillotson, *Novels of the Eighteen-Forties*, London: Oxford University Press, 1961, p. 13.

7 Ermarth, *Wilhelm Dilthey*, p. 135.

8 ibid., p. 133.

9 T. Dunne 'A polemical introduction: literature, literary theory and the historian', in T. Dunne (ed.) *The Writer as Witness: Literature as Historical Evidence*, Cork: Cork University Press, 1987, p.3.

10 ibid., p. 7; Le Roy Ladurie's detailed study of a socio-literary model, the Occitan 'love square', is a major illustration of the approach. See E. Le Roy Ladurie *Love, Death and Money in the Pays D'Oc*, trans. A. Sheridan, Harmondsworth: Penguin Books, 1984. M. Poovey *Uneven Developments: the Ideological work of Gender in Mid-Victorian England*, London: Virago Press, 1989, provides another excellent illustration.

11 R. Gilmour *The Novel in the Victorian Age: a Modern Introduction*, London: Edward Arnold, 1986, p. 7.

12 Related arguments are made in A. Blum 'The uses of literature in nineteenth and twentieth century British historiography', *Literature and History*, 11(2), 1985, 176–202; and F. Duke and P. Stigant '. . . when so much of it is invention: history in literature', *Literature and History*, 11(1), 1985:17–23.

13 M.J. Weiner *English Culture and the Decline of the Industrial Spirit*, Cambridge: Cambridge University Press, 1981, see especially Ch. 3., pp. 27–40.

14 Anti-commercialism and a southern intellectual and gentry distaste for overt money-making are certainly evident in literature of the second half of the nineteenth century. Arnold, quoted in Weiner, *English Culture*, p. 37, is a good illustration. This is not, however, the same as anti-industrialism (also evident), although Weiner frequently discussed the two as though they were synonymous, especially with reference to Dickens, pp. 33–5. Despite the anti-commercialism of some writers, and the active promotion of backward-looking, rural, lifestyle fantasies, the commercial and financial sector (dominated by the south of England) did not fail in the late nineteenth century. Indeed, the considerable success of this sector (in generating invisible earnings overseas)) helped to secure a more favourable balance of payments than would have been evident from industrial exports and visible earnings alone. Certain economists now believe that British industrial performance (and entrepreneurs) also did not fail in the late nineteenth century which casts further doubt on the implications in practice of literary expressions of anxiety or dislike arising out of modern industry and commerce. See F. Crouzet *The Victorian Economy*, London: Methuen, 1982 pp. 342–422, on recent interpretations of British 'decline'.

15 The most obvious omission is Elizabeth Gaskell, a northern writer familiar with industrial life, whose *North and South*, first published in *Household Words* in 1855 immediately following Dickens' *Hard Times*, presents, in contrast to the latter, a favourable picture of the industrialist.

16 As an account of the development of middle-class values Weiner's *English Culture* has been subject to considerable assault by historians of the middle class. See most recently S. Gunn 'The "failure" of the Victorian middle class: a critique', in J. Wolff and J. Seed (eds) *The Culture of Capital: Art, Power and the Nineteenth-Century Middle Class,* Manchester: Manchester University Press, 1988.

17 O. MacDonagh *'Sanditon*: a Regency novel?', in T. Dunne (ed.) *The Writer as Witness: Literature as Historical Evidence*, Cork: Cork University Press, 1987, p. 130, and noted in Dunne's introduction to the volume, p. 6.

18 See A. Briggs 'The language of "class" in early nineteenth century England', in *Essays in Social History*, edited by M.W. Flinn and T.C. Smout, Oxford: Clarendon Press, 1974. Also R. Williams, *Keywords: A Vocabulary of Culture and Society*, London: Fontana, 1976.

19 Those novelists who do not address these issues are sometimes held to task. Everyone knows the criticism of Jane Austen. Why did she ignore the industrial revolution and Napoleonic Wars, and not refer to the poor and rural unemployment? It takes a shift in interests towards a fuller understanding of the dynamics of the landed or

establishment institutions and a concern with modernization and commercialism rather than industry to bring Austen into focus as a source of history. See, for instance, MacDonagh, '*Sanditon*: a Regency novel'.

20 A. Briggs '*Middlemarch* and the doctors', in *The Collected Essays of Asa Briggs*, Vol. 2, Brighton: Harvester Press, 1985, p. 49. A similar point is made in P. Laslet *The World we have Lost Further Explored*, London: Methuen, 1983. p. 88. See Blum 'The uses of literature in nineteenth and twentieth century historiography'.

21 On the theoretical analysis of consumers of literature, and the implications of the reader for the literary work, see S. Suleiman, and I. Crosman (eds) *The Reader in the Text: Essays on Audience and Interpretation*, Princeton, N.J.: Princeton University Press, 1980, especially S. Suleiman 'Introduction: varieties of audience-oriented criticism', pp. 3–45.

22 The term 'middle class', as used in this essay, refers broadly to those who were neither manual workers, except where employers, nor aristocrats and landed gentry. For a discussion of the character of the nineteenth-century middle class, see S. Nenadic 'Record linkage and the exploration of nineteenth century social groups: a methodological perspective on the Glasgow middle class in 1861', *Urban History Yearbook*, 1987, pp. 32–42; and idem, 'The rise of the urban middle class', in T.M. Devine and R. Mitchison (eds) *People and Society in Scotland*, Edinburgh: John Donald, 1988.

23 The term 'silver fork' is derived from Hazlitt's comment that one such novel was fascinated with the fact that the rich 'eat their fish with a silver fork'. Gilmour, *The Novel in the Victorian Age*, p. 16.

24 Quoted in Tillotson, *Novels of the Eighteen-Forties,* p.84.

25 R. Williams *The English Novel from Dickens to Lawrence,* London: Chatto and Windus, 1970. p. 14.

26 See C. Christ 'Victorian masculinity and the Angel in the House', in *A Widening Sphere*, M. Vicinus (ed.) London: Methuen, 1980.

27 The implications of the 'governess issue' are discussed in M.J. Peterson 'The Victorian governess: status incongruence in family and society', in M. Vicinus (ed.) *Suffer and be Still: Women in the Victorian Age*, Bloomington: Indiana University Press, 1982.

28 Evident, for instance, from the literature which Jane and other characters refer to, such as Scott's *Marmion*, published in 1808 and described as a 'new publication' in Chapter 32, at a point in the narrative when approximately ten years have passed. C. Bronte, (first published 1847) *Jane Eyre*, London: Penguin Books 1977, p. 396. However, Bronte is not especially consistent in her use of literature since, as indicated by Q.D. Leavis in footnotes to the above edition, p.488, in Chapter 17 and at other earlier points in the narrative sequence there is oblique reference to *The Corsair* by Byron which was not published until 1814.

29 See S. Smith *The Other Nation: the Poor in English Novels of the*

1840s and 1850s, Oxford: Clarendon Press 1980, especially
pp. 135–71.
30 K. Robinson, *Wilkie Collins: a Biography*, London: Bodley Head,
1951, p. 20.
31 It is worth noting that Charles Reade was also trained as a lawyer
and used his legal knowledge in his fiction.
32 D.L. Sayers, *Wilkie Collins: a Critical and Biographical Study*, edited
and introduced by E.R. Gregory, Toledo, Ohio: Friends of the
University of Toledo Libraries, 1977, p. 55.
33 In the preface to *Basil*, an early work published in 1852, Collins
states 'the Novel and the Play are twin sisters in the family Fiction'.
W. Collins *Basil*, London: Chatto and Windus, 1890, p.v.
34 Robinson, *Wilkie Collins*, pp. 128–36.
35 Quoted in W. Hughes *The Maniac in the Cellar: Sensation Novels of
the 1860s*, Princeton, N.J.: Princeton University Press, 1980, p. 5.
See Ch. 1 of Hughes for details on the nature and antecedents of the
genre.
36 'Prospectus of a New Journal', *Punch*, 9 May 1863, also quoted in
W. De La Mare, 'The early novels of Wilkie Collins', in *The
Eighteen–Sixties,* Cambridge: Cambridge University Press, 1932 p.
95.
37 H. James (1865) unsigned review 'Miss Braddon', in *Nation,* 11(1),
1865, p. 593. Reprinted in N. Page (ed.) *Wilkie Collins: The Critical
Heritage*, London: Routledge & Kegan Paul, 1974, pp. 122–4.
38 C. Reade (first published 1863) *Hard Cash*, London: Collins, 1901,
p. i.
39 Collins, *Basil*, p.v.
40 James, 'Miss Braddon', p. 594.
41 M. Oliphant 'Novels', *Blackwood's Edinburgh Magazine*, 102(9),
1867:275 and quoted in Hughes *The Maniac in the Cellar*, p. 67.
42 S. Lonoff *Wilkie Collins and His Victorian Readers: A Study in the
Rhetoric of Authorship*, New York: AMS Press, 1982, pp. 1–2. See
also Ch. 1 pp. 1–16; and Ch. 3 pp. 38–78; which consider the
extensive correspondence between Collins and his reading public,
friends, and critics.
43 Robinson, *Wilkie Collins*, p. 149.
44 S. Mitchell *The Fallen Angel: Chastity, Class and Women's Reading
1835–1880*, Bowling Green, Ohio: Bowling Green University Popular
Press, 1981, p. 90.
45 Lonoff *Wilkie Collins*, p. 51.
46 See note 22.
47 See Mitchell (1981) *The Fallen Angel*, especially Ch. 4 pp. 73–99, on
the appeal of this type of fiction and its place in the development of
women's reading.
48 From the 1850s both literature and painting, notably of the
Pre-Raphaelites, urged a greater understanding of women who had
erred. For further elaboration on this point, see N. Auerbach 'The

rise of the fallen woman', *Nineteenth Century Fiction* 35(1), 1980: 29–52.

49 The legislative context of Collins' fiction is considered in D.B. MacEachen 'Wilkie Collins and the British law', *Nineteenth Century Fiction* 5(1),(1950–1): 121–39.

50 N.L. Tranter *Population and Society 1750 to 1940*, Harlow, Essex: Longman, 1985, p. 57.

51 D. Gorham *The Victorian Girl and the Feminine Ideal*, London: Croom Helm, 1982, pp. 3–13.

52 W. Collins (first published 1860) *The Woman in White*, Harmondsworth: Penguin Books, 1974, p. 507.

53 L. Davidoff and C. Hall *Family Fortunes. Men and Women of the English Middle Class 1780–1850*, London: Hutchinson Education, 1987, p. 195.

54 General Register Office (1838) 'Registration Act Explanatory Notice', extracts printed in 'Miscellany. The New Registration Service (part two)', *Local Population Studies*, 1987, 39: 54–7.

55 The later Dickens was highly influenced by the sensation style and by Collins; see *Bleak House* (1853), *Great Expectations* (1861), and *Our Mutual Friend* (1865). He was also interested in the law and the legal process, but in contrast to Collins he rarely presented a sympathetic picture of the legal profession.

56 A detailed discussion of the development of this popular theme in nineteenth-century fiction and in the sensation novels in particular is given in Hughes *The Maniac in the Cellar*, pp. 59–60.

57 Again there is a link here with Pre-Raphaelite painting and popular 'Ophelia' images.

58 E. Showalter *The Female Malady. Women, Madness and English Culture 1830–1980*, London: Virago, 1987, p. 17.

59 ibid., p. 52.

60 See especially M. Foucault, *Madness and Civilization: A History of Insanity in the Age of Reason*, trans. R. Howard, London: Tavistock Publications, 1971.

61 Nineteenth-century domestic manuals indicate many of the idealized expectations of middle-class life. A good illustration is H. Southgate *Things a Lady Would Like to Know Concerning Domestic Management and Expenditure Arranged for Daily Reference with Hints Regarding the Intellectual as well as the Physical Life*, Edinburgh: Nimmo, Hay and Mitchell, 1885 and earlier editions. The implications and consequences of such manuals are explored in P. Branca *Silent Sisterhood: Middle Class Women in the Victorian Home*, London: Croom Helm, 1975, especially pp. 22–36.

62 Showalter, *The Female Malady*, pp. 145–62.

63 Mitchell, *The Fallen Angel*, p. 87.

64 See *Glasgow Herald*, 1857, especially the editorial of 10 July for the development and impact of this case. An account is also given in A. Phillips *Glasgow's Herald: Two Hundred Years of a Newspaper*

1783–1983, Glasgow: Richard Drew Publishing, 1982, pp.64–7. One of Collins' late novels, *The Law and the Lady* (1875), was based on the Madeline Smith trial and considered the issues raised by the equivocal 'not proven' verdict with which it ended.

65 W. Collins (first published 1866) *Armadale*, Toronto: Dover Publications, 1977, p. 562.

66 See N. Russell *The Novelist and Mammon: Literary Responses to the World of Commerce in the Nineteenth Century,* Oxford: Clarendon Press, 1986, especially the 'Introduction', pp. 1–24.

67 F. Crouzet *The First Industrialists, the Problem of Origins*, Cambridge: Cambridge University Press, 1985, especially Ch. 3. pp. 37–49. On why this myth was believed, see S. Nenadic 'Businessmen, the middle classes and the "dominance" of manufacturers in the nineteenth century', *Economic History Review* 2nd ser. 44(2), forthcoming.

68 See J.A. Banks *Prosperity and Parenthood,* London: Routledge & Kegan Paul, 1984, especially pp.86–102 on middle-class consumerism and the 'paraphernalia of gentility' in the mid-nineteenth century.

69 A case illustration of income variations is provided by R.J. Morris, 'The middle class and the property cycle during the industrial revolution', in T.C. Smout (ed.) *The Search for Wealth and Stability*, London: Macmillan, 1979. For an analysis of middle-class income and wealth, see S. Nenadic 'The structure, values and influence of the Scottish urban middle class. Glasgow 1800 to 1870', unpublished PhD Thesis, University of Glasgow, 1986, Ch. 2:4 'Property, wealth and income'.

70 Indicated in S. Marriner 'English bankruptcy records and statistics before 1850', *Economic History Review* 2nd ser. 33(3), 1980:351–66.

71 Notably by Dickens in *Little Dorrit* (published 1855–7) and by Trollope in *The Way We Live Now* (published 1874–5). The fictional characters Merdle and Melmotte, the inventions of Dickens and Trollope respectively, are archetypal commercial villains.

72 Marriner, 'English bankruptcy records', p. 366.

73 Mrs Craik's *John Halifax, Gentleman* (first published in 1856), and Elizabeth Gaskell's *Cranford* (first published 1853) both deal with fictional bank failures. The 1850s saw a series of real local financial disasters. Typical was the collapse of the Western Bank in Glasgow in 1857. According to the *Glasgow Herald* (5 July 1860), over 100 individuals (many of them middle-class women) were reduced to total penury by this failure. This was perceived to be such a disaster that a public subscription was raised on their behalf.

74 See L. Holcombe 'Victorian wives and property: reform of the married womens property law 1857–1882', in M. Vicinus (ed.) *A Widening Sphere*, London: Methuen, 1980.

75 This perception of the development of marriage, sometimes regarded as evidence of the evolution of affective individualism from the late

seventeenth century, is particularly associated with L. Stone *The Family, Sex and Marriage in England 1500–1914*, London: Weidenfeld & Nicolson, 1977. But it is a contentious view. A. MacFarlane *Marriage and Love in England 1300–1840*, Oxford, Basil Blackwell, 1986, broadly suggests there was no fundamental change in ideas of love or the purposes of marriage. These issues are discussed in L. Stone *The Past and the Present Revisited*, London: Routledge & Kegan Paul, 1987, pp. 327–43.

76 J. Dwyer *Virtuous Discourse, Sensibility and Community in Late Eighteenth-Century Scotland*, Edinburgh: John Donald, 1987, especially Ch. 6. pp. 141–67.

Note: Since this paper was first presented to the Social History Society in January 1988, the publication of A.D. Harvey *Literature into History*, London: Macmillan Press, 1988, has made major contributions to a coherent theory of literature as history which should be noted though it has not been possible to address the implications of Harvey's work in this chapter.

6 Art and tourism in Southern Germany, 1850–1930

Robin Lenman

Although well established before 1800, travel for pleasure and improvement – with the British in the lead – only became a really large-scale phenomenon after the end of the Napoleonic Wars. It went on growing throughout the nineteenth century and reached an initial peak shortly before the First World War: in 1910, for example, the number of guest/nights in Swiss hotels exceeded twenty-two million, a figure not regularly reached again until the mid-1950s.[1] In the interwar years, political and economic conditions hampered further development, though welfare legislation in many countries broadened tourism's social base. But since the 1950s mass travel has expanded at a spectacular pace, and continues to do so despite political, ecological, and health problems barely apparent only a couple of decades ago. Its future growth potential is enormous.

Contemporary tourism's scale and obtrusiveness has generated fierce controversy, part of a wider debate about modernization and mass culture.[2] Its supporters have seen it as a force for economic development and international understanding, revitalizing stagnant cultures and disseminating democratic and free-market values. But it has been denounced as disruptive and parasitical, exploiting host societies – above all in the Third World – for the benefit of multinational companies and other outsiders. Conservative cultural critics have contrasted the old-fashioned traveller, contact-hungry and sensitive to his surroundings, with the coach-borne, hotel-insulated mass tourist,buying an essentially false experience. But other writers have dismissed such views as elitist and simplistic, pointing to the complexities of tourist motivation and arguing that the structures of the industry can be used or subverted by tourists (and hosts) for all kinds of purposes. Controversy about tourism has often resembled controversy about the mass media. Film and

television, too, have been defended as culture-bringing and progressive, and demonized as corrupting and imperialistic. Both they and tourism have been widely regarded (in the case of film and tourism, since before 1914) as prime vehicles of 'Americanism': suspect to the elites, but welcome to the masses. Theory and polemic have tended to outrun empirical research, and even in the late twentieth century it has been hard to refine crude and patchy quantitative data – box-office returns, viewing-hours, tourist arrivals – in ways that reveal the meanings attached to media consumption and travel by the consumers themselves, and how these experiences affect them and society. The present essay examines the relationship between late nineteenth-century tourism and salon painting – at least a semi-mass medium, given the huge expansion of the contemporary reproduction industry – in one very popular European region.

One reason for tourism's comparative neglect by historians has probably been the scarcity of statistics.[3] Though the travel industry's economic importance was clear well before 1900, governments virtually ignored it and left its promotion to private organizations whose home-made figures tended to reflect their own interests. Even in Switzerland, official regional statistics were not compiled until 1920, and national ones not until 1933.[4] By 1911, however, the Royal Bavarian Statistical Office had at least begun to tabulate such vital data as seasonal travel patterns, length of stay, and visitors' nationality.[5] This and other evidence gives some indication of the scale and impact of tourism just before the First World War threw it into disarray.

Tourism's expansion in the nineteenth century went hand in hand with the revolution in communications, which from about 1850 onwards became increasingly diversified as well as extensive. In the new alpine and sub-alpine 'playgrounds' of Switzerland, Bavaria, and the Tyrol, branch railway lines connected outlying places such as Frutigen, Oberammergau, and Meran, and motor buses were putting even more remote spots on the map by 1914. The post-1880 bicycle craze brought a new wave of trippers, nature-worshippers, and artists out into the countryside, and by the eve of the First World War the motor car was established as a means of transport for the very rich. In the meantime guide-books and travel agencies had simplified and routinized the whole business of travel for the inexperienced. A particularly important role was played by the alpine clubs, pioneered by upper-class Britons in the 1850s and soon imitated locally. The *Deutsch-*

Österreichische Alpenverein, which had more than 50,000 members by 1905, opened up the Alps to masses of middle-class mountaineers and walkers and eventually offered (segregated) facilities to working-class groups as well.[6] And from the 1880s onwards local tourist associations were formed to improve facilities, organize publicity, and lobby the authorities for financial support and better communications.

The ideological precondition of mass recreational travel was, of course, the continuing popularization of the new attitudes towards nature which had emerged in the eighteenth century, when 'wilderness' regions such as the Alps, the Scottish Highlands, and the English Lake District had gradually been redefined as poetic and sublime.[7] Their inhabitants, and to a growing extent country people in general, were now perceived as virtuous, freedom-loving, and egalitarian rather than crude and superstitious. Animals too were increasingly depicted in sentimental and didactic terms very different from, and often explicitly opposed to, the magical/ utilitarian animal culture of the traditional countryside.[8] This new sensibility, and the idea of an 'unspoiled' and 'authentic' natural world (despite the relentless encroachment of scientific farming and forestry, modern engineering projects, laws, and education), distinct from the artificial, mechanistic world of the city, were already fully developed by the 1820s and 1830s. Over the next hundred years, as industrialization produced greater wealth, mobility, and literacy, but also anti-industrialism, they were more and more widely disseminated off-the-peg via popular literature and painting, prints, postcards, and ultimately films, and structured the expectations of the modern tourist.

In the last decades of the nineteenth century growing prosperity and the gradual extension of paid leave to state and commercial employees created more economy tourists, who drove the travelling elite towards more exclusive seasons, pursuits – serious mountaineering, winter sports – and places.[9] By 1914 bicycles, buses, and company outings were broadening the age and social range still further, and the phrase 'rucksack tourist' had become an hotelier's term of abuse. National composition also changed. In German-speaking Europe from the Rhineland southwards, the British became less overwhelmingly predominant. Americans were already conspicuous in Munich and elsewhere in the late 1860s, and by 1914 roughly 150,000 of them were crossing on the 'Atlantic Ferry' every year.[10] Though this was a modest number distributed over the whole of Europe, Americans were universally regarded as big

spenders, and tourist facilities – lifts, pullman cars (built by Bavarian Railways from imported kits: an early example of tourism burdening the balance of payments), and 'American' bars – increasingly reflected their tastes. Finally, the proportion of German, Swiss, and Austrian tourists grew greatly during the *Belle Epoque*. Satire reflected the new diversity, lampooning brash, disorientated Americans, Saxons poised to create instant kitsch with their Kodaks, and Berliners done up in department-store versions of alpine costume (see Figure 6.1).

New resorts developed in response to the demand. At Meran in the Tyrol, which became a spa in 1844, a classic combination of assets, including royal patronage, new rail links, and more or less genuine 'cures', skilfully managed and effectively publicized, created a highly successful industry.[11] Oberammergau, a poor and isolated village until Cook and his competitors discovered the Passion Play, had attracted more than five million marks' worth (£250,000) of investment by 1910.[12] Such sums, of course, partly reflected the problems of absorbing large seasonal influxes of visitors, and the drawbacks of really rural Bavaria, from primitive cooking and man-trap-like privies to diphtheria, continued to deter visitors for a long time. Even Munich had an evil health reputation for much of the nineteenth century and suffered a severe cholera outbreak in 1873. Years of research and massive spending on new drainage and water-supply systems were as vital for its tourist industry as the new hotels, shopping, and entertainment facilities which had appeared by 1914.

By this time, Munich was undoubtedly one of Central Europe's most popular holiday destinations and an example of a conspicuously tourist-oriented economy. Remote from raw materials and markets, the Bavarian capital was slow to develop from a royal *Residenz* into an industrial city and remained under-industrialized until after the Second World War. But the nineteenth-century transport revolution made it the gateway to the lakes and mountains of Upper Bavaria. Its own appearance had already been transformed by Ludwig I and Maximilian II, and it underwent a second transformation – though this time mainly by private developers and the municipality – during Prince Luitpold's regency (1886–1912). In the intervening period, Ludwig II had made his own contribution to Munich's and Bavaria's fame. His strange life, fabulous buildings, and mysterious death in the Starnbergersee in June 1886 might have been specially invented for the travel industry. Like the Mayerling tragedy, the Ludwig myth inspired a

6.1 Franz von Defregger, *Der Salon-Tiroler*. Nationalgalerie, West Berlin.

torrent of press speculation and pulp fiction and helped to found the modern media-cum-tourist cult of royalty.[13] (Ludwig's youthful portrait, visible today on countless T-shirts and souvenirs, remains one of the nineteenth century's most durable popular images.) Linderhof, Herrenchiemsee, and Neuschwanstein, opened to the public almost immediately after the king's death, were soon drawing tens of thousands of visitors a year. Munich itself, though the pace of life remained noticeably rural (even fire-engines were booked for speeding), was profoundly marked by tourism. As a British official wrote in 1911, a city which 'thirty years ago had about 200,000 inhabitants with scarcely any trade and life, now caters for her 600,000 souls and her stream of thousands of tourists – mostly Anglo-Saxons – in quite American fashion, placing at their disposal numerous modern hotels, theatres, places of amusement and sport'.[14] The negative aspects, as police reports and other sources pointed out, included inflation, a spreading taste for luxury and idleness, crime, and vice; even in the *Alte Pinakothek*, allegedly, innocent Rubens-lovers risked harassment by prostitutes posing as artists.[15]

Culture was one of the city's strongest selling points. Whether trying to emulate the old aristocratic Grand Tour, or distancing themselves from vulgar trippers, nineteenth-century tourists sought improvement as well as pleasure: a fact attested by Cook's exhibition packages and Baedeker's art-historical treatises. Like other royal capitals – Dresden especially – Munich had many priceless assets, created mostly by the dynasty but then expanded by private and municipal initiative as tourism increased. Paul Klee, newly arrived from provincial Berne in 1898, was overwhelmed by the spectacular productions at the royal theatres,[16] made possible by Europe's first revolving stage and elaborate gadgetry which owed its origin to Ludwig II. Munich's celebrated Artists' Theatre opened in 1908 as part of a major exhibition designed to meet competition from Berlin and other cities. Above all, there was the delayed exploitation of Wagnerian opera. By the late nineteenth century, Bayreuth's fame and the rise of international Wagnerolatry[17] was underlining the commercial folly of Munich's expulsion of Wagner and rejection of Ludwig II's festival opera-house project in the 1860s. (In 1905 sixteen per cent of the Bayreuth opera audience was British or American.)[18] So Munich's own Wagner festivals were inaugurated in the 1890s and the elaborate purpose-built Prince Regent Theatre was opened in August 1901. But although the enterprise was backed by a heavily capitalized syndicate of builders

and property companies (with an eye to nearby residential development), spiralling production costs meant that – even with exorbitant seat prices – large subsidies were needed from the city and the Civil List. So Wagner's great saga about the corrupting power of gold, *The Ring*, soon became the focus of sordid disputes, with hotel-owners and tourist organizations insisting on full-scale programmes every year, and angry tax payers denouncing the cost. As one anonymous writer claimed in 1914, 'From the few hundred plutocrats who come here to visit the theatre *the citizenry as a whole gets absolutely nothing*. Only half a dozen hoteliers get rich. And as with *the whole tourist trade* the end-effect is that *super-expensive* Munich gets more and more dear'[19] It was a classic early example of a loss-leading cultural enterprise artifically sustained for wider prestige and economic purposes.

Variously described as the artistic capital of Central Europe or 'the city of museum feet', [20] Munich owed much of its appeal to the visual arts. The Wittelsbach art treasures (including the huge Rubens collection which amazed the Goncourt brothers on their erotic and art-historical expedition to Germany in 1860),[21] had been magnificently housed by Ludwig I and, like the Dresden Gallery, were an obligatory part of the tourist itinerary. But contemporary art was equally important. Since the pioneering international salon of 1869, when Courbet came in person to collect a medal from Ludwig II,[22] Munich's major art shows had attracted large numbers of visitors. On the eve of the First World War, against a background of exhibition-fever all over the Reich, there were plans for an elaborate new gallery complex to replace the city's ageing crystal palace. By 1907, moreover, about a quarter of Germany's professional artists lived in or near Munich and their efforts were visible everywhere: from the allegorical frescoes in the railway station to the murals in the smart new Café Luitpold (mostly done by experts in panorama-painting, a highly commercialized, tourism-related branch of nineteenth-century art), the law courts, and many other Regency buildings. As there were far more resident painters than either local private collectors or royal patronage could support, the art trade was strongly orientated towards tourism and exports. The Heinemann Gallery, one of the very few German firms of the period to have left detailed records, was a striking example of this.[23] Occupying elegant premises on the new Lenbachplatz (named after Munich's celebrated portraitist) close to the big banks, Bernheimer's elite department store and the *Künstlerhaus*, Heinemann catered for conservative clients who liked

Barbizon and Hague School pictures and comparable German products, particularly from Munich. Like other dealers, he had a stable of artists who provided a regular supply of the right pictures at suitable prices. He did business with the state galleries and in 1912 endowed two bursaries at the academy.[24] Though a good number of his buyers were local, the overwhelming majority – literally thousands – came from other German cities and abroad. By 1914 he had clients or contacts in more than forty North American cities and in the pre-war decade earned tens of thousands of dollars from transatlantic sales. Even if, as alarmists often pointed out, some American collectors were turning to French Impressionism or back to old masters (the 'Duveen effect'), the growth potential of American tourism in Bavaria was probably enormous, and with it the prospect of new waves of comparatively unsophisticated art-souvenir buyers to sustain the Munich market.

In other respects too, the relationship between art and tourism was extremely close. Painters, lithographers, and eventually also photographers played a vital part in publicizing the new nineteenth-century 'landscapes of leisure': Switzerland, Scotland, the Rhineland, Holland, as well as North Africa and the Near East.[25] In Bavaria painters like Georg von Dillis, Heinrich Bürkel, and Lorenz Quaglio had begun this process in the early decades of the century, but it became vastly more important during the long reign – roughly from the 1860s to the 1920s – of the Munich Academy's Piloty and Diez schools and their successors.[26] Indeed, one writer described South Bavarian genre painting as 'artistic propaganda on a scale not matched for any other region, Switzerland not excepted'.[27] By 1900 there could hardly have been a district of *Oberbayern* which had not harboured at least the occasional summer landscapist, if not squadrons of bicycle-borne beginners contaminating the meadows with their palette-scrapings. Further north, the medieval Franconian town of Rothenburg on the Tauber was discovered by the American Piloty-student Toby Rosenthal: 'The whole place seemed draped with cobwebs', he recalled later. 'It was as though I'd stumbled into a fairy-tale.'[28] Subsequently the town got so much publicity from artists – including Kandinsky – that it put special studios at their disposal. By the late nineteenth century, growing competition for visitors and the development of modern advertising brought many artists into the business of poster-design for resorts and railway companies in Switzerland, Bavaria, and the Tyrol.[29] Finally, there was also the huge *Belle Epoque* postcard boom (in 1906 one and a half *milliard* cards were posted in the German

Empire alone),[30] to which individual painters and groups like the Karlsruhe *Künstlerbund* made an important contribution.

Not surprisingly, cards, posters, and most of the paintings on sale at dealers' and artists' salons conveyed a highly selective, escapist image of country and provincial life. On his first night in Rothenburg, actually, Rosenthal had nearly been beaten to death by a dipsomaniac. Yet he and his more famous older colleague Karl Spitzweg, and the public, were interested in a quaint, 'fairy-tale' view of such places, not their unhealthier aspects. The immensely popular *paysage intime* depicted a poetically tinted countryside conducive to reverie but not too bleak or threatening. Well-fed, contented, and productive farm animals were matched by cutely domesticated, anthropomorphic pets (see Figure 6.2). (Nineteenth-century animal painters were among the profession's top earners, and pre-1914 Düsseldorf's projected new campus-centred academy was designed to accommodate the growing numbers of would-be animal specialists and their four-legged models.)[31] Peasant *genre* was executed in a pseudo-realist mode: extreme, almost ethnographic exactitude in the depiction of costumes and furniture, with much 'delightful' anecdotal or humorous detail, but with the harsher realities of rural life discreetly blurred (see figure 6.3). Painters like Wilhelm Leibl, who showed gnarled hands, coarse features, and the other effects of hard physical labour on both men and women, were marginalized by critics, dealers, and the public. For most of the time, country people were either prettified or monumentalized, according to whether the end-product was to be *genre* or, later, *Heimatkunst*. The real contemporary countryside, which was adapting slowly and at times – as in Bavaria in the 1880s and 1890s – turbulently to the exigencies of an international capitalist economy and a modernizing state bureaucracy, was absent from these productions, as it was from the publicity apparatus of the tourist industry.[32] Artists' images of a problem-free, timeless, rural world reflected both the aesthetic idealism propagated by academies and critics and the 'nature versus civilization' ideology of an increasingly cosmopolitan public. No doubt the filtering process between the initial sketch or photograph and the finished painting was largely automatic and unconscious, and comparisons were rarely drawn by the critics. But an early (admiring) biographer of Franz von Defregger, creator of celebrated genre pieces like *The Visit* (Figure 6.4), described the transformation of a dispirited urban model into one of the master's delicate highland maidens with remarkable candour:

6.2 Gustav Süs, *Gaenseliesl.* Christie's.

The girl who sits on the dais before the artist is certainly anything but attractive. If she is a child of the Tyrol, hard work in the big city has deprived her of much of her pedigree and even more of her high spirit. Defregger has made good this loss in his picture and made a being that has become dull and insensible into a dreamy, sensitive Tyrolean girl.[33]

The reputations of Defregger and his peers were solidly based, and even their potboiling work revealed skill and imagination. But their more pedestrian colleagues often sank to blatant *kitsch*: work without originality dependent for its appeal solely on 'pre-set' responses to such stereotyped subject-matter as set-piece sunsets,

6.3 Emil Rau, *A Good Score*. Christie's.

6.4 Franz von Defregger, *The Visit*, 1875. Staatsgemäldesammlungen, München.

rosy-cheeked children, and fluffy kittens.[34] By the turn of the
century at the latest, markets like Munich, but also Düsseldorf and
the Hague, were clearly silting up with this kind of thing, a fact that
commentators readily blamed on the export trade. In 1903, the
Dutch critic Marius attacked

> that degrading [American] market which now . . . asks one year
> for 'Sheep going to pasture' and the next for 'Sheep returning'
> and the year after for something else, much as the height and
> breadth of our hyacinths is laid down for us by the exigencies of
> Anglo-American taste.[35]

Many German writers had begun to share these sentiments and,
even allowing for the chauvinism which permeated contemporary
cultural debates, with some reason. Decades of large-scale 'formula'
production eventually contributed to the protracted price slump for
salon genre and landscape which set in after the First World War.[36]
Long before then, it had been a factor in the formation of the
German secessions and their offshoots, which sprang, especially in
Munich, from a desire to revitalize local art-production in the face
of competition from other places. In the same period, interestingly
enough, there was increasing concern about the physical quality of
the product – some Munich paintings melted in the mid-West[37] –
and both technical corner-cutting and the use of eye-catching but
ill-tested materials might also be seen as characteristics of a market
geared to rapid output for a travelling clientele.

If peasants were idealized as denizens of a purer, more 'authentic'
world than that of the contemporary city, so too were the artists
who depicted them. Like writers and composers – Richard Wagner
above all – mainstream nineteenth-century painters had exceptional
status: not as craftsmen or, despite the efforts of artists' organiza-
tions, as professionals, but as mediators of higher spiritual truths in
an age of rampant materialism. (Some painters' involvement in
spiritualism, and the contemporary vogue for mystico-spiritualist
pictures, was an interesting related phenomenon.) Böcklin and
Klinger, purveyors of myth and enigma to a prosaic world, became
the focus of an extraordinary cult, first among an elite of art-lovers
and then, as their works were more and more widely reproduced,
throughout Central Europe. Images like Stuck's nymphs and
Böcklin's mysterious islands became so famous that they were
adapted to advertise mouthwashes and other commercial
products.[38] Monumental works like Klimt's famous *Beethoven
Frieze* and Klinger's bust of the same composer were manifestations

of full-blown culture- and genius-worship.[39] In their demeanour and lifestyle, and especially in the elaborate pageants staged by the big art communities, artists readily endorsed their own popular image as seers, truth-bringers, and creators of national mythology. The pre-war avant-gardes were not fundamentally different in this respect, and it would be interesting to follow the myth of the artist-as-redeemer further into the twentieth century: in the 1920s at least, Hitler's credentials as both 'unknown soldier' *and* artist doubtless enhanced his credibility as a crusader against modern class society. Not surprisingly, artists also became a tourist attraction in their own right. Summer painting colonies like the island of Frauenchiemsee were eventually overrun with visitors, and celebrities' studios were shown off to the public either directly or via popular magazine journalism. Such adulation, and the wealth and social influence which sometimes accompanied it, inevitably attracted many new recruits into the profession, aggravating the problems of overcrowding and poverty endemic among artists since the end of the old guild system.

The First World War and its aftermath made this much worse. Tourism, especially of the luxury kind, was devastated by hostilities and later failed to regain its pre-1914 level – in Switzerland the stagnation of the 1920s led to the demolition of hotels in some places[40] – despite much greater efforts by governments and local authorities. Germany's 15,000 or so artists endured years of chronic hardship even before the onset of the Depression. This was also true in Berlin, whose huge indigenous wealth had to a certain extent cushioned painters against the vagaries of the international market, but it was undoubtedly worst in traditionally tourist-orientated centres like Dresden, Düsseldorf, and Munich. The total destruction by fire of the old Munich Crystal Palace in 1931, together with thousands of pictures, symbolized the plight of a whole sector of the German art market.

If 1914 brought the end of an era, it did not end the needs which both tourism and art partly served: adaptation to an industrial, urbanized, increasingly disciplined, and bureaucratic society. Travel since the nineteenth century has not only been a form of recreation, but also, often, a quest for more satisfying and meaningful alternative environments. Tourism 'proper', with its elaborate infrastructure, has been only one manifestation of this. Nineteenth-century German patriots journeyed in search of their national roots in the landscape and in 'unspoiled' peasant communities, and to visit the countless national monuments created between the end of

the Napoleonic Wars and 1914.[41] The German youth movement was a reaction, middle-class and male to begin with, but then much broader, against 'denatured' city living and industrial work. Both before and after the First World War, nudists, vegetarians, and *Lebensreformer* founded permanent settlements in the countryside. Finally, there were the peripatetic Bohemians wandering between Friedrichshagen, Schwabing, and Ascona: scattered but genuine representatives of an anti-bureaucratic, anti-militaristic, and anti-patriarchal Wilhelmine counter-culture. Though in a much more limited and temporary way, many tourists also sought escape from a world of alienation and fragmented relationships into an alternative one of self-fulfilment and community. (Pre-1914 battlefield fantasies and perhaps, for a small minority, interest in psychoanalysis may also have reflected this need.) Art, especially the products of nineteenth-century idealism, helped to structure their expectations, and their responses to what they found. Artists emphasized their own separateness from the prosaic 'flatland' world either by withdrawing physically from it – like Fidus, Diefenbach, and the Worpswede painters – or symbolically, by the pastiche-Renaissance, -classical, or -Oriental environments they created for themselves. They enjoyed exceptional status outside the ordinary social hierarchy. Their works articulated myths – heroic, arcadian, erotic – which called in question the validity of the everyday world. This was the background to the flourishing picture-markets of Munich and other tourist centres, and to the vast contemporary trade in popular reproductions.

Notes

1 A. Schärli, *Höhepunkt des schweizerischen Tourismus in der Zeit der 'Belle Epoque', unter besonderer Berücksichtigung des Berner Oberlandes. Geist und Werk der Zeiten*, 67, Bern, Nancy, Frankfurt/Main, New York, 1984: 9–11. On tourism generally, see G. Young, *Tourism: Blessing or Blight?*, London: Penguin Books, 1973; R. Lanquar, *Le Tourisme international*, Paris: Presses Universitaires de France, 1981; E.K. Scheuch, 'Soziologie der Freizeit', in R. König (ed.) *Handbuch der empirischen Sozialforschung*, 2nd edn, 1977, 11, Munich and Stuttgart: Enke & dtv; H.-J. Knebel, *Soziologische Strukturwandlungen im modernen Tourismus. Soziologische Gegenwartsfragen*, 8, Stuttgart: Enke, 1960.
2 See D. Boorstin, *The Image: A Guide to Pseudo-Events in American Society*, New York: Harper, 1964; J. Forster, 'The sociological consequences of tourism', *International Journal of Comparative Sociology* 5, 1964: 217–27; E. Cohen, 'Toward a sociology of international tourism', *Social Research* 39/1, 1972: 164–82; D. MacCannell, 'Staged authenticity: arrangements of social space in tourist settings', *American Journal of Sociology* 79/3, 1973: 589–603; E. Cohen, 'Re-thinking the sociology of tourism', *Annals of Tourism Research* 6, 1979: 18–35.
3 See J. Simmons, 'Railways, hotels and tourism in Great Britain 1839–1914', *Journal of Contemporary History* 19, 1984: 201–22.
4 Schärli, *Höhepunkt des schweizerischen Tourismus*, p. 2.
5 *Jahresbericht des Vereins zur Förderung des Fremdenverkehrs in München und im bayerischen Hochland für das Jahr 1910/11*, Anhang: 36–45.
6 Knebel, *Soziologische Strukturwandlungen im modernen Tourismus*, pp. 28–33.
7 See the excellent essays in G. Grossklaus and E. Oldemeyer (eds), *Natur als Gegenwelt. Beiträge zur Kulturgeschichte der Natur*, Karlsruhe, 1983.
8 See O. Löfgren 'Our friends in nature: class and animal symbolism', *Ethnos*, 1985: 184–213; idem, 'Natur, Tiere und Moral: zur Entwicklung der bürgerlichen Naturauffassung', in U. Jeggle et al.

(eds) *Volkskultur in der Moderne. Probleme und Perspektive empirischer Kulturforschung*, Reinbek: Rowohlt, 1986.

9 See especially Leslie Stephen, *The Playground of Europe*, London, 1871.

10 Young, *Tourism: Blessing or Blight*, p. 24.

11 See W. Duschek, 'Vom Wesen und Wandel Merans, 1860–1900', in *Leo Putz 1869–1940. Gedächtnisausstellung zum 40 Todestag*, Bozen: Athesia, 1980.

12 M. Krauss, *Die Grundlagen des Fremdenverkehrs in München und im bayerischen Hochland. Kleine Beiträge zu einer Geschichte des Fremdenverkehrs in München*, Munich, 1917: 54.

13 See R. Hacker (ed.) *Ludwig II von Bayern in Augenzeugenberichten*, Düsseldorf: Karl Rauch, 1966.

14 House of Commons Sessional Papers 1911, vol. 93: *Commercial Reports*, no. 4798, Bavarian Commerce 1910/11: 8.

15 *Münchener Neuigkeitsblatt* 9/32, 7 August 1912. More generally, see annual police reports in *Staatsarchiv für München*, Munich, *Polizeidirektion* 4124–6; *Regierungsakten* 3830/58113.

16 Paul Klee, *Briefe an die Familie 1893–1940*, ed. F. Klee, Cologne: Dumont, Vol. 1, 1980, 34: Klee to family, 14 November 1898.

17 See D.C. Large and W. Weber (eds) *Wagnerism in European Culture and Politics*, Ithaca and London: Cornell University Press, 1984.

18 House of Commons, Sessional Papers 1908, vol. 112: *Commercial Reports*, no. 3936, Trade and Agriculture of Bavaria 1906/7: 11–12.

19 *Stadtarchiv*, Munich, *Kulturamt* 397 (Prinzregententheater); see also petition of *Verein zur Förderung des Fremdenverkehrs* to city authorities, 23 October 1905.

20 J. Huret, *En Allemagne. La Bavière et la Saxe*, Paris, 1911: 29.

21 E. and J. de Goncourt *Journal. Mémoires de la vie littéraire*, Paris: Fasquelle-Flammarion, Vol. 1, 1956: 809.

22 See E. Ruhmer (ed.) *Die Münchener Schule 1850–1914*, Munich: Haus der Kunst/Bruckmann, 1979.

23 *Germanisches Nationalmuseum*, Nuremberg, Heinemann Archive. See also Robin Lenman 'A community in transition: painters in Munich 1886–1914', *Central European History* 15/1, 1982: 3–33; and idem, 'Painters, patronage and the art market in Germany 1850–1914', *Past & Present*, Nr 123 (May 1989): 109–40.

24 Hauptstaatsarchiv, Munich, MK 14 174, deed of 1 November 1912.

25 See C. Bugler, '"Innocents abroad": nineteenth-century artists and travellers in North Africa and the Near East', in M.A. Stevens (ed.) *The Orientalists: Delacroix to Matisse. European Painters in North Africa and the Near East*, London: Weidenfeld & Nicolson, 1984.

26 See Ruhmer, *Die Münchener Schule 1850–1914.*

27 Krauss, *Die Grundlagen des Fremdenverkehrs in München...*, p. 24.

28 T.E. Rosenthal, *Erinnerungen eines Malers*, Munich: Pflaum, 1927: 45.

29 Scharli, *Höhepunkt des schweizerischen Tourismus*, pp. 41–53.

30 ibid, p. 48.
31 See S. Wiese, 'Die Düsseldorfer Kunstakademie 1900–14, zwischen Restauration und Reform', in *Düsseldorf: Eine Großstadt auf dem Weg in die Moderne*, Dusseldorf, 1984.
32 See I. Farr, 'Populism in the countryside: the Peasant Leagues in Bavaria in the 1890s', in R.J. Evans (ed.) *Society and Politics in Wilhelmine Germany*, London: Croom Helm, 1978.
33 A. Rosenberg, *Defregger*, Bielefeld and Leipzig: Velhagen & Klasing,1900: 42.
34 See T. Kulka, 'Kitsch', *British Journal of Aesthetics* 28/17, 1988.
35 Marius, *Dutch Painters of the Nineteenth Century*, ed. G. Norman, London: Antique Collectors' Club, 1973: iv.
36 See A. Reverdy, *L'Ecole de Barbizon. L'Evolution du Prix des Tableaux de 1850 a 1960*, Paris and The Hague, 1973; and C. Carter, 'Where stands the Hague School now?', Part 1, *Apollo* 71, 1960a: 173–6.
37 M. Doerner, *The Materials of the Artist and Their Use in Painting*, rev. edn, London: Harrap, 1949: 89.
38 H. Väth, '"De arte odoleo": zum wechselseitigen Verhältnis von Reklame und Kunst um die Jahrhundertwende', in U. Geese and H. Kimpel (eds) *Kunst im Rahmen der Werbung*, Kassel, 1982.
39 M. Bisanz-Prakken, *Gustav Klimt: Der Beethoven-Fries. Geschichte, Funktion und Bedeutung*, Munich, 1980: dtv.
40 Schärli, *Höhepunkt des schweizerischen Tourismus*, conclusion.
41 L. Tittel, 'Monumentaldenkmäler von 1871 bis 1918 in Deutschland. Ein Beitrag zum Thema Denkmal und Landschaft', in E. Mai and S. Waetzoldt (eds) *Kunstverwaltung, Bau- und Denkmalpolitik im Kaiserreich. Kunst, Kultur und Politik im Deutschen Kaiserreich*, 1, Berlin, 1981; compare M. Klinge 'The North, nature and poverty: some background on the Nordic identity', in *Dreams of a Summer Night. Scandinavian Painting at the Turn of the Century*. London: Arts Council of Great Britain, 1986.

7 Art as a weapon: social critique and political orientation in painting and print in Weimar Germany

Willi Guttsman

This essay is not concerned with an art historical subject in terms of style or connoisseurship, but looks instead at the interface of art and politics and at the political symbolism conveyed by works of art and at art's role in persuasion and propaganda. In any case the days when art history was conceived largely in terms of techniques and aesthetics are long past. There is today a growing interest in representational painting and sculpture, in artistic symbolism, and in the social context of the production and reception of art.[1] The last is of particular interest to social and cultural historians. We can approach it at the macro-level, as in attempts to link broad changes in style and techniques to major social shifts; or we can look at it at the micro-level, in terms of emotions and attitudes which a work of art evokes in the viewer. The latter is particularly significant when the art in question is avowedly didactic and political and when it deliberately sets out to influence attitudes and to induce action, and when it is used by political organizations for such purposes.

The art of the years of the Weimar Republic is a model *par excellence* for the creation and dissemination of political and social art. There is probably no other place or period in which this was more in evidence. Indeed, among the names that figure prominently are artists like Max Beckmann, Otto Dix, Conrad Felixmüller, George Grosz, John Heartfield, and Käthe Kollwitz whose art portrays social misery and economic deprivation or satirizes the role of the bourgeois elite groups, attacks war, and castigates philistinism, nationalism, and militarism. Much of the relevant art is only concerned with the criticism of existing conditions but there is also art of a politically more affirmative kind which seeks to raise the self-esteem and the self-confidence of the worker.

The production and dissemination of such art was intimately connected with the political parties of the left and helped by the cultural organizations which they had created. Their ideas and ideals received a wider circulation after the revolution and this led to the formation of associations of artists with political aims or with artistic aims influenced by radical or socialist beliefs. All this helped to create pictorial imagery which was influenced by left-wing ideologies and which assisted with their wider ciculation. Posters and popular illustrations were particularly important in this process and this essay will pay special attention to them.

Committed art of this type hardly existed in Germany before the beginning of the twentieth century. Work and industry had been themes for painting and sculpture at least from the middle of the previous century. So had the poor, but unlike in Britain where the widespread discussion of the 'Social Question' was reflected in paintings and prints with a socially critical theme, in Germany this art had been conceived largely as *genre* painting; Wilhelmine art up to 1900 only rarely concerned itself with issues relating to social justice or politics.[2]

One minor exception, but one that is significant in the context of this essay, was some of the graphic art associated with publications of the German labour movement. Linked to the rise of the Social Democratic Party (SPD) founded in 1875, there arose a number of political journals and magazines. Among them was the satirical fortnightly *Der Wahre Jakob* (1881–1932) with a circulation of 100,000 within a decade and 400,000 by 1914.[3] Although much of its content was devoted to broad humour it also regularly published cartoons that commented on the political and social situation as well as allegorical drawings which took the political struggle of the proletariat as their theme.[4] Thus a New Year illustration of 1903 shows a compact between a muscular worker and the figure of Liberty, wearing the phrygian cap of the revolution and holding the palm of peace. At their feet the representatives of Monarchy, Church, and Bourgeoisie rail at them in vain (Figure 7.1).

Stylistically and thematically this magazine art was firmly rooted in the world of naturalist and representational art. The political art of the immediate post-revolutionary period was much more influenced by the expressionist style of the first two decades of the century. It now became for a short time the dominant art-form and the idiom in which most politically committed artists worked.

Expressionism was itself a revolutionary art, departing radically from what was traditionally conceived as realism in its treatment of

7.1 'A Happy New Year' Illustration from *Der Wahre Jakob*, 1903.

colour and form. It wished to penetrate beyond the outward
appearances of things to reach the essential aspects of physical
phenomena. Artists who worked in this style tended to oppose what
they regarded as the false outward appearance of society, rejecting
the philistinism and the materialism of existing bourgeois society.
Against a tradition which, they felt, was hostile to new develop-
ments, they looked for a 'new consciousness, new ideas and new
forms'.[5] What is important in the present context is however not
just the stylistic origins and developments but the tendency for
expressionist painters and others to get away from the concept of
l'art pour l'art, to engage themselves politically, and to identify
with some of the social and political ideals of the time. This had
happened already to a certain extent before the war, but it was
strengthened by the war and it became more widely popular among
artists with the advent of the Weimar state after the revolution of
1918.

Even before the war some artists had chosen revolutionary
subjects in their work. Thus Käthe Kollwitz, who grew up in a social
democratic family and married a socialist doctor, created two great
graphic cycles illustrating the story of the 'Weavers' Uprising' and
of the 'Peasants' War'. Though historical, these etchings were often
interpreted as comments on contemporary society and her etching
'Outbreak' (*Losbruch*), which portrayed revolutionary fury, was
frequently reproduced in socialist magazines (Figure 7.2). The
widespread feeling in these years, that cataclysmic changes were
imminent, influenced expressionist art. Ludwig Meidner painted a
series of apocalyptic landscapes, in which towns seemed to be rocked
by quakes, as well as 'The Agitator' (also known as 'Revolution' and
'Fighting on the Barricades') which captured the feeling of impend-
ing doom and violence. He urged his fellow artists to choose the city
as an appropriate theme for the modern style: 'Our quavering hands
should scratch on frescoes and large canvasses the monstrous and
dramatic aspects of avenues, railway stations and towers.' Behind
the aesthetic concept stood a somewhat wider idea; Meidner was
not only concerned with stylistic matters, he sought to cover 'life in
all its complexity, space, light and shade and the movement of
things, in short a deeper penetration of reality'.[6]

The violence which Meidner had foreseen in his canvasses did
indeed erupt and the war and the events associated with the
revolution of 1918 affected post-war painting and the graphic arts.
'The war, that great practical demonstration of how to see things in
a new way', as Bertolt Brecht had put it, not only led to an increase

7.2 Käthe Kollwitz, *Losbruch* ('Outbreak') etching, 1903.

in the number of those who painted and wrote in the expressionist style, but it made many of the young and iconoclastic artists sympathetic to socialist, pacifist, and even revolutionary thinking. As one of the earliest writers on Expressionism put it in 1920, 'a deep-rooted socialist attitude was before the war alive in only a few. The war has carried it into very wide circles. Three sentiments merged into it: an antipathy to the bourgeoisie, resistance to the military and an approach to the proletariat.'[7]

Max Beckmann expressed such sentiments in an essay entitled 'Bekenntnis' written obviously during the war but published in 1920. He wrote that

> the war is now coming to its sad end . . . we shall be experiencing hard times. Yet now even more than before I have the wish to be among people and in the city. That is where we now belong. We must take part in all the misery that is now before us; we must open our hearts and minds to the desperate cries of pain from the deceived humanity.

He admitted that selfishness and philistinism were widespread and that a hankering after success had touched everybody, but thought that the war may have sobered up people. Beckmann hoped that 'a lessening of business acumen and perhaps . . . a more vigorous pursuit of communist principles will lead to a growing love of things for themselves'.[8] Beckmann spent part of 1919 in Berlin and experienced the city in its suffering and in its revolutionary upheaval. Berlin was obviously the background for a portfolio of ten lithographs which he published in the city in the same year. The prints undoubtedly illustrate the purgatory of hell in both a general and a personal sense. They also present a 'spectacle' as the title page, with Beckmann in the guise of a circus barker, indicates. But above all, the work describes the reality of life in the city with its hunger, sleaziness, and violence as well as the political struggle. Prints illustrate the arguments among the ideologues, the last desperate stand of the revolutionaries, and the brutal murder of Rosa Luxemburg by the soldiers of the Free Corps at the entrance to the Hotel Eden – an almost literary representation of the actual event. The series also harks back to the war and its aftermath as in the first folio, entitled 'The Way Home', which shows the artist, in the role of a *flaneur*, encountering a hideously disfigured and crippled soldier under a street lamp.[9]

The symbolic figure of the crippled war-veteran occurs repeatedly in the paintings and prints of the early years of the Weimar

Republic. He appears as the blind beggar, a young man on crutches, or as an amputee sprawled on the pavement selling bootlaces or matches. 'The streets [of Berlin] were peopled by crippled beggars, men blinded by shrapnel or by the legless across which one stepped hastily in shoes or bootees, as George Grosz or Otto Dix had drawn it.'[10] Such figures were not only meant to arouse pity or express the horrors of war, but by showing the disabled in an uncaring society, they often commented critically on contemporary society.[11] Otto Dix, in particular, repeatedly returned to the theme in paint and in print. For example, in the juxtaposition of the disfigured soldier and the whore, published as 'Two Victims of Capitalism', or in the blind matchseller with no legs, sitting on the pavement, with only the legs of elegantly dressed and well shod passers-by in view. A peeing dachshund completes the picture and the symbolism (Figure 7.3).

Such pictures also symbolize the failure of the German revolution, which did not succeed in changing the structure of society in any fundamental sense. This failure is at the root of much of the political art of the period. The representatives of the old order remained very powerful even after the revolution and they formed the subject of much of the satirical art of the period. It found its public outlet above all in the satirical magazines of the left, in particular in a series of journals published by the Communist Party or associated with it. Prominent among the art reproduced in e.g. *Die Pleite* (1919–20; 1923), published by the *Malik Verlag*, was the work of George Grosz. No artist hit his targets more tellingly and more fiercely than he. He produced stereotypes of such biting irony that they survived the contemporary setting to be used later in more overtly propagandist forms. At the first *Internationale Dada Messe* (1920) Grosz exhibited a large canvas – *Deutschland, ein Wintermarchen* ('Germany, a Winter's Tale'), echoing Heinrich Heine's celebrated poem. He called it a great political picture consonant with his view that art which did not serve the political struggle was meaningless and irrelevant. The painting is unfortunately lost but Grosz described it at the time:

In the middle of the canvas I placed the eternal German bourgeois, thick-set and anxious, sitting at a rickety table with cigar and morning paper in front of him. Underneath I put the three pillars of society, Army, Church and School – the schoolmaster with a black, white and red cane, the colours of the German Empire. The bourgeois holds fast on to knife and fork, for the world was shaking

7.3 Otto Dix, *Matchseller*, oil, 1920.

underneath him A naval rating and a prostitute complete the picture of the world which I then had.[12]

The naval rating was clearly symbolic of the revolutionary forces which had received a first impetus in the naval mutiny in Kiel at the beginning of November 1918, while the prostitute, a common subject in the art of the period, stood for exploitation and the evils of the capitalist system. When Grosz returned to the theme a few years later in his *Stützen der Gesellschaft* ('Pillars of Society'), the world no longer shakes and the representatives of the old order, some with piss-pots on their heads or with their skulls open to reveal their strange phantasies, are again firmly in the ascendant.

Grosz is the artist who, during the first few years after 1918, created by far the largest number of images which were inspired by a critical political judgement as well as by a moral disapproval of the mores and attitudes of bourgeois society. He took Hogarth and Rowlandson as his examples and he wished to become a German Hogarth.[13] It was in his drawings that he expressed his criticism and his revulsion, and it was largely through the insistence of the brothers Wieland Herzfelde and John Heartfield that these drawings were translated into lithographs or other prints and published in limited or in popular editions by *Malik* or reprinted in magazines.[14] 'Art', Grosz wrote in 1924 'is for me not a matter of aesthetics, the reflection of a mystical experience . . . rather drawing must subordinate itself to a social purpose.' He saw himself as a popular artist who had come to the firm decision not to 'stand on the side of the exploiters but on that of the exploited, who wished to come to grips with their exploiters'.[15]

Grosz created a class-specific typology of the German bourgeoisie and thus provided visual ammunition for anti-bourgeois sentiment. Other works provided a more specific political lesson so that 'the spectrum of his position stretches from a broad anti-bourgeois feeling to a specific communist position'.[16] To teach such political lessons Grosz often used the principle of simultaneity and of dialectical presentation in his work. He would show a variety of scenes in one drawing or combine different scenes in juxtaposition. Thus in 'The Communists fall and the Dividends Rise' he shows in the foreground the champagne-sipping bourgeois and in the background the bayoneted workers. Even more pointedly is his 'For the Fatherland – to the Slaughterhouse', which was published in the Communist satirical magazine *Der Knüppel* ('The Truncheon') on 25 July 1924. The cartoon shows at the top a trio consisting of an

arms manufacturer sitting back to back with a General on whose knees Adolf Hitler shares the ride while below manacled and blindfolded soldiers are led away (Figure 7.4).

The ferocity of Grosz's images, coupled with a certain naivety in his style of drawing, posed problems for some of his audience. His irony and his eye for the ironical did not stop at the proletariat. Kurt Tucholsky, himself a satirist in words, said of Grosz that 'he knew of no one who had shown the physiognomy of the powerful, down to the reddish hue of the drinker, as faithfully as he. His secret – he does not only laugh, he hates.'[17] His portrayal of the working

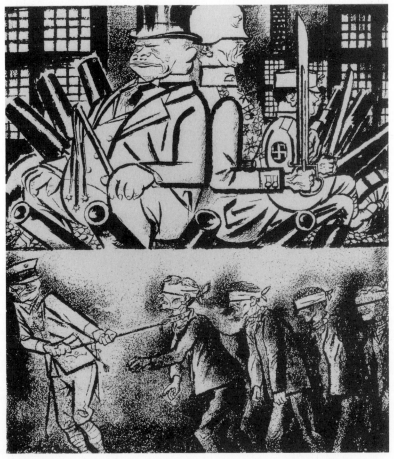

7.4 George Grosz, 'For the Fatherland – to the Slaughterhouse', *Der Knüppel*, 25 July 1924.

class is not hostile, yet it lacks empathy and understanding. His workers are not shown as heroic fighters but every inch as the oppressed and the meek. Class-conscious workers, it was argued, would fail to recognize themselves in his drawings, and the Communist Party, of which Grosz was a member until 1923, attacked him for his failure to paint the revolutionary working class.[18]

Problems of the link between artists and the working class became important in the years immediately after the revolution. Unlike Grosz few artists were politically organized, although more were in broad sympathy with the aims of the left. Under the influence of the humanitarian communitarianism which we associate with the *'O Mensch'* type of expressionism, a number of artists' circles and societies sprang up soon after the revolution. The best known are the two Berlin associations, the *Novembergruppe* and the *Arbeitsrat für Kunst*, which were active during the first two years after the revolution.[19] They claimed 'to stand on the fertile ground of the revolution. Our slogan Liberty, Equality, Fraternity'. They were not only concerned to make the arts more democratic – 'to liberate art from age-long tutelage' as the *Arbeitsrat* put it and take artists down from the high pedestal on which bourgeois aesthetics had put them and to treat them more like craftsmen – they also declared their adherence to broad socialist principles, though of an ethical rather than an economic kind.[20] As the Dresden journal *'Menschen* – a journal for new art' put at its mast-head, the new movement sought to counter the materialism which in its view had caused the war with idealist principles.

> In literature and the arts this idealism is expressionism, which is not a matter of techniques or forms but a matter of the spirit, not of yesterday but found eternally in the history of man. On the political plane this idealism is a non-nationalist socialism which must be realised.[21]

One of the aims of many of these new enthusiastic associations of artists was a desire to reach the masses, to be of the masses. They generally wished to popularize art, not in some 'reach-me-down' fashion but by making the artist became a worker among workers. In his plans for the Bauhaus, Walter Gropius spoke of a new guild of craftsmen 'without the class-dividing pretensions which in the past sought to create a high wall between artists and craftsmen'.[22]

Yet however strongly politically committed such artists were, most of their art was not political, or its 'political' character was

expressed in symbolic forms and often needed a verbal explanation. This could take the form of a text which formed an integral part of a picture, or a picture which needed an accompanying literary allusion. The former can be seen in Schmidt-Rottluff's war-time woodcut of the head of Christ with 1918 written on his forehead and the legend 'Did Christ not appear to you' cut into the block. And Lyonel Feininger's print of a church against a background of slanting beams of light, known as 'The Cathedral of Socialism', on the cover of the *Bauhaus Manifest* is explained in the text by reference to the 'crystalline symbol of a future faith which would come out of the co-operation of architecture, painting and sculpture'.[23] The flourishing graphic art of the period contained a sizeable number of expressionist portfolios and single prints which dealt with quasi-political themes in a general and usually abstracted fashion.[24] Some of these reached a wider audience through publication in magazines like *Die Aktion*, whose title-page generally carried reproductions of prints, or in other similar journals. However, few of these would have come to the notice of German workers, or impinged on their consciousness if they did.

There was however one area where expressionist art with a political message came before the broad masses – namely a poster campaign which the new government instituted immediately after the revolution. Its propaganda agency, the *Werbedienst*, commissioned a number of artists of the *Novembergruppe* to design a series of posters which combined a general appeal to support the new government with the specific call to vote at the elections for the National Assembly and not to boycott the reconstruction programme by strikes or other 'irresponsible' acts. A contemporary account relates that the visual effect of this poster campaign was striking: 'A flood of paper covered walls and windows in Berlin and created orgies of colour in the city.'[25] Cesar Klein's poster (Figure 7.5), whose translated text reads 'Workers, Bourgeois, Peasants, and Soldiers from all German Regions, unite in the National Assembly' is an appeal for a classless national community. The sectional representatives are dressed in historical costumes and they, and the anonymous masses behind them, are raising their arms in an act of oath-taking. Their affirmation of the utopian national community of the future is echoed by the symbolism of the rising sun, which bathes the scene in a golden light, and by the colours used: the blue, white, and red of the tricolour and the black, red, and gold, the colours of German's nineteenth-century radicals which were to become the colours of the republic.[26] At the same time Max

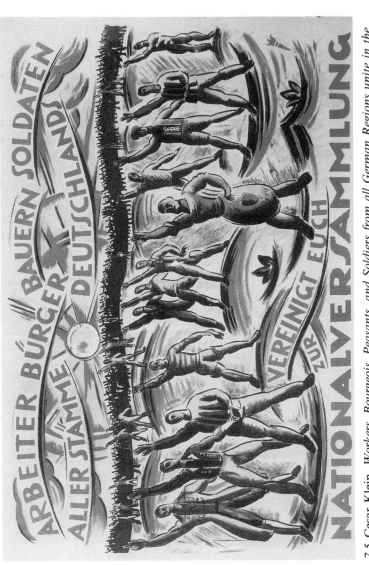

7.5 Cesar Klein, *Workers, Bourgeois, Peasants, and Soldiers from all German Regions unite in the National Assembly*, poster, 1919.

Pechstein had created a similarly symbolical poster, 'The National Assembly, the Cornerstone of the German Socialist Republic', in which a bricklayer, trowel in his right hand and the left raised in a gesture of salutation, kneels on the foundation stone against a background of fluttering red flags. Such posters convey feelings of excitement, pathos, and movement, but by all accounts they did not find favour with the working-class public. The workers did not recognize themselves in these highly stylized accounts. They felt they were being ridiculed, while the expressionist artists, who had sought to build bridges to the working class, felt themselves rebuffed.[27]

It is not surprising that the Social Democratic government or its propaganda machine should have disseminated images which conveyed sentiments of a peaceful reconstruction of society and the economy. Yet despite its desire for a quick and orderly transition to stable political and economic conditions, the revolutionary struggle continued for some months. This struggle gave rise to works of art either in the form of quasi-documentary accounts, as discussed above, or as more symbolic images. Thus the brutal murder of the Communist leaders Karl Liebknecht and Rosa Luxemburg was a traumatic event for large sections of the labour movement and prompted a series of drawings and prints which commemorated the dead and which, in cheap copies or reproduced in magazines, reached a wider audience. Given the secular, anti-religious character of socialist ideology it is interesting to observe how many of these works convey religious or transcendental images. Käthe Kollwitz drew Liebknecht on his bier and eventually created a woodcut of a lamentation with the caption 'The Living to the Dead' in reversal of the title of a poem by Freiligrath in which he commemorated the dead of the revolution of 1848. Conrad Felixmüller portrayed the pair in a lithograph which shows them in apotheosis floating over the rooftops. The most blatantly ideological was a small woodcut by K.J. Hirsch of Liebknecht's head surrounded by a halo in the memorial issue of *Die Aktion*.

Alongside the interpretation of the political events and the creation of the bourgeois 'enemy' in the radical satirical art of the period we have another strand of political art which is best described as 'critical social reportage'. It advances a critique of social conditions and at the same time, conveys an exhortation to fight for a better society. We find this in artists like Felixmüller and Kollwitz who show the worker in his social and industrial situation and in doing so restrict themselves to the essentials of suffering, of

the burden of work and of acts of protest. Felixmüller had been awarded a scholarship to study in Rome but he used the money to go to the Ruhr and paint and draw there. 'To show the toiling proletarian', he recalled many years later, 'I was reduced to the simplest forms, to reproduce simple, organic things which could be comprehended in their natural, their human and their social context.'[28] The language may be clear but the meaning may be hidden. In 'Children in the Ruhr' Felixmüller showed barefoot and rickety children against the grim background of industrial buildings and the gasworks. His 'Comrades' makes a political statement in what at first looks like the portrayal of a meeting. The clue lies in the background, for the two workers meet in a cemetery in front of graves, one of which has the inscription 'Ein Matrose' (a naval rating); this refers almost certainly to the execution of Köbis and Reichpietsch, who in August 1917 led the crew of the ship *Prinzregent Luitpold* in a protest action. The greeting is the sealing of a compact to continue the work of the revolution (Figure 7.6). 'Such works', wrote the playwright and critic Carl Sternheim, 'peel the mask from the faces of our contemporaries and there appeared for the first time the proletarian, hitherto passed over in silence.'[29]

In Käthe Kollwitz's art the central themes are human suffering, the downtrodden, and the oppressed. Her subjects are care-worn women, those bereaved in war, the hungry, and the sick. Workers had always attracted her, but initially purely aesthetically. Only later, when she realized the burden and the tragedy of the life of the proletariat, was she 'stirred to her depth by the proletarian fate in all its aspects'.[30] Thus identifying with her subjects she made her work serve specific political ends, endeavouring to stimulate remedial action. Many were used as posters, seeking help for the hungry, advocating pacifism, or opposing the strict anti-abortion legislation. Being thus issue-related, her art, Kollwitz recognized, was not as 'pure' as that of the *Brücke* artist Schmidt-Rottluff with whom she had compared herself, but 'it was art nevertheless . . . 'I accept that my art has a purpose' she wrote in 1922: 'I wish to be effective in these times in which people are so much in need of help and advice.'[31]

Towards the end of our period Kollwitz created 'The Demon-stration' which showed the positive side of working-class existence. This strand of political art grew in importance during the later years of the Weimar Republic and found expression in groups and organizations of left-wing artists like the Political Constructivists, based in Cologne and the nationwide ASSO, founded in 1928.

7.6 Conrad Felixmüller, *Comrades*, lithograph, 1920.

The ASSO (*Assoziation Revolutionärer Bildender Künstler Deutschlands*) was formed by members of the Graphics Studio of the German Communist Party. It continued the tradition of earlier radical groups of artists, especially the *Rote Gruppe* of 1924.[32] Its statutes committed its members to be active in the political struggle. That meant helping with the agitational activities of the KPD through the design and execution of banners, flags, leaflets, and displays, and in general with the 'revolutionizing of the street scenes' through posters and other devices. The ASSO did not only involve professional artists but also amateurs, like the members of the *Arbeiterzeichner* (Workers' Illustrators) who were the foot-soldiers of communist visual propaganda, illustrated broadsheets and handbills, and made simple posters.[33] At a more sophisticated level members of the ASSO were urged to 'further the class struggle through the creation of art that was adapted to the needs of the working class stylistically and content-wise'.[34] This did not imply that all the artists were expected to follow a common style but that their art should be sufficiently realistic to be comprehended by the masses.

The Association did, however, advocate art which not only took workers and their lives as its theme but which also showed them as self-confident and self-assured, no longer sufferers but healthy and untroubled and joining the struggle with confidence. Such paintings as Otto Griebel's 'The International' and Wilhelm Lachnit's 'Communist Frölich' extol the virtues of the revolutionary fighters, the dignity of work, and the quiet confidence of the worker in his belief in a better future (Figure 7.7): 'The exploited and impoverished worker is shown so to speak from below, not seeking or needing compassion but conscious of his own personality.'[35] The belligerent and critical art of the early years of our period continued – indeed, it was particularly marked in the work of the small Berlin group *Die Zeitgemässen*, which affiliated in 1932 – but the constructive and creative element of the workers' movement became more important. The Dresden group of the ASSO was particularly active in the production of this kind of art and its members were very assiduous in providing visual material for political agitation. Hans and Lea Grundig made political propaganda with simple woodcuts or linocuts incorporating such slogans as 'Suicide is no solution, fight with the KPD' and 'Strike – join the RGO' (the revolutionary trade union opposition). These were sold for pennies in pubs and at meetings.

In contrast with the ASSO which was a comparatively large organization of about 800 members, the Political Constructivists

7.7 Otto Griebel, *The International*, oil, 1928–30.

were a small group. Franz Seiwert, their intellectual leader, Gerd Arntz, and others were anarcho-syndicalists or dissident communists but they also published their graphic work in the local Communist paper *Sozialistische Republik* or in *Die Aktion* in addition to anarchist publications. They were not only strongly committed politically but they were also anxious that their work should reach the masses. They sought to instruct and agitate and distil in their work their theoretical interpretations. Much of their work was strongly didactic, paintings and prints which show a highly stylized representation of people and events.[36] By using stereotypes Seiwert wished to bring out the common and uniform nature of the worker's experience and of his role in the social conflict and the political struggle. As Seiwert put it, 'proletarian tendential art does not come from putting a proletarian prefix to bourgeois paintings of historical or battle scenes. The transformation of form is just as important as transformation of content.'[37] If the workers were presented as faceless this was because this represented both their fate as members of an oppressed class as well as their individual anonymity in the common struggle. Other social groups, too, are often treated symbolically, as in Franz Seiwert's small drawings, etchings, linocuts, or woodcuts like 'Bourgeois and Unemployed', 'Workers between the Transmission Belts', or 'People in Prison'; or the crowded, analytically conceived prints by Arntz in series like '12 Buildings of our Time' showing Bank, Barrack, Hotel, Theatre, etc., or the so-called *Lehrstücke* (didactic pieces). They are all concerned with the pictorial representation of elementary social situations and conflicts. Arntz's woodcut 'Above and Below' demonstrates some of the techniques and concepts of the Political Constructivists. The print uses the symbolism of the mine and it contrasts bourgeois love with proletarian death. At the top of the print a motorcar carrying a bourgeois and, presumably, a prostitute, symbolizes the rich and the powerful. In the middle miners are at work with a fully laden coal trolley which contrasts with the mechanical power of the automobile. A miner buried by a fall of coal, with a stretcher waiting to receive his body, denotes the bottom of the social ladder (Figure 7.8).

Contrast and simultaneity such as we find in this didactic and dialectical art resembles that of George Grosz, but the satirical element in the latter's drawing and his moralizing is almost completely absent from the art of the Cologne group. Gerd Arntz showed his awareness of this when he said that he only wished to put political principles and their solution into his pictures. His

7.8 Gerd Arntz, *Above and Below*, woodcut *c.* 1931.

capitalist did not have to be an ugly and criminal; he could be good-looking and a decent family man. And Arntz rejects the view of the worker as a creature of misery:

> We too show the worker as miserable because he is the product of miserable circumstances, but with us he was also the revolutionary who tackled things. Our art was to make a contribution to tearing the old society apart. It was propaganda, it attempted to reveal social contrast and show social opportunities, not just mobilizing criticism.[38]

For the ASSO, too, art was propaganda or, as a leaflet put it in 1932, 'art was a weapon in the class struggle'.[39] How effective this weapon was in the case of the highly abstracted art of Seiwert and his colleagues is an open question. Seiwert was aware that their art required a prior analytical understanding. He wrote that his pictorial language was that of a 'coded telegram conceived in paint which, however, could only be read and decoded by the class conscious'.[40]

Poster art, especially, was a major form of communication of visual and literary messages, which was extensively used and was widely available. Elections were frequent and as local party organizations might produce their own posters in addition to using national ones the total number of posters, including posters for May Day celebrations and for general political propaganda, must have run into hundreds. Mass demonstrations and meetings also used visual displays in the form of banners, placards and even three-dimensional objects, such as a model of a soldier entangled in barbed wire used in an anti-war demonstration. Next in importance to the poster and other public display art is the workers' press with its illustrations. Here the satirical magazines are of central importance. The Social Democratic *Wahre Jakob* and *Lachen Links* and the Communist *Knüppel* and its successors *Eulenspiegel* and *Roter Pfeffer* had circulations of 50–100,000 copies. The most popular of the weeklies, the Communist *Arbeiter Illustrierte Zeitung* (AIZ), reached a circulation of half a million, considerably more than *Volk und Zeit*, an illustrated supplement to many Socialist dailies.

Poster and media material was clearly of the greatest importance in the process of political visual communication. They transmitted to a broad public social criticism and views on Socialist and Communist policies 'and goals. This art also provided a relatively extensive store of images which permit an analysis of themes and symbols used and an examination of the relationship

of this to the ideological stance of Social Democracy and of the Communist Party. Such a comparative analysis must concentrate on specific criteria of which a few are given here as examples. One of these is the way in which the parties project themselves and their potential following in terms of class and background. There is some indication that Communist visual imagery refers almost exclusively to manual workers while the SPD's desire to be a *Volkspartei* – a People's Party – is likewise reflected in some of the media.[41] Next to their self-assessment figures the assessment of the 'enemy'. Posters of both parties refer to the bourgeoisie, or to sections of it, and we can observe that in Communist poster-art the 'enemy' is portrayed more often and is treated with greater acerbity than in Social Democratic imagery. In the iconography of the divided left of the Weimar Republic the two parties' views of each other became increasingly important as their conflict became increasingly bitter and as the KPD in particular concentrated its fire as much on the SPD as on the other parties. This can be seen in the various media. Through this kind of analysis the study of politically-oriented visual images can be a useful adjunct to the study of ideology and party politics based on the documents; yet we should not conclude that the public art of the left can be neatly divided between these two camps. On the contrary, there is much symbolism in common, the picture of the 'Giant Proletariat', for example. This is one of the oldest and most powerful iconographical motifs used in the struggle of the working class. It has its origin in Daumier's cartoon in defence of the freedom of the press (1834) in which the printer asserts his strength against the machinations of the royalist camps. Combined with the image of Gulliver and the Lilliputians we find it used in illustrations and posters throughout the period. The proletarian acquires his 'stature' as a giant, either in relation to his environment, as in the 1930 SPD poster which shows him against the background of what appears to be a closed-down mine, asserting his right to existence (Figure 7.9), or just by expressing enormous strength as in a Communist drawing, probably of the same year, with the caption 'Make Room for the Worker' (Figure 7.10).[42]

Such alleged power was also expressed through parts of the human body like the boot-clad foot or the outstretched hand, as in John Heartfield's famous poster with the caption '5 Fingers has the hand, with 5 you grasp the enemy, vote list 5 Communist' or in the Social Democratic drawing by W. Krain showing a phalanx of

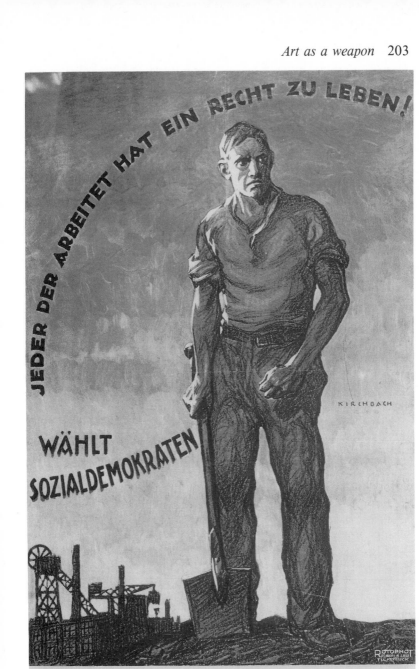

7.9 G. Kirchbach, *Everyone who works has a right to live*, poster, 1930.

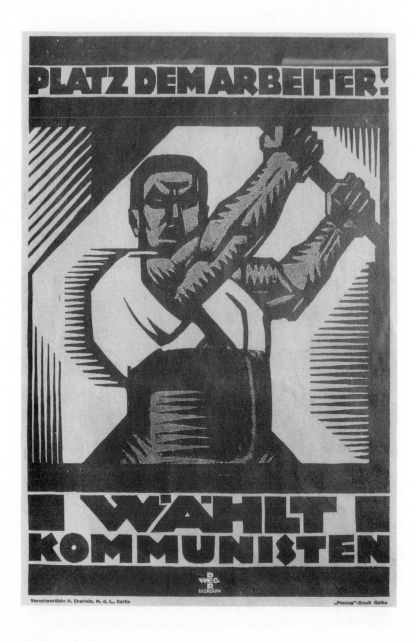

7.10 N. Sagrekow, *Make Room for the Worker*, poster 1930.

raised fists against small figures of Nazis with the text 'Clench your fists now so that one day you will not have to clench them in your pockets'.

Other symbols were also used in the agitational art of the German labour movement. Red symbolized the struggle and after 1918 the fluttering red flag increasingly replaced the stiff banner in demonstrations. Sun or fire symbolized hope and enlightenment and in the form of a torch it also stood for the ideal and for tradition, as in a poster by Rudolf Schlichter with the caption 'The Flame of the Revolution must not be Extinguished'. Nor must we forget the often replicated historical portrait of Liberty as a young woman on the barricades, holding the tricolor. After Delacroix's painting (1830) it regularly recurred in socialist illustrations, 'Tableaux Vivants', or in 1936 in Heartfield's photomontage on the Spanish Civil War with the caption 'Liberty Herself Fights in their Ranks'.[43]

Satire had comparatively little place in poster art, perhaps for no other reason than that the poster must make an immediate impact and should not require detailed study. Where we find a more narrative image there is some evidence of specific party political orientation. Good examples are two formally similar posters of 1928 (Figures 7.11 and 7.12) Both posters appear to borrow from George Grosz's painting 'A Winter's Tale' and its portrayal of the 'Pillars of Society', discussed earlier. In the SPD poster a muscular worker stands tall not only above the cringing figures of officer, cleric, and Junker, but also above a simpleton-like Communist worker. The Communist double-take poster also uses representatives of the ruling class but they manoeuvre the Social Democrat, all mouth and no strength, from behind, while the robust Communist worker chases the old gang away. The double heading reads 'Through coalition to socialism' (sic!) and 'Vote Communist'. Here is not only a visual representation of the 'Social Fascists' slogan which the KPD used increasingly in its attacks on the SPD but also evidence in support of the SPD's view of Communist policy as manipulative.[44]

The difference in the way in which satire was used can also be traced stylistically. Communist artists tended to use sharper outlines and their caricatures were often more brutal than those of the SPD. A comparison of the satirical magazines of the two parties demonstrates this. Before the revolution the illustrations in for example, *Der Wahre Jakob*, even if critical, conveyed a certain gentleness; they were to induce laughter and derision, not blind hate. This tradition still lingered on in the post-war *Lachen Links*

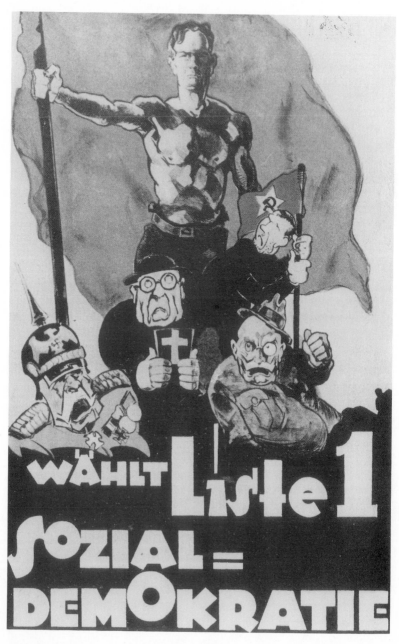

7.11 Social Democratic Party election poster, 1928.

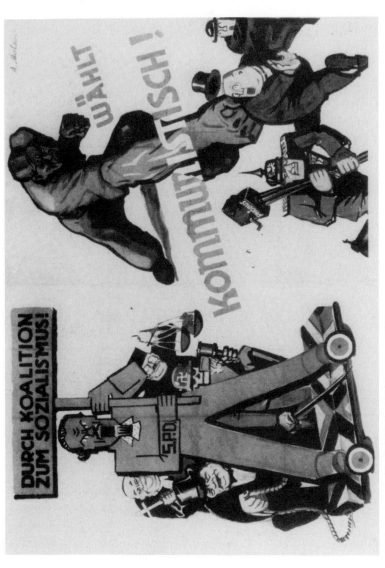

7.12 Communist Party election poster, 1928.

(Laughter on the Left). We see it in a cartoon which derides the philistine and bigoted petty bourgeois family which in the Presidential elections of 1925 had supported the candidate of the Right, the ageing Field Marshall Hindenburg (Figure 7.13).

By contrast the communist *Der Knüppel* saw the world with keener eyes and engaged in more destructive criticism. Thus the death of Hindenburg's predecessor, the Social Democrat Ebert, gave rise to a strong attack. A cartoon by Schlichter shows representatives of state and industry paying their last respects while a wounded and shackled worker writes in blood across the

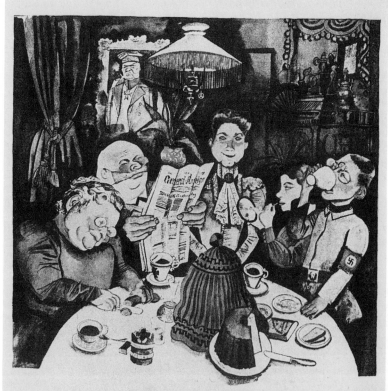

Der Sieg der Unpolitischen Zeichnung von Karl Holtz

Das traute deutsche Heim hat Hindenburg gewählt . . .

7.13 'The Victory of the Unpolitical. The cosy German home has voted for Hindenburg', by Karl Holtz, *Lachen Links* No. 19, 1925. Reproduced by permission of Wolfgang U. Schütte.

tombstone the word 'Traitor'. Crosses in the background illustrate the caption which reads 'The Judgement of history. 20,000 Murdered Revolutionaries Accuse'[45] (Figure 7.14).

The posters and broadsheets produced by the parties for the May Day celebrations offer further examples of different traditions. Before 1914 Socialist May Day illustrations were realistic in style, often exuberant in design, and optimistic in outlook. The Social Democratic May Day pictures of our period still convey many images of hopefulness if not utopianism. By contrast, the relevant art of the Communist movement makes greater use of the symbolism of the struggle and of the serried ranks which fought in it. In the SPD May Day posters and illustrations there are happy throngs, flower-decorated banners, the sun shining above modern factories, a rainbow above the summit rock just reached by a muscular worker, and a small band marching under a gigantic red flag with the caption 'Ahead of them there is Light' (Figure 7.15). Communist May Day art, on the other hand, shows more violence and more action. The masses demonstrate against reaction and capitalism, heavy boots march, an imprisoned worker breaks his chains and, Samson-like, shatters the columns of the house, while the sun, with a hammer and sickle, rises in the background. A fettered fist breaks loose and the pigmy-sized enemies of the workers scatter, as we see in a drawing from the *Rote Fahne* of 1 May 1928 (Figure 7.16).[46]

This paper has attempted to show some links and correlations between political ideology as expressed by the parties and by groups of the left and visual images and artistic styles. This is based on an extensive but not an exhaustive 'archive' of the relevant material. A complete record, including the clearly impossible reconstruction of the large corpus of work destroyed by the Nazis in their drive against the so-called 'degenerate' art and of material lost in the war, would permit a quantitative analysis. This would be an immense task and I doubt whether it would alter radically our analysis and interpretation of the political art of the Weimar period. Ideally, a study such as this should advance from the production of art with a political message to its reception and, hence, to its popular impact. If we assume that the commissioning and selection of material for publication or display reflects an assessment of working-class perception and of working-class taste, an aesthetic and iconographical analysis helps towards this. We have, however, some other more general evidence. We saw that German workers did not take readily to expressionist art and that art hardly figures in articles

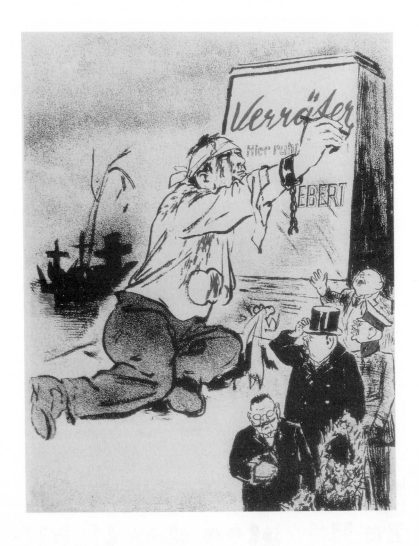

7.14 Rudolf Schlichter, 'The Judgement of History. 20,000 Murdered Revolutionaries Accuse.' *Der Knüppel*, March 1925.

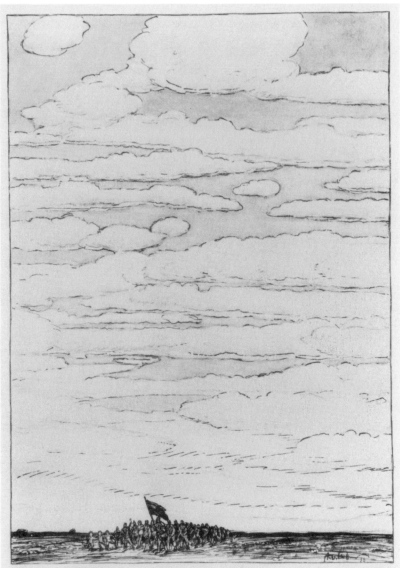

Zu Häupten das Licht!

7.15 A.O. Hoffmann, 'Ahead of Them There is Light', *Volk und Zeit*, 1 May 1931.

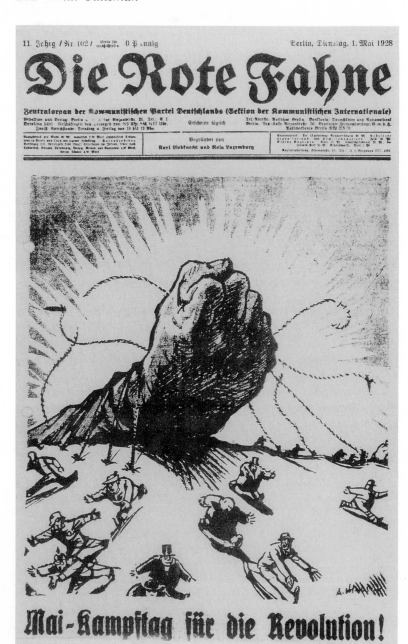

7.16 'May Day, Day of Struggle' title-page *Rote Fahne*, 1 May 1928.

on art and artists in Social Democrat or Communist cultural journals. It also seems that there was resistance to strongly satirical art. Cartoons that were too acerbic or too scurrilous did not always find favour, even among Communist workers. At the 1925 party conference of the KPD a motion criticized *Der Knüppel* for being often obscure and not relevant to the day-to-day political struggle.[47]

Given the well-attested conservatism of the broad masses when faced with modern art, this is hardly surprising. Most of the potential proletarian audience lacked any education in art appreciation and the individual probably approached art largely with an eye trained by the visual experience of everyday life: 'His senses only know the hard reality...and in art too he looks for the concrete.'[48] Against this background the persistence of original and innovative art within the penumbra of the German labour movement must be seen as truly remarkable.

Notes

1 A.L. Rees and F. Borzello (eds) *The New Art History*, London: Camden Press, 1986.
2 P. H. Feist, 'Die "soziale Frage" in der bildenden Kunst und die Herausbildung sozialistischer Kunst', *Wissenschaftliche Zeitschrift der Humboldt Universität, zu Berlin* Gesellschaftwissenschaftliche Reihe, 1985, vol. 1, no. 2, pp. 21-6; J. Treuherz, *Hard Times: Social Realism in Victorian Art*, London: Lund Humphries, 1987.
3 The circulation figures of *Der Wahre Jakob* were much higher than those of bourgeois cartoon journals like *Simplicissimus* or *Kladderadatscl.*
4 K. Hickethier, 'Karikatur, Allegorie und Bildfolge – zur Bild-Publizistik der Arbeiterbewegung', in P. von Rüden, (ed.) *Beiträge zur Kulturgeschichte der deutschen Arbeiterbewegung 1848–1918*, Frankfurt/M: Gutenberg, 1981, pp. 79-165.
5 K. Pinthus (ed.) *Menschheitsdämmerung: Ein Dokument des Expressionismus*, 1920, reprinted Hamburg: Rowohlt, 1984, (from the new [1959] preface). *Menschheitsdämmerung* was one of the few representative anthologies of the new poetry.
6 L. Meidner, 'Anleitung zum Malen von Grosstadtbildern' (1914), in D. Schmidt, (ed.) *Manifeste, Manifeste ... 1905–1953*, Dresden: Verlag der Kunst, 1964, pp. 84-95. The city did indeed become a major theme in the visual art of the Weimar period. Cf. *Ich und Die Stadt*, Exhibition Catalogue, Berlinische Gallerie, Berlin, 1987.
7 E. von Sydow, *Die deutsche expressionistische Kultur und Malerei*, Berlin: Furche, 1920, p. 33.
8 M. Beckmann, 'Bekenntnis', in Schmidt, *Manifeste*, p. 140.
9 Beckmann's Hell cycle, like much of his work, has been the subject of much critical attention. See W. Menne, *Gedanken zu Beckmann's 'Die Hölle'*, Frankfurt/M, 1960; A. Duckers, *Max Beckmann's Die Hölle*, Berlin: Kupferstichkabinet, 1983.
10 C. Zuckmayer, *Als wär's ein Stück von mir (Erinnerungen)*, Frankfurt/M: Fischer, 1966, p. 312.
11 Of 114 prints in two of Grosz's early portfolios, *Das Gesicht der*

herrschenden Klasse and *Abrechnung folgt*, sixteen showed one or more war cripples.

12 U.M. Schneede, *Georg Grosz: Leben und Werk*, Stuttgart: Hatje, 1975, p. 60. These supporting figures were reproduced as no. 32 of Grosz's portfolio, *Das Gesicht der herrschenden Klasse*, published in English as *The Face of the Ruling Class*, (ed.) F. Whitford, London: Allison & Buzby, 1984.
13 L. Fischer, *George Grosz*, Hamburg: Rowohlt, 1976, p. 61.
14 ibid., p. 43.
15 G. Grosz, *Situationen*, Ulm: Hermelin, 1924, p. 24.
16 Schneede, 1975, *Georg Grosz*, p. 138.
17 K. Tucholsky quoted in *Kritische Grafik in der Weimarer Zeit*, Stuttgart: Institut fur Auslaudsbezickungen 1985, p. 42.
18 'Durus' i.e. A. Kemenyi, article in *Rote Fahne*, 1926, 9 April.
19 The *Novembergruppe* existed until 1932 but after 1921 it became solely concerned with the exhibition of members' work.
20 *Novembergruppe*, 'Manifest' (1919), in U.M. Schneede (ed.) *Die Zwanziger Jahre: Manifeste und Dokumente deutscher Künstler*, Cologne: Du Mont, 1979; *Arbeitsrat für Kunst*, 'Ein neues künstlerisches Program' (1918), in *Der Arbeitsrat für Kunst*, Exhibition Catalogue of the Akademie der Künste, Berlin, 1980.
21 F. Loeffler and E. Bertonati, *Die Dresdner Sezession, 1919–1923*, Dresden: Verlag für Kunst, 1977, (no pagination).
22 Bauhaus Manifesto, Weimar (leaflet, u.p.), 1919.
23 ibid.
24 S. von Wiese, *Graphik des Expressionismus*, Stuttgart; Hatje, 1976; W. Neuerburg, 'Der grafische Zyklus im deutschen Expressionismus und seine Typen, 1905–1925', PhD thesis, University of Bonn, 1976. Neuerburg lists 299 collections of expressionists' prints published between 1905 and 1925. About half of these were published in the five years after the war.
25 I.K. Rigby, *An alle Künstler: War Revolution Weimar*, San Diego: San Diego State University Press, 1983, p. 35. This is an exhibition catalogue.
26 The new black, red, and gold colours introduced by the National Assembly were not universally accepted. The parties of the Right kept the old colours of the Empire and 'Black, White, and Red' were identified with the reaction in the political art discussed here.
27 Rigby, *An alle Künstler*, pp. 35-7.
28 C. Felixmüller, *Legenden, 1912–1976*, Tübingen: Wasmuth, 1977, p. 42.
29 C. Sternheim, 'Felixmüller', *Der Cicerone*, 1923, pp. 379-87.
30 Kollwitz, *Aus Meinem Leben*, 1967, p. 50.
31 Kollwitz, *Tagebucher*, 1948, p. 93.
32 The *Rote Gruppe* was a short-lived association of artists and writers.
33 U. Kuhirt, 'Die Arbeiterzeichner Bewegung', in W. Jacobeit and U.

Mohrmann (eds) *Kultur und Lebensweise des Proletariats*, Berlin (Ost), 1973.

34 ASSO Statutes (1928), in Schneede, (ed.) *Die Zwanzige Jahre*, pp. 148-9.

35 H. Gärtner, 'Revolutioñare Programmatik in der Kunst der Dresdner Asso', in *Entwicklungsprobleme der proletarisch-revolutioanären Kunst*, Berlin (Ost), 1978, p. 173. Arbeitskonferenz des Bereich Kunstwissenschaft der Humboldt Universität, 1977.

36 The use of social stereotypes was developed further by Arntz after he had joined the staff of the Vienna *Sozial und Wirtschafts-Museum* under Otto Neurath, the inventor of the isotype method of representing social and economic statistics.

37 F.W. Seiwert, 'Nicht im Bild die Welt zu erklären sondern sie zu verändern', *a-z*, 1929, vol. 1, p. 1.

38 G. Arntz, 'Der Ludergeruch der Revolution', *Aesthetik und Kommunikation,* 1977, vol. 29; p. 11.

39 The phrase is the concluding sentence of a leaflet published by the Berlin ASSO group in protest at the removal of forty-one works of their members from the *Grosse Berliner Kunstausstellung* in 1932.

40 Neue Gesellschaft fur Bildende Kunst, *Politische Konstruktivisten*, Berlin, 1975. This is an exhibition catalogue.

41 SPD posters would from time to time include figures not obviously identifiable as workers. In the case of the KPD there was one rather folksy poster through which in 1932 the party sought to appeal to the peasants.

42 The emphasizing of relative importance through the juxtaposition of figures of different size occurs in religious painting – e.g. in the small donor figures in altarpieces. On socialist iconography in general, see U. Horn, 'Zur Ikonographie der deutschen proletarisch-revolutionären Kunst zwischen 1917 und 1933', in *Revolution und Realismus*, Berlin (Ost), Exhibition catalogue of the Staatliche Museen, 1978, pp. 53-69.

43 E.J. Hobsbawm, 'Men and women in socialist iconography', *History Workshop Journal*, 1978, vol. 6, pp. 121-36.

44 H. Weber, *Hauptfeind Sozialdemokratie: Strategie und Taktik der KPD 1929-1933*, Düsseldorf: Droste, 1982.

45 The caption refers to the death of many thousand workers in the revolutionary fighting and uprisings after 1918.

46 Social Democratic May Day illustrations can be found in special *Mai Zeitungen* published by the SPD or issued as special numbers of e.g. *Volk und Zeit*. The *Archiv der sozialen Demokratie* at the *Friedrich Ebert Stiftung* in Bonn has a good collection. Communist material is less accessible.

47 The party leadership defended the artistic freedom of the contributors to *Der Knüppel* but in 1927 the magazine was replaced by *Eulenspiegel* which set out to provide more popular humour.

48 A. Kreiter, 'Was bedeutet dem Arbeiter die Kunst', in *Kulturwoche Leipzig Program*, Leipzig 1924, p. 11.

8 Political thrillers and the condition of England from the 1840s to the 1980s

Christopher Harvie

It sounds like a thriller, doesn't it, but the thrillers are like life –
more like life than you are, this lawn, your sandwiches, that pine.
You used to laugh at the books Miss Savage read – about spies,
and murders, and violence, and wild motor-car chases: it's what
we've all made of the world since you died. I'm your little Arthur
who wouldn't hurt a beetle and I'm a murderer too. The world
has been made by William Le Queux.

> Graham Greene, *The Ministry of Fear*, 1943

As he fell, Leamas saw a small car smashed between great lorries
and the children waving cheerfully through the window.

> John le Carré, *The Spy who came in from the Cold*, 1963

I

In Britain political fiction has been, since the 1840s, a type of
political convention. From Disraeli, Trollope, George Eliot, and
George Meredith to H.G. Wells, and in the twentieth century from
Arnold Bennett to Joyce Cary and C.P. Snow, important writers
have attempted to depict, in novels and novel-sequences, the
experience of life in party, legislature, and administration. A corpus
which has come to indicate the permissible manners and mores of
parliamentary government in a state which lacks a written consti-
tution, has also acquired an exegetical literature, from essays by T.
H. S. Escott and H. D. Traill in the 1890s, via Morris Speare and
H.A.L. Fisher in the 1920s to Asa Briggs in the 1950s, George
Watson in the 1970s and Roy Foster in the 1980s.[1] In the last
quarter-century, however, the genre has qualitatively deteriorated.
Although the output of fiction relating to politics has increased
enormously, there has been no real classic since Joyce Cary's *Not*

Honour More in 1955, and when something like Jeffrey Archer's *First among Equals* (1984) is regarded – at least by its blurb – as a 'masterly' treatment of parliament, it is not surprising that a fiction of complete disillusion with British constitutionalism, such as Julian Rathbone's *Nasty ... very* (1984), has developed, along with an equally negative critique in theatre, television, and film.[2]

But one form of novel about politics has grown with unbounded vitality, as the British constitutional consensus has broken up: the political thriller. In airport bookstall shelves and supermarket dump buckets one encounters, on an unprecedented scale, thrillers which feature British politics, written by politicians and political commentators, as well as professional authors, mainly, but not exclusively, taking a right-wing position. At a time when Britain's international position is that of a decidedly second-rank power, the rhetoric and style popularized by writers like William Le Queux in the imperial heyday of the 1890s seem to grip as strongly as they ever did.[3]

II

But what is a political thriller? To the Germans *Polit-thriller* is the usual term for all 'action' novels which have to do with the exercise of state power – whether in Bonn party intrigue, espionage, or involvement in foreign affairs. The British version is, paradoxically, both narrower and broader. For Michael Denning in *Cover Stories: Narrative and Ideology in the British Spy Thriller* (1987), the espionage element seems to stand on its own – a game played by its own rules – on the whole separate from the transactions of British civil society although, of course, informed by its prevailing ideologies, and tending to converge with it as that society becomes more insecure.[4] But in Jerry Palmer's *Thrillers* (1978) we encounter a definition which seems to grant itself a universally political quality: 'What one looks for is a hero whose presence, or stature, is credible, and a conspiracy which appears to pose a real threat.'[5] The thriller is, to Palmer, both 'paranoid' and politically individualist; its authors are convinced of the satisfactory nature of the state, while troubled about threats to it. This is reflected in the relative positions of hero and villain. The hero fights for the state, although he will inevitably be placed in a situation where he has to act as an isolated individual; while the villain represents an egoism operating without constraint and hence a menace to civil society.

The hero is naturally an ambiguous figure. Palmer quotes Hegel: 'once the state has been founded, there can no longer be any heroes.'[6] By rights, in modern civil society, the hero should not exist. His success – the usual terminus of the thriller – amounts to his refounding of the state: he rescues it, in extraordinary circumstances, from the peril of dissolution. Now, by Palmer's definition *all* thrillers – all 'mysteries' dealing with crime and detection – are political; if it cannot be proved that it was the butler who stabbed Sir Geoffrey in the locked library, then the mechanisms of civil society are destroyed. The hero, even if he is a fat Belgian who rarely gets off his backside, is thus the essential guardian of the state.

I am sceptical of this. The 'brain-teasing' attraction of the classic English detective story – essentially a creation of the 1920s – is closer to the crossword puzzle (invented at roughly the same time) than to what John Buchan called the 'shocker'. People read Agatha Christie or Freeman Wills Crofts for the puzzle, not to see the civil society delivered from peril. (Although Agatha Christie cannot be dismissed from our inquiries at this stage, as she was given to producing 'red plot' stories like *The Secret Adversary* (1922)). A critical case, however, would be the detective stories of that hyper-activist couple G.D.H. and Margaret Cole. These – and there are dozens of them – seem, under the foregoing criteria, utterly apolitical.

'Political' thrillers (or 'shockers') for the purposes of this essay are action-dominated romances whose mysteries have to be resolved within the context of power-relationships in British politics and government. Palmer sees the thriller genre first emerging with mature economic individualism in the 1840s, in the fiction of Edgar Allan Poe, and beginning its modern career in the 1880s with Arthur Conan Doyle's Sherlock Holmes stories. I would substitute Disraeli, and *Sybil* in particular, for Poe, but I think this only strengthens, in the British context, Palmer's notion of the thriller hero *re-founding the state*. It was Disraeli who stressed the crucial role of convention in British constitutionalism in his *Vindication of the English Constitution* (1835); *Sybil* (1845) coincides both with the decline of Chartism and Disraeli's defence of the two-party basis of this constitution.[7] In 1886 the constitution was literally re-founded by the failure of Gladstonian Home Rule and the publication of A. V. Dicey's *Law of the Constitution* with its fetishization of parliamentary sovereignty.[8] Sherlock Holmes, who first appeared in the *Strand Magazine* in 1887, is not just an action hero rather than a detective *à la* Poirot: his activities – chronicled fictionally by a Scottish doctor, and in fact by a Scots-Irish-Catholic-

Liberal-Unionist doctor – are those of a 'patriot' confronting the debatable land of metropolitan London in a period when increasing international tension challenged the efficiency and probity of British civil society, personified by its incorruptible if intellectually limited police force.[9]

The thriller has further 'intrinsic' requirements. The sequence of action in the thriller has to hold the reader's attention, to build up tension and release – or change – it. 'Keeping the reader on a knife edge' means both exciting feelings and controlling them: restraining him or her from skipping to find out what happens, or simply getting bored and giving up. The thriller has strong mythic and epic elements, as we shall see, and since these tend to be predictable, the writer has to complicate and ornament the action, usually by the addition of violence and circumstantial 'realistic' detail, with sex (more recently) as an optional extra. The detective story demands an input of logic to lead the reader to his goal, the solution; the thriller-writer has, as Buchan once put it, to justify his seat nearest the tribal fire, as the story-teller who earns his extra-large ration of mammoth-meat by getting his audience salivating for the next instalment. Regardless of explicit goals in terms of ideology or entertainment, the first is an individual and competitive, the second a collective, experience.

III

What are the chronological and statistical dimensions of the genre? The evidence that follows is very provisional but it does, I think, show up a particular pattern. In the course of research on British political fiction I have accumulated upwards of 600 titles (not limited to novels) published or produced between 1790 and the present. These show, decade by decade, a steady increase in their numbers – as might be expected with the expansion in fiction publishing. But if we take the political thriller genre, as previously defined (amounting to 80–100 titles), the pattern is more irregular. A very few works before the 1880s, and then a sizeable clump between then and 1914. Thereafter a lapse, followed by a certain increase in the 1930s. An even deeper trough 1940–1970, and then an unprecedented rate of growth, until in the 1980s the political thriller becomes the chief contribution to *printed* fiction about British politics. As to political tendency, these thrillers have been generally (two-thirds plus) right-wing. Only in the 1930s has there been a majority of books of left-wing tendency.[10]

This suggests that our most important periods are 1880–1914 and the present, in so far as readership, reception, generic ideas, etc.– and a connection with political practice – are concerned. Both periods, moreover, show a mounting political crisis in the identity of the British state: the build-up to the 'Strange Death of Liberal England' in the first period, and (perhaps) to the 'Break-up of Britain' in the second.[11] Yet the most successful and enduring works of the genre, which either give it its accepted qualities, or are frequently referred to for purposes of comparison, do not fall into these periods. There are three groups of works which bridge the division between entertainment-literature and literature which has pretensions to classic or at least political-elite-influential status: the trilogy of Disraeli's middle-period novels, *Coningsby* (1844), *Sybil* (1845), and *Tancred* (1847); John Buchan's Richard Hannay tetralogy – *The Thirty-Nine Steps* (1915), *Greenmantle* (1916), *Mr Standfast* (1919), and *The Three Hostages* (1922) – the apotheosis of the 'shocker'; and a third group, originating in the 1930s with works like Graham Greene's *The Confidential Agent* (1938). The last group is the most ambiguous, in that the books concerned, while exploring the secret service area, are not always thrillers, but rather psychological studies of men in extreme situations. The 'art' thriller – whose masters are Greene, Eric Ambler, and John le Carré – tends to express a dissenting position in which individuality and personal loyalties cannot always be co-terminous with 'official' patriotism.

All of these writers have been determined communicators, with a flair for story-telling, and Disraeli and Buchan in particular used the adventure story, in a political setting, both to explore British society and to prescribe for its ills. From the Disraeli trilogy comes the idea of party politics as the basic convention of British constitutionalism, from Buchan the image of the agent as a decent man guarding British liberties in bad times: to quote the title of one of his novels 'a Prince of the Captivity'. The third group express increasing disquiet about the structure and powers of a declining but still authoritarian state in the era of the superpowers. All, remarkably for a society which emphasizes the apolitical nature of its intelligentsia, bear the marks of 'inside experience'.

IV

The secondary literature on political novels regards them as stemming from Disraeli's trilogy in the 1840s. Political novels by John Galt, R. P. Ward, and Disraeli himself existed before this

time, but *Coningsby, Sybil* and *Tancred* gave the genre a recognized style and subject-matter.[12] In various subsequently written prefaces Disraeli made the political intention of his novels explicit, while their reprinting in the 1850s commenced a golden age of three-decker political novels, which lasted until the publication of *Endymion* and Trollope's *The Duke's Children* in 1880, and contributed to an incalculable extent to the 'myth' of representative government in Britain during the transition to democracy.[13]

By and large the circulation of such works was restricted to those classes which disposed of executive political power, that is, peers, MPs, local magnates, etc. If Mudie's Library had 30,000 subscribers then, as regards *men*, this was probably quite close to the 'upper 10,000'.[14] Only Disraeli, through the mass editions of his works in the 1870s, reached a really substantial audience, by appealing to it by means which were more those of the thriller-writer than those of the political pamphleteer or the moral fabulist. I want to prove this by using *Sybil*, after the 1870s adjudged the most politically significant of his works, as my first subject.[15]

Leslie Stephen, in the first serious and appreciative study of Disraeli's novels, published in 1877, gave little attention to *Sybil* beyond describing it as a kind of dramatized Blue Book, but Stephen wrote as an upper-class radical don of the sort who was only just prepared to regard even the 'serious' novel as real literature.[16] Later, more socially-aware commentators like Louis Cazamian accepted its credentials as a manifesto of interventionist radical Toryism, on the basis, it seems, of a rather superficial reading.[17] I do not want to rehash *Sybil's* contorted plot, but its readers will recall that it ends with Disraeli's hero Lord Egremont, married to the now equally noble Sybil, going out to dinner with the Palmerstons. *Sybil* is not a Young England manifesto (Young England was dead, anyway) but a justification of the two-party system. The secret of the British state, Disraeli argues, is not ideology, not class, but the existence of parties which sink their cultural roots deep in history and tradition. Disraeli gets to this satisfactory point by literally eliminating every alternative ideological option in the great culminating blood-bath at Mowbray Castle: Owenite socialist, Catholic Chartist, Utilitarian nobleman, pagan lord of misrule, all end up dead.

Disraeli's methods in achieving this outcome go beyond melodrama. William Godwin, in *Caleb Williams* (1794), and his disciple (and Disraeli's friend) Bulwer-Lytton in *Paul Clifford* (1829) had linked a didactic theme to a crime story. To this Disraeli added an

explicitly political setting and the pace of popular entertainment (for which he always had, like Dickens, a soft spot). *Sybil*, as Morris Speare remarked in the 1920s, operates like a Douglas Fairbanks movie,[18] jump-cutting from one bit of plot to another, with the same effect as the pantomimes with which Disraeli seems to have started his authorial career. Fascinated by just how the whole daft structure is going to be resolved, readers can still find *Sybil* literally compulsive. Disraeli in fact meets Q. D. Leavis's description of the popular best-seller (Marie Corelli, Warwick Deeping, Guy Thorne, etc.) as providing 'bad writing, false sentiment, sheer silliness, and a preposterous narrative... all carried along by the magnificent vitality of the author'.[19] In contrast to such of his contemporaries as George Eliot or Anthony Trollope, Disraeli 're-founds' his state by pioneering the methods of the political thriller. *Sybil* is – like his subsequent novels – about a conspiracy, and the defeat of the conspiracy both resolves the personal problems of the hero, or in this case 'hero-and-heroine' (Disraeli is an equal-opportunity writer, a rare bird) and stabilizes the state.

First, the conspiracy. Disraeli believed in conspiracies. They come prominently into *Lothair* and his last, unfinished novel *Falconet*, and their 'theory' is fairly exhaustively outlined in his *Life of Lord George Bentinck* (1852). In 1876 he informed the bewildered farmers of Aylesbury that the Eastern Crisis was the work of the 'Secret Societies of Europe': the Masonic *illuminati* in their lodges, leagued to destroy two things: the ownership of land and the power of the Semitic revelation, otherwise known as organized religion.[20] Where did Disraeli get this 'King Charles's Head' from? He seems to have been as serious about it as he was about any of his other political convictions. It may have derived from his father's Voltaireanism and his anti-Jacobin novel *Vaurien* (1796) in which a French revolutionary comes to Britain to stir things up. This coincided with John Robison's famous attack on the European secret societies as a form of Jacobin menace,[21] and I suspect also that it owed something to Disraeli's enthusiasm for Byron (which brought him into the ambit of the Carbonari) and Carlyle. Disraeli discovered Carlyle early, adulated him (a regard which was not returned), and had surely read Carlyle's essays on 'Count Cagliostro' and 'The Diamond Necklace' affair, published in *Fraser's Magazine* in 1834 and 1837, as forerunners of *The French Revolution* (1837). Carlyle showed the mysterious Sicilian *illuminatus* Count Cagliostro convulsing the French court by embroiling Queen Marie Antoinette in a sexual intrigue with the Archbishop

of Paris, an event that foreboded the downfall of the *ancien régime*, while in other writings of the time, notably 'Characteristics', he stressed the fragility of 'the thin rinds of habit' which separated civil society from catastrophic upheaval.[22]

In *Sybil* the conspiracy is represented in two – enduring – halves: the Chartists are the impractical idealists, fronting for the trade unionists with their hooded, anonymous members, sinister rituals, and blood-curdling oaths. Somewhere in the background, and never fully explained, is the figure of Baptist Hatton, the creator of 'most of the modern nobility of Britain' who dines at the Athenaeum while his thuggish brother, the file-grinder 'Bishop' Hatton, rules over Wodgate and the 'people of Woden'. When economic depression comes it is this explosive Jacquerie – the 'hell-cats' – which is released by the meddling reformers. They are ultimately incinerated in Mowbray Castle, 'the funeral pyre of the people of Woden' but not before 'Bishop' Hatton has made his entry to Mowbray town on a donkey, in an almost blasphemous parody of the New Testament.

The assault on Mowbray Castle releases the documents which prove Sybil's right to her property. Egremont rescues her at the last moment, which is about the only heroic thing he does. The conspiracy in fact falls to pieces on its own, making Disraeli's point that it was impossible for the working class to organize itself coherently: it consisted of too many groups with mutually antagonistic aims. In contrast to the alarm with which Liberals like Dickens and Mrs Gaskell regarded potential working-class solidarity, or the Christian Socialists' dream of a co-operative millennium, Disraeli's vision of normative politics – conveyed in his description of Mowbray's 'Temple of the Muses' in which well-off Joe Lampton-style proles watch high-class music hall turns – is of 'a good time' plus parity of esteem: a modern, not to say Macmillanite, image of Tory Democracy.[23]

V

'High Victorian' novelists took a much more serious view of political institutions: the need for a superior ethic to replace deference to landed power preoccupies George Eliot in *Felix Holt* (1866); Trollope's *Pallisers* series (1863–80) sets out quite methodically to show how the system worked, involving and altering its participants; and George Meredith's *Beauchamp's Career* (1875) showed how remote its actuality was from the heroic images of Carlyle and the romantic revival. These are essentially books for the

informed and involved minority, those who were members of local Liberal parties, readers of the *Fortnightly Review* or the *English Men of Letters* series, devotees of John Morley or Frederic Harrison as literary pundits. Yet even these writers were jolted by more visceral styles of political fiction, either of the 'moral fable' or 'sensation novel' type, by the output of such as Ouida, Charles Reade, Edward Jenkins and Laurence Oliphant.

The Liberal practitioners were not best pleased when Disraeli, now an ex-prime minister, emulated the 'sensationalists' and burst into print with *Lothair* in 1870.[24] And in *Lothair* the secret societies in the shape of 'The International League of the Peoples' are back. Combining the causes of radicalism, anti-clericalism, and socialism, personified by the beautiful Theodora Campian, they nearly manage to carry off the susceptible Lothair. They have competition. The Catholic Church, a Good Thing in *Sybil*, has now itself become a secret society, as sinister as the rest; to be combated equally resolutely. The results of this are interesting. First, Disraeli does indeed seem to have taken bodies like Marx's International Working Men's Association seriously. In fact, the Tory Party may have infiltrated an agent, Maltman Barry, into it in 1871.[25] Secondly, *Lothair* has a carefully structured 'national' theme from which the alien Catholic Irish can be excluded: an image of Britain in which monarchy, empire, and the protestant religion bind Scotland and England together in a harmony otherwise to be found only (in a more limited way) among the Christian Socialists, notably in Charles Kingsley (also deeply influenced by Carlyle).

Disraeli kept his conspiracies going to the last, in his unfinished *Falconet*. But in the meantime another component of the classic political thriller arrived, also courtesy of the Tory Party. In 1871, John Blackwood, always adept at exploiting sensation fiction, published in *Maga* a story by George Chesney, a colonel in the Royal Engineers: 'The Battle of Dorking'. To the machinations of secret societies was added the invasion threat. In the author's engaging *précis*:

We have the quarrel with America and Russia, dispersion of all our forces, followed by a rising in India. Sudden appearance of Germany on the scene. Sentimental platitudes of Messrs Gladstone and Co., trimming leaders in the *Times*. Destruction of our 'Field Line' by new torpedoes. Arrival of 100,000 Sanskrit-speaking Junkers brimming over with 'Geist' and strategy. Hurried defence of the chalk-range by volunteers and militia, no

commissariat, line turned, total defeat, retreat on London, occupation of that place, and general smash up.[26]

These two components provided the background to the pulp fiction of political intrigue churned out from the 1890s on, chiefly by William Le Queux and E. Phillips Oppenheim, but the interesting thing is that the invasion threat was essentially a Conservative hijacking of two radical causes. The volunteer movement of 1859 had strong radical and Christian Socialist tendencies: citizens in arms could do better than 'old corruption' represented by the standing army;[27] while the notion of a coming struggle for power in Europe – Britain against Russia – accorded both with the radical 'Foreign Affairs Committees' seeded by the anti-Russian propagandist David Urquhart and, even more intriguingly, with millennialist literature like *The Coming Struggle among the Nations of the World* (1857) by the most popular of newspaper serial writers, David Pae.[28] In this the prophecies of Revelation were worked out in some detail in terms of an Anglo-Russian clash in the Middle East, predicted for 1864. The invasion threat could therefore mean real French or real German troops, or Armageddon, according to readers' inclinations; and Armageddon could be the preface to an earthly paradise.[29]

VI

In the last quarter of the nineteenth century wars on the mid-century scale were absent, but new weaponry and war-plans were not. Such were the complexities of military mobilization by rail that the imparting of General Staff plans – and associated treaties – could result in enormous advantages to an enemy, and one spy case – the Dreyfus affair in France (1894–1906) – convulsed a republic. The theme of stolen treaties first arrives with Sherlock Holmes in 'The Bruce-Partington Plans' in 1890, and two years later the journalist William Le Queux started a career in this sort of fiction which carried him into the 1920s. He was shortly to be joined by the Leicester leather merchant E. Phillips Oppenheim.

The content of the political thrillers which proliferated at the turn of the century was not demanding. Disraeli can be winnowed for a magpie-like collection of allusions (Leslie Stephen – rightly – thought him remarkably well read) but although Le Queux said he was influenced by his friend Emile Zola, his work, like that of Oppenheim, is as lacking in literary distinction as in political

credibility.[30] Plots are a predictable jumble of 'intrigue in high places', cloaks and daggers, double agents, and highly-placed traitors.

David Stafford has written in *Victorian Studies* that 'The world presented by these novels is a dangerous and treacherous one in which Britain is the target of the envy, hostility and malevolence of the other European powers, singly or collectively according to context.'[31] In these, a conspiracy aimed at securing a secret treaty or information on a new weapon is usually masterminded by a cosmopolitan agent, frequently a Jew, while the hero-figure is an upper-class product of a public school and Oxford or Cambridge. Stafford argues that such plots had resonance in a country now apprehensive of challenges from other powers. But these novels, usually cheaply produced in the aftermath of the collapse of the three-decker, also played on the insecurity of a growing lower-middle-class readership which craved both the political information to which it believed its 'betters' had access, and feared for its own status, the archetypal clerks on 'thirty bob a week' who read Harmsworth's *Daily Mail*. To them these novelists offered apparent inside information and a consoling myth of solidarity with the national elite.

As to information, Le Queux's friend Douglas Sladen, the first editor of *Who's Who*, reported:

> He has travelled continually, and acquired a unique knowledge of the secret service of the Continental Powers. He is one of the most popular novelists of the day, the secret of his popularity lying in his brilliant handling of mysteries, and the use he makes of his knowledge behind the scenes in continental politics A member of the Athenaeum Club told me once that judges and bishops almost quarrelled with each other when a new William Le Queux book came into the Club.[32]

Against this, two things. First, because of Home Offce releases, we now know a lot about the personnel of the security services. It turns out that most of the people involved in the Special Branch were either Irish or Bengali, not public school paragons but fish who could swim in the waters of the disaffected.[33] Second, if we look at the *fin de siècle* thriller writers – Erskine Childers, Conan Doyle, Le Queux, Oppenheim, Edgar Wallace, Ernest Bramah, John Buchan himself – they seem, at first glance, less than 'British'. Most of these writers, like the secret agents, were, in F. W. Bateson's classification, 'métèques', trying to integrate with

the British right by fanning xenophobic prejudices.[34] The fact that the right was also under attack from a xenophobic, anti-semitic left, which – in the writings of Chesterton, Belloc and J. A. Hobson – saw imperial expansion as the work of cosmopolitan, Jewish, finance-capital, only heightens the sense of pessimism and insecurity that, among others, Samuel Hynes has seen pervading Edwardian Britain.[35]

The closer we look at the individual writers, the more ambiguous the picture appears. Of all these I have cited, only Le Queux seems to have been a convinced conservative. Oppenheim and Conan Doyle were, in their notions of crime and society, environmentalist liberals. 'Everyone of us is at heart potentially a criminal,' Oppenheim wrote in his memoirs. 'The accident of our remaining virtuous is the accident of circumstances. Given sufficient temptation of the sort which appealed, there are few of us who would resist the act of sin.'[36]

Edgar Wallace was politically illiterate but ended his career as that rare (unique?) thing, an idealistic Lloyd George Liberal. Childers became an irreconcilable Irish republican, and as such was executed by the Irish Free State in 1922. It is more plausible to see their output as a reaction to their own and their readers' unsettlement within British civil society – an inability to establish norms of conduct in a period of rapid social change – rather than as a reflection of the 'real' menace of German militarism or revolutionary socialism.

The novel of 'imperilment' actually seems to have peaked *before* 1910, when the naval race reached serious proportions. *The Riddle of the Sands* dates from 1904; in 1906 Le Queux and H. W. Wilson, of the *Daily Mail*, updated Le Queux's invasion scare of 1894, *The Great War in England in 1897* to 1910 (changing the enemy from France to Germany), and Northcliffe and the *Daily Mail* used it as the centre-piece of a campaign, fronted by Lord Roberts, for national service. An aspect of the Conservatives' would be-populist attack on an otherwise impregnable Liberal government, it was overshadowed by the developing clash between the government and the House of Lords, and the Conservatives' open challenge to parliamentarianism. Northcliffe reduced the invasion to the level of a promotional stunt – the Germans being routed via the large towns, in which potential *Mail* readers could be presumed to reside, rather than via the undefended but – circulation-wise – unpromising coastline of East Anglia. P. G. Wodehouse guyed the genre mercilessly in *The Swoop – or How Clarence saved England* (1909)

in which the eight invading forces (Germans at Bournemouth, Young Turks at Scarborough, etc.) are seen off by a resourceful Boy Scout.

I. F. Clarke argues that such levity as Wodehouse's expired under the volume of war hysteria,[37] but this is not completely convincing. The leading propagandists of the services could be wildly opposed to one another on many issues, and the 'blue water' school, who stressed the importance of the navy and imperial commitments, regarded invasion and conscription propaganda as a distraction.[38] Conscription was one aspect of periodic Tory hysteria; protection had been another; Ireland would be the next.

VII

It is, however, just at this time that the Janus face of the genre shows itself. Joseph Conrad's *The Secret Agent* (1907) is not a thriller. The 'political' outcome of the Russian-inspired attempt to blow up Greenwich Observatory and the destruction of the innocent Stevie, who carries the bomb, is known scarcely halfway through. Much of the book is a psychopathological study of the pressures which drive Stevie's sister Winnie Verloc to kill her *agent provocateur* husband and then herself. But its penetrating images have left a lasting mark in the 'art' thrillers of Graham Greene, Hitchcock, and le Carré.

At one level Conrad's portrayal of British political society is as reassuring as that of Victorian political fiction. The Assistant Commissioner who detects a Russian plot represents that imaginative use of authority which is prepared to skip bureaucratic formulas and can get away with it. His Holmesian approach – taking the plodding Inspector Heat off the case and going direct to the Minister – succeeds; 'going by the book' would have played right into the Russians' hands.

Yet the ultimate images are of fragility: 'You look at Europe from its other end,'[39] says the Assistant Commissioner to Mr Vladimir of the Russian Embassy, motioning him tactfully out of the country, but the implication is that the Russian's and, of course, Conrad's Europe is the more 'real'. A passage in Conrad's 'Preface' – admittedly written fifteen years later and after World War I – invests London with this disturbing power:

It was at first for me a mental change, disturbing a quieted-down imagination, in which strange forms, sharp in outline but

imperfectly apprehended, appeared and claimed attention as crystals do by their bizarre and unexpected shapes. One fell to musing before the phenomenon – even of the past: of South America, a continent of crude sunshine and brutal revolutions, of the sea, the vast expanse of salt waters, the mirror of heaven's frowns and smiles, the reflector of the world's light. Then the vision of an enormous town pressented itself, of a monstrous town more populous than some continents and in its man-made might as if indifferent to heaven's frowns and smiles; a cruel devourer of the world's light. There was room enough there to place any story, depth enough there for any passion, variety enough to bury five millions of lives.[40]

This mood and language were echoed by two great poems published shortly afterwards, Eliot's 'The Waste Land' and Yeats' 'Meditations in Time of Civil War' (1923), both threnodies for a traditional culture torn apart by war and industrialization, and of individuals trapped in claustrophobic isolation by anomie and violence. Conrad's foreword seemed to confirm that his monstrous pre-war vision had now become, for many intellectuals, reality.

Conrad, the refugee from Tsarist despotism, always saw Europe 'from the other end'. Although a temperamental conservative, his own background as the son of a Polish revolutionary placed him in an ambiguous position *vis-à-vis* both sides. The documented events on which Conrad drew for his story involved the secret service career of Sir Robert Anderson, an Irish Unionist member of the Special Crimes squad, also involved in 'dirty tricks' against Parnell; Conrad made him into a figure of liberal legality.[41] Conrad denounced the crazy anarchist 'Professor', clutching his 'perfect' detonator, as a toxic bacillus, but he also wrote to his friend, the aristocratic Scottish socialist Cunninghame-Graham: 'By Jove!...if I had the necessary talent I would like to go for the true anarchist – which is the millionaire. Then you could see the venom flow. But it's too big a job.'[42] The image that remains after reading *The Secret Agent* is that of anonymous city and isolated humans, as if the activities of spying and subversion accentuated, rather than challenged, the dislocations of modern mass society.

VIII

David Monaghan in his study of John le Carré, has remarked on the mythopoeic and epic qualities of the early twentieth-century spy

novel.[43] Conrad offers hints in that direction, if only in a negative sense: portraying the moral and social wasteland which could only be redeemed by the mission of the holy fool. Chesterton also anticipated T. S. Eliot in giving this a metaphysical quality in *The Napoleon of Notting Hill* (1904) and *The Man who was Thursday* (1908). The remarkable oeuvre of John Buchan fits better into this context than into the 'Clubland Hero' docket into which he is usually inserted.[44]

Buchan, the son of the Free Church manse, the Oxford scholarship boy, the Milner kindergarten graduate, the boss of Nelsons, was already, at thirty-eight, a veteran novelist when, to entertain Arthur Balfour, the former leader of the Conservative Party, he wrote *The Power House* in 1913.[45] This is a more than usually coincidence-ridden novella, in which most of the action stems from the sheer stupidity of Buchan's first (and last) hero, Sir Edward Leithen. M. R. Ridley, in one of the most acute discussions of Buchan, has dismissed it out of hand as a 'complete misfire'.[46]

But it contains what is perhaps Buchan's most famous line, when the arch-villain, Andrew Lumley, high Tory and undercover leader of an international anarchist conspiracy, tells Leithen: 'You think that a wall as solid as the earth separates civilisation from barbarism. I tell you the division is a thread, a sheet of glass.'[47]

This has been taken, by Graham Greene, as expressing Buchan's own view,[48] but we ought to remember that it comes from the villain, not from Leithen. Now, where does Lumley come from? This issue can be illuminated, I think, by a close reading of the texts, and what these show is very interesting indeed. Lumley's views and indeed Lumley as a character imply a continuation of Disraeli's last novel, *Falconet*, published by *The Times* in 1905, in which a sinister unknown turns up who states:

> Society is resolving itself into its original elements. Its superficial order is the result of habit, not of conviction. Everything is changing, and changing rapidly. Creeds disappear in a night. As for political institutions, they are all challenged, and statesmen, conscious of what is at hand, are changing nations into armies.[49]

We can push this back yet further, to Carlyle's 'thin rinds of Habit ... 'shivered asunder' 'thin rinds shivered asunder' by the by the French Revolution.[50]

My own hunch is that *The Power House* is a joke and that Lumley is in fact Arthur Balfour, who (disguised as 'Mr Evesham') voiced precisely the same sentiments in 1910 in H. G. Wells' *The New Machiavelli*.[51] What *The Power House* shows is not conservative

paranoia but an ambiguous and somewhat reluctant relationship between Buchan and a political party which during this period was noisily running amok.

War then intervened and mobilized Buchan and not a few writers like Oppenheim into Charles Masterman's propaganda outfit in Wellington House and its successors. Political and propaganda fiction became a tool of war policy and Buchan himself rose by the end of the war to a controlling position in war propaganda.[52] This was accompanied by a series of thrillers which have remained a sort of reference point for subsequent writers: *The Thirty-Nine Steps* (1915), *Greenmantle* (1916), and *Mr Standfast* (1919). These three novels were an attempt to convey the health of British society as it stood the test of war. If one reconstructs the chronology and geography of *The Thirty-Nine Steps* fairly precisely the success of Buchan's initial attempt seems almost purely adventitious. My hunch is that, barred by security (in the shape of Masterman, his cousin by marriage) from pursuing his original plot – Hannay's discovery of a spy ring around the great new naval base at Rosyth – Buchan more or less stumbled into the formula (the hero chased by police *and* villains over the Scottish moors, and then a sudden switch into Whitehall intrigue) which was to make *The Thirty-Nine Steps* perhaps the most enduring thriller of all.[53] But the essential message conveyed is: however many mistakes the brain of the country makes – and a careful examination of *Thirty-Nine Steps*'s chronology shows that Sir Walter Bullivant of MI5 sits on Hannay's information on the Black Stone gang for ten vital days – the body of the country is sound (although the country in question seems less British than Scottish).

In *Greenmantle* the spotlight is turned on Germany, not to disclose it as a Pandemonium – in the literal sense – but as a country whose people, more or less good, have been badly led, and are unsure of their own identity – something which stemmed directly from Buchan's own extensive research into German psychology, which seems to have owed much to Jung (Buchan's exact contemporary and also a son of the manse).[54] The process is repeated in *Mr Standfast,* the longest and most complex of the three. Here Hannay has to sound the spirit of Britain after four years of war, and there are great loops of plot which have little to do with the conspiracy, but a lot to do with explaining the integration (or lack of it) into the war effort of regions, classes, and groups in British and especially Scottish society. To give

strength to his narrative, Buchan returns to the style and symbolism of Bunyan's *Pilgrim's Progress* – an epic treatment drawn from the nonconformist tradition – and ends with an even-handed distribution of honours throughout the Empire and the British class system.

At the end of the war Buchan at first seems to have been optimistic, to judge from the *causerie The Island of Sheep* 'by Cadmus and Harmonia' which he wrote with his wife in 1919. Set on an island off the west coast of Scotland, this advertises a process of consensual adjustment within the mythical context of the fall of Ragnarok and the awakening of Baldur from the dead, a Nordic image common to Buchan and Matthew Arnold, and not far from the German legend of Siegfried and the fall of Valhalla. German right-wing opinion, of course, held British propaganda (at that time headed by Buchan) responsible for the 'stab in the back' of November 1918, usually symbolized by Hagen's fatal blow against Siegfried![55]

The dream of consensus perished in 1921–2 when unemployment surged to two million and further agonies of industrial contraction foreboded. After *The Three Hostages* (1924) Buchan replaced the German peril with sinister forces, akin to Lumley, forcing their way out of a Europe where all the usual constraints on social and political behaviour had been broken. Most of his post-war thrillers are in fact Jungian searches for the sort of archetypal figures which promise social and political stability in a world gone adrift (a venture not far from that of T. S. Eliot in *The Waste Land* (1922)). But by the 1930s it became evident that this was carrying him away from Clubland and the idea of 'Britain' to the sort of folkloric, pre-agricultural, *mythos* of Scottish nationalists like Lewis Grassic Gibbon and Neil Gunn. In *A Prince of the Captivity* (1933) for example, he re-runs Disraeli's *Sybil* scenario, only to denounce the English establishment's corrupting effect on the autonomy of Labour, while his hero is sustained by his vision of *Eilean Ban*: the Gaelic 'land of youth'. Buchan's subversives come, in fact, close to Conrad's 'millionaires': commercial manipulators of a politics in which people are reduced to economic units. By his last stories, in fact, Britishness has ceased to matter: the values of 'Scotland', or 'Canada', have taken over. Buchan's *Sick Heart River* (1941) ends when World War II breaks out, but Leithen does not return to London and high office – the obvious propaganda ending – and instead dies ministering to – hunting for – a demoralized Indian tribe in Canada.

IX

Buchan's inter-war pilgrimage – he would have used the word – was
far different from the behaviour of the heroes of Sapper, Dornford
Yates, and the like. This was evident to a perceptive observer like
Graham Greene, who jibbed at Buchan's worship of success, but
thought Lumley had got things just about right, and defended
Buchan against what he saw as Hitchcock's flippancies in the 1935
film version of *The Thirty-Nine Steps.*[56] Greene, even in his
'entertainments', and Eric Ambler belonged to the only generation
in which the left-wing political thriller prevailed, whose villains – as
in Ambler's *The Mask of Dimitrios* (1936) – were conservative or
fascist politicians and arms syndicates, and whose tone was closer
to Conrad than to Le Queux.[57] Echoes of *The Secret Agent* are
patent in Greene's *It's a Battlefield* (1935). The plot hinges on
attempts to get a reprieve for a Communist bus driver, Drower,
sentenced to hang for stabbing a policeman during a demonstration.
His brother, Conrad (who has the vaguest memories of a Polish
seaman who once lodged with his parents), hunts the Assistant
Commissioner assigned to the case. The Assistant Commissioner,
under pressure from a woman-friend, an elderly aristocratic leftist,
doubts his own motives and loyalties:

> He sat down again at his desk. I am a coward, he told himself;
> I haven't the courage of my convictions; I am not indispensable
> to the Yard; it is the Yard which is indispensable to me. He
> began to read the papers before him, but it was not his conscious
> mind which took their meaning in. If I had faith, he thought
> wryly; if I had any conviction that I was on the right side;
> Caroline has that; when she loses it, she has only to change her
> side.[58]

He is no longer the olympian figure who saw Mr Vladimir off; he
could be the bureaucrat who, 500 miles away, was stamping
'Erledigt' on a sequestration order on a Jewish shop.

The unmistakeable and threatening presence of the Nazis dis-
lodged the 'no enemies on the right' ethos of the popular
practitioners, at least for the duration. Even in a censor-ridden
decade, which saw any filming of Walter Greenwood's *Love on the
Dole* banned in advance in 1935 and Winifred Holtby's *South
Riding* turned by Victor Saville into virtual Conservative propa-
ganda in 1938, the menace on the right could produce some
interesting subversive effects.[59]

Chief among these is the notorious Hitchcock version of *The Thirty-Nine Steps*. Hitchcock was alleged (I think falsely) by John Grierson never to have read the book,[60] yet his version is close to the Buchan ethos, and Robert Donat gave Hannay a style and wit that the original never had. But a much greater distrust of establishment society is visible: the villain Professor John is thoroughly integrated into upper-class Anglo-Scottish society (caricatured in a hilarious election scene); Hannay remains on the run – no Bullivant succouring him – until the last sequence. The film closes with the dying Mr Memory – one of Hitchcock's 'little men feeding the birds' – gasping out the aero-engine formula. In the last frame a policeman looks up from the body, and we see his face through the handcuffs which still join Hannay and Miss Smith: a profoundly unsettling ending. It is more than intriguing to find that Hitchcock's producer was the Hon. Ivor Montagu, the Communist son of the Jewish oil millionaire, Lord Swaythling: to the uninitiated the identikit Buchan villain.[61]

This leftish ethos survived into the war period itself, where film had an especial significance because of the drastic curtailment of paper – and thus books – by rationing. The image of Britain projected alike in the fiction and movies of the time was unexpectedly and refreshingly pluralistic and demotic, whether in the 'Commonwealth Britain' ethos of Joyce Cary's *To be a Pilgrim* (1942), Alberto Cavalcanti's (and Graham Greene's) *Went the Day Well?* (1942), or the first Ealing films. But by 1945 a counter-revolution was already on the way. John le Carré, no less, speaks of the wartime hopes of a democratic socialism being betrayed and replaced by the exhumation of an antique social order which institutionalized both the established 'in-group' and the conspiracy.[62]

X

The result – the cold war thriller – remains with us. Its moral framework – 'supporting the bad against the worse' – was itself derived substantially from an experience or apprehension of Soviet communism mediated by literature: Orwell, Koestler, Rebecca West. Given the closed nature of Soviet society this was only natural, yet it led to the projection into the future of the horrors of the Stalin era, at a time when, drab, conformist, and managerially incompetent though they were, the 'socialist countries' had little more actual blood on their hands than the 'free world'. Although, as

le Carré and others have insisted, in its 'pure' type the spy novel can represent a retreat from a corrupted and corrupting civil society into the 'closed' – and no less ambiguous – community of 'intelligence', the 'cold war thriller' must bear much of the blame for an oversimplification of political vision.

The usual plot of the run-of-the-mill cold war thriller is that a left-wing government is elected in Britain and is manipulated into an anti-nuclear and anti-Western stance by Soviet agents in high places. The genre made its debut with Constantine Fitzgibbon's *When the Kissing had to Stop* in 1960, the year in which the first wave of support for nuclear disarmament peaked. Fitzgibbon was an intelligent *Encounter*-style ex-communist, Irish-American in origin, and his novel has sharp observation (a credible Michael Foot figure as premier), some style, and a distinctive element of irony. The Soviet takeover is actually accelerated by the hero, an Irish peer turned advertising man, attempting to kill the left-wing strong man who is playing the Russians off against the Americans. I doubt, however, whether its literary merits led to its republication by a right-wing press (Tom Stacey) in 1971 and a paperbacking (Granada 1978) which coincided with the CND revival and an imminent election.

If, among the subsequent works in this style, I refer to Sir David Fraser's *August 1988* (1983) it is simply because it is routine enough to be a paradigm: 'Britain disarms, Russians threaten to nuke Scarborough, Britain caves in'. With the usual result:

> Obscure men, ill-mannered with all around them, had moved from shadowy parts of the back benches.... Senior officials, bred to a long tradition of ordered liberty and democratic responsibility in a free society, met each other and exchanged horror stories in hushed tones. Whatever these new men loved it was not England.[63]

Sir David Fraser, however, is not an obscure hack but a former Vice-Chief of the Defence Staff and Commandant of the Royal College of Defence Studies. The tally of those guilty of perpetrating such literature now includes the Queen's former press secretary, at least three senior journalists and three Conservative ministers.[64]

The explanation is not simply right-wing hysteria. In the present state of publishing a 'high profile' – i.e. a propensity to appear on television – and a topic which is never out of the news, means so many copies sold, regardless of the skill of the author.[65] There have been several attempts by Labour politicians to break into the

business, equally depressing aesthetically yet not, apparently, damaging to their authors' careers,[66] while two left-wing cultural historians with awesome credentials – the late Raymond Williams and David Craig – have used the genre to explore the dilemma of a left confronted with a coercive bureaucracy and a collusive media.[67] The contribution of both camps, however, adds up not to an elucidation of the processes of representative government – as with Trollope or Cary – but to their rejection.

One aspect of the right-wing thriller, however, is new and intriguing. Its portrayal of the British governing elite is not flattering. The country is divided and decaying. If it is saved – and in present fiction that is no foregone conclusion – it is by the near-superhuman activity of some agent, not perhaps British at all. By contrast, the Soviets are (given what we know about their society) remarkably logical, calculating, well-organized, ruthless. The implication is that such qualities, and not any notion of democratic solidarity, are going to be the right stuff to save the state. Given the sort of people who seem to read this stuff – the staple pabulum of the airport bookstall – it is somehow appropriate that it reads like the tougher type of management manual, mid-Atlantic in its mores and loyalties.

The revival of this form of fiction has coincided with the accelerated destruction of much of the conventional structure of British politics, first through centralizing responses to the institutional backwardness which was blamed for poor economic performance in the 1960s, and then through Mrs Thatcher's simultaneous assault on collectivism and strengthening of the central state apparatus. At the same time the problems of the multinational state have destroyed British homogeneity and created a twenty-year conflict in Ulster which now puts British party politicians under daily threat. A plot to wipe out most of the Cabinet at a Tory Party conference – fantasy in the 1950s – became fact in 1985. Mediocre though it is as literature, the contemporary political thriller does, I feel, illuminate certain aspects of the pathology of the political elite confronted with this situation.

XI

Andrew Osmond and Douglas Hurd's *Scotch on the Rocks* is a superior version of its kind; Hurd is an intelligent politician, a Tory traditionalist rather than a free-market ideologue, patently concerned with malformations in the British political system. The

novel's subject-matter concerns one such: an election (sometime in the 1980s) in which the Scottish National Party wins thirty-four out of seventy-two Scottish seats and holds the balance of power at Westminster. In order to get SNP support the Tories are prepared to pass a Home Rule Act, but SNP radicals intrigue with a Tory ex-premier, Lord Thorganby, to sabotage this and introduce direct rule, with Thorganby as Secretary of State. Some of the SNP radicals provoke a military uprising, which holds the Fort William area and looks like advancing on Glasgow, but the secret service manages to disclose that one section of them is being supplied with East European money and guns via the French Communist Party. This splits the Scottish Liberation Army and passes the initiative to the SNP moderates, who get Home Rule. One SLA leader, the leftist, escapes on a Russian submarine; the rightist, Col. Cameron, commits hara-kiri in front of the dignitaries assembled at Holyrood Palace for the transfer of power.

As to the origins of *Scotch on the Rocks*: Osmond and Hurd wrote it in and after 1968, when the SNP were getting around 30 per cent in the polls and doing remarkably well at the local elections. They undertook some serious research, both in Scotland, through the Conservatives' Commission on the Constitution, then sitting under Sir Alec Douglas Home, and through Dr Ian Maclean, then working on the SNP at Nuffield College, Oxford. The picture of the SNP and of contemporary Scotland is therefore pretty accurate. Then, sometime around 1969, Hurd, as the Tory Party's foreign policy expert and the Leader of the Opposition's private secretary, seems to have been involved in a Ministry of Defence exercise, carried out at Ditchley Park, in which politicians and defence planners play at 'emergencies'.[68] This was predicated on an armed nationalist uprising in Scotland, in which the area around Fort William was captured. Thirdly, Douglas Hurd himself, although English-born, had an uncle, Robert Hurd (d.1964), who had been a prominent Scottish nationalist, and had connections with one Major F. A. C. Boothby (cousin of the Tory politician Lord Boothby) a well-known, right-wing, nationalist militant who was also thought to be a double agent for the Special Branch – a possible original for Col. Cameron.

Although, by the time Collins published the book in 1971, the SNP's hour seemed to have passed, it sold well and, despite SNP protests, was made into a four-part BBC television serial in 1973, just in time for a revival of the SNP which came close, in 1974, to confirming *Scotch on the Rocks*' main political premise. So, it turned out to have some political weight, above all in the

impression given of who might call the shots in an autonomous Scotland. Hurd and Osmond were perceptive about the douce, somewhat ineffectual respectability of the SNP leadership, and about some of the posturings of the movement's militants, but they made a quite illegitimate 'conspiratorial' linkage between nationalism and Glasgow gang-fighting (a prominent news story at the time) to suggest that public order in Scotland would collapse into a form of anarchy – in ways which were to be predicted by that great oracle on Scottish history, Lord Dacre:

> The pre-1707 tradition of Scotch government is not dead For 50 years of this century we have seen Scotch home rule and are therefore able to say whether, or how far, its principles have been changed in the interim. We have seen it at work in the Scotch province of Ulster from 1922 till it had to be suspended there too, in 1972. It is interesting to compare the system of government in Scotland before 1707 and in Ulster after 1922, and to see . . . certain resemblances, which I think that I need not specify, but which bear eloquent testimony to the well-known tenacity of the Scotch people.[69]

Dacre took a leading part in stoking up the anti-devolution shift in the Tory Party which became absolute with Mrs Thatcher's assumption of the leadership in 1975.[70]

Far from dabbling in illegality, the Scottish national movement is the most boringly constitutional in Europe. In 1977, when Parliament wrecked the Devolution Bill, the Home Office disclosed contingency plans which envisaged sending bobbies to Scotland to deal with anticipated rioting. 'That just shows how little they know about us', was the reaction of Gordon Wilson, the SNP's chairman.[71] *Scotch on the Rocks*, especially through its television adaptation, and shuddering comparisons with Ulster, reinforced this legalistic stereotype among the nationalists, even though the cumulative effect of political change has simply been to force the two nations further apart. Support for autonomy has lodged itself deeper in the non-Tory parties in Scotland, and the country's sense of alienation from England, latent in Buchan and even in Disraeli (Bute, the real-life hero of *Lothair*, was the first prominent aristocrat to embrace Scottish nationalism), has now become explicit. In 1988, justifying his party's ideal of citizenship, Hurd wrote that it was underpinned by three traditions: 'the diffusion of power, civic obligation, and voluntary service . . . central to Conservative philosophy, and rooted in British (particularly English)

history'.[72] Given that the Conservatives returned only eleven Scottish MPs and controlled only three small district councils, the parenthesis was apt.

XII

Written (in part) by a politician of some standing, and dealing with a salient challenge to the constitution, *Scotch on the Rocks* is above the ruck of the 'cold war' thrillers and closer to the Buchan level. But what is interesting is that the state is not 're-founded' but compromised. The solidities of Lord Thorganby's pre-war world dissolve as he himself dies. Lady Thorganby

> noticed the quiet as if it were new. In early years the house had been full of her children: happy squeals on Christmas morning, sudden tears at a broken toy or the end of holidays, endless noise and rush. Then the parties which she and David had given, this room piled high with coats, men and women separately and then again together arguing, laughing, tossing this way and that the small talk of power. Then, later again, her own charitable committees, calmer elderly talk and the tinkle of coffee spoons against Worcester. A splendid spread of worthwhile noise over forty years. Through her grumbles she had enjoyed it all. Now the quiet was coming.[73]

This is both touching and, literally, hopeless. The implication is that the 'one nation' Toryism of Thorganby (loosely based on Macmillan and so in the Disraeli tradition) is as dead as he soon will be. What will then emerge will be a much more selfish, regionally-specific capitalist politics. In Hurd's later, 'serious', political novel *The Palace of Enchantments* (1984), the pessimism intensifies: a dull, decent junior minister loses wife and seat to multinationals and predatory constituents. *The Palace of Enchantments* has both elements of psychological self-examination and references to the political fiction tradition. But it lacks the effectiveness of Disraeli: a senior minister uses 'serious' fiction to question his party's morality and no one seems to pay him a blind bit of notice.

At the beginning of this paper I argued that political fiction provided one of the conventions which 'fixed' behaviour under an unwritten constitution. To turn from the novels of Trollope to Bagehot or, even in the 1950s, from those of Maurice Edelman to Sir Ivor Jennings, is to be struck by common combinations of imagination and didactics.[74] Although within this genre the thriller

explores more pathological conditions, those written by Disraeli and Buchan end up affirmative, and 're-found' the state in the face of the menaces of Chartism and world war. The right-wing political fiction of the present day, by contrast, presents a Britain subject to almost overwhelming threats of break-up or takeover, and deploys an ideology so frenzied as to suggest that, only such over-amplified simplicities enable its arguments to be heard.

There may, of course, be the more mundane explanation that the relevance of 'normal' British politics (when fictionalized) to an international English language (mainly American) market has become so limited that only an overwhelming 'action' element can make the genre saleable. In the output of an entrepreneur like Jeffrey Archer, there is conscientious adaptation to the American market. *First among Equals* (1984) has a new ending in its American edition (the Tory, not the Labour man, becomes prime minister) and *A Matter of Honour* (1987) has an English hero but an 'American' plot. This is not new. The exotic locations Ian Fleming chose for his Bond thrillers obviously had a similar 'international-izing' function thirty years ago. Even Fay Weldon, a writer possessed of a quality singularly lacking in Archer – talent – sets her most 'political' novel *The President's Child* (1985) in 'mid-Atlantic': an Australian girl, living in London, but at one time sexually involved with an American presidential hopeful, who has to be 'taken out'. Here, however, the sense of powerlessness and being possessed – sexually and politically – by the predominant power, has a metaphorical effect which goes beyond marketing consider-ations.

After Archer published *First among Equals*, he was appointed Vice-Chairman of the Conservative Party. A few months later, on 9 January 1986, Michael Heseltine resigned over the Westland affair, telling waiting reporters that he had respected Mrs Thatcher only while she had functioned in the cabinet as 'first among equals'.[75] Perhaps this was the moment of nemesis of British political fiction: a notion of prime ministerial power which would have been false for Gladstone, let alone any of his successors, justified by allusion to a mediocre novel which latter-day print capitalism had processed as a best-seller. Far from reinforcing the conventions, political fiction had now come to corrode them.

By contrast, in the hands of John le Carré, the 'art thriller' has come to assume a critical role in probing the pathology of a multinational state in terminal decline. To turn to le Carré is in fact to come back to where we started: with the conspiracy theory

adumbrated by Carlyle. Monaghan observes le Carré's debt to the categories of Schiller, in his *Lectures on Aesthetic Education* (1793).[76] Schiller's opposition to the atomism of the Enlightenment was also the departure-point for Carlyle, in 'Signs of the Times' and 'Characteristics'. Against 'mechanism' Schiller erected the ideal of the 'national community', loyalty to which forms the necessary basis of any fiction dealing with state security.[77] To him the linguistic community and the German race were synonymous: a notion which ran into trouble when many of the greatest triumphs of German literature in the age of unification were written by Jews. By contrast, the imperfect ability of large numbers of people in the British Isles to believe themselves truly part of their community formed the *imaginative* problem which the British political thriller helped overcome. Of all the writers discussed, hardly any have fallen into the 'national' stereotype, le Carré, while English, no more than the others.

In le Carré's case the alienation comes through his father, fictionalized into the con-man Rick Pym, the major figure in the semi-autobiographical *A Perfect Spy* (1986). This complex novel seems, like *The Secret Agent*, remote from the thriller, as the 'solution' becomes patent early on, and the reader's fascination lies not in the uncovering of Magnus Pym's treachery, but in the growth of his relationship to his father and to his Czech control Otto. The character of Rick bears some resemblance to Chester Nimmo in Cary's trilogy, but one senses a harsher element of criminality and exploitation, and an absence of Cary's confidence in Puritan-radical English patriotism. The England Magnus Pym views from successive embassies is hierarchical and parasitic, as corrupt and corrupting as Rick Pym himself: the relationship that matters is that between the two eccentric seekers after truth, Magnus and Otto.

In interview, le Carré has in the past stated his liberal beliefs and his opposition (thoughtful but ultimately resolute) to the totalitarianism of the Soviets. Is *A Perfect Spy* evidence of a change, in the decade of *glasnost* and an unusually rapacious and pitiless international capitalism? Le Carré has also stressed the provisional nature of commitment, the need of men for a community to which they can relate, often the 'Circus' or the 'Section' rather than the nation.[78] If, in *A Perfect Spy*, he seems to go further, to suggest that the traitor can be the more honest man, then he implies criticism of the nation which employs him. This is not the place to analyse a dense and allusive text, but the pilgrimage Magnus (whose alias is Mr Canterbury) and Otto make to meet Thomas Mann, the

writer-in-exile *par excellence*, seems to act as its epiphany. Both in its loyalties and in its consciously 'modernistic' – or 'European' – narrative technique *A Perfect Spy* seems a gesture of farewell to the idea of Britain.[79]

The political thriller, I have been arguing, has roots which perhaps go even deeper into society than the realist novel, back to the epic and the romance, and the archetypes of early social organization. When it came in contact with the methods and mechanics of realist fiction and print capitalism, two things happened: a popular genre was precipitated which broadcast social solidarity in the era of competitive nationalism; and, at a much higher level of intellect, the nature of the individual's relation to nation and society was put under analysis – 'tested to breaking-point'.

The combination of both has created a genre with considerable social influence, most of the time in favour of a crude version of the 'British' national myth, yet, because largely provided by an intelligentsia marginal to the English, class-structured core, the myth has been liable from time to time to 'go critical', with surprising results. In a multi-national state, this myth is not a stable ideology; it can inspire loyalties which it is incapable of fulfilling. In the 1930s one young intellectual sensed this betrayal:

> The real turning-point in my thinking came with the demorali-sation and rout of the Labour Party in 1931. It seemed incredible that the party should be so helpless against the reserve strength which reaction could mobilise in time of crisis. More important still, the fact that a supposedly sophisticated electorate had been stampeded by the cynical propaganda of the day threw serious doubt on the validity of the assumptions underlying parliamen-tary democracy as a whole.[80]

As an explanation of what he then did, he turned to one of Graham Greene's political thrillers, and quoted a passage:

> 'No. Of course not,' he replied. 'But I still prefer the people they lead – even if they lead them all wrong.' 'The poor, right or wrong,' she scoffed. 'It's no worse – is it? – than my country, right or wrong. You choose your side once and for all – of course, it may be the wrong side. Only history can tell that.'[81]

The book was *The Confidential Agent*, the young man was Harold Philby, nicknamed after Kipling's hero in the 'Great Game' of espionage. He was joining the KGB.

Notes

1 For the purposes of this paper, the best introductions are Morris Speare, *The Political Novel*, (Oxford: Oxford University Press, 1924); and Roy Foster, *Political Novels and Nineteenth Century History*, Winchester: King Alfred's College, 1981. There will be a fuller discussion of the genre and its secondary literature in Christopher Harvie, *The Centre of Things: Political Fiction from Disraeli to the Present*, London: Unwin Hyman.

2 George Bull, *New British Political Dramatists*, London: Macmillan, 1984.

3 Joan Smith, 'Who's afraid of Federick Forsyth?', in *The New Statesman*, 15 January 1988.

4 Michael Denning, *Cover Stories*, London: Routledge, 1987, pp. 33–5.

5 Jerry Palmer, *Thrillers*, London: Edward Arnold, 1978, p. 38.

6 ibid., p. 84.

7 Disraeli, *Sybil* (1845), Harmondsworth: Penguin Books, 1980; a 'classic' text such as Ivor Jennings, *The British Constitution* (1941), Cambridge: Cambridge University Press, 1966, relies on imagination much more than logic; 'liberty is a consequence not of laws but of an attitude of mind' (p.203), etc.

8 See Christopher Harvie, 'Ideology and Home Rule: James Bryce, A.V. Dicey and Ireland, 1880–1887', in *The English Historical Review*, Vol. XCI, April 1976, pp. 298–314.

9 Palmer, *Thrillers*, p.108. He wrongly gives the date of the first Holme story as 1875. See Erik Routley, *The Puritan Pleasures of the Detective Story*, London: Gollancz, 1972, p. 19; and Owen Dudley Edwards, *The Quest for Sherlock Holmes*, Harmondsworth: Penguin Books, 1984, pp. 286ff.

10 Cf., the statistical appendix of *The Centre of Things* .

11 These notions are taken from George Dangerfield, *The Strange Death of Liberal England*, London: Constable, 1934; and Tom Nairn, *The Break Up of Britain*, London: Verso, 1977.

12 See Speare, *Political Novel*, p. 184.

13 One example (among many) of this interpretation is Asa Briggs, 'Bagehot, Trollope and the English Constitution', in *Victorian People*, London: Odhams, 1957.

14 See Guinevere Griest, 'A Victorian Leviathan: Mudie's Select Library', in *Nineteenth Century Fiction*, Vol. 20, No. 1, September 1965, pp.103ff

15 Foster, *Political Novels*, p. 18.

16 Leslie Stephen, 'Mr Disraeli's novels', in *The Fortnightly Review*, 1877, reprinted in *Hours in a Library*, Vol. II, Smith Elder, 1892, p. 124.

17 Cazamian, *The Social Novel in England*, trans. Martin Fido, London: Routledge, 1973, pp. 175–210.

18 Speare, *Political Novel*, p. 88.

19 Q. D. Leavis, *Fiction and the Reading Public*, London: Chatto & Windus, 1932, p. 62.

20 See J. M. Roberts, *The Mythology of the Secret Societies*, London: Secker, 1972, pp. 2–7.

21 Quoted in ibid, pp. 248, 313.

22 'Characteristics' was published in the *Edinburgh Review*, 1831, reprinted in *Scottish and Miscellaneous Studies*, London: Dent, n.d., p. 221.

23 *Sybil*, p.74; and see Sheila M. Smith, *The Other Nation*, Oxford: Oxford University Press, 1981, p. 73.

24 See Trollope's verdict on it in *Autobiography*, 1883, Oxford: Oxford University Press, 1947, p. 230.

25 See J. T. Ward, 'Michael Maltman Barry, Tory Socialist', in the *Scottish Labour History Society Journal*, No. 2, April 1970, pp. 25ff.

26 Chesney-Blackwood, 11 March 1871, quoted in Mrs Gerald Porter, *John Blackwood*, Blackwood, 1898, p. 300.

27 Hugh Cunningham, *The Volunteer Force*, London: Croom Helm, 1977, ch. 1.

28 William Donaldson, *Popular Literature in Victorian Scotland*, Aberdeen: Aberdeen University Press, 1985, p. 92.

29 For the link between fundamentalism and radicalism, see Edmund Gosse, *Father and Son*, 1907; and the imaginative capture of this mentality among West Country radicals in Joyce Cary, *Except the Lord*, London: Michael Joseph, 1953.

30 St Barbe Sladen, *The Real Le Queux*, London: Nicholson and Watson, 1938, p. 3; Christopher Andrew in *Secret Service*, London: Heinemann, 1985, p. 38, calls him simply a fraud.

31 David T. Stafford, 'Spies and gentlemen: The birth of the British spy novel, 1893–1914', in *Victorian Studies*, Vol. 24, 1980–1, p. 497.

32 Douglas Sladen, *Twenty Years of My Life*, London: Constable, 1915, p. 294.

33 See Bernard Porter, 'Secrecy and the Special Branch, 1880–1915', in the *Bulletin of the Society for the Study of Labour History*, Vol. 52, No. 1, 1987, pp. 8–15.

34 For this concept, see John Gross, *The Rise and Fall of the Man of Letters*, 1969, Harmondsworth: Penguin Books, 1973, p. 314.

35 See Samuel Hynes, *The Edwardian Turn of Mind*, Princeton: Princeton University Press, 1968, p. 68.

36 E. Phillips Oppenheim, *The Pool of Memory*, London: Hodder & Stoughton, 1941, p. 29.

37 Ignatius F. Clarke, *Voices Prophesying War*, 1966, London: Panther, 1970, pp. 145–55.

38 Jay Luvaas, *The Education of an Army*, London: Cassell, 1965, pp.307ff.

39 Joseph Conrad, *The Secret Agent*, London: Methuen, 1907, p. 227.

40 Preface (written 1920) to ibid., pp. xi–xii.

41 Preface, p.xi; and see Leon O'Broin, *The Prime Informer*, London: Sidgwick & Jackson, 1971, pp. 122ff.

42 Quoted in Frederick R. Karl, *Joseph Conrad, The Three Lives*, London: Farrer, Straus and Giroux, 1979, p. 596.

43 David Monaghan, *The Novels of John Le Carré*, Oxford: Basil Blackwell, 1985, p. 77.

44 See Richard Usborne, *Clubland Heroes*, London: Hutchinson, 1953; Colin Watson, *Snobbery with Violence*, London: Eyre, 1971.

45 For biographical background, see Janet Adam Smith's excellent *John Buchan*, London: Oxford University Press, 1985.

46 M. R. Ridley, 'A misrated author', in *Second Thoughts*, London: Dent, 1965, p. 3.

47 John Buchan, *The Power House*, in *Blackwood's Magazine*, 1913, London: Hodder & Stoughton,1916, p. 64.

48 Greene, 'The Last Buchan' (1940), in *The Lost Childhood*, (1951), Harmondsworth: Penguin Books, 1962, p. 119.

49 *Falconet* was later published in Monypenny and Buckle, *Disraeli*, Vol.II London: Murray, 1920, pp. 1548ff.

50 'Characteristics', in *Scottish and other Miscellanies*, Dent, n.d., p. 221.

51 H. G. Wells, *The New Machiavelli*, London: Cape, 1911, Harmondsworth: Penguin Books, 1946, p. 358; and for a damning reassessment of Balfour's moral character, Anthony Lentin, *Lloyd George, Woodrow Wilson and the Guilt of Germany*, Louisiana University Press, 1986, p. 125.

52 See David Wright, 'The Great War, government propaganda and English "Men of Letters"', in *Literature and History*, No.7, Spring 1978, pp. 70; and Oppenheim, *The Pool of Memory*, pp. 41–4.

53 See Christopher Hardie, 'Second thoughts of a Scotsman on the make: nationalism, myth and John Buchan, in H. Drescher and J. Schwend (eds) *Literature and Nationalism*, Frankfurt: Peter Lang, 1988.

54 See Catharine Carswell, in *John Buchan, by his Wife and Friends*, London: Hodder & Stoughton, 1947, pp. 148–73; it is also interesting that Ian Fleming was a convinced Jungian.

55 ZDF TV Film, *Der Siegfried Mythos*, 15 January 1987; and see Michael Balfour, *Propaganda in World War II*, London: Routledge, 1979, p. 5.

56 Graham Greene, *On Film*, New York, Simon & Schuster, 1972, p. 1.

57 Denning, *Cover Stories*, pp. 75ff.

58 Graham Greene, *It's a Battlefield*, London: Heinemann, 1935, pp. 216–17.

59 Jeffrey Richards, *The Age of the Dream Palace*, London: Routledge, 1984, pp. 119–20, 320–2.

60 John Grierson, *On the Movies*, London: Faber, 1981, p. 165.

61 John Russell Taylor, *Hitch*, London Abacus, 1981, pp. 138ff.

62 Introduction to B. Page, D. Leitch, and P. Knightley, *The Philby Conspiracy*, London: Deutsch, 1968.

63 Sir David Fraser, *August 1988*, London: Collins, 1983, p. 233.

64 Michael Shea, *Tomorrow's Men*, London: Weidenfeld, 1981; Chapman Pincher, *Dirty Tricks*, London: Sidgwick & Jackson, 1980; Hardiman Scott, *No Exit*, London: Vanguard, 1983; Michael Spicer, *Final Act*, London: Severn House, 1981; Lord Denham, *Two Thyrdes*, London: St Martin's, 1983.

65 See John Sutherland, *Bestsellers: Popular Fiction of the 1970s*, London: Routledge, 1981, p. 154.

66 Cf. Chris Mullin, *A Very British Coup*, London:Coronet, 1982; Brian Sedgemore, *Mr Secretary of State*, London: Quartet, 1978; Robert Kilroy-Silk, *The Ceremony of Innocence*, London: Enigma, 1983.

67 Raymond Williams, *The Volunteers*, London: Chatto & Windus, 1978; David Craig and Nigel Gray, *The Rebels and the Hostage*, London: Journeyman Press, 1978.

68 See Christopher Harvie, *Scotland and Nationalism*, London: Allen & Unwin, 1977, p. 250; information from Duncan Campbell of the *New Statesman*.

69 Quoted in Craig Beveridge and Ronald Turnbull, *The Eclipse of Scottish Culture*, Edinburgh: Edinburgh University Press, 1988, p. 7.

70 See his foreword to Tam Dalyell, *Devolution: The End of Britain*, London: Cape, 1977, pp. ix–xii.

71 Interview with Gordon Wilson, 1 October 1987.

72 Douglas Hurd, 'Citizenship in the Tory democracy', in *New Statesman*, 27 April 1988.

73 Douglas Hurd and Andrew Osmond, *Scotch on the Rocks*, London: Collins, 1971, Fontana, October 1972, p. 218–19.

74 Maurice Edelman, *Who Goes Home*, London: Allan Wingate, 1952; *The Minister*, London: Hamish Hamilton, 1962.

75 *Guardian*, 25 January 1986.

76 David Monaghan, *The Novels of John le Carré*, Oxford: Blackwell, 1985.

77 Eli Kedourie, *Nationalism*, London: Hutchinson, 1960, p. 45.
78 See John Atkins, *The British Spy Novel*, London: John Calder, 1984, pp. 174–5.
79 This section owes much to a conversation Neal Ascherson and Dr Erhard Eppler.
80 H. A. R. Philby, *My Silent War*, London: MacGibbon and Kee, 1968, p. xvii.
81 ibid., p. xviii.

9 *Room at the Top*: the novel and the film

Arthur Marwick

Though my interest in these two cultural artefacts (the novel, written in the early fifties, and published in March 1957, the film, completed in 1958, and released in January 1959) is that of a social historian, I am clear that in interpreting them the skills of literary and filmic analysis must be added to those of historical study. My general concern is with what I have elsewhere termed 'The International Cultural Revolution of the 1960s'.[1] I believe that, in Britain, a number of influences, indigenous and international, economic and cultural, reached critical mass in 1958–9, initiating the sustained and accelerating period of cultural change which, by the early seventies, had radically transformed British society. The argument, of course, is contentious, yet the evidence in support of it overwhelming. To get right to the heart of the matter let us compare the lot of various sorts and conditions as it was in the middle fifties with what it had become for analogous individuals and groups in the early seventies: consider the teenage girl, not just the one who is already pregnant, but all the others who are terrified of becoming pregnant; consider the young person (male or female) with a talent for design, drawing, acting, music-making, football; consider the disabled of all ages and either sex; consider the homosexual; consider the young people (male or female) tied to home until they can establish a marriage of their own; consider the couple trapped in an unworkable marriage; consider the young women in the public dance halls for ever shuffling expressionlessly backwards; consider the sniggering, the furtiveness, the guilt over sex; consider the dominance over all walks of life, from government to entertainment, of those with the correct education and correct accents; consider the earnings, the material circumstances, and the leisure activities of working-class and lower-middle-class families; consider the ubiquitousness of the songs of Guy Mitchell and Doris

Day and the feebleness of British movies after the collapse of the Ealing studios; consider the slavishness to fashion and proper decorum; consider the contortions of female sunbathers endeavouring to combine maximum exposure to the sun with minimum outrage to public decency; consider the edict of Malcolm Muggeridge and his like that women not only should not be, but could not be, humorous about sex. What happened between the late fifties and the early seventies was not a political revolution, not a revolution in economic thought and practice, but a transformation in the opportunities and freedoms available both to the majority and to distinctive individuals and groups within the majority to the exceptional and to the ordinary.

In this chapter I am concerned principally with three areas of change: changes relating to class attitudes, social structure, and social mobility; changes in sexual attitudes and behaviour; and the new cultural practices and products themselves. Britain remains a class society, but by the early 1970s working-class consumption patterns had greatly altered, individuals from working-class origins, belligerently projecting working-class manners and accents, were highly visible and highly successful in the new popular culture, provincial accents had become acceptable, while the old plummy, upper-class accent was being replaced by 'posh cockney'. In sexual matters, the almost Victorian fears and pruderies which still dominated the middle fifties had been replaced by permissiveness and explicitness. The survey material is copious: perhaps the single most significant statistic is that while in 1951 only 51 per cent of women interviewed had declared sex to be very important in marriage, in 1969 the percentage was 67.[2] The ribald novels produced by Molly Parkin in the 1970s and onwards simply would not have been possible.[3] Despite the very real achievements in war-time, and the postwar flowering of the Ealing Studios, British films in the fifties did not carry a very high status either at home or abroad; popular music was dominated by American imports; British design, British fashion, British photography were hardly thought to exist. By 1970 British achievements in all of these spheres were legendary.[4]

It is indeed very hard to deny the existence of these changes, though, certainly, their significance has been challenged from both left and right. In a lapidary pronouncement of March 1982 Mrs Thatcher denounced the trends of the sixties as involving a deplorable abandonment of Victorian self-discipline (thus, at least, recognizing that changes did take place): 'We are reaping what was

sown in the Sixties ... fashionable theories and permissive claptrap set the scene for a society in which the old virtues of discipline and restraint were denigrated.'[5] On the left the changes have been written off as essentially trivial and superficial, the films and other cultural artefacts of the time dismissed as traditionalist, inegalitarian, commercial, and sexist.[6] Among other objectives, this chapter may be taken as a further contribution to that debate, though there is no space here to summarize the enormous mass of evidence supporting the contention that the changes were both considerable *and* significant. It is certainly *not* my claim here that the film and the novel, *Room at the Top*, in themselves, demonstrate the nature, extent, or significance of change – the evidence for that must overwhelmingly be sought elsewhere.[7] My hypothesis, rather, is a much more limited one, which can be summarized under four headings:

1 the process of creating the film out of the novel reveals that striking changes in cultural attitudes were crystallizing in 1958;
2 the film, in its treatment of class and of sex, was so stark and concentrated as to be genuinely revolutionary;
3 thus, as a massive popular success, it both ratified and reinforced changes in social behaviour and opened the way to a series of highly successful British films which took still further the realistic treatment of class and sex, which in turn became an important part of the transformations of the sixties;
4 in short, *Room at the Top*, the film, for all its traditionalism in filmic style, was a vital component of the critical 'take-off' developments of 1958–9.

Much of my argument depends upon comparing and contrasting the 'meanings' (that is to say what readers and viewers, individually and collectively, took from the novel and film; these may well vary from social group to social group and, of course, for relatively 'innocent' readers and audiences in the later fifties differed from the meanings that would be perceived by the post-permissive generation of today) of the two texts. An important first task (here I am in entire agreement with Marxist-derived practice on the matter) is to establish the conditions of production and consumption, and the status which was allocated to the two texts through the usual modes of publicity, reviews, and consumer reaction. I also take it as axiomatic that meanings are produced by an interaction between content and form (highly traditional in regard to both novel and film, though, of course, the formal devices of a film are very

different from those of a novel). In crudest outline, the basic plot for both texts is the same, and was, of course, laid down by the novel. Joe Lampton, son of a mill-worker, having acquired an accountancy qualification while a prisoner-of-war in Germany, comes in 1947 from working-class Dufton to the Yorkshire city of Warley (changed in the film, since a real Warley did exist near Halifax,[8] to Warnley – presumably, anyway, modelled on Bradford) to take up a post in the City Accountant's office, under the Chief Accountant, Hoylake. He becomes involved both with Alice Aisgill, 'an older woman' married to a prosperous businessman, and with Susan Brown, daughter of the richest and most powerful man around, who is himself married to a member of the aristocracy. He ditches Alice to marry Susan and thus goes straight to 'the top'. Alice kills herself in an horrific car accident.

Let us consider then the questions of production, consumption, and status. In 1950 John Braine had set himself up in London as a freelance writer, a self-conscious 'intellectual', who wrote primarily to earn a living. Braine's father, as a child, had worked half-time in the Yorkshire woollen mills, but by the time of the birth in Bradford in 1922 of the future writer, he had moved into the lower middle class as a sewage works supervisor; Braine's mother was a librarian. Already Braine was something of an outsider, since the family were Catholic: he left his Catholic grammar school at the age of sixteen, taking up various marginal white-collar jobs, before ending up in the Bingley library. He served as a telegraphist in the Royal Navy between 1940 and 1943, before being invalided out with tuberculosis. Between 1952 and 1954 he had two further years with the illness, taking him still further into the world of literary creation. Braine has said that the first seeds of the novel came when the sight of a rich man in an expensive car set him wondering how one achieved such a position.[9] The novel is retrospective in mode, the rich man in the fifties looking back on his first arrival in Warley, and the events which then unfold across twenty-nine short chapters sequentially up to Joe's engagement to Susan (she is pregnant by him), and then his final parting from Alice (very matter-of-fact in the novel); there are occasional references back to childhood, war experiences, and to postwar cronies in Dufton. Chapter 30, the final chapter, is twice as long as any previous chapter, and three, four, or five times as long as most other chapters: in it Joe hears of Alice's suicide, goes on a long drunken binge in which he has sex with a working-class girl, Mavis, manages through his military experience to inflict considerable damage on Mavis's boyfriend and his

companion who try unsuccessfully to beat him up, and finally collapses to be rescued by friends who tell him that nobody blames him for the death of Alice: '"Oh my God," I said, "That's the trouble"' – the last words of the book.[10]

The novel, then, concerns loss of innocence, the moral compromises involved in getting to the top ('the muck one's forced to wade through to get what one wants'),[11] the ambiguities and contradictions of different kinds of love (Joe *is* in love with Susan, to whom he is both fastidious and protective;[12] his love for Alice is a combination of friendship and profound sensuality), the material circumstances of post-war Britain, including some rather muted elements of social criticism. In sexual content the novel was not really more shocking than many which had been published earlier in the century, but it was down-to-earth and naturalistic, somewhat in the manner of William Cooper and Kingsley Amis,[13] and it did deal explicitly with the realities of class and income differences. In short, it fitted well into the general (and really very loose) category which journalists had defined as the Angry Young Man school[14] and was published by the highly respectable publishers Eyre and Spottiswoode. The critics reacted enthusiastically: 'If you want to know the way in which the young products of the Welfare State are feeling and reacting', wrote Richard Lester in the *Evening Standard*, '*Room at the Top* will tell you.'[15] Hard-cover sales amounted to 34,000 (greatly assisted, according to the publishers, by a mention on the BBC television programme *Panorama*), there was serialization in the *Daily Express* and a book club edition sold 125,000; Penguin Books offered for the paperback rights on 7 May, and the deal was concluded by 15 May 1957.[16] This was in advance of the purchase of the film rights by John and James Wolfe, sons of one of the great pioneers of British commercial films, and proprietors of the small Romulus company: Romulus specialized in serious films which, often because of their sexual content, were usually awarded X certificates, which could actually have a commercial value. They hoped both to make money and earn prestige as the makers of a serious and innovative film. The Wolfes had three very competent professionals, Jack Clayton to direct, Neil Patterson to write the screenplay, and Mario Nascimbene to compose the music, and one highly distinguished one, cameraman, Freddie Francis. It was thought that no British actress could carry off (or, perhaps, would be acceptable in) highly sensual scenes, whereas the French actress Simone Signoret carried with her the aura of French X certificate films. Thus Alice Aisgill became French, while Laurence Harvey (Lithuanian by origin), who

had had several screen roles, but little critical acclaim, was signed up to play the key role of Joe Lampton. Penguin held up publication of their paperback till the film had been released, so that as 'the film of the book' it had sales of 300,000. But the truly outstanding success was that of the film itself: advertised as 'A Savage Story of Lust and Ambition – The Film of John Braine's Scorching Best Seller' it played to packed houses across the country. It generally received high critical praise, both at home and abroad. A leading trade magazine, in its 'Reviews for Showmen', provided this epigraph: 'Outstanding British adult offering and obvious money-spinner'.[17] The novel was essentially a middle-brow cultural artefact, receiving the status both of 'best-seller' (the term is relative, and did not connote truly massive sales in the Britain of the time) and of being a work of serious social realism. Being reckoned (accurately) 'revolutionary' in content (if not in style) the film gained considerable high art status as well as being a very successful artefact of popular mass culture.

In considering the conditions of production for a film, one must, of course, look closely at the censorship process. It is a complete misunderstanding to see film-makers and British Board of Film Censors in some kind of dialectical relationship. From very early on the Wolfe brothers acted in consultation with the censors seeking to establish what would be acceptable. Historically, the correspondence between John Wolfe and John Trevelyan, Secretary of The British Board of Film Censors,[18] is most important for its revelation that Trevelyan recognized that within a short space of time what was acceptable to public mores had considerably changed. Only one alteration to the narrative content was enforced by the censorship: Joe's sexual couplings with Alice and Susan were obviously integral to the plot, but the sequence involving Joe and Mavis was altered so that this encounter was no longer explicitly sexual. The other alteration of substance concerned the gruesome description of Alice's death, the word 'scalped', despite John Wolfe's protests, being removed. Other alterations were exclusively concerned with what Trevelyan at one point referred to as 'language'. Objections were raised to: 'he can shove it up his waistcoat'; 'damn you to hell you stupid bitch'; 'have a quick bash'; 'educated and moral bitch'; 'an old whore like that'; and a general reduction in the use of 'bitch', 'bloody', 'bastard', and 'lust' was called for. In the end, all of the phrases got through, one 'lust' was dropped, and in one case 'witch' was substituted for 'bitch'.[19] That the film was still considered highly daring was, of course, recognized in the award of an X

certificate. One of the Board's examiners, attending early public screenings, commented: 'I am not surprised that people have talked about the frankness of the dialogue – certainly the most "adult" we have allowed in a non-continental film.'[20] The film, then, was recognized as being unprecedented in its frankness, while at the same time it was being acknowledged that such frankness was acceptable in a way that it had not been a few years before.

These points lead easily into a consideration of whether there is any utility in a 'dominant ideology–alternative ideology' hypothesis. My contention (in the introduction to this book) that there is not seems to be supported by the evidence that censors and film-makers shared values, rather than came into conflict over them (the concept of 'negotiation' would quite misrepresent this process). New social attitudes and new social relationships were emerging, but to speak of an alternative emergent ideology would be to simplify and parody. The working class was better-off in the late fifties than it had been in the early fifties, and the process accelerated in the sixties, but in no sense was it a dominant, or even an emergent class. The meanings of both novel and film cannot in any useful way be related to any alleged working-class consciousness. A film can present new attitudes without having to be representative of an alternative ideology.

Some of the changes as between novel and film were, of course, dictated by the medium itself: the number of characters has to be cut down, interior monologues on the whole have to removed, resulting, in this case, in Charles, an old Dufton crony, becoming a new friend, and fairly constant companion, acquired in Warnley. But my main purpose in the rest of this chapter is to bring out how changes, not necessarily enforced in this way, served in the film to concentrate and intensify certain particular meanings, above all for mass (largely working-class) audiences. During my presentation at the Social History Society conference I actually showed certain extracts from the film and circulated pages of text from the novel. Unfortunately, I have no means here of showing film (and the few stills I have reproduced do not, I have to confess, really take us very far). Simply to print extracts from the screenplay would be entirely false to the particular features of the film medium. I shall therefore do my best on the printed page to convey *all* the significant elements of certain important passages in the film, in order then to contrast them with analogous passages in the novel. By concentrating, altering, and frequently developing, material in the novel, the film, it seems to me, has two major and two lesser preoccupations

(or 'meanings'). The major ones are: class power, class rigidities, and the possibility of social mobility; and sex, frankly presented and still more frankly discussed. The issues of moral integrity, loss of innocence, and so on are reduced to incidental elements in the early sex scenes with Alice, but then emerge in a romantically charged manner quite different from the novel in the last sex scenes at the seaside cottage, and very fully in Joe's manifestations of guilt after Alice's death; in fact the ambivalences and contradictions of love as presented in the novel disappear in the film to be replaced by a categorical assertion that Joe's true love is for Alice, his love for Susan really non-existent, the better of course to bring out: (1) the predatory character of Joe; (2) that though social mobility is possible up one avenue, the class power of Aisgill can destroy true love. As visual medium, the film gives very strong representations of the physical differences in social environments. While Joe Lampton in the novel was fastidious and self-questioning, Joe Lampton in the film is straightforwardly predatory, a figure much more likely to impact strongly on mass audiences. Almost every sequence of the film makes a clear statement about class or about sex, and sometimes both; no such analysis could be applied to the chapters of the novel.

To bring out the contrast in meanings, it is essential to clarify the crucial differences in narrative structure, some of course inherent in the different media, but most evidently deliberate. Let us suppose that *Room at the Top*, the novel, conforms to the model identified by Professor John Sutherland, allowing for half-an-hour's reading in bed for a fortnight,[21] that is to say its reading time is six to seven hours. The running time for the film is one hour and forty-three minutes. The need for condensation, dropping of characters, etc., in the film has already been recognized. However, there was no inherent need to rearrange the narrative sequence. In fact, the film unfolds in a manner which at times is quite strikingly different from that of the novel. The novel, as we have seen, is divided into thirty chapters: the last chapter, certainly, is a particularly long one, but indisputably Braine intended the speeding-up, and summing-up, effect of cramming so much incident into one chapter (clearly he could have broken it up into two or three chapters if he had wished). Following the method of analysis recommended by Pierre Sorlin,[22] the film can be divided into forty-nine sequences. More significantly, though, through the simple technical device of the fade to black, the film is divided into four major sections: one long exposition running to the end of sequence 27, then three much

shorter sections as the film hurtles to its climax (see Table 9.1). The general effect of this division is to privilege Joe's affair with Alice as the central narrative component of the film, and to underline Alice's consistently tragic role (in the novel she is much more of a manipulative woman of the world). The first fade to black follows the quarrel which seemed to signal the end of the relationship (and is immediately followed by the long sequence at the Civic Ball in which Joe's lower-class status is cruelly driven home (see Figure 9.4), and which in turn leads to Joe's seduction of Susan). The second fade to black comes after the romantically-charged cottage sequence with its sequel in the foreboding sequence in which Alice and Joe part at the local railway station, in order that they may each return separately to Warnley (the fade is immediately followed by Aisgill's arrival in his Daimler to threaten to break Joe if Alice seeks a divorce). The third fade to black follows Joe's final visit to Alice where he breaks the news of his engagement to Susan and the immediate sequel where we see her in the pub alone, getting drunk (this fade is immediately followed by the sequence which picks up Joe outside the Town Hall and follows him into the office where, eventually, he hears of Alice's horrific suicide).

The novel had provided no basis for this division into four sections. Four other changes in narrative structure require to be identified. First, despite the pressure of time in the film, there are one or two important sequences in the film which have no analogues in the novel: their essence, as we shall see, is a very direct commentary on class or, alternatively, upon the relationship between class and sex. Second, certain very important developments are positioned at an entirely different place in the film from their original positioning in the novel. Most important, while Joe's seduction of Susan in the novel takes up a rather cursory half-page at the end of chapter 27, it forms one of the most important set-piece sequences in the film, sequence 30, only just over half-way through. Throughout the novel the contrast is between Joe's almost innocent and almost paternal love for Susan, and his carnal love for Alice; in the film there are two kinds of carnal love. By chapter 27 in the novel Joe has already come to feel that his relationship with Alice is over,[23] and the seduction is largely the by-product of a quarrel with Susan over how exactly he should make his final break with Alice.[24] The scene in which Joe returns to the aunt who brought him up in Dufton, and where he admits to his involvement with Susan, comes (as we shall see in a moment) relatively early in the novel (chapter 10, less than a third of the way through), whereas

in the film it is related to other newly introduced narrative developments and comes at sequence 22 getting towards half-way through the film. Table 9.1 shows the different narrative structures of the two texts, and the relative positioning of these two episodes, and also the warning by Hoylake, which I shall discuss shortly.

Though technically retrospective in mode, the novel does move forwards at a good narrative pace. However, this is nothing to the exhilarating drive of the film which, traditional though the devices employed undoubtedly are, certainly contributed to its stupendous box office success. The standard technical device for driving on the narrative pace of a film is the dissolve, which gives the sense of one sequence blending rapidly into the next. In addition to the three fades to black already mentioned, there are only four cuts between sequences in the entire film, and all of these come well within the first half, so that the continuous narrative pace accelerates in the second half of the film, where also the sections with their intense climaxes are concentrated (see Table 9.1). There is a simple cut between the opening sequence, silent, with the credits laid over it, and the second sequence with Joe actually arriving in the Warnley City Treasurer's Office. At the end of sequence 6, Joe, watching Susan in an expensive dress shop, is interrupted by her boyfriend, Jack Wales who, among other things, taunts him with his Distinguished Flying Cross (see below): a direct cut is required to take us a few days ahead in time to the dog racing track where Joe complains about Wales, and the DFC, to his cronies. A cut is needed too to separate Joe's first discussion with Alice in the pub, and Susan in her home receiving Joe's first telephone call, again presumably a day or so later. The fourth cut comes between a series of shots of Dufton, establishing the proletarian ambiance, and Joe's discussion, in sequence 22, with his aunt and uncle. Otherwise, the standard technique of the film is to link one sequence to the next through a dissolve which is set up by some linking idea or word. For example, just as it is fairly clear towards the end of the sequence (sequence 18) in which Alice and Joe go up to the moors together that they are about to make love (a female character, Eva, has commented, 'Alice is all woman', and Alice herself has explained getting out of the car with the phrase 'this is a very moral car') the shot dissolves to Joe coming into the office next morning yawning widely. When Brown undertakes to his wife to dispose of Joe, that sequence ends with him picking up the telephone. The dissolve takes us into Hoylake's warning chat to Joe. When Charles tells Joe that the invitation to Dufton is the chance of a free trip home, Joe

Table 9.1

Novel – 33 Chapters

10	17	27	30
* (1)	* (3)	* (2)	I

Film – 49 Sequences
with three fades to black, four cuts between sequences, and forty-one dissolves between sequences

6	9	16	21	22	27	34	40	49
I	I	* (3)	I	* (1)	■ * (2)	■	■	I

I = cut between sequences ■ fade to black
(1) visit to Dufton (2) Seduction of Susan (3) Warning by Hoylake

responds that he does not have a home: the dissolve is to him inspecting the bombed-out ruins of the house in which his parents were killed. Dissolves are quite often used within sequences, particularly to convey fairly rapid movement in time, as in the sequence which ends up on the moors. Rapid cutting, naturally, is used when we are taking in different scenes at roughly the same point in time, as when Joe looks out of his new office window and sees Susan and Wales and the Lagonda for the first time. But they are also used very strikingly when Joe moves from outside the Town Hall, along the corridors, and into the office to receive both congratulations on his engagement to Susan and, very quickly, the dreadful new of Alice's death; the technique is then echoed as the different characters in the office register their views about Alice, all in sharp contrast to Joe's reactions: all this as a prelude to the poignancy of the dissolve to Joe's return to Elspeth's flat where his affair with Alice had been mainly conducted.

The novel is not particularly rich in the devices of metaphor or allusion, but it is enriched by much retrospective analysis. The reflections on Jack Wales, the University of Cambridge, and the class structure, for instance, are acute.[25] However, the film had at its disposal not simply visual imagery, but also the highly professional use of the musical score. There is a very aggressive, slightly discordant, 'social mobility theme', with which, in fact, the film opens. The one truly poignant theme is reserved for the relationship with Alice, thus again privileging that relationship as the one of true love abandoned in the face of class-conflict and class-ambition. The music associated with Susan seems to be almost deliberately cliché-ridden in its sweetness. The whistle of the steam train is a frequent accompaniment to the score: it is actually the first sound we hear before we even see the pre-credit sequence. We hear it when Joe returns to Dufton, we hear it after Joe is beaten up. Feature films, of course, do not simply pick up sound randomly: these whistles play their part in reinforcing the sense of geographical and, therefore, social mobility.

From its opening shot the film commands attention by a combination of stark visual image and powerful, almost screaming, soundtrack (train whistle, then 'mobility theme'). What we see is a pair of shoeless feet silhouetted in the window of a railway compartment. Then we take in Joe Lampton luxuriously sprawled behind his newspaper. The theme of this long opening sequence, over which the credits now begin to roll, is clearly that of social mobility, represented in a direct visual way. A distant shot of

Warnley features prominently Brown's engineering factory. Not a word is spoken as Joe takes a taxi to the City Treasurer's Office. As Joe, in the second sequence, enters the office the camera hints at the second major preoccupation of the film by registering the tremendous sexual excitement of the secretaries working there as they take in Laurence Harvey's handsome presence. For seconds he is deliberately posed in profile. Although the action does, somewhat shakily, take place in 1947 (the plot requires frequent references to the war) we are clearly in present time; the opening of the novel, on the other hand, had firmly established the retrospective mode. This second sequence has no analogue in the novel. Joe meets his new boss Mr Hoylake (Raymond Huntly) who immediately drives home the major purposes of these opening sequences, telling Joe he will now 'meet a different class of people'; Joe's awareness of the contrast, and residual but ambivalent pride in his working-class origins, emerges in his response that the people of Dufton are 'not exactly savages'. Joe is introduced to Charles, with whom he will share digs in the vicinity of the better part of town, 't'top'. In a short sequence, Joe sees Susan Brown with the upper-class, ex-RAF, Cambridge student, Jack Wales and his Lagonda (a snobbier and 'nastier' car than the Aston Martin of the novel). Nascimbene's music expresses Joe's envious thoughts while Charles comments, 'That's not for you, lad.' In the film, Charles serves to delineate clearly the class territory Joe must not tread on; in the novel he had served an exactly opposite purpose, spurring on the often hesitant and self-doubting Joe. There follows the long culmination to this interlinked series of opening sequences. Back in the digs Joe verbally establishes the working-class environment from which he is escaping: the Sunday treat was 'fish and chips wrapped in a greasy *News of the World*'; then in a classic statement of the nature of working-class life-chances he declares that living in Dufton 'seemed like a lifetime's sentence'. But then, in an utterance which really was revolutionary (there is no precise analogue in the novel, only various details meticulously presented here and there) Charles establishes the limits of middle-class life, as distinct from the upper-class amplitude of life represented by Jack and Susan and 't'top', which he indicates from the window. (Traditionally, British films had presented some form or other of a clearly delineated two-class society, the educated classes and the popular classes, without ever considering whether the dichotomous model actually corresponded with reality.) Charles explains that if Joe works hard for twenty years he might reach Hoylake's chair with a salary of

£1,000 a year, 'a semi-detached down town, a second-hand Austin and a wife to match' – the first of several bits of blatant sexism, novel at the time, and brought into the foreground of the film since it becomes one of the functions of Alice Aisgill (as played by Simone Signoret) to contest Joe's rampant male chauvinism. Charles (in another departure from the novel) undertakes to introduce Joe into the arena where upper class and middle class do meet, the local dramatic society The Thespians, promising to get him a ticket for their next production which will take place in two weeks' time. The shot dissolves into the opening shot of a sequence at the theatre. We first of all pick up Joe in the audience, then rather nicely, over the audience's heads, we see Susan standing on the stage, while we hear another woman's voice with a heavy French accent. Only with the fourth shot of this (fifth) sequence do we have the screen entirely filled by the two women who are to dominate the remainder of the film.

The camera then turns back on the audience, discovering a young colleague of Joe's, who is lusting after Alice, and Joe himself, who is lusting after Susan. Heather Sears (as Susan Brown) was in the existing tradition of English actresses: competently girlish, but scarcely outstandingly beautiful (the Julie Christies, Vanessa Redgraves, and Charlotte Ramplings were yet to come). As yet there was no tradition, as noted, of the woman *d'un certain âge*. This sequence also serves to introduce two characters who, in the novel are fairly agreeable, but who in the film become obnoxious class stereotypes, George Aisgill, the vicious businessman, and Jack Wales (whom we have already seen in the distance), the arrogant, upper-class snob. (The change from novel to film was recognized by one of the censorship examiners who remarked on 'the inevitable loading of the dice' against upper-class characters like Jack Wales.)[26] Wales recognizes immediately that Joe, introduced to him as a 'fellow flyer' in the war, must have been a Sergeant-Observer. When Joe asks how he knows, he produces the perfect upper-class put-down: 'Oh, I can tell.' Outside the theatre, Joe looks covetously at Wales and Susan, again with the Lagonda. Another dissolve takes us into a daytime sequence in which class distinctions are driven home as Joe takes a corporation bus into town (later two important scenes take place on buses, and the contrast with the car-owning classes is frequently made: the Aisgills have two cars, but deprived of one of them Alice is unable to go to the ballet in Manchester, a train apparently being beyond consideration). Arrived in town,

Joe catches a glimpse of Susan inside an elegant dress shop. During the last external shot of the previous sequence, and throughout this one there is no dialogue: the imagery alone speaks potently of class and of envy. The silence is strikingly broken by the condescending greeting of Jack Wales: 'Hello Sergeant.' Rendering Wales offensively unpleasant, of course, sharpened up the sense of class antagonism. Wales shows himself to be a braggart in pointing out ('you're selling me short, Sergeant') that not only was he a squadron leader in the war, he also won the Distinguished Flying Cross.

In the next sequence, set with great physicality in the lower-class ambience of a dog track (see Figure 9.1), with in the distance a factory belonging to 'old millionaire Brown', the point is made that while officers like Jack Wales would be awarded a cross, similar heroism by other ranks would win only a medal. Critics, rightly, latched on to this as evidence of the film's message about class antagonism;[27] in the novel the point is made much later on as an incidental aside by a minor character and without reference to Jack Wales.[28] The dog track sequence has great importance in the structure of the film for it is here that the Joe Lampton scheme for grading women is given great prominence. In the novel the scheme had been something of a joke shared by Joe and Charles as Dufton cronies: there the grading was entirely by sex appeal, the argument being that rich and successful men got their women from the top grade, others having to make do with lesser grades (the humorous, if no doubt male chauvinist, aspect is brought out in the rumination that since grade one women were so extremely good in bed, it was just as well their husbands had inherited money, since they would have had no energy left for earning it).[29] In the film an important shift has been made towards linking the grades with the *woman's* social class. While in the novel the fastidious Joe Lampton had not been sure that Susan rated above a grade two, in the film he unambiguously rates her grade one, stressing her upper-class position rather than her sex appeal – indeed the word he uses to describe her at this juncture is 'wholesome'. ('You lust after her,' Charles insists. 'Well partly that,' Joe admits (see Figure 9.1)) An attractive actress in the part of a working-class patron of the dog track is written off as grade ten. All of this, today, sounds disgracefully sexist: but the hard truths about physical appearance and sex appeal, and the links between sex and class, had scarcely been considered appropriate subject-matter for British films; they were to become a commonplace in the exuberant, but sometimes cruel, sixties.[30]

9.1 At the dog track. (Millionaire Brown's factory in the background). In a reversal of his role in the novel, Charles (Donald Houston) admonishes the predatory, self-confident Joe Lampton (Laurence Harvey) of the film. National Film Archive.

There follows one of the five great set-piece dramatic sequences which contributed so much to giving the film its bite, and its popular appeal. This sequence does have an exact analogue in the novel. A rehearsal is taking place at The Thespians. Joe (in the novel) is reflecting cynically on the other members, miffed because he has been rebuffed by Eva, who, he feels, had led him on, and because he is making no progress with Susan.

> They all had more money than me, but it wasn't big money. It was all too easy to reach their grade, so consequently I didn't respect them very much. I looked at them gesturing freely but jaggedly as they talked in their best accents about *The Lady's Not for Burning*, and jeered at them mentally, one of the landed gentry watching the trades-people ape their betters. But my feeling of superiority was short-lived; the first reading went very badly. Perhaps because I was still irritated about Eva and Susan, I made a thorough hash of my lines, mispronouncing the simplest words and emphasizing almost every sentence incorrectly. We had to stop for a moment when I referred to a roadman's brassière; I joined in the laughter but it was a considerable effort.
>
> 'D'Eon Rides Again,' said Alice, 'What a thought – erotic vice among the working-classes.' She spoke directly to me. 'I am working-class,' I said sulkily. 'And you needn't explain your little quip. I know all about the Chevalier. I read a book once.'
>
> She flushed. 'You shouldn't –' she began, then stopped. 'I'll tell you afterwards.' She smiled at me and then turned back to the script.
>
> I kept glancing at her throughout the rest of the play. Sometimes when she wasn't reading her part she looked plain, in fact downright ugly: her chin had a heavy shapelessness and the lines of her forehead and neck were as if scored with a knife. When she was acting her face came to life: it wasn't so much that you forgot its blemishes as that they became endearing and exciting. She made the other women look dowdy and careless; Eva, too, I realized with astonishment.[31]

Joe's comical mispronunciation is over very quickly, and is mainly of importance in bringing his attention to bear for the first time on Alice. Jack Wales is not present. In the film, immediately after the mispronunciation of 'brazier' as 'brassière', Jack Wales is revealed to be standing in the balcony where he roars with derisive laughter. Alice makes the same joke, though without the literary reference. Joe's response is given an altogether different emphasis: 'I *am*

working-class. *And* proud of it.' The sequence which follows immediately is very faithful to the novel (Joe and Alice go off for a drink together), but again class indicators suggested in the novel are strongly emphasized (the question of being able to drive a car) or new ones are introduced ('it's like a castle,' Joe says about the Brown mansion. 'My father never even owned his own house'). The pub is called the St Clair, after the landowning family to which Susan's mother belongs. In the novel, Alice was a pioneer drinker of real ale; but the film inevitably opts for the obvious middle-class symbol, gin-and-tonic. There is an additional line to express Joe's resentment of Jack Wales – 'The boys with the big mouths and the silver spoons stuck in them', but otherwise the original dialogue is followed quite faithfully. It is Alice who suggests that Joe try telephoning Susan, and Joe's avowal to Alice, 'I like you. I don't mean sex, I mean I like *you*', comes straight from the novel.

. Joe does make the telephone call, which is taken by a housemaid, and passed to Susan, sprawling on her bed clad in fashionable fifties jeans (which of course should have had no place in a film meant to be set in 1947), and then brought to a hasty conclusion by the appearance of Susan's mother who now has the opportunity to unload her aristocratic disdain: 'Curious names some of these people have.' However, the pace of the film is maintained with an immediately succeeding sequence in the public library in which Joe has a chance meeting with Susan, enabling him to make a date with her for the same evening, though not for the ballet, as in the novel, but for a musical at the local cinema. Immediately on securing his date Joe goes off (in a sequence unique to the film) to claim the winnings on a bet he had made with his mates on the matter: thus Joe himself is shown as a cynical, bumptious, and rather heartless schemer, somewhat different from the hesitant character in the novel who has to be egged on by Charles. The action continues to move rapidly. The next sequence is in a café *after* the film. Joe, as in the novel, tells Susan that he likes her because 'she's not a dear kipper' (however, this phrase subsequently gets muddled, when Susan boasts that Joe calls her 'a dear kipper', as if it were a term of endearment). The *tête-à-tête* is broken up, in a most offensive fashion, by Jack Wales. Immediately, we are in Mr Brown's office with Brown behaving domineeringly and rudely. Mother and daughter come in, with mother expressing a wish that Susan be told that she should not contemplate further dates with Joe Lampton. Because the action of the film has been condensed and speeded up, we now move at once to a sequence (sequence 16) between Joe and

Hoylake whose analogue comes rather later in the novel (chapter 17 – see Table 9.1). In the novel there are only vague warnings about how if Joe goes on seeing Susan, Brown would be in a position to block any promotion for him. The language of the film is much more direct, in the now familiar way. Hoylake advises Joe to find 'a girl of your own . . .' Here, he pauses, and Joe fills in the word 'class'. Embarrassed, Hoylake continues: 'Well let's say background.'

The next substantial sequence is one which again I wish to contrast with the analogue in the novel. It is quite early in the novel that Joe goes back on a routine Christmas visit to the aunt in Dufton who had brought him up after both his parents were killed in a bombing raid. Here is the scene, Joe having just offered his aunt a cigarette:

To my surprise, she accepted it. 'I am a devil, aren't I?' she said, puffing away inexpertly.

The tea was both astringent and sweet, and she'd put some rum in it. 'That's t'first right cup of tea Ah've had sin Ah left home,' I said.

'Time you had a home of your own.'

'I'm too young yet,' I said weakly.

'You're old enough. Old enough to be running after all t'lasses in sight. Ah do know.'

'No one'll have me, Auntie. I'm not rich enough.'

'Fiddlesticks. you're not bad-looking and you have a good steady job, and you're not shy, you're brass-faced, in fact. Don't try to tell *me* you can't get a lass, Joe Lampton, because Ah'll noan credit it. Haven't you met anyone at this theatre you keep writing about?'

It was no use; I never could withstand her questioning for very long. (I think that perhaps I was unconsciously making up to Mother through her for all the times I'd answered perfectly reasonable questions with boorish grunts or studied vagueness.)

'There's a girl named Susan Brown,' I said. 'I've taken her out a few times. She's rather attractive.'

'Who is she?'

'Her father owns a factory near Leddesford. He's on the Warley Council.'

She looked at me with a curious pity. 'Money marries money, lad. Be careful she doesn't break your heart. Is she really a nice lass, though?'

'She's lovely,' I said. 'Not just lovely to look at – she's sweet

and innocent and good.'

'I bet she doesn't work for a living either, or else does a job for pin money. What good's a girl like that to you? Get one of your own class, lad, go to your own people.'

I poured myself another cup of tea. I didn't like its taste any longer; it was too strong, stuffy and pungent like old sacking. 'If I want her, I'll have her.'

'I wonder how fond you really are of her,' Aunt Emily said sadly.

'I love her. I'm going to marry her.' But I felt shamefaced as I spoke the words.[32]

In the film, Joe's much later visit to his aunt (sequence 22) is brought about because, in a plot twist absent from the novel, he has been offered a very good job in Dufton. (He soon discovers that this has been engineered by Brown, again to try to separate him from Susan.) The indoor sequence is preceded by one in which a series of external scenes bring out the working-class physicality of Dufton (see Figure 9.2): a distant train whistle suggests both desolation and the possibility of mobility. To reinforce the working-class wisdom, and to stress the discrepancy in the class positions of Joe and Susan, an uncle is added to the cast (a crucial decision since, as noted, films usually *drop* characters). Joe tells them both that 'Warnley's a different kind of town, with a different sort of people.' Aunt Emily expresses wholehearted moral condemnation: 'I ask you about a lass, and all you tell me is about her father's brass.' With Aunty making the moral points, the class lines are left to Uncle: 'Money marries money'; 'stick to your own people'. Joe, 'shamefaced' in the novel, responds vigorously with a line which is nowhere to be found in the original: 'Oh that's all old-fashioned that class stuff. Things have changed since the war. I'm as good as the next man.'

Joe, in one of several short sequences with Charles, is gloatingly triumphant when he finds that the Browns have sent Susan abroad. 'And anyway', says Joe, 'I've got compensation.' Another perfect, if, no doubt, highly conventional dissolve through the fluttering curtains of a flat owned by Alice's older friend Elspeth to the first of the famous sex scenes. On the soundtrack we have the poignantly lyrical theme which, in a manner which is not entirely true to the novel, deliberately privileges Alice as Joe's only true, but tragically fated, love. The dialogue of the novel is followed faithfully, though viewed now, in our post-sixties world, the scene seems incredibly tame, with Joe not even removing his vest (see Figure 9.3). The

9.2 Joe Lampton returns to the working-class physicality of Dufton. In the distance a train whistles. National Film Archive.

Fig. 9.3 The first 'sex scene' between Joe and Alice Aisgill (Simone Signoret). Much of what was shocking was in the language used. National Film Archive.

excitement is all in the words, very much those of the pulp pornographic literature of the time: 'I never dreamed it could ever be like this . . . so good . . . all of me's alive.'

A later sequence (the second of the five set-piece dramatic scenes I have already mentioned) has the quarrel which leads to their parting (Joe gets into a mulish fury because Alice once posed in the nude for an artist). The whole scene is very faithful to the original, save that in the novel Alice is portrayed as being both waspish and then calmly sensible,[33] while Simone Signoret appears consistently martyred. The lines come straight from the novel, yet it is still possible today to feel something of the shock of contemporary audiences when Alice taunts Joe with looking at nudes in a magazine and saying 'he wouldn't mind having a quick bash'. They part, and this very long first section of the film (27 sequences) ends with the final fade to black.

Class positions are very clearly delineated in the group sequence at the Civic Ball (see Figure 9.4), where Joe is very thoroughly put down, with Susan in some distress, but unable to do anything. It is followed by a sequence between Joe and Susan alone together, and then immediately by the third great dramatic set-piece, which is also entirely sexual. This is the sequence in which Joe seduces Susan. The film has been running for rather more than an hour; there is three-quarters of an hour still to go. In the novel, as I have already pointed out, the seduction does not come till chapter 27, and then it comes about rather as a by-product of a quarrel over the manner in which Joe will finally break with Alice[34] than as the culmination of a deliberate campaign, as it is presented in the film. Here, the seduction of Susan is much more central and is presented in clichés which audiences probably found it easy to engage with. Joe's demand is: 'It's what all the Joe's want . . . The thing any girl would do for the man she loves.' Susan's reaction at the moment of surrender is: 'Joe, be gentle with me.' Afterwards, Joe is sunk in post-coital gloom, irritated while Susan prances around chirpily asking, 'Do I look different?' In the middle of the sequence there had been yet another of the dissolves which Jack Clayton deployed so well, to a brief shot of Alice and Elspeth drinking gin, with Elspeth commenting, 'He was a coarse brute.'

Joe goes back to Alice, expressing a sentiment which is quite untrue to the novel in identifying Alice as his one true love: 'I tried to fall in love with Susan', but he couldn't. Immediately there follows the long sequence (sequence 33) which most fully expresses what I identified as a third and lesser theme in the film, concerning

9.4 Joe (in black tie) is made to feel a complete outsider at the Civic Ball, with Susan helpless and Jack Wales contemptuous. Left to right: Mr Bram (Donald Wolfitt), Susan (Heather Sears), Jack Wales (John Westbrook), and Joe. National Film Archive.

Joe's character development, and the nature of the love he is to throw away. The sequence centres on a West Country cottage and is much more concentratedly romantic than the analogous scenes in the novel, where after four days with Alice Joe sends her home and is immediately joined by Charles and another boisterous crony.[35] But this episode ends with a second, highly ominous, fade to black. When this stage has been passed in the novel, Alice becomes ill, and it is clear that Joe, advised by his friends about the risks of divorce, has effectively decided to give Alice up for good, even though Aisgill suspects nothing.[36]

In the film, the issue is far more dramatically posed in the first of the two final dramatic set-pieces which follow each other rapidly. Aisgill, arriving in a Daimler, vicious businessman flauntingly unfaithful to his wife yet fanatically determined to hold on to her as a possession, threatens to use all of his social power to 'break' Joe if there is any question of Alice seeking a divorce. There is a minor diversion as it becomes clear that Charles is going to marry the office girl, June, and then we are into the melodramatic sequence (sequence 37) in the Conservative Club where Brown simultaneously offers to buy Joe off and, if he refuses, threatens also to 'break' him (the sequence broadly follows the novel, but departs from it in the crude emphasis on class power). Joe does refuse, but he is actually more believable in the novel since he has already effectively decided that his affair with Alice is over. (Wouldn't Brown's offer – in the film – have been good enough to enable him to take Alice and defy Aisgill? This is the one place where the film's simplification of the notion of love brings it near to trouble. But obviously we are meant to read the episode as honourable working-class contempt for class power.) Then comes the theatrical switch (faithful to the novel): Susan is pregnant, and Joe is to marry her as quickly as possible.

Brown has insisted that Joe must irrevocably break with Alice, 'an old whore like her'. Joe sees Alice for a last time and breaks the news in what comes over as an irredeemably callous fashion. Once again the theme of Joe's loss of his true self emerges. In the analogous scene in the novel Alice takes matters in a more commonsense way (and it has incidentally been revealed that she herself has had a sexual liaison with Jack Wales).[37] In the film, she is a purely tragic figure: 'What else have I got?' she asks forlornly.

We have now reached what, in the novel, is the long final chapter. In the novel Joe is less than totally distracted, indeed is still slightly detached, at the news of Alice's horrible death,[38] which in the film

hits him very hard. He gets drunk (self-consciously and wryly observing himself in the novel)[39] but, as already explained, the film censors made sure that the audiences are left uncertain as to whether or not he has sex with the girl he picks up, Mavis. In compensation, however, Mavis' boyfriend has a additional line which ironically reflects on the way Joe has already moved up in the world: 'You stick to your own class', he says. The film dramatizes Joe's punishment by having him beaten up (in the novel, as I have already explained, Joe does far more damage to his attackers than they do to him).[40] The censors had insisted that there should not be excessive violence.[41] As Joe lies in the gutter a child's toy car tumbles off the pavement beside him, a perhaps banal but not totally ineffective symbolic reminder of what he has done to Alice. Joe is collected by Charles and June. 'I've murdered her,' he says. 'Nobody's blaming you,' says June. 'She'd have ruined your whole life.' The film has an extra sequence, a quick fade leading to Joe's wedding, where the preacher has some ironically telling words about the lawful and the unlawful joining of men and women. As Joe and Susan are driven away from the church, the tears in Joe's eyes are romantically misinterpreted by Susan: 'I believe you really are sentimental after all.' The last shot of the road up which the bridal car has driven is held for much longer than might at first seem necessary: a most effective parody of the conventional happy ending.

What the painstaking comparison of the novel and film brings out is that the film, very consciously, concentrates, strengthens, and clarifies the meanings in respect of class and sex: that conclusion, I think, is inescapable (usually, incidentally, films diluted the meanings of the originals on which they were based: the earlier fifties films *Lucky Jim* and *Look Back in Anger* are notorious examples). From a study of the content of earlier British films,[42] from the censorship correspondence, and from reviews, it is clear that this treatment of these two topics was, and was seen to be, revolutionary. If we look at other cultural developments of 1958–9 the contention that *Room at the Top* (the film) was an important component of an important moment of change seems a soundly-based one: Alan Sillitoe's novel *Saturday Night and Sunday Morning* was published in October 1958; *Room at the Top* itself was followed in 1959 by two other strikingly original films, *Sapphire*, a pioneering treatment of racial issues, and *I'm All Right Jack*, the first ever comprehensive satire on the British class system; it was in this same year that there was a relaxation in the Law of Obscenity

as it affected literary artefacts, and that, in consequence, Penguin Books took the decision to publish *Lady Chatterley's Lover*, subject of a celebrated court case the following year.[43] What wider influences the film had as an actual agent of change must, as with most of the larger issues in historical study, be a matter for intelligent interpretation rather than conclusive demonstration. The film was widely seen, was widely commented on; while at the same time, British society moved into an era of accelerating change with respect, in particular, to attitudes and behaviour relating to sex and to class.[44] *Room at the Top* cannot have influenced *Sapphire* or *I'm All Right Jack* (very different films in any case). Yet it certainly fits into an expanding production of serious 'adult' films.

Table 9.2 British X certificate films, 1952–61

1952	2
1953	2
1954	1
1955	2
1956	3
1957	7
1958	9
1959	11
1960	17
1961	16

The figures in my table are crude, but I would estimate that out of the seventeen X certificate films released in 1960, six dealt seriously with contemporary social and human issues, with the same figure out of sixteen in 1961. I fully recognize that, in its formal elements, *Room at the Top* was highly traditional, though certainly very professional. However the formal elements were most effectively deployed to drive home the revolutionary content.

Room at the Top comes at the very beginning of an era of rapid change. Thus the treatment of sex seems tame in comparison with what was to come in the middle and late sixties. Much of the film is redolent of the narrow, stuffy world of the post-war era. It is very British, parochial even. The import of Simone Signoret is ambivalent in this respect. But British culture in the sixties did open up to foreign influence and innovations. Again *Room at the Top* stands only at the threshold: a comparison of Signoret's role with that of Lesley Caron in *The L-Shaped Room* (1962) is instructive (pregnant, Caron tries to determine her own destiny; Signoret is tragically passive, though often bitingly critical of Joe). The blatant

sexism of *Room at the Top* is readily identified. Less noticed are its anti-chauvinist responses; Alice is the noble victim of two unpleasant males, Aisgill and Joe; Susan shows courage and independence in being prepared to conceal her pregnancy and reject Joe. The great British films which followed were more rounded, and some had very strong female characters: all dealt in an increasingly explicit and mature way with questions of sex and of class: I've mentioned *The L-Shaped Room*; think also of *Saturday Night and Sunday Morning* (1960, with Rachel Roberts playing with humour the kind of part Signoret had played with heavy pathos), *A Taste of Honey* (1961), *A Kind of Loving* (1962), *The Loneliness of the Long Distance Runner* (1962), *Darling* (1965), *Alfie* (1966), *Georgy Girl* (1966). The accents in *Room at the Top* had not been perfect, but a clear effort had been made to have everyone (save Alice, her husband, Susan, and her mother) speak with roughly the same Yorkshire intonation, rather than the workashire of earlier films. *The Angry Silence* (1960) strove even harder for authentic recreation of working-class speech patterns.[45] Many of the stars of the sixties genuinely came themselves from working-class backgrounds (Albert Finney, Michael Caine, Rita Tushingham etc.) – something very new: there had been no working-class actor available to play Joe Lampton. One short article can deal only with detail (significant, I hope): the broader interpretations – within which this article is set – of what happened, and when, between the late fifties and the early seventies can only be established in the full-length, nuanced, but structured, enterprises which are the characteristic product of the historian working at full capacity.[46]

Notes

1 A. Marwick, *Beauty in History: Society, Politics and Personal Appearance, c. 1500 to the Present*, London: Thames & Hudson, 1988, chapter 8. See also A. Marwick, *British Society Since 1945*, Harmondsworth: Penguin Books, 1982, Part Two, esp. p. 125; 'Was there a Cultural Revolution in the 1960s?', *Contemporary Record*, 1988, vol. 2, no. 3, pp. 18-20.
2 G. Gorer, *Exploring English Character*, London: Cresset Press, 1955, p. 94; G. Gorer, *Sex and Marriage in England Today*, London: Nelson, p. 113.
3 M. Parkin, *Uptight*, London: Blond & Briggs, 1975; *Switchback*, London: W.H. Allen, 1978; *Up and Coming*, London: W.H. Allen, 1980; *Breast Stroke*, London: W.H. Allen, 1983.
4 See works cited in note 1.
5 *Daily Mail*, 30 March 1982, quoted in B. Masters, *The Swinging Sixties*, London: Constable, p. 14.
6 J. Hill, 'Working-class realism and sexual reaction: some theses on the British "New Wave"' in J. Curran and V. Porter (eds) *British Cinema History*, London: Weidenfeld & Nicolson, 1983, pp. 303-11; idem, *Sex, Class, and Realism: British Cinema 1956–1963*, London: BFI, 1986; P. Graham, *The Abortive Renaissance: Why are Good British Films So Bad?*, London: Axle Publications, 1963; R. Armes, *A Critical History of British Cinema*, London: Secker & Warburg, 1978.
7 See works cited in note 1.
8 I am indebted to Gill Wood, Senior History Department Secretary at the Open University, for pointing this out to me.
9 J.W. Lee, *John Braine*, New York: Twayne, 1968; K. Allsop, *The Angry Decade*, London: Peter Owen, 1958, pp. 79, 82.
10 J. Braine, *Room at the Top*, London: Eyre & Spottiswoode, 1957; *Room at the Top*, Harmondsworth: Penguin Books, 1959, p. 235. All subsequent references are to the Penguin editions.
11 ibid., p. 8.
12 The evidence is in his retrospective comments, not, of course, in his games-playing conversational gambits. See ibid., p. 38 ('I fell in love

with her at first sight. I use the conventional phrase like a grammalogue in shorthand to express in a small space all the emotions she evoked in me.'), p. 128 ('I've never loved her more than I did then She loved and she wanted to be loved, she was transparent with affection; I could no more deny that correct response in my heart than refuse a child a piece of bread. In the back of my mind a calculating machine ran up success and began to compose a triumphant letter to Charles; but that part of me that mattered, the instinctive, honest part of me, went out to meet her with open hands').

13 W. Cooper, *Scenes from Provincial Life*, London: Cape, 1950; K. Amis, *Lucky Jim*, London: Gollancz, 1953; *That Uncertain Feeling*, London: Gollancz, 1955.

14 See Allsop, *The Angry Decade;* H. Ritchie, *Success Stories: Literature and the Media in England, 1950–1959*, London: Faber & Faber, 1988, is a careful general study, but with practically nothing on *Room at the Top.*

15 Quoted in Allsop, *The Angry Decade*, p. 79.

16 Maurice Temple Smith, Eyre and Spottiswoode Ltd, to Eunice C. Frost, Penguin Books Ltd, 16 April, 13 May 1957, Eunice E. Frost, to Maurice Temple Smith, 17 May 1957. I am indebted to Peter Carson of Penguin Books for allowing me to see copies of these letters.

17 *Kinematograph Weekly*, 22 January 1959.

18 I am indebted to Dr Tony Aldgate for making this file of Censorship correspondence, which was kindly loaned to him by James Ferman, available to me.

19 Censorship File.

20 Censorship File: 'Note from Examiners', 4 February 1959.

21 J. Sutherland, *Fiction and the Fiction Industry*, London: Athlone, 1978, p. 15.

22 P. Sorlin, *The Film in History: Re-staging the Past*, Oxford: Basil Blackwell, 1980, Part I, 'Principles and Methods'.

23 Joe reflects that he loves Warnley and could not leave it: 'And if I married Alice I'd be forced to leave it. You can only love a town if it loves you, and Warnley would never love a co-respondent' [i.e. in a divorce suit], Braine, *Room at the Top*, pp. 196-7.

24 Joe says: 'Shut up. I'll do what I promised – I'll finish the affair [with Alice] once and for all when she comes out of hospital. And face to face. Not by letter. That's cowardly' (ibid., p. 198).

25 ibid., p. 56. See A. Marwick, '*Room at the Top, Saturday Night and Sunday Morning*, and the "Cultural Revolution" in Britain', *Journal of Contemporary History*, 1984, vol. 19, no. 1, p. 134.

26 'Note from the Examiner', 29 January 1959.

27 There is a complete file of reviews of the film in the British Film Institute Library.

28 Braine, *Room at the Top*, p. 192.

29 ibid., p. 37.
30 See A. Marwick, *Beauty in History*, chapter 8.
31 Braine, *Room at the Top*, p. 49.
32 ibid., pp. 90-1.
33 ibid., pp. 115-19.
34 ibid., p. 198.
35 ibid., pp. 185-6.
36 ibid., pp. 195, 198.
37 ibid., p. 214.
38 ibid., p. 219.
39 ibid., p. 223.
40 ibid., pp. 232-3.
41 Censorship File.
42 The indispensable guide is D. Gifford, *The British Film Catalogue*, Newton Abbot: David & Charles, 1986.
43 See C.H. Rolph, *The Trial of Lady Chatterley*, Harmondsworth: Penguin Books, 1961.
44 See note 1.
45 B. Forbes, *Notes for a Life*, London: Collins, 1974. Forbes was screenwriter and co-producer (with Richard Attenborough) of *The Angry Silence*, which was directed by Guy Green.
46 See note 1. I hope by the end of the century to have published a comparative study of 'The International Cultural Revolution of the 1960s'.

10 Modern 'classical' plays on contemporary English stages

Brian Stone

Michael Billington, weighing up the achievement of Sir Peter Hall's fifteen years at the National Theatre, contrasts Hall's approach to directing Shakespeare with 'the current tendency' which, he writes, 'is to tailor Shakespeare to fit our conceptions rather than adapt ourselves to his scale'.[1] In this essay, whether and how such an opinion as Billington's, with its implications for our theatre and our society, may be sustained will be considered in relation to three main examples of current theatre practice. The argument will include not only Shakespeare, but modern dramatists whose works may be called 'classical' if they begin to be revived often, and in different countries, a generation or so after their first presentation. The basis on which a play is transmitted from one historical society to another, as well as the performed result, are the subject of inquiry, which throws light upon a cultural phenomenon: the way in which one age regards, presents, and receives the artefacts of another age. Since drama is an art the original performance of which cannot be studied through documentary or visual record owing to the absence of technological means to provide verifiable evidence, it is impossible faithfully to reproduce original performances; and since drama is a social art, presented by and to groups of people, every production in action expresses aspects of society, however that term is defined.

A play exists in full form only when performed; the verbal plan, consisting of dialogue and stage directions, constitutes its basis, which was written down by its inventor with or without the collaboration of its initial executants, the members of the first theatre company to present it. There is no concern here with literary pseudo-playwrights like Byron who, in publishing two of his tragedies and dedicating the second to Goethe, emphasized 'that they were not composed with the most remote view to the stage'.[2]

Yet the historical fact is that, the better and the more 'classical' a play, the more likely it is to be met as literature than as performance art, both in education and in life in general. If we cannot reach a theatre where a play is being performed, or have no access to a performance while teaching it, we can but treat its text as literature, and try to exercise the doubtful caveat that at all events, while we ponder it, we must 'produce it in the mind'.

A modern classical play in performance is the product of three societies. The first of these existed in the past, and often in another country as well – Renaissance England for Shakespeare, late nineteenth-century Norway for Ibsen, turn of the century, pre-revolutionary Russia for Chekhov, southern Italy just after the First World War for Pirandello, and so on. Many a play is written for a particular group of people to perform, for communicating to a group from that contemporary society. Accordingly, manners and morals expressed in a play are affected, often limited, by societal notions and external laws more severely than when they are expressed in books. Tolstoy, a minor figure as a playwright, bitterly reflected that he could write only what he was allowed to write. So every play in its inception and first performance has a societal aspect.

When a play is revived, besides the initial society with its divisions of author, performers, and paying audience, two further societies, related to each other, necessarily exist: the societies of the performing company and the audience. The former is a professional group which is newly performing the play – translator or adapter, director, theatre company, and business manager in their perform-ing space. The latter society, that of the audience, is envisaged or notional during rehearsals, then actual and different every night of the play's run. The presence of these two societies is necessary for the act of transmitting the essence of a play which belongs to another age or country. And 'society' is the correct word to describe the two groups, because one is organic on account of its various allied functions and theatrical purpose, and the other is organic by reason of its act of self-selection: those people, attracted by the play or its performing group, or both, paid that night to sit or stand together and be entertained.

Of these two groups, neither the one nor the other, nor both together, can safely be regarded as a microcosm of the society of its time. The cultural determinants of drama presentation and recep-tion include such diverse factors as, on the production side, the type of theatre, its geographical location, its means of financial support

(state or local authority subvention or other patronage, independent resources) and, if it is a permanent company, its prevailing ethos, whether aesthetic or political, or both. On the audience side, the main determinant appears to be a matter of class heritage, in which the historical factor of theatre becoming confirmed during the late nineteenth century as a middle- and upper-class diversion with a refined ambiance of its own, is the most important.

Yet today there are marked varieties of audience atmosphere to be experienced, in such different environments as, for example, West End theatre in London, major subsidized theatre, minor subsidized theatre, provincial theatre. These major categories persist despite honourable attempts to restore theatrical art to society at large. These include offering low-priced tickets to such special groups as students and old age pensioners, and the promoting of plays not set in exclusively middle- and upper-class environments. Furthermore, theatre ambiances have often, as a matter of policy, been made less refined; bench seating may be provided instead of upholstered seats with arm rests, and the separation of actors and audience may be dissolved into a common promenade area.

The art experienced by performing group and audience, theatre in action, is images in motion; chiefly, images of the body or groups of bodies. But, since visual records of performance rarely exist even now, the brief for re-staging theatrical classics is text, most of which, it is assumed, issues from mouths on the front of those bodies. Besides the dialogue, there are stage directions, but actors tend to ignore these when they offer advice on performance because they interfere with, and even prejudge, interpretation of the character they are playing. In any case, it appears that most dramatists, with such exceptions as the enlighteningly garrulous Shaw, use stage directions chiefly for matters within the stage manager's province. The latter are excluded from this inquiry because, although they may well be important when decisions concerning interpretation are made, the main thrust of this inquiry concerns the dialogue of plays.

The problem of the dramatic text, the dialogue on which a play in transmission from one age to another subsists, is that the written word itself carries no performance indications except the limited effect of rhetorical punctuation. Not even pronunciation is indicated: that is the job of phonetics. Attempts have been made to devise phonetic systems which can register pitch, pace, volume, and intonation; Shaw experimented with spellings intended to simulate phonetic values, and made his printers space

the letters in words he wished actors to emphasize. I once supervised a speech therapist in an M.Phil in radio drama who was determined to evolve such a system, but had to give up that aspect of her work. The only safe basis for reproduction of a word-text is its apparent meaning, and if that were as simple as it sounds, there would be limited need for such a discipline as literary criticism.

So, compared with a musical score, the word-text of a play is deficient as a guide to performance. Of course, musical performance of a fixed score can and does vary, but only within comparatively narrow limits. The prescription of instrumental and vocal sounds is both comprehensible and comprehensive, so that if the director of an opera has a vision of making a performance appeal especially to our times ('relevant' is the cant word) as, say, Jonathan Miller did with *Rigoletto* (1987), then it is the theatrical rather than the musical elements which have his chief attention, and provide him with largest scope.

The performance art which should be thought of beside drama in this respect is dance, another system of images of bodies in motion. In modern times, since about 1700, that is, forty-six systems of dance notation, all of them defective in one way or another, have been evolved in the attempt to preserve the choreography of important ballets. The arrangement of abstract symbols to represent known postures and movements of the ballet convention was characteristic of such systems of notation[3] – not altogether unlike words, which are also abstract symbols of a kind. A play text stands between an opera score and a ballet notation – a better guide to spoken performance than the latter is to danced performance, but much less accurate and comprehensive than an opera score. However, as will be seen, productions of modern 'classical' plays may be based not only on authentic text expressed in today's dramatic conventions, but also on either re-writing of the text, or re-interpretation of existing text by ironic or gestural counter-suggestion, or both.

Study of the words of a classical play text, and of the theatre and society in which it was first produced, goes into any new production, but does not result in, or aim at, historical reconstruction of a dramatic event. The latter is the province of one kind of research scholarship at universities, but rarely finds expression in the professional theatre, where it usually meets with disfavour. It is not in a spirit of inquisitive archaeology that companies are 'faithful' to Shakespeare or Chekhov, and give 'authentic' performances.

Many of today's theatre patrons nevertheless regard authenticity of performance as some kind of artistic ideal, but performing companies, if they accept the idea of 'authentic' performance at all, seek authenticity by parallelism, not copying. That is to say, they operate a contemporary and/or local equivalent of the authentic product of a former time. We have already had a new version, in which the original playwright concurred, of *Serjeant Musgrave's Dance* (original production, the Royal Court Theatre, October 1959); in it, the troubles of Northern Ireland replaced those of Cyprus as the site of conflict arising from imperialism.[4]

This takes us into the matter of updating. As far as mere words are concerned, to take today's productions of Shakespeare for a start, it has long been common practice in both the Royal Shakespeare Company and the National Theatre to remove words which are now obsolete and to replace them with words in today's vocabulary – John Barton's interesting safe-guard being that he usually rehearses a Shakespeare play with the Folio text open in front of him. Such adjustment has its historical precedent in the theatre, even in Elizabethan and Jacobean times. There are also lines or passages which, by tradition, actors find 'unsayable'; a well-known example occurs in the closet scene in *Hamlet*, when Gertrude sees her son distracted by the Ghost which she cannot see:

Forth at your eyes your spirits wildly peep,
And as the sleeping soldiers in th'alarm,
Your bedded hair, like life in excrements,
Start up and stand an end.
 (III.iv.119-22)

It is, of course, the third line quoted which causes the trouble.[5]

The next step after simplifying the text is editing, which usually means cutting it. If a Shakespeare production uses the full text of either the Folio or a good Quarto, it is an event which receives special publicity; every age cuts or adds to Shakespeare in its own way. But every such act is critical, even if the motive – such as the need to avoid paying stage hands overtime, or to get audiences home on the last buses and trains, or the desire to build up or reduce a particular actor's part, or to fulfil the dramatic aim despite the employment of fewer actors than the play requires – is not intended as criticism. A major factor may be an injunction from the star: Timothy Bateson, who at Stratford in 1951 played the Clown-bringer of asps to Vivien Leigh as Cleopatra, had his lines

reduced and was forbidden to be funny because of the disturbance it might cause to the tragic atmosphere the actress wished to maintain on her own terms.[6]

On the whole, modern actors and directors like to streamline productions and keep the action going. So beautiful moments of emblematic stasis such as, in *King Lear* IV.ii, the Gentleman's description of Cordelia sorrowing over Lear's suffering are cut, as are many of the scenes in which minor characters explain or comment on what is happening: for example, the cushion-laying officers in the Capitol in *Coriolanus* II.ii. Such cuts may be regarded not as expedients, but as responses to the aesthetics of drama recognized by our generation, which are conditioned in part by recent theatrical and social history – not only who goes to the theatre and why, but who are the adapters and presenters, and what their interpretative standpoints are.

Among 'classical' playwrights of the last hundred years, Ibsen, Chekhov, Strindberg, Shaw, Pirandello, Lorca, O'Neill, and Brecht will be mentioned in what follows. In my view, they fall into three main categories of treatment when their works are revived – and 'revived' is a key-word – in England. Dramatists who are overtly didactic, that is, who declare their teaching purpose, resist the kinds of transmutation suggested by the word 'updating'; Shaw and Brecht, with their finely honed and explicit messages, are cases in point – though apparently no play is safe from being transformed into a musical. Next are those whose preoccupations, though originally located within a society remote in time or place, may still seem, to an intending director, to be likely to appeal to his notional audience as significant: Strindberg with his sex wars and mysogyny; O'Neill with his poetic pessimism and conviction about the self-destructive potential embedded in the American way of life; and Lorca with his tragic apprehension concerning the life-denying rigidity of Andalusian life, possibly projected through a sense of his own sexual separateness. O'Neill and Lorca appear to me too locally fixed for any transmutation to be performed upon them. Hence the varying success, in recent years, of English companies in stage representations of southern Spain and the eastern seaboard of the United States. Under advancing mid-Atlanticism in Britain, the latter is easier, as the recent fine 'English' *Who's Afraid of Virginia Woolf* (Young Vic, March 1987), with Patrick Stewart and Billie Whitelaw, demonstrated; and I think O'Neill's late plays, and particularly his masterpiece, *Long Day's Journey into Night*, have always succeeded in English productions. Strindberg must always be

presented as phenomenal on account of the narrow and obsessive psychology of the plays usually chosen for performance here – *Miss Julie*, *The Father*, and *The Dance of Death*. There can be no tampering with the art-form of that psychology, it seems to me, without risk of toppling over into fantastic farce or Berkoff-type Grand Guignol satire. But there is another Strindberg, who dramatized history and religion and could write visionary expressionistic plays.

Of the three remaining dramatists listed, Pirandello is a special case to which I shall return, but Ibsen and Chekhov, both long out of copyright, have often been subject to 'transmutation' by directors who would agree with Shaw about their universality. In his Preface to *Heartbreak House*, Shaw's 'Fantasia on British themes in the Russian manner', which is a lavish but convoluted compliment to the playwright of *The Cherry Orchard*, Shaw wrote:

> Just as Ibsen's intensely Norwegian plays exactly fitted every professional and middle class suburb in Europe, these intensely Russian plays fitted all the country houses in Europe.[7]

Three instances of 'transmutation' from Trevor Griffiths' version of *The Cherry Orchard* (Nottingham Playhouse, March 1977) will now be considered. The theme of the play is the self-inflicted loss of their estate by a romantically inclined and improvident landed family. The first instance concerns the character of Trofimov, the mature student who is a friend of the family, and has a sort of love relationship with Ania, the daughter of the house. In Chekhov he is an idealist whose stance may be rather vaguely aligned with progressive politics, whereas in Griffiths' version that stance is sharpened into something like that of a committed radical of the left. Trofimov's half-playful, half-serious debate in Act II with Lopakhin, the businessman who is also a friend of the family, and buys the cherry orchard at the unavoidable auction, becomes a confrontation by the injection of additional animus into Trofimov's responses to Lopakhin. And that is not the only change, as a comparison between two translations of the scene, those of Michael Frayn and Trevor Griffiths, shows.

(Frayn)
1 *Lopakhin*: Our Wandering Student always seems to be wandering with the young ladies.
2 *Trofimov*: Mind your own business.
3 *Lopakhin*: He'll be fifty before he knows where he is, and still

a student.

4 *Trofimov*: Why don't you leave off your stupid jokes?

5 *Lopakhin*: Not losing your temper, are you, O weird one?

6 *Trofimov*: Don't keep badgering me.

7 *Lopakhin*: (laughs) May I ask you something? What do you make of me?

8 *Trofimov*: I'll tell you what I make of you. You're a wealthy man – you'll soon be a millionaire. And just as there must be predatory animals to maintain nature's metabolic system by devouring whatever crosses their path, so there must also be you.[8]

(Griffiths)

1 *Lopakhin*: (sees Trofimov) Aha. The 'everlasting undergraduate' is never very far from the ladies.

2 *Trofimov*: So? What's that to you?

3 *Lopakhin*: Fifty next birthday and still no degree.

4 *Trofimov*: You have the wit of a polar bear, Lopakhin.

5 *Lopakhin*: Easy, boy, easy, just joking,

6 *Trofimov*: So don't. All right?

7 *Lopakhin*: (laughs) One question then, and I'll leave you alone. (Trofimov doesn't dissent) What do you think of me? (Small silence. The others watch.)

8 *Trofimov*: (finally) Well, I think of you this way, Alex: you're rich already and nothing will stop you getting richer; in the larger perspective, based upon the scientific laws of nature, I'd say you were 'necessary' in exactly the way that a wild animal that must eat its prey is necessary.[9]

In Griffiths, the earnest pseudo-cultural speech of Lopakhin, who confesses that his attempts at reading have failed to give him the fruits of education, is simply missing.[10] In Frayn, his reference to Trofimov's age is clearly a humorous exaggeration (Chekhov suggests that Trofimov is twenty-seven): in Griffiths, 'fifty next birthday' is presented as factual. The tone of Trofimov's responses in speeches nos 2, 4 and 6 is more aggressive in Griffiths than in Frayn. Then the characterization of Lopakhin in speech no. 8, which is ponderous in both versions, is again changed. In Griffiths the animus is explicit in the use of 'rich', 'wild animal', and 'prey', and the windy nineteenth-century Darwinisms of Frayn's Trofimov give way to the hideous late twentieth-century jargon of 'in the larger perspective'. Lastly, in case the director should follow usual Chekhovian practice in having other characters on stage hardly

hear, or take lightly, a duologue, Griffiths inserts directions which require the stage audience to take the debate seriously: 'Small silence. The others watch' before Trofimov (finally) speaks.

Both the other examples of transmutation in the Griffiths version are taken from the ending of the play. The first is the weakening of Ranyevskaya's central position; her two speeches of heartfelt grief at leaving the cherry orchard (Frayn, p. 66) are simply omitted by Griffiths, so that the optimistic departure of the idealistic young, Trofimov and Ania, is highlighted (p. 53). The final example concerns the last seconds of the play, which in Frayn show the old footman Firs moving naturally towards death while the only expressionistic device in Chekhov, 'the sound of a breaking string, dying away, sad', which is repeated from the end of Act II, follows the first distant thuds of the axes chopping down the cherry trees. In Griffiths, the ending is melodramatic as well as expressionistic. Instead of lying down in his terminal exhaustion, as in Frayn, Firs rocks back and forth in a chair and eventually 'topples to the floor, felled' as the amplified sound of the axe closes in, finally 'pounding towards the house'. That noisy and violent ending is hard on the posterity of a dramatist who prided himself on his own development in managing, in his last two plays, to get rid of the tragic on-stage pistol shots of his earlier *dénouements*.[11]

Chekhov has been out of copyright for so long that there is no one authorized translation of his works that is widely accepted. But Lorca and Pirandello both came out of copyright only in 1986. Lorca was always poorly served by his official translators, Graham-Lujan and O'Connell,'[12] who could not find a system of imagery in English to cope with the Spanish of, in particular, *Blood Wedding* and *Yerma*; but *The House of Bernarda Alba*, which is entirely in prose, presents less difficulty, and was produced by the Spanish director Espert at the Lyric, Hammersmith (September 1986) with high success. And it was the physicality of Spanish men and women, rather than the translation problem, that occasioned difficulty for the company which performed *Yerma* in the Cottesloe Theatre (March 1987).

With regard to Nicholas Wright's version of Pirandello's *Six Characters in Search of an Author*, which was directed by Michael Rudman and presented in the Olivier Theatre (September 1987), it must be observed at the outset that Wright in his script made changes which go far beyond the linguistic adjustments of tone and slight modification practised by Griffiths on Chekhov's *The Cherry Orchard*. If his alterations to the end of the play are discounted,

Griffiths' claim, in his prefatory note, that he edited out next to nothing and added fewer than fifty words (p.vi), might justly be entertained. By contrast, Wright's changes to Pirandello are so radical that it is surprising that the piece was not advertised as a variation on a Pirandellian theme rather than as a version of the play.

As Pirandello wrote it, and as his authorized translator Frederick May represented it, *Six Characters in Search of an Author* may be described thus: it is one of three plays by Pirandello which follow the 'play-within-a-play' model, with this difference, if one compares it with, say, *Hamlet*: the play within a play is conducted interruptedly throughout the action, and provides a continuous discussion of the nature of the reality of experience. There are two sets of *dramatis personae*: the Characters who arrive in a theatre where a rehearsal is taking place, and wish to express and perform their reality in front of the acting company there at work; and the company of Actors, who are at first rehearsing another play by Pirandello, but are persuaded to become involved in the two scenes of the unfinished play which had been abandoned by the author who created the Characters. Structurally, the play is a debate between the two groups, in which the Father leads for the Characters and the Director for the Actors. Wright took over this framework, a framework which has led major critics such as Northrop Frye and Robert Brustein[13] to observe that Pirandello, as a practising philosopher, built his debate plays on an Ancient Greek mechanism used implicitly by Aristophanes and others: in *Six Characters,* one leader is an *eiron,* or self-deprecator, whose inquiring state of mind eventually leads to an enlarging definition of the philosophic truth, while the other leader is an *alazon,* a self-confident impostor or buffoon, whose answers to the *eiron's* questions eventually force him to accept a degree of enlightenment.

It is in the kind of debate between the *eiron* and the *alazon* that the chief difference between Pirandello and Wright shows, and it does this in two matters fundamental to the debate between reality and illusion. In Pirandello the *eiron,* the Father among the Characters, effectively demonstrates to the *alazon,* the Director, that the reality of the fictional people is truer than that of the real actors. The reality demostrated is of the validity and passion felt by the Characters concerning their family tragedy, which turns on questions of the birth and upbringing of children, fidelity, lust, incest, and above all, shame and honour; matters which are presented and felt by the protagonists with the fierce conviction of

a southern Italian Catholic sensibility of the early years of the present century. Besides this, Pirandello's device of viewing his Characters as fictional persons enables him to claim, and them to feel, that because they are fixed in time, their total predicament is not only eternal, but that all its component actions are for ever taking place. Their whole world is contrasted with the changeability and consequent insignificance of the ephemeral and superficial life of the Actors. So that when the latter, apprised of the Characters' predicament in preparation for their rehearsal, attempt to present the scenes of the Characters' lives, they appear so unreal as to arouse contempt, not only among the Characters, their on-stage audience, but among the real theatre audience.

To achieve this effect, Pirandello allows the Actors only limited scope. Except for the Director, they contribute rarely, and then largely to express astonishment, or admiration, or incomprehension, or even fear, while their rehearsed performances of the Characters display the normalizing processes of stock actors in repertory – and bad ones at that – interpreting stock conventional characters. Pirandello, in contrasting their triviality and insensitiveness with the force and passion of the Characters, gives vent to his hatred of conventional popular theatre as an integral element of his play.

In Wright's version, two complementary adjustments to this scheme seem to have been felt necessary, one to each group of *dramatis personae*. The Characters' distress and sense of moral outrage at their predicament is muted, both in the passion of their performance and in the almost complete re-writing of the dialogue in colloquial modern English, so that their moral sensibility and behaviour, in their verbal and gestural language, can scarcely be understood as Pirandellian. Indeed, they seem occasionally to be confused about the validity of their own existence. The parts of the Actors, on the other hand, are considerably extended, and changed in the enlargement. Their speaking time in the play is probably five times as long as in Pirandello: in a protracted run-up to the initial appearance of the Characters, during which they are rehearsing a performance of *Hamlet* (in Pirandello they have barely begun to rehearse a snippet from another Pirandello play) the Actors are given sense and substantiality both as persons and as a group. Their leader, who in Pirandello is rightly described by Eric Bentley as 'something of a grotesque',[14] in the performance of Robin Bailey, in the Olivier Theatre, expressed magisterial authority and intellectual depth.

It is almost as if the National Theatre company could not bear to present the life and work of directors and actors with the derisive dismissiveness of a Pirandello. A necessary outcome of this double adjustment is that the Director replaces the Father as the central figure in the play. He is hardly an *alazon* who stumbles towards the truth at the prompting of the Father. In Pirandello this Father, aided particularly by the Step-Daughter, argues and stage-manages the demonstration of the reality of each of the Characters. The strong *peripeteia* of the two scenes, the one in the brothel at the back of a dress shop where the Father is interrupted by the Mother when about to have sex with his prostitute step-daughter, and the other in the garden where the two small children die, one by drowning and the other by a revolver shot, are muted; instead of being disoriented and appalled, as in Pirandello, the Actors resume their serious professional life, and at the end of the play, Pirandello's virtual apotheosis of the Characters, in a supernatural flood of green light to the sound of the Step-Daughter's 'terrible laughter', has no counterpart in Wright. In sum, the softening of the Characters' passions and sensibilities, and the shoring up of the Actors' roles as detached and serious spectators of the Characters, as well as reputable sustainers of their own profession, necessitates an altogether slower and more reflective style of performance. The fierce *grotesquerie* and scorn, the uncompromising moral scheme and the consistent decorum of the dialogue, of Pirandello, are weakened if not substantially absent. So too are the extended pleas of the Father and Step-Daughter to have their reality accepted, which in Pirandello ring out like philosophic arias; with the consequence that every climax, whether grotesque or pathetic, is muted.

To support these observations, an indication of the kind of textual changes made by Wright is now given, with two specific examples, both taken from the scene in Madame Pace's shop mentioned earlier.

The first extract concerns the Step-Daughter's working into the brothel scene with the Father, while the Director considers how his actors will present it. Here is May's translation of part of the scene:[15] the girl has just repeated the Father's instruction to her to take off her frock, although she has said that she is in mourning for her father:

Producer: . . . That would bring the house down!
Step-daughter: But it's the truth!

Producer: But what's the truth got to do with it? Acting's what we're here for! Truth's all very fine . . . But only up to a point.

Step-daughter: And what do you want then?

Producer: You'll see! You'll see. Leave everything to me.

Step-daughter: No, I won't! What you'd like to do, no doubt, is to concoct a romantic, sentimental little affair out of my disgust, out of all the reasons, each more cruel, each viler than the other, why I am this sort of woman, why I am what I am! An affair with him! He asks me why I'm in mourning and I reply with tears in my eyes that my father died only two months ago. No! No! He must say what he said then, 'Well then, let's take this little frock off at once, shall we?' And I . . . my heart still grieving for my father's death . . . I went behind there . . . Do you understand? . . . There, behind that screen! And then, my fingers trembling with shame and disgust, I took off my frock, undid my brassiere . . .

Producer: (running his hands through his hair) For God's sake! What on earth are you saying, girl?

Step-daughter: (crying out excitedly) The truth! The truth!

And here is Wright:[16]

S-Daughter: . . . So he said, 'I've got a good idea, let's get that frock off.'

Director: Well I'm not having that.

S-Daughter: Why not? I thought you actors were meant to be wild bohemians.

Director: No, don't you see, if the scene has a sexual undercurrent, which this does –

Gertrude [i.e. the actress rehearsing that part in *Hamlet*]: To put it mildly –

Director: – it creates a certain atmosphere. The audience becomes expectant, tense. And you only have to pop the balloon with a down-to-earth phrase, and you get a big laugh. Do you want a big laugh?

S-Daughter: It's *true*.

Director: If it is true, and I've no reason to doubt your word, you'll get a very big laugh indeed.

S-Daughter: So what will he say?

Director: I'm working on it!

S-Daughter: Working on it! Watering down the sickness, the horror, the lies, the shame into something they'll like, into –

Director: Something they'll take.

S-Daughter: I don't want them to take it! I don't want them to want it. It isn't attractive, it doesn't make sense, it isn't tidy, isn't generous, there's no hope of redemption. He isn't awake to the fact that somebody close to me has died; he knows but he isn't aware, he doesn't want to be. I don't have tears in my eyes. I don't have visions of my father's smiling face in front of me. I'm not remembering how he loved me, though he did. I'm unhooking my clothes, that's all. It's cold. I'm feeling nauseous. I'm embarrassed. I'm thinking of doctor's surgeries. Can't you show *that*?

Director: No.

S-Daughter: Why?

Director: Because it isn't dramatic.

The coarsening of the Step-Daughter's sensibility consequent on the updating appears in her language. When commenting on the actress's representation of her, which she finds risible, she says, 'I'd piss myself' (p.62), and her reaction to the actress's further performance is: 'Talk about tragic! If that's how she looks when she takes her hat off, what's she going to do when she shows her knockers?' (p.65). Then, Wright's audience is asked to accept that the Step-Daughter's disgust leads her to 'slide downwards until her face is level with the Father's crotch' (stage direction, p.70). The loss here, as elsewhere, is not in the representation of the prudery of another age, but of the severe *gravitas* of the deeply felt system by which the Characters feel they live, together with the existential agony of their creator, Pirandello.

A little later in the scene, the Mother tries to prevent the Director allowing the brothel scene to take place. May's version is given first:

Director: But since it's already happened, I don't understand!

Mother: No, it's happening now! It happens all the time! My torment is no pretence, sir. I am alive and I am present always...At every moment of my torment...A torment which is for ever renewing itself. Always alive and always present. But those two children there ... Have you heard them say a single word? They can no longer speak! They cling to me still... In order to keep my torment living and present! But for themselves they no longer exist! They no longer exist! And she (pointing to the Step-daughter)...She has run away- ... Run away from me and is lost...Lost! And if I see her here before me it is for this reason and for this reason

alone . . . To renew at all times . . . For ever . . . To bring before me again, present and living, the anguish that I have suffered on her account too. (pp. 51-2)

And here is Wright's version:

> *Director*: Hasn't it happened already?
> *Mother*: It's happening now! All of it! It doesn't come and go, don't you see. I'm alive and *there* every moment. Every second, over and over. God help me, if I could only die. My children! My two dear little ones! They can't even speak any more. They cling to me to keep my agony alive. And she! (the Step-daughter) She's lost, she's lost to decent society, she's lost to me! Yet over and over I see her here before me. Over and over I suffer! (p. 69)

Wright shortens the Mother's impassioned explanation with its *crescendo* of repetitions; the latter are represented only by the word 'lost' and the Americanism 'over and over', the English for which is 'again and again'. Then, 'if only I could die' contradicts not only the Pirandellian Mother's sense of inevitable and everlasting torment, but her religious sense, which would resist such a sin as wishing for death. Lastly, her significant vocative to the Director, 'sir', which helps to establish her lower-class origin – an essential matter in Pirandello's scheme – is omitted. It was painful to watch that fine actress Barbara Jefford, who commands a capacious range of emotion, limited to a muted expression of this, the Mother's single great outpouring in the play.

A concluding observation about Wright's exemplification of 'the current tendency' might be that his adaptation of this modern classic has an interesting fore-runner: according to Eric Bentley,[17] Tyrone Guthrie in his production of the play also elevated the Director at the expense of the Father.

My Shakespearean examples are taken from two plays which end with broadly the same kind of moment for the female lead: in both *The Taming of the Shrew* and *Measure for Measure* she accepts the conclusive request of the male lead. In *The Shrew* she is required to lecture disobedient wives while displaying her own obedience, and in *Measure for Measure* she silently accepts a marriage proposal which is not prepared for in any way in the preceding text. I take the later play, *Measure for Measure*, first, because the betrothal is less integral to the whole action of the play, being apparently a fulfilment of the tradition that comedies end with eligible couples

marrying. That would certainly be the expectation of the original audience. In the play the Duke of Venice, Vincentio, emerging from disguise to resume his ducal function, twice proposes to Isabella[18] while dispensing final justice to all before the curtain falls. To neither proposal does Isabella reply. In fact, she is silent for the last hundred lines, during which the Duke forgives the confessed murderer of her brother and then brings the latter back, very much alive. Some directors have been concerned to make this last-scene betrothal credible in the light of the whole preceding action of the play, which is difficult. In the Royal Shakespeare Company production of the play (April 1984), Daniel Massey as the Duke and Juliet Stevenson as Isabella, interacting during the long period of the Duke's being in disguise as a monk, indicated increasingly harmonious collusion in the Duke's intrigues, by laughing together in the excitement of their conspiracy, and touching each other at least once. Consequently their eventual coming together was no surprise, and at the final curtain they radiated pre-conjugal harmony hand in hand. Unfortunately the text of the play works to the opposite effect: Isabella is confused by the intrigues in which the disguised Duke involves her, and is reluctant to tell the lies he foists on her, though she trusts him on account of his holy office:

> *Isabella*: To speak so indirectly I am loth;
> I would say the truth, but to accuse him* so
> That is your part; yet I am advis'd to do it,
> He says, to veil full purpose.
> *Mariana*: Be rul'd by him.
> *Isabella*: Besides, he tells me that, if peradventure
> He speak against me on the adverse side,
> I should not think it strange, for 'tis a physic
> That's bitter to sweet end.
> (IV.vi. 1-8)

*'him' here being Angelo, the supposed murderer.

Helen Mirren's resort, at the Riverside, Hammersmith (May 1979) was to ignore the Duke's proposal and to come forward at the final curtain in no sort of contact, physical or spiritual, with him. That was another way of flouting Renaissance conventions: the stage convention that eligible couples are betrothed in the final scene of a comedy, and the social convention that women must fall in line with the dispensation of men, particularly when the latter hold temporal or spiritual power.

The final conjugal harmony of Petruchio and Katherina in *The Taming of the Shrew* is more complex, being a necessary outcome of the whole action of the play. As is well known, in this early play, which may well be his first, Shakespeare uses the old folktale theme of the taming of a termagant wife. In most of the old stories the husband beats his wife savagely and commits other brutalities in order to make her obedient.[19] But Shakespeare develops the cruel popular jest with a most unfolksy sophistication. The physical indignities and hardships inflicted on Katherina by Petruchio are presented as a process of education; throughout, he compliments her on her character while insisting on absolute obedience until he gets it. Her eventual acceptance of his rule is indicated when she gives him a kiss 'in the midst of the street'[20] before the famous final scene and its much-discussed 'speech of submission'. In that scene, when Petruchio takes Katherina to visit her father's house, the wife-tamer agrees a wager with the two other new-made husbands present that the husband of the wife who shows herself the most obedient shall win twenty crowns. Katherina is the only one who comes at once when called, and then, having won the bet for her husband, she lectures the other women on their wifely duties in a long speech, on the instruction of Petruchio. But at the end of the speech, unbidden, she offers the symbolic action of putting her hand under his foot:

> Then vail your stomachs, for it is no boot,
> And place your hands below your husband's foot.
> In token of which duty, if he please,
> My hand is ready, may it do him ease.
>
> (V.ii.177-80)

There is a modern tradition, not uniformly followed in every production, by which Katherina delivers her long speech with something like tragic irony, indicating that although she submits, she resents doing so, and suffers, having been forced. I think it began with Charles Marowitz's production, in which Thelma Holt played Kate. It may be noted that Marowitz honestly called his re-shapings of Shakespeare plays, in which he re-allocated some speeches and re-arranged the text so as to bring out his view of their modern relevance, 'adaptations and collages'.[21] He was not forcing the actual text into a modern mould into which it either did not fit, or fitted with difficulty.

But for all its sophistication in Shakespeare's hands, the theme of the taming of a shrew remains, in Renaissance as well as modern

terms, a huge anti-feminist joke. Katherina is repeatedly forced by a man, whether his purpose is to humble a termagant by humiliation and violence, as in the underlying folk stories, or to fulfil the need for love and harmony in a woman who has lacked them, as in Shakespeare. In August 1978, after an Open University summer school visit to the RSC production of the play, Paola Dionisotti, who played Katherina to Jonathan Pryce's Petruchio, discussed the play and its performance with the students. She had delivered the 'submission speech' in such a way that when she placed her hand under his foot, it was a gesture of triumph, which ironically and subtly diminished Petruchio. When asked what were the directorial instructions for playing that last part of the scene, she replied, 'There weren't any. We fought it out every night.'

It is clear from the text that Petruchio raises her from her submissive position, and the couple enjoy another public kiss before Petruchio proposes the next step: 'Come, Kate, we'll to bed' (V.ii.185). The implication is that, although the couple had been married before Katherina's trials at Petruchio's hands began, consummation is not achieved, or even proposed, before this moment. As in the case of Isabella, the silence of Katherina at this point can mean only one thing in the Shakespearean scheme of things: 'Silence means consent.' And that is what some theatre companies and sections of modern audiences find it hard to swallow. English Renaissance modes and assumptions were different from those which prevail in our society, and to conceal or smooth over the differences in the theatre would appear to be a heavy cultural responsibility, with implications both social and aesthetic.

Fiona Shaw, the Katherina in Jonathan Miller's Stratford production of 1987, has written vividly about her predicament as a feminist playing a part in a play which, however it may be considered, is antipathetic to the values of all today's feminist movements. She recalls a late night rehearsal of that last speech, at the end of which the director proposed a walk to the grave of Shakespeare to ask him whether 'the biological difference' between men and women must result in 'irredeemable disharmony'.

> As we left the room I asked him if he still thought that the play had nothing to do with feminism. He turned and smiled and said Shakespeare would laugh at the amount of worms still in his corpse.[22]

Regarded in Jonathan Miller's amusing and accurate terms, it may be said in the light of the whole of the above argument that,

for today's directors and actors who wish to present 'classical' plays in a contemporary and usually progressively motivated interpretation, the works of many a dramatist of the past are found to contain 'a can of worms'. In each of the examples here considered in detail, identification of the worms has resulted in positive directorial action to obscure the fact of their existence. Thus, the broadly idealistic social thrust of *The Cherry Orchard* is sharpened into a political demonstration in dramatic terms acceptable to today's left-wing forums. In *Measure for Measure* and *The Taming of the Shrew*, elements hurtful to modern women's aspirations to equal citizenship with men are either heavily adjusted so that they give less pain, or so transformed as to give a virtually opposite effect in performance.

Nicholas Wright's doctoring of Pirandello is more complex because less overtly political; and it is more of a transformation than the other examples cited, being essentially a new play which cannot fairly be attributed to Pirandello, even allowing for the fact of translation. The debate about the nature of reality, with its essential aesthetic proposition that art is more real than life, is so altered as to give the Actors' reality parity with that of the Characters. The early nineteenth-century southern Italian moral and religious framework by which the Characters live disappears, to be replaced by one of contemporary northern European irreligion and permissiveness. And with those two fundamental changes, the original tone and impact of Pirandello's play, which are described above (pp. 14–16), to all intents and purposes disappear.

Simon Callow notes in his 'Manifesto' that it is easier to plunder the past

> for works on which they [directors] can impose their personalities, or exemplify the playing styles of their companies . . . than to undertake the enormous task of entering the mind and hearts of a people of another time . . . What is valuable about dramatic literature is that it constitutes a living record of other lives and other worlds. It is live history; and by failing to take the pains to discover the Atlantis that it represents, we turn our backs on history, on the richness of culture and on the lessons of the past.[23]

Callow's declaration, and the supporting anecdote about Jonathan Miller cited from the production work on *The Taming of the Shrew*, confirm what may be called a purist and traditional approach to the performance of modern 'classical' plays. But they

do not directly counter the arguments which might be advanced by those who seek to present such plays in a way which brings out their eternal qualities in dramatic, and sometimes verbal, terms which, being modern, appeal to today's audiences. Perhaps society can rightly expect to be so addressed, in which eventuality its members would not accuse their theatres of becoming museums, as Brecht accused those of the Soviet Union:

> When Stanislavsky was at the height of his powers the Revolution broke out. They treated his theatre with the greatest respect. Twenty years after the Revolution it was like a museum where you could still study the way of life of social classes that had meantime vanished from the scene.[24]

In conclusion, no argument is advanced against the use of new techniques and modes of presentation in new productions of old plays. But directors and actors must understand that if they dilute, distort, or change the message in the cause of 'modern relevance', they condescend to today's audience by suggesting that the society of a previous age, as represented, moulded, or criticized in the work of one of its major dramatists, had much the same social and moral values as our own society. Their creative freedom should be exercised not in changing the meaning content of the play but, as it happily so often is, in the modes and techniques of presentation – the development of dramatic images and styles of today as applied to the inviolable creations of yesterday.

Notes

1 Michael Billington, 'The National Champion'. *The Guardian*, 31 May 1988.
2 Lord Byron, Dedication of 'Sardanapalus' (1821), in *The Poetical Works of Lord Byron*, London: Oxford University Press, 1945, p.453.
3 Since early this century, the systems which have won wider recognition take account of all movement, not just that of classical ballet. Since Laban, work is proceeding effectively at the Dance Notation Bureau in New York (founded 1940) and the Benesh Institute of Choreography (founded in London 1963).
4 John McGrath's adaptation for the 7/84 Company. Ref: contract between John Arden and John McGrath of September 1972, courtesy of Margaret Ramsay Ltd, Play Agents.
5 In 1970, in the BBC television studio at Alexandra Palace, where Open University programmes used to be made, Elizabeth Spriggs, playing Gertrude, tried to include these lines at my suggestion despite the tradition; but we all agreed that they did not work, and they were therefore cut (Open University Foundation Course in Arts, 1971).
6 Private conversation, c. 1954.
7 Bernard Shaw, Preface to 'Heartbreak House' in *Prefaces by Bernard Shaw*, London: Odhams Press, 1938, p. 378.
8 Anton Chekhov, *The Cherry Orchard* (1904), trans. Michael Frayn, London: Eyre Methuen, 1978, pp. 30–1.
9 Anton Chekhov, *The Cherry Orchard* (1904), in a new English version by Trevor Griffiths from a translation by Helen Rappaport, London: Pluto Press, 1978, p. 25.
10 Lopakhin's uncomprehending misrepresentation of Hamlet's greeting to Ophelia at the end of his most famous soliloquy (III.i.88–9 of the Arden edition) is amusingly tackled by both translators, especially so by Griffiths:
(Frayn) Nymph, in thy orisons, by all my sins dismembered! (p. 3.5)
(Griffiths) Euphemia, sprite, remember me in your horizons. (p. 28)
11 Anton Chekhov, 25 September 1903, letter to Olga Knipper, cited in

David Magarshack, *The Real Chekhov*, London: Allen & Unwin, 1972, p. 190.

12 Federico Garcia Lorca, *Three Tragedies*, trans. James Graham-Lujan and Richard L. O'Connell, London: Penguin Books in association with Secker & Warburg, 1961.

13 Robert Brustein, *The Theatre of Revolt*, London: Eyre Methuen, 1965, pp. 292–309.

14 Eric Bentley, *Theatre of War*, London: Eyre Methuen, 1972, p. 57.

15 Luigi Pirandello, *Six Characters in Search of an Author*, trans. Frederick May, 1954, London: Heinemann, 1921, p. 49.

16 Nicholas Wright, *Six Characters in Search of an Author* by Luigi Pirandello in a version by Nicholas Wright. Typescript of unpublished work supplied by Judy Daish Associates, London, 1987, pp. 66–8.

17 Eric Bentley, *What is Theatre?* London: Eyre Methuen, 1969, pp. 271–2.

18 J.W. Lever (ed.), *Measure for Measure*, London: Methuen, 1965, V.i.490 (p. 147) and V.i.534 (p. 149).

19 The editor of the Arden edition, Brian Morris, notes analogues in which the husband kills animals for their disobedience in order to terrify his wife into submission. He also notes (p.75, note 1) that the stories include examples of 'the shrew triumphant' as well as 'the shrew subdued'; Chaucer's Wife of Bath and the Griselda of his Clerk's Tale are respective examples.

20 Brian Morris (ed.), *The Taming of the Shrew*, London: Methuen, 1981, V.ii.132 (p. 286).

21 Charles Marowitz, *The Marowitz Shakespeare*, London: Marion Boyars, 1978, title page.

22 Fiona Shaw, 'An Actor's Diary' in *Drama*, vol. 4, 1987, London: British Theatre Association, p. 54.

23 Simon Callow, *Being an Actor*, London:Penguin Books, 1985, pp. 218–20.

24 Bertolt Brecht, *The Messingkauf Dialogues*, trans. John Willett, London: Eyre Methuen, 1965, p. 23.

ACKNOWLEDGMENTS

I am grateful to the following:

Simon Callow and Messrs Methuen, London, for the quotation from *Being an Actor*; Michael Frayn and Messrs Methuen, London, for the quotation from *The Cherry Orchard*; John Willett and Messrs Methuen, London, for the quotation from *The Messingkauf Dialogues*; Trevor Griffiths and Messrs Peters, Fraser and Dunlop for the quotation from *The Cherry Orchard*; Nicholas

Wright and Messrs Judy Daish Associates for the quotations from *Six characters in Search of an Author*; Messrs William Heinemann and the International Copyright Bureau Ltd for the quotation from Frederick May's translation of *Six Characters in Search of an Author*.

Conclusion

Arthur Marwick

Do 'the arts' and 'literature' exist? Are there distinct, knowable 'societies' to which these can be related? Wiggins has an interesting comment relevant to Barrell's contention that there can be no society distinct from the representations of it presented in different discourses, and to my challenge to that position in the Introduction. Wiggins (p. 41) rejects the possibility that *Macbeth* 'is simply a document which was overlooked in compiling the survey in the first half of this paper.' There are much better sources (including other plays) out of which a reliable view of legal beliefs and practices in the society of the time can be established. The special significance of *Macbeth* in relation to this aspect of society can then be discussed. The very structure of Wiggins' chapter, a survey of legal attitudes painstakingly built up from mainly traditional historical sources, followed by a detailed analysis of *Macbeth*, indicates that he has no difficulty with the notion of a juxtaposition between society on the one hand and literature on the other. That, of course, is very much my own position, my essay setting up a strongly defined account of a society moving into and through a period of social and cultural change, then, largely by reference to the novel, endeavouring to establish the relationship of the film *Room at the Top* to that social context. No difficulty is found by Stone in identifying the pressures and preoccupations of society today (for example, feminism) which influence the way in which classical plays are produced, nor by Nenadic and Burnett in identifying the social classes or groups to which the literary artefacts they have studied can then be related, nor by Harvie in defining the main political trends against which his political thrillers are to be studied. Lenman clearly establishes the broad contours of tourism, before indicating relationships between the social practice and certain artistic products and practices. For Barrell and Pointon, on

the contrary, there remain only competing discourses which do, however, as Barrell puts it, indicate that 'real' history (or society) consists of 'competition among different material and psychic interests' (p. 97); but we cannot, he insists, directly apprehend this 'real' society. His definition of the reality of history is, of course, in any case, extremely general.

Even if, as the majority seem to feel, cultural artefacts can be studied in a relationship to society, are the terms 'art' and 'literature' really justified? All contributors recognize that the terms are not without their problems, are not absolutes, and range from seeing them as simply useful in indicating a socially sanctioned classificatory system, to believing that aesthetic and quality judgements can be made. Some plays, Stone points out, are revived often, and in different countries, a generation or so after the first presentation – these may not unreasonably be termed modern 'classical' plays, to distinguish them from the vast numbers no one thinks worth reviving or translating. Stone then goes on to make the ironic point that 'the better and the more "classical" a play, the more likely it is to be met as literature than as performance art' (p. 281). Without using these evaluative distinctions Stone would have found it impossible to make this striking point. An important part of Harvie's argument is based on distinctions between 'the art thriller' (p. 221) and the pulp fiction of political intrigue, and on his contention that there has been no classic since Joyce Cary. While Wiggins perceives special value and qualities in his Shakespearian text, Nenadic argues for the peculiar value to the historian of popular literature, as distinct from what she refers to as 'fine' or 'intellectual' art: both recognize the importance of, indeed the necessity for, the distinctions. Though Lenman's chapter is in essence a study in integrated cultural history, he does single out 'culture', in the canonized sense, when he remarks (p. 168) that it was 'one of the city's [Munich's] strongest selling points': obviously a range is intended, including 'spectacular', and quite possibly trivial, plays, but also Wagner and Rubens, clearly seen both by tourists and author as in a class of their own. Even where dealing with pot-boiling art, Lenman distinguishes between paintings showing 'skill and imagination' and near kitsch. It does, as always, depend upon the topic being studied, but it would seem that the headlong flight away from making value judgements would, for many topics, severely deplete the resources necessary for intelligent analysis.

Now to my six questions. At the risk of trying the patience of readers (and probably my contributors as well) I am again going to

set these out in schematic form, trying this time to summarize the responses which have emerged from the chapters of this book.

METHODOLOGY

The contributions could be divided up in two ways. On the one hand, a distinction could be made between those by historians (Nenadic, Lenman, Harvie, and myself) and those by scholars from the realms of literature and art history (Wiggins, Burnett, Pointon, Barrell, and Stone) – it is highly symbolic of the way in which literary studies have moved that I had automatically classified Burnett as an historian while, I was informed when finally revising his chapter, his subject in fact is English. On the other hand, the distinction could be made between those who take a linguistic, discourse theory, or cultural studies approach and those who see themselves as essentially practitioners of a traditional disipline. I think it can be said that no contributor is as traditional as to see the different disciplines as embodying totally different practices or to adhere to the routine criticized by Raymond Williams whereby literature or art is seen as illustrating history, or history as setting the background for literature or art. Wiggins actually starts by distinguishing between the aims of history and the aims of literary criticism, making (to me) an entirely persuasive contrast between the historical activity of producing reconstructions of past societies or aspects of them from an immense range of source material, and the literary activity of rendering more intelligible individual items of written material. I am less certain about the 'fundamental difference' which he then identifies between the nature and value of the 'historian's documents' and of the literary scholar's 'texts'; but while I doubt if 'documents' can properly be described as 'statements' (as those familiar with my *The Nature of History* will know, I attach great importance to the 'unwitting testimony' of documents), there is force in the point that literary texts are 'artefacts about which statements may be made', whereas one does not usually waste much time making statements about single historical documents of the traditional type. However, Wiggins then goes on to admit that such distinctions belong to the traditional single-discipline approach, and to argue for 'cross-fertilization' and 'interdisciplinary co-operation', without (and this is important) postulating that the two methodologies would in any way merge into one. Again, my own position is close to that of Wiggins, since I speak of *three* skills being necessary to the discussion of two

cultural artefacts (novel and film) and their relationship to society. Nenadic also discusses the traditional uses of literature by historians, the better to find it wanting, and goes on to offer a model whereby historians might incorporate literary sources within their historical studies. The model is presumably not of universal validity since Nenadic recognizes differences of genre, and is herself concerned with the genre of popular novels; she also, very properly, attaches high importance to the notion of *mentalité* (mental set, attitudes, fears, hopes, values, etc.), an important topic but far from the only one for which novels provide evidence. Nenadic argues that the text itself, in its integrity, should be taken as 'the point of departure': two possible routes are the linguistic (that followed, of course, by Barrell and Pointon), and the approach (followed by Nenadic herself) which involves 'the systematic exploration of the situations, circumstances, or relationships that typify novels within a particular genre', and which by 'taking account of the evolution of the novel as a cultural artefact . . . seeks to understand the significance of changes in the typical situations, circumstances, and relationships that occur in this fictional genre.' The Nenadic model attaches great importance to 'perceived audience'. The popular sensation novels, she proposes,

> are concerned with the desires and anxieties of those groups that furnished both the writers and the audience, namely the middle class. These novels presented fantastic situations which allowed the vicarious enjoyment of those things that were commonly desired, the vicarious suffering of the common causes of anxiety and by their juxtaposition the resolution of anxiety through the attainment of desires. (p. 142)

Lenman and Burnett are clearly both fully aware of recent developments in cultural studies: Burnett refers to the 'New Historicism' within Renaissance Studies, and Lenman's chapter is in itself an essay in cultural history leaning more to popular than to elite culture. But both essentially follow the traditional (pragmatic) historical methods of source criticism, applied, of course, to a very imaginative range of source materials. When Burnett refers to the manner in which religious writers unwittingly reveal the preconceived attitudes of the 'middling sort' towards their social inferiors, he is using documentary analysis to add to our knowledge of a past society. Burnett is involved in evaluating and penetrating his documents in a manner which is more rewarding than resolving them into different discourses would have been. Harvie is by

profession an historian, Stone a literary critic, but both exemplify the traditional virtues of careful analysis of texts, the strict definition of terms, and the appropriate deployment of relevant grouping concepts or technical terms. Harvie pays due attention to the particular nature of the political thriller, the demands of narative, the structure, for example, of *Sybil* and acknowledges the mythic elements in his sources. Stone avoids rash generalization about the historical context, noting meticulously that when a play is revived, 'besides the initial society with its divisions of author, performers and paying audience two further societies, related to each other, necessarily exist: the societies of the performing company and the audience' (p. 281). Guttsman combines a precise sense of historical period, with aesthetic, iconographical and content analysis of his visual texts.

Seven authors, then, recognize the separate, but related methodologies of the disciplines of history and literature. Nenadic moves towards a single methodology suited to her particular type of enquiry. This brings her closest to Barrell and Pointon, with their linguistic, discourse theory, approaches. Pointon explicitly disavows, at least for this particular study, the methodologies of style analysis, iconography, and reception and patronage study, long espoused by specialist art historians. In analysing the first of her Turner letters, she contrasts the basic factual information which traditional art historical practice would extrapolate, with the deeper illuminations revealed by linguistic theory (p. 81).

It may seem presumptuous if I attempt to pull this range of approaches together and suggest conclusions as to what is irreducibly essential in the kind of interdisciplinary study envisaged in this book. Yet the following conclusion does seem to jump out at one: whatever the discipline, whatever the view about single or separate methodologies, two characteristics appear to be necessary, though not, of course, sufficient, conditions for the success of each chapter: the very thorough and meticulous analysis of specific texts, and the precise use of exact categories, concepts, and technical terms. Both Stone and Wiggins light on the essential features of the play as a category distinct from other literary forms, and this is critical to the development of their arguments. In the words of Wiggins, 'being an acted event, a play is less dependent on already existing concepts than any other form of fiction' (p. 43). He also most effectively deploys the concept of the taboo. It is by reference to the Ancient Greek concepts of the *eiron* and the *alazon* that Stone manages most effectively to illuminate the drastic changes brought about in

Wright's translation of Pirandello. We find our way the better through Barrell's rich, subtle, and fascinating account because of his precise use of such concepts as 'faculty languages', 'occupational idiolects', and 'master narrative'. Lenman, despite Pointon's rejection of the approach, fruitfully draws our attention to the humble iconography of the most saleable of tourist paintings: 'well-fed, contented, and productive farm animals were matched by cutely domesticated, anthropomorphic pets' (p. 171). Lenman's, followed by Burnett's, are actually the chapters which make least use of extended textual analysis; being the most historical they depend, rather, upon a vast range of frequently archival material. With regard to the other chapters, it is not really necessary for me to draw attention to the way in which inferences and conclusions are so subtly and persuasively winnowed out from Turner's Letters and the *Liber Studiorum*, Pyne's *Microcosm*, passages of dramatic dialogue, classical and modern, and the prose of Collins and Buchan.

THEORY

Theory most obviously and openly underpins the chapters by Pointon and Barrell, and in slightly different shape, figures prominently in that by Nenadic. Pointon begins with a quotation from Foucault, discussing the relationship between representations and the (ungraspable) 'real' world and stressing the absolutely central importance of language. There is, she continues, no history as an authoritative body of knowledge: history consists simply of the narratives we construct from our own perspective in the present. Writing is never a simple act, but necessitates a deal of some kind between the writer and the reader even if the latter is never specifed. Language had an especially powerful place in nineteenth-century culture, but was under severe challenge in the period with which Pointon herself is particularly concerned. Verbal constructions about Turner are not revelatory of a hidden truth about him but are 'a domain of communication which functions according to certain rules which formulates and gives prominence to particular problems and effectively excludes others, which develops characteristic vocabularies and orders of priorities' (p. 77).Turner is suspended in 'webs of significance' which he in common with the collective cultural practice of his age has helped to spin. Elucidation requires linguistic theory and the perception of passages as discourse, defined as 'those sequences of linked and cohesive speech

acts the understanding of which requires more than simply knowing what any particular linguistic act refers to.' Then, perhaps most significantly of all: 'Discourse alerts us to ideology in language and to questions of who controls language (and, therefore, forms of knowledge); it defines its object and there are, therefore, no criteria of truth external to it' (p. 79).

Though never explicitly referred to in his chapter, the notion of ideology is obviously also critical to John Barrell's chapter. His central contention is that sequences of ideas

> are always linked together within specific rhetorical structures or discourses, each of which has its own rules of procedure, embodies its own account of reality, and embodies also the position from which that account is assembled and the discourse is articulated. The discourse within which we make an utterance determines to a large extent the nature of the connections we can make between ideas . . . (p. 96)

The notion of competing discourses has clearly overtaken the notion of dominant and alternative ideologies derived from Marx and featured prominently by Raymond Williams. The notion of ideology, in whatever form, is not used by any other contributor and it was left to my chapter to state explicitly that the notion of ideology, and particularly that of alternative or emergent ideologies, was utterly irrelevant to my study of *Room at the Top*. Rather than being derived directly from Marx, the theoretical approach favoured by Nenadic depends heavily upon the views about history and the humanities put forward by Wilhelm Dilthey who sought to resist the assimilation of the humanities to the sciences by arguing for their own unique value and methodology: the humanities could express profound inward truths, not accessible to the sciences. Nenadic takes up Dilthey's notion that literature expresses the essence of society, has a 'pre-scientific immediacy'. I have to confess to some uneasiness myself with Dilthey's high-flown nineteenth-century views and am much more comfortable with the more limited notion of *mentalité* to which Nenadic then moves. More directly within the Marxist tradition is Nenadic's suggestion (p. 139) that 'novels, as with other forms of art, are to do with creating, affirming, testing, or undermining the dominant ideas and perceptions that characterise a society.' Here, indeed, we are teetering on the edge of the notion of dominant and alternative ideologies. However, the move on to the notion of the *desires* and *anxieties* of consuming groups is surely a most fruitful one. From

Marxism as transformed by Foucault comes the notion that madness is socially constructed. Whether this is universally so may be open to some doubt, but undoubtedly the examples Nenadic gives relating to the way in which women failing to conform to their expected roles were conveniently declared insane, are persuasive.

Theory is not mentioned in any of the other contributions save that I, while insisting on the importance of analysis based on the concepts of cultural production, consumption, and status, make it clear that I do not find value in any single overarching theory. Presumably all other contributors are, in some form or another, what Barrell refers to as 'liberal humanists'. They believe, apparently, that the world which they perceive is indeed in some sense 'real'; or at least that it is not a complete travesty of reality, its true nature obscured by ideology. They believe that by the disciplined use of tried-and-tested methodologies they can elucidate genuine truths (or as near as fallible scholars can ever get to truths). Their most important belief, of course, with respect to the purposes of this book, is in the possibility and desirability of the disciplined and systematic study of literature and the arts in their relationship to society.

STYLE, PERIOD, TASTE

Periodization is central to almost all historical writing, and all of the contributions to this book evince a clear sense of pertaining to a particular era or moment in time. Chronology is as clearly defined by Pointon and Barrell as it is by the more conventional historians. My own chapter is founded upon the search for the critical point of change as between the 'Cultural Revolution' of the 1960s and, as it were, 'the pre-1960s'; however, it has to be admitted that my study concerns changes in content to a much greater extent than changes in style, and that the more essentially 'cultural' concepts of style and taste are not universally used in this book. This, I believe, is because, as noted in the Introduction, this particular group of authors are not (Wiggins, Stone, and, in some degree, Guttsman, apart) concerned with high art, nor (save for Stone and Guttsman) with aesthetics. I would not myself wish to abandon this conceptual heading for *all* types of cross-disciplinary historical study. It is Pointon who is absolutist in rejecting the concept of style. Barrell, as author, allows for the existence of a 'concept of cultural modernity' which, presumably, governs all style and taste in the 'modern' period, and his subjects are very much preoccupied

with questions of taste, as, for instance, among the protagonists of the Picturesque: he speaks of the 'concern for correctness of tastes' (p. 106).

It is in the very nature of Stone's enterprise that questions of taste should feature very prominently: he speaks openly of 'the aesthetic of drama recognized by our generation' (p. 285), and his entire fascinating study very largely concerns how plays from other eras are presented to conform with the taste of contemporary Britain. Much of Guttsman's analysis, too, depends upon the concepts of style and taste. He speaks of the conflict between representational and non-representational styles, and of the importance of the Expressionist style in Germany in the first two decades of the twentieth century (p. 182). His entire chapter is an important contribution to the assessment of working-class taste. In discussing the changing nature of the political thriller, from the time when it endeavoured to validate the representative character of the British constitution, to the era of the break-up of British political consensus, Harvie, by contrast, is primarily concerned with content, but he clearly indicates what he perceives as a decline in taste. Lenman quite directly engages with the question of the taste of the developing tourist trade, which articulated with the longer term Romantic fascination with 'wilderness', redefined as poetic and sublime, with an 'unspoilt' and 'authentic' natural world, and called for animals depicted in sentimental and didactic terms. He notes how, at the beginning of the twentieth century, the taste of conservative tourists for paintings of the Barbizon and Hague school influenced cultural production in Munich (p. 170).

NATIONAL CULTURE AND FOREIGN INFLUENCES

Unfortunately, British scholars still tend to confine themselves very largely to British topics so that the questions implicit here are not asked as often as, I believe, they should be, and the most profound sense of a national style emerges in Guttsman's discussion of German Expressionism. Harvie, however, has long had a specialist interest in the separate cultures within the British Isles and the nature of these national cultures, and their particularities, strongly informs his chapter. In his careful analytical discussion of the nature of the British political thriller as it emerged in the mid-nineteenth century, Harvie brings out its peculiar Britishness, its intimate dependence upon the constitutional theories of the

time. Disraeli's *Lothair* 'has a carefully-structured "national" theme from which the alien Catholic Irish can be excluded: an image of Britain in which monarchy, empire and the protestant religion bind England and Scotland together' (p. 225). One of the most joyful of Harvie's many joyful revelations is of how many thriller writers, as well as actual secret agents, were 'less than "British"' (p. 227). And, of course, the national and communal ingredients of the patriotism of the fictional Watson are fascinating: he was 'a Scots-Irish-Catholic-Liberal-Unionist doctor' (p. 219). The body of the country represented in *The Thirty-Nine Steps* is sound, but 'the country in question seems less British than Scottish' (p. 232). Harvie's arguments about the 'break-up' of Britain would be impossible to sustain without this conception of national and cultural differences. In the later Buchan, Harvie claims, 'Britishness has ceased to matter: the values of "Scotland", or "Canada", have taken over' (p. 223). Coming into the period of 'break-up' proper, Le Carré's *A Perfect Spy* 'seems a gesture of farewell to the idea of Britain' (p. 243).

In discussing the 'classical' playwrights of the last hundred years, Stone most illuminatingly divides the works revived in Britain into three categories (I have already stressed the paramount importance of exact categorization in this kind of cultural-historical study): the overtly didactic; the remotely set, which none the less have preoccupations which, when the work is 'transmuted', will appeal to British audiences; and works which are 'too locally fixed' for any transmutation to be possible (p. 285). Stone writes forcefully about the difficulties of finding a system of imagery in English to cope with the Spanish of Lorca; most interestingly – and here I found parallels with the apparent difficulties in finding British-born actors to play Joe Lampton and Alice Aisgill – 'it was the physicality of Spanish men and women, rather than the translation problem, that occa-sioned difficulty for the company which performed *Yerma* in the Cottesloe Theatre' (p. 288). The revelation of the full effect of the Wright translation of Pirandello is given added force by the explanation of the feelings of the Characters as being those held 'with the fierce conviction of a southern Italian Catholic sensibility in the early years of the present century' (p. 290). For cultural historians of the contemporary period, an ever present motif, as I noted in the Introduction, is that of Americanization or American-ism. Stone notes both outright Americanism and 'advancing mid-Atlanticism' (p. 285), the same thought being in Harvie's mind when he describes the contemporary spy thriller as reading like 'the tougher type of management manual, mid-Atlantic in its mores and

loyalties' (p. 237). Lenman notes the widespread view of both the mass media and tourism as 'prime vehicles of "Americanism"' (p. 164). Lenman identifies as additional influence adding to the tourist boom, the desire of German nationalists to seek out their known urban origins (p. 176)

AUTONOMY VERSUS SOCIAL CONSTRUCTION

The dichotomy is perhaps too stark. The particular positions, preoccupations, or 'logic' of a specific art-form could be said themselves ultimately to be socially constructed. However, as the phrase is generally used it has a pronounced 'short-term' implication, that of works of art being related directly to the immediate society which produced them. In any case, the interesting questions have to be: even *if* socially constructed, *how* and *why* socially constructed? Then again the whole issue is approached rather differently by the apostles of discourse theory and the ungraspability of the real world. However, Barrell allows that, for example, there was a specific aesthetic which governed the sketches of George Morland and his like (p. 107). What is vital is to establish the range and nature of the different kinds of influence which affect artistic or cultural production, avoiding naive and unspecific invocations of the society of the time. It is, as Nenadic remarks, 'a truism that works of literature or art are products of the relationship between artists as individuals, the cultural environments in which artists work and the societies and economies that give rise to those cultures' (p. 133). Adding the rider that it must be recognized that cultural traditions sometimes go a long way back in time, I would then remark that the task is to establish the detail, the relative weights, and the balance of the factors indicated in the 'truism'. Nenadic herself speaks of the importance of the individual author and of the author's life and experiences. She thus gives some detail on Collins and refers specifically to his legal style with its 'curiously satisfying intellectual quality' (p. 143). Guttsman lays stress on the personal characteristics of George Grosz. Wiggins discussed the established philosophical systems within which discussions of murder could take place (p. 25); Burnett shows how the conduct literature he is interested in has its roots in much earlier traditions, while at the same time it is responding to contemporary problems (p. 50). Lenman at one point suggests that the demand of the tourist trade was a far more important consideration that any possible talent possessed by the artists who catered to it. Stone's very

topic, in one sense, is an exploration of the balance between the aesthetic qualities of plays written in a previous age, and the influences operating in the society in which they are actually presented on stage. I have twice emphasized the importance of detail. Stone provides a most impressive instance in explaining the National Theatre Company's attitude towards *Six Characters in Search of an Author*:

> It is almost as if the National Theatre company could not bear to present the life and work of directors and actors with the derisive dismissiveness of a Pirandello. A necessary outcome of this double adjustment is that the Director replaces the Father as the central figure in the play. (p. 291)

Harvie, while in one place insisting on the intrinsic requirements of the thriller, and in another pointing to the style and symbolism of *Pilgrim's Progress* revealed in Buchan's novels, is fascinating on the contemporary political situations and pressures which operated upon the genre he is studying, for example the real facts of the new weaponry and war-plans of the late nineteenth century:

> Such were the complexities of military mobilization by rail that the imparting of General Staff Plans – and associated treaties – could result in enormous advantages to an enemy, and one spy case – the Dreyfus affair in France (1894–1906) – convulsed a republic (p. 226).

CULTURAL PRODUCTION

In my brief to contributors as quoted (in slightly revised form) in my Introduction I use the phrase 'cultural production, consumption, and status'; it may be noted right away that Nenadic finds more fruitful the alternative formulation 'cultural production, consumption and impact'. There is no need to fuss over this point since indeed Nenadic does discuss the status of sensation novels as compared with 'higher' forms of literature. Only Pointon finds questions of reception and patronage of no value to her particular type of enquiry. Otherwise all the other contributions do seem to support my initial contention that this is one of the most useful, and perhaps fundamental, areas of inquiry for any study of the historical and social relations of cultural products and practices. Wiggins is fascinating on the questions of how much foreknowledge of the basic plot of *Macbeth* Shakespeare could take for granted, and on

how the political exigencies of the time made it essential to disassociate Banquo from Macbeth at an early stage (p. 34). Burnett speaks of 'texts addressed to a range of social classes and dictated by different cultural assumptions' (p. 49), gives very precise and quantitative attention to the details of production and consumption, and finally locates his main audience as among the prospering middling groups desperately in 'need of instruction which would ease the process of adjustment to a new family life- style' (p. 66). The conditions of consumption of Pyne's *Microcosm* are brilliantly defined by Barrell (pp. 101-11): in summary, 'it is looking for a market among those whose interest is in art as a polite accomplishment, as well as among those concerned to acquire "useful knowledge", or concerned that their children should acquire it' (p. 105). The entire line of argument takes a stunning, and very modern, twist when Lenman describes the 'loss-leading' production of Wagner, the Munich art shows, and the tourist-based export trade in art (pp. 169-75). The readership for political novels in the mid-nineteenth century, Harvie suggests, came very close to the celebrated 'upper 10,000' (p. 222) – note how often we are involved in class, or class-related judgements. Harvie echoes Nenadic in the colourful, and vital, personal details he supplies with regard to such authors as Constantine Fitzgibbon and Sir David Fraser (p. 236), and his careful analysis of the production of *Scotch on the Rocks* is surely a model of this kind of highly important exercise (pp. 237–40). Finally, Harvie goes beyond the usual clichés in identifying the significance in recent times of the American market (p. 241). My own discussion of cultural production, consumption, and status with respect, *Room at the Top* is so direct that I shall not refer to it here. With respect to Stone's chapter, the word 'model' (in its evaluative, pre-statistical sense) again seems appropriate. A modern classic in performance, Stone tells us, is the product of three 'societies'. The first of these existed in the past, often in another country. Stone goes on to point out that plays are often written for a particular group of people to perform, for communicating to a group within that contemporary society, and that plays are more severely restricted in the manners and morals they may express than are, say, novels. This, I believe, would generally be true in our own period, of, first, films, then television. This is why *Room at the Top* is so important – it was actually more outspoken than the book it was based on. The two further 'societies' are that of the performing company and of the audience. The latter is self-selecting and cannot be regarded as necessarily a microcosm of the society of

its time. Stone identifies the cultural determinants of both perform-
ing company and audience: on the audience side – we return again
to a central point – 'the main determinant appears to be a matter
of class heritage' (p. 282).

What, then, has this book achieved? First, for those uneasily
familiar with the linguistic theory which has so strongly affected
academic study in the last dozen years or so, we have, I believe, two
first-class examples of that theory put into practice. Whether one
agrees with the form of analysis or not, one cannot but recognize
that, to take just one example, Pointon makes abundantly clear
what she means by 'the discourse of Authority' and, more, just what
its significance is. Let me quote a powerfully persuasive passage:

> I want to draw attention to a second discourse that is present
> within these letters. This is the discourse of Authority which
> encompasses the invocation of a whole series of authorities.
> Turner, the young artist here without authority in the public
> sense, issues what amounts to an instruction: 'You may prepare
> a frame.' Wyatt's (and Middiman's) authority underlies the
> anxiety to complete. The authority of artist is in interplay with
> the authority of patron. But the real authority is Oxford, town
> and institution, the embodiment of learning and knowledge
> which is linguistically instructed and verbally experienced.
> Oxford, to put it bluntly, is full of words and it is with a cascade
> of words about bishops, beadles, clerics and their *proper* at-
> tributes that Turner seeks approval of this ultimate authority
> 'for', as he says, 'I could wish to be *right*'. Within the public
> domain of learning, a domain which we have already remarked
> upon in relation to Turner's careful imparting of information in
> the titling of paintings, knowledge is constituted by the ability to
> name correctly and in proper order. Only that ability lends
> authority. (p. 85).

After reading Barrell, page 97 and onwards, one could be in no
doubt as to what is intended by 'the processes of conflict between
discourses and the appropriation of one discourse by another', nor
as to the significance which is attached to these processes:

> In the *Microcosm* title, picturesque drawing seems to have
> become a victim of the process by which, as social knowledge
> was increasingly defined in the late eighteenth and early nine-
> teenth centuries as economic knowledge, the arts were increas-
> ingly denied a cognitive function. And so it has become, rather,

a rhetoric, a style, and one which, I shall suggest, can usefully be appropriated by the discourse of the division of labour to give a visible form to its account of social organization.

However, there is resistance from the discourse of the Picturesque, which unlike the discourse of division of labour, is able to recognize such romantic, though uneconomic, members of existing society as gipsies, robbers, and smugglers. 'In this process of resistance to the totalizing aspiration of the discourse of the division of labour, that discourse is itself revealed as an occupational, an interested discourse, with its own specialized account of what knowledge is' (p. 127).

In my Introduction I raised the question of purpose in academic endeavour and suggested that for historians the purpose is to increase knowledge of the past since understanding of the past is vital to us in comprehending the present. What new knowledge about the past emerges from this book? To me the argument that *Macbeth* (and other less sophisticated Renaissance plays) played a critical role in socializing the notion of premeditation as an essential ingredient in the concept of murder, is totally persuasive, and I found some of the comments made in Chapter 1 intensely illuminating for some of my own studies. Shakespeare, writes Wiggins, 'does not simply import the idea of criminal intent for use in the play; rather the play itself contributes to the articulation of that idea' (p. 41). In many ways I wished I had read this before composing my own piece on *Room at the Top*, for that is exactly what I am trying to say about that film. Utterly relevant to my own case is Wiggins' contention that watching a play (or, I would add, a film) does not exactly involve teaching and learning, but rather a mutual process of finding out (pp. 43–4). A play (or a film) helps to resolve the conflict between perception and preconception (with regard to *Room at the Top*, this seems to me highly relevant to public attitudes towards sexual behaviour, and to actual behaviour as old taboos were increasingly sloughed off). The attitudes, the fears, the values of a quantitatively important section of seventeenth-century society, what was felt to be entirely appropriate in the powers (the right to inflict punishment) which masters had over servants, are significantly illuminated in Chapter 2. The elemental significance of the two very different types of title given by Turner to his paintings (p. 78), the constraints under which Turner had to operate as an artist, the case interested contemporaries were making to present the *Liber Studiorum* as the functioning evidence of Turner as

innovator and painter of originality, emancipated from the legacy of his predecessors: all of this emerges from Chapter 3. That there were discourses of the Picturesque and of the division of labour, and that they were as detailed in Chapter 4 seems beyond dispute. The analysis of the 'strategy and structure' of Smith's 'extraordinary sentence' is brilliantly done both in its analysis of the language used, and in the use of the conditional tense, and fully justifies Barrell's conclusion that 'throughout this long recital [Smith] has had his eye on the enunciation of a general truth, though the reader my have been blind to it' (p. 104). The notion that Victorian society was an utterly secure and confident one has long been under challenge: that challenge is taken significantly further in Chapter 5 where illegitimacy, insanity, and insolvency are convincingly presented as forming the recurrent 'nightmares' of middle-class families, particularly the female members, and are seen as important agents in the eventual 'deconstruction' of the Victorian family. Chapter 6 opens up a whole new area that of the study of 'travel for pleasure and improvement', and marks an important contribution to the important debate on the consequences of modernization and the growth of mass culture. Chapter 7 gets firmly to grips with the question of art as political weapon. Chapter 8 is so full of striking *aperçues* – insights through a particular literary genre into the insecurities of the late nineteenth-century lower-middle class and those of Edwardian Britain, the way in which the Cold War thriller ratified simplistic pronouncements on Eastern Europe – that it is difficult to know where to begin here: I content myself with restating the basic and convincing thesis, that in the mid-nineteenth century, political fiction helped to underpin the conventions of government, whereas political fiction over a century later offers important signposts to a society and constitution in extreme disarray. Chapter 9 is a contribution to a big debate on the nature and origins of cultural and social developments in Britain in the 1960s. By showing us how and why we present classic plays today in the way in which we do, Chapter 10 gives us an unusual insight into our current prejudices and preconceptions.

In addressing the particular task at hand, slightly different methods and concepts have been employed. Most of the discoveries so cavalierly summarized in the previous paragraph have not depended upon discourse or any branch of language or cultural theory. I feel (and here I clearly express a personal judgement) that on the (admittedly limited, and in a sense pre-selected) evidence of *this* book discourse theory does not establish itself as *the* universal

approach. Historians with the purposes I have outlined must constantly discover new information, they must be constantly opening up new archival sources. Burnett gives a virtuoso display of the interpretation and analysis of often quite intractable archive, as well as printed sources; Lenman has opened the Heinemann archive in order to give precise substantiation to statements about the Munich art market; from work done on recently released papers in the Public Record Office, Harvie is able to tell us what secret agents were really like (they were *not* clubmen), and from a publisher's archive I have been able to establish the not insignificant point that *Room at the Top* was bought up for paperback publication before a film production had been decided upon. Discourse theory, it seems to me, is simply irrelevant to this kind of indispensable historical activity. So too is it irrelevant to such critical pieces of information as that Shakespearian audiences would understand the double meaning of 'this strange intelligence', crucial to the development of the plot (Wiggins, p. 33).

What does seem to emerge consistently in every chapter is the central significance of social structure. My point, this being so, is that in this kind of investigation we cannot afford to take social structure for granted, as conforming to the Marxist, or any other, scenario, but that social structure too must be a subject for careful investigation. If we are to talk of dominance (other than in some woozy, generalized way) we have to be precise about what are the dominant and what the subordinate, groups; where we are analysing readership or audience we must concretely envisage the social groups we are talking about; if we are to talk of conflict we must be clear about which groups actually were, and can be shown to have been, in conflict; if we are to talk of ideology, then we must be clear about what group is profiting from ideology, and which groups are being fooled by it, and, as I remarked in the Introduction, we have to clarify what would actually happen to society if ideology did not exist.

That, for me, is the discovery of this book: the central importance for any study of the arts, literature, and society of a careful analysis of, for lack of a better word, class (and class relationships). Beyond that, the six major issues already identified do seem to me to have stood up to the test of separate studies by separate authors operating to varying assumptions. Many readers will disagree with what I have said in both Introduction and Conclusion. They are very welcome to ignore both: what this book has offered is a first-class series of essays, from which readers should draw their own conclusions.

Select annotated bibliography

This bibliography is confined to works directly related to the major issues raised by this book; for specialist references see the individual chapters.

Adorno, T., *Prisms*, tr. S. and S. Weber, London, Neville Spearman, 1967. Translation of important work in the realm of cultural theory.

Althusser, L., *Reading Capital*, tr. B. Brewster, London, New Left Books, 1970. Translation of work by key French theorist vigorously attacked by E. P. Thompson (see below).

Anderson, P., *Arguments with English Marxism*, London, Verso, 1980. Interesting discussion by leading English Marxist.

Arato, A. and Gebhardt, E. (eds), *The Essential Frankfurt School Reader*, Oxford, Basil Blackwell, 1978. Useful collection.

Atkinson, R. F., *Knowledge and Explanation in History*, London, Macmillan, 1978. A clear exposition of the beliefs and practices of 'traditional' historians.

Bagby, P., *Culture and History*, London, Longmans, 1959. 'Culture' is here used in the anthropological sense; Bagby was rather critical of 'traditional' historical methods.

Barrell, J., *The Idea of Landscape and the Sense of Place 1730–1840: An Approach to the Poetry of John Clare*, Cambridge, Cambridge University Press, 1972. Pioneering early work by one of the contributers of this volume, placing great stress on language.

------*The Dark Side of the Landscape: The Rural Poor in English Painting 1730–1840*, Cambridge, Cambridge University Press, 1980. As well as language, the concept of 'ideology' in the 'critical' or 'Marxist' sense is very important in this book.

------*English Literature in History 1738–80*, London, Hutchinson, 1983. This book is also important for the editorial introduction to what was planned as a new series by Raymond Williams.

------*The Political Theory of Painting from Reynolds to Hazlitt*, New Haven and London, Yale University Press, 1986. Fascinating application of the notion of 'discourse'.

Barret, M. et al., *Ideology and Cultural Production*, London, Croom Helm, 1979. Useful collection.

Barthes, R., *Elements of Semiology*, tr. A. Lavers and C. Smith, London, Cape, 1967. Translation of central work in linguistic theory. See also under Lane, Michael.

Barzun, J., *Berlioz and the Romantic Century*, London, Gollancz, 1952. Example of cultural history by an ultra-conservative historian.

Bennett, T., et al. (eds) *Culture, Ideology and Social Process*, London, Open University Press and Batsford, 1981. Excellent examples from a group of 'cultural theorists', many strongly influenced by Gramsci.

Berger, J., *Ways of Seeing*, Harmondsworth, Penguin Books, 1972. Central work of leading English Marxist art critic.

Berger, P. and Luckmann, T., *The Social Construction of Reality*, Harmondsworth, Penguin Books, 1966. Standard work on its topic.

Bloch, M., *The Historian's Craft*, Manchester, Manchester University Press, 1954. Imaginative exposition of 'traditional' approaches by one of the joint-founders of the first generation of the *Annales* school.

Bottomore, T. B. and Rubel, M., *Karl Marx: Selected Writings in Sociology and Social Philosophy*, London, Watts, 1956. Useful collection of readings.

Braudel, F., *On History*, tr. S. Matthews, Chicago, Chicago University Press, 1980. Collection of writings by the historian regarded by many as the greatest of his generation.

Briggs, A., *The History of Broadcasting in the United Kingon*, 4 vols, Oxford, Oxford University Press, 1961–79. Standard work relating the important media of communication to their social context.

Burckhardt, J., *The Civilization of the Period of the Renaissance of Italy*, tr. S. G. C. Middlemore, 2 vols, London, Kegan Paul & Co., 1878. Classic demonstration that the arts have long been a preoccupation of at least some historians.

Burke, P., *The Italian Renaissance: Culture and Society*, Cambridge, Polity Press, 1986. Brilliant example of interdisciplinary cultural history.

Canary, R.H. and Kozicki, H., (eds) *The Writing of History: Literary Form and Historical Understanding*, Madison, University of Wisconsin Press, 1978. The title well describes the nature of this book, a challenge, of course, to 'traditional' notions about historical writing.

Centre of Contemporary Cultural Studies, *Making Histories: Studies in History-writing and Politics*, London, Hutchinson, 1982. Collection of sophisticated essays, essentially seeing history as politically motivated discourse.

Colls, R. and Dood, P. (eds) *Englishness: Politics and Culture 1800–1920*, London, Croom Helm, 1986. Useful collection of essays relating to one of the central issues of this book.

Conway, David, *A Farewell to Marx: An Outline and Appraisal of His Theories*, Harmondsworth, Penguin Books, 1987. Useful textbook.

Coward, R. and Ellis, J., *Language and Materialism: Developments in Semiology and the Theory of the Subject*, London, Routledge & Kegan Paul, 1977. Standard work on its topic.

Curran, J. and Porter, V. (eds) *British Cinema History*, London, Weidenfeld, 1983. Excellent collection of articles.

Dickens, A. G., *The Age of Humanism and Reformation*, Englewood Cliffs, New Jersey, Prentice Hall, 1972. Fine example of integrated political and cultural history by a conservative historian.

Dunne, T. (ed.) *The Writer as Witness: Literature as Historical Evidence*, Cork, Cork University Press, 1987. Collection of fairly 'traditional' essays with a rather incoherent introduction by the editor which argues that 'history is a statement as personal in its way as that of the poet or novelist'.

Eagleton, T., *Literary Theory: An Introduction*, Oxford, Basil Blackwell, 1983. Well-known work by a leading British exponent (which, to me, reveals an all-too-typical ignorance of history).

Ferro, M., *The Use and Abuse of History: Or How the Past is Taught*, London, Routledge & Kegan Paul, 1984. The book's basic premise is that we can distinguish between reliable history and mere propaganda, and it is the best rebuttal I know of the argument that all history is simply narrative or discourse.

Film and the Historian, London, British Universities Film Council, 1968. Interesting collection of essays characteristic of the great outburst of interest in this topic in the later 1960s.

Foucault, M., *The Archaeology of Knowledge*, tr. A. Sheridan, London, Tavistock, 1972.

------*Mental Illness and Psychology*, tr. A. Sheridan, New York, Harper & Row, 1976.

------*Discipline and Punish*, tr. A. Sheridan, Harmondsworth, Penguin Books, 1979.

------*A History of Sexuality*, tr. R. Hurley, 3 vols, London, Allen Lane, 1980–7. All of these are translations of key works in the discourse theory canon.

Fussell, P., *The Great War and Modern Memory*, Oxford, Oxford University Press, 1975. Classic interdisciplinary work on the literature of the First World War.

Gardiner, P., *The Nature of Historical Explanation*, Oxford, Oxford University Press, 1952. Classic philosopher's exposition of the 'traditional' position.

Gay, P., *Style in History*, New York, Basic Books, 1974. Through studies of Gibbon, Ranke, Macaulay, and Burckhardt concludes that history is both art and science.

------*Art and Act: On Causes in History – Manet, Gropius, Mondrian*, New York, Harper & Row, 1976. Interesting use of three creative artists in order to study the nature of historical causation.

------*The Bourgeois Experience: Victoria to Freud*, 2 vols, Oxford, Oxford University Press, 1985–7. Masterly interdisciplinary cultural history.

Gerth, H. H. and Wright Mills, C. (eds) *From Max Weber: Essays in Sociology*, London, Kegan Paul, Trench & Trubner, 1947. Useful readings.

Gombrich, E. H., *In Search of Cultural History*, Oxford, Oxford

University Press, 1969. Splendid discussion of the different types of cultural history (and Gombrich's own approach) prior to the era, in this country, of cultural theory.

Gramsci, A., *The Modern Prince and Other Writings*, tr. L. Marks, New York, International Publishers, 1957.

------*The Prison Notebooks*, eds Q. Hoare and G. Nowell Smith, London, Lawrence & Wishart, 1971. Both are translations of keyworks in the development of the theory of 'cultural hegemony'.

Hall, S. *et al.*, *Culture, Media, Language*, London, Hutchinson, 1980. Invaluable collection.

Hartman, G. H., *Saving the Text: Literature/Derrida/Philosophy*, Baltimore, Johns Hopkins University Press, 1981. Useful introduction.

Hawkes, T., *Structuralism and Semiotics*, London, Methuen 1977. Useful introduction.

Held, David, *Introduction to Critical Theory*, London, Hutchinson, 1981. Useful introduction.

Kress, G. and Hodge, R., *Language as Ideology*, London, Routledge & Kegan Paul, 1979.

Lane, M, (ed.) *Structuralism: A Reader*, London, Cape, 1970. Excellent editor's introduction; contains essay by Roland Barthes on 'Historical Discourse'.

Mandelbaum, M., *The Anatomy of Historical Knowledge*, Baltimore, Johns Hopkins University Press, 1977. Philosophical work which finds 'traditional' historical explanations adequate, and 'traditional' historical knowledge securely-based.

Marwick, A., *Class: Image and Reality in Britain, France and the USA since 1930*, London, Collins, 1980. Draws upon film and novels; proposes the term 'class awareness' as an alternative to 'class consciousness'.

------*The Nature of History*, London, Macmillan, 1989. This third, totally revised, edition discusses 'the place of theory', 'the historian at work' (two chapters), 'literature and art as primary sources' and 'history, philosophy, and interdisciplinary studies'.

Marx, K. and Engels, F., *The German Ideology*, ed. C. J. Arthur, London, Lawrence & Wishart, 1970. Translations of three key works.

Marx, K., *Grundrisse*, tr. M. Nicolaus, Harmondsworth, Penguin Books, 1973.

------*Early Writings*, intro. L. Colletti, Harmondsworth, Penguin Books, 1975.

Plantinga, T., *Historical Understanding in the Thought of Wilhelm Dilthey*, Toronto, University of Toronto Press, 1985. Discusses, among other things, Dilthey's view (taken up in this book by Stana Nenadic) that the humanities penetrate human experience more deeply than the sciences.

Pointon, M., *History of Art: A Student's Handbook*, 2nd edn, London, Allen & Unwin, 1986. A revised edition which refers both to 'traditional' approaches and to the newer ones.

Poster, M., *Foucault, Marxism and History: Mode of Production vs Mode

324

of Information, Oxford, Polity Press, 1984. Lucid and helpful.

Punter, D., (ed.) *Introduction to Contemporary Cultural Studies,*London, Longman, 1986. Useful collection confined to Britain since 1945.

Reddy, W. M., *Money and Liberty in Modern Europe: A Critique of Historical Understanding,* Cambridge, Cambridge University Press, 1986. American Marxist shows where Marxist analysis of the various allegedly bourgeois revolutions has gone wrong.

Schama, S., *The Embarrassment of Riches: An Interpretation of Dutch Culture in the Golden Age,* New York, Knopf, 1987. Splendid example of integrated cultural history without benefit of cultural theory.

Scribner, R. W., *For the Sake of Simple Folk,* Cambridge, Cambridge University Press, 1981. Brilliant exploitation of woodcuts for the study of popular mentalities during the Reformation.

Smith, P. (ed.) *The Historian and Film,* Cambridge, Cambridge University Press, 1976. A sound introduction.

Sorlin, P., *The Film in History: Re-staging the Past,* Oxford, Basil Blackwell, 1980. The opening section on methodology is particularly useful.

Stanford, M., *The Nature of Historical Knowledge,* Oxford, Basil Blackwell, 1986. Lucid study of the use of structures in history.

Thompson, E.P., *The Poverty of Theory and Other Essays,* London, Merlin, 1978. The main essay is indispensable reading, with the defence of sound historical method coming over at least as strongly as the Marxist inflections.

Thompson, J. B., *Studies in the Theory of Ideology,* Berkeley, University of California Press, 1984. Invaluable introduction.

Veyne, P., *Writing History: Essay on Epistemology,* Middletown, Wesleyan University Press, 1984. Presents the writing of history as analogous to the writing of novels.

White, H., *Metahistory: The Historical Imagination in Nineteenth-Century Europe,* Baltimore, Johns Hopkins University Press, 1973. Declares all history to be rhetorical, poetic, philosophical.

Williams, R., *Culture and Society,* Harmondsworth, Penguin Books, 1971.

------*Keywords: A Vocabulary of Culture and Society,* London, Fontana, 1976.

------*Marxism and Literature,* Oxford, Oxford University Press, 1977.

------*Problems in Materialism and Culture,* London, Verso, 1980.

------*Culture,* London, Fontana, 1981. Key works by leading British cultural theorist. (See also Barrell, J.).

Wolff, J., (*The Social Production of Art,* London, Macmillan, 1981. Sensible introduction to cultural theory.

Index